ART DECO

LIVING WITH THE ART DECO STYLE

MILLER'S ART DECO
by Judith Miller

First published in Great Britain in 2016 by Miller's,
a division of Mitchell Beazley, imprints of Octopus Publishing Group Ltd,
Carmelite House, 50 Victoria Embankment, London EC4Y 0DZ
www.octopusbooks.co.uk
www.octopusbooksusa.com

Miller's is a registered trademark of Octopus Publishing Group Ltd
www.millersonline.com

An Hachette UK Company
www.hachette.co.uk

Distributed in the US by Hachette Book Group USA,
1290 Avenue of the Americas, 4th and 5th Floors, New York, NY 10020

Distributed in Canada by Canadian Manda Group,
664 Annette Street, Toronto, Ontario, Canada M6S 2C8

ISBN 978 1 78472 106 0

A CIP record of this book is available from the British Library and the Library of Congress.

Printed and bound in China

10 9 8 7 6 5 4 3 2 1

Chief contributors:
Julie Brooke (Furniture; Ceramics; Posters), **Lesley Jackson** (Glass), **Lisa Lloyd**
(Sculpture; Textiles), **Sarah Yates** (Introduction; Silver, Metalware, Clocks & Plastic)

Publisher: Alison Starling
Art Director: Jonathan Christie
Designers: Isabel De Cordova, Jaz Bahra
Senior Production Manager: Peter Hunt
Senior Editor: Alex Stetter
Editorial Co-ordinator: Zenia Malmer
Copy Editor: Linda Schofield
Proofreader: Jane Birch

VALUE CODES
Throughout this book the value codes used at the
end of each caption correspond to the approximate
value of the item. These are broad price ranges and
should be seen only as a guide to the value of the
piece, as prices vary depending on the condition of
the item, geographical location, and market trends.
The codes are interpreted as follows:

A £200,000/$300,000 and over
B £100,000–200,000/$145,000–300,000
C £75,000–100,000/$110,000–145,000
D £50,000–75,000/$72,500–110,000
E £30,000–50,000/$44,000–72,500
F £20,000–30,000/$30,000–44,000
G £15,000–20,000/$22,000–30,000
H £10,000–15,000/$14,500–22,000
I £5,000–10,000/$7,250–14,500
J £2,000–5,000/$3,000–7,250
K £1,000–2,000/$1,500–3,000
L £500–1,000/$725–1,500
M £100–500/$150–725
N under £100/$150
NPA No price available

ART DECO

LIVING WITH THE ART DECO STYLE

JUDITH
MILLER

MILLER'S

CONTENTS

14

62

102

FURNITURE **CERAMICS** **GLASS**

la ligne

AURORE
est inimitable

DAUDE FRÈRES

INTRODUCTION

Art Deco was the first truly international modern style. It began to develop before the First World War but reached its height during the 1920s and 1930s, taking its name from the *Exposition Internationale des Arts Décoratifs et Industriels Modernes* held in Paris in 1925. Emerging in a period of optimism after the destruction of the war, it transformed all branches of design, from transport and product design, to fashion, graphic design, and architecture. The movement was at its zenith in a period of dramatic technological change, social and economic upheaval, political crises, and globalization, as well as an explosion in the production of consumer goods.

Art Deco is a complex movement that celebrates a myriad of contrasting influences and new developments: machine production and handicraft, tradition and modernity, luxury and affordability, escapism and reality. A fascination with Egypt, Africa, and Asia is apparent in the themes, motifs, and materials of many Art Deco wares, while cocktail paraphernalia, radios, and other new products and technology of the period evoke changing lifestyles and new leisure pursuits. This was also the era of new musical genres like jazz, of Diaghilev's Ballets Russes, and the risqué performances of Josephine Baker at the Moulin Rouge as well as the energetic dances of the modern "flapper". Art Deco's association with innovation, glamour, and modernity led to it reaching all corners of the world.

Origins and the 1925 Exhibition

Often seen as a reaction against the curvilinear, florid Art Nouveau style, Art Deco was in many ways its successor, as the simplified, rectilinear forms, and geometric, stylized, or abstract motifs so associated with the new movement could be found in the work of designers such as Josef Hoffmann in Vienna and elsewhere in the early 1900s. The style is, however, identified most closely with the *Exposition Internationale des Arts Décoratifs et Industriels Modernes* in Paris, which was dedicated to showing works that demonstrated "new inspiration and real originality".

The exhibition attracted 16 million visitors between April and October 1925, with more than 150 temporary stands on a site in central Paris. Its primary aim was to promote France as the pre-eminent centre for the production of luxury goods,

RIGHT
Held in Paris in 1925 primarily to promote modern decorative arts from France, the Exposition Internationale des Arts Décoratifs et Industriels Modernes put Art Deco on the map. The show's pavilions devoted to designers, manufacturers and department stores included this one by Galeries Lafayette.

OPPOSITE
The Art Deco style originated in Paris, but it soon spread around the world. With its streamlined curves and row of portholes, the Essex House Hotel in Miami Beach brings to mind an ocean liner. Built in 1938, this prime example of Art Deco architecture in Florida was designed by Henry Hohauser.

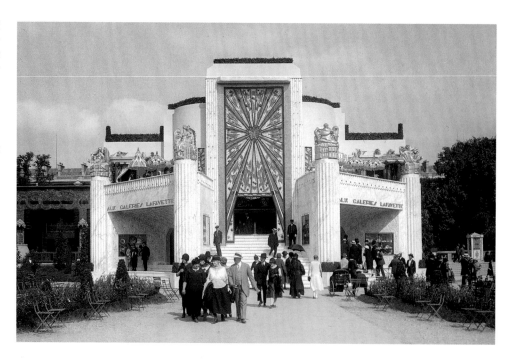

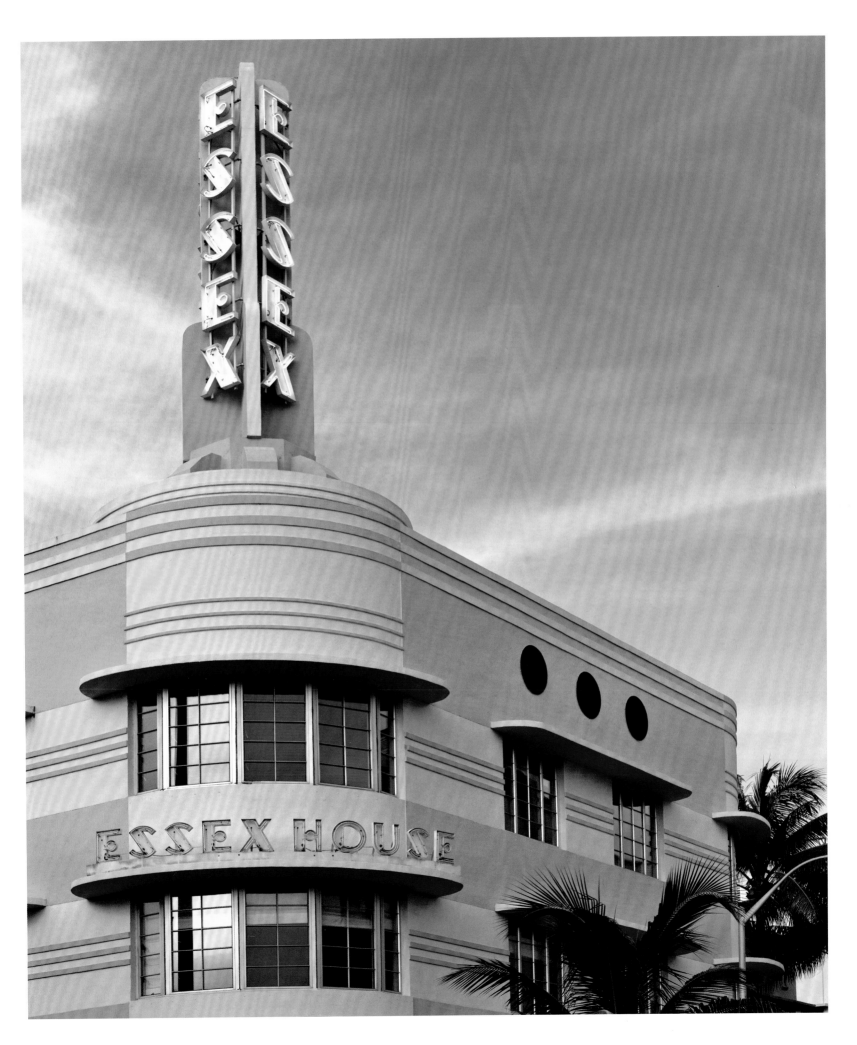

although other countries (except the USA, which declined to take part) also displayed wares. The exhibition was dominated by French designers, including the furniture maker Jacques-Émile Ruhlmann, the glassmaker René Lalique, and the silversmith Jean Puiforcat, along with pavilions representing the design studios of the major French department stores, such as Printemps and Galéries Lafayette. Extravagant novelties were a popular feature of the event: the Eiffel Tower was lit up by the Citroën company with thousands of electric lights (artificial lighting was a relatively new invention), while the couturier Paul Poiret played a "perfume piano" that emitted different scents for different tunes. Contrasting with the lavish display of luxury goods was the *Pavillon de L'Esprit Nouveau* (Pavilion of the New Spirit) designed by the modernist Swiss-born architect Le Corbusier, which comprised a full-size model of a two-storey house based on a modular, standardized system of construction that contained mass-produced furniture and abstract paintings.

Motifs, forms, influences, and materials

Encompassing a bewildering diversity of expression, Art Deco has sometimes been described as a "taste" in design rather than a coherent style or movement. There are, however, some common features: simplified, often angular forms; bold colours; stylized or geometric decoration; high-quality materials and craftsmanship; often indirect references to historic styles, both Western and non-Western; and themes reflecting contemporary culture and new technology in electrification, mechanization, and transport.

Early Art Deco designs of the 1920s featured rounded motifs such as formalized baskets of flowers, fountains, stylized birds and animals, elongated figures of young women, and rosebuds. As the style developed motifs became increasingly geometric, symmetrical, and rectilinear – drawing inspiration from the fascination with travel and speed of the new Machine Age – and included spirals, sunbursts, chevrons, zigzags, and lightning bolts. Huntresses and dancing figures were derived from the

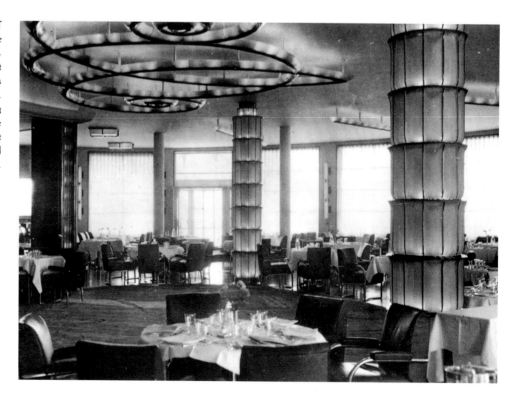

RIGHT
When the SS *Normandie* was launched in 1935, she was the world's largest and fastest ocean liner, as well as the most luxurious. First-class passengers making the crossing from Le Havre to New York dined in a vast room featuring illuminated columns of Lalique glass.

figural sculpture and decoration of classical Greece and Rome and appeared in a wide variety of designs, including those for glass and ceramics. The predominant palette of vibrant, primary and neon colours was influenced by the early 20th-century Fauvist movement paintings of Henri Matisse and Maurice Vlaminck, among others.

A taste for the "exotic" also permeated Art Deco motifs, themes and materials, reflecting the widespread fascination with non-Western cultures as ocean liners, trains, and aeroplanes – as well as new forms of mass communication including radio – opened up new worlds of inspiration to designers and makers. This is especially evident in the use of tropical woods such as amboyna and macassar ebony, as well as ivory, sharkskin, enamel, and lacquer, used by manufacturers for the luxury market.

A craze for all things ancient Egyptian appeared after 1922, when the discovery of the tomb of the boy pharaoh Tutankhamun and its extraordinary contents, including the pharaoh's spectacular gold funerary mask, caused a sensation. Motifs such as lotus flowers, hieroglyphics, and pyramids, as well as turquoise, gold, and semi-precious stones, became all the rage, appearing on everything from buildings to jewellery. In the Americas, the art and architecture of the indigenous ancient Maya and Aztec cultures proved influential, especially in architecture, where the stepped forms of skyscrapers reflected the construction of ancient ziggurats.

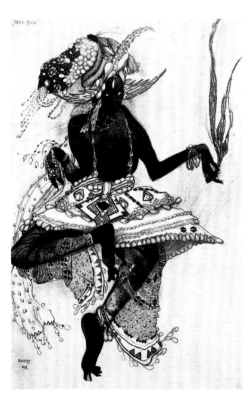

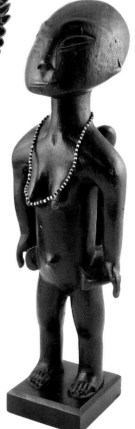

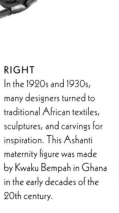

LEFT
A costume design by Leon Bakst for "Le Dieu bleu", a ballet choreographed by Michel Fokine that was first staged in 1912 by the Ballets Russes in Paris. Led by Sergei Diaghilev, the company's ground-breaking work caused a sensation.

ABOVE
The discovery in 1922 of Tutankhamun's treasure led to the appearance of ancient Egyptian motifs in architecture and the decorative arts. Dating from c1325 BC, this pectoral jewel shows the god Horus in the form of a falcon.

RIGHT
In the 1920s and 1930s, many designers turned to traditional African textiles, sculptures, and carvings for inspiration. This Ashanti maternity figure was made by Kwaku Bempah in Ghana in the early decades of the 20th century.

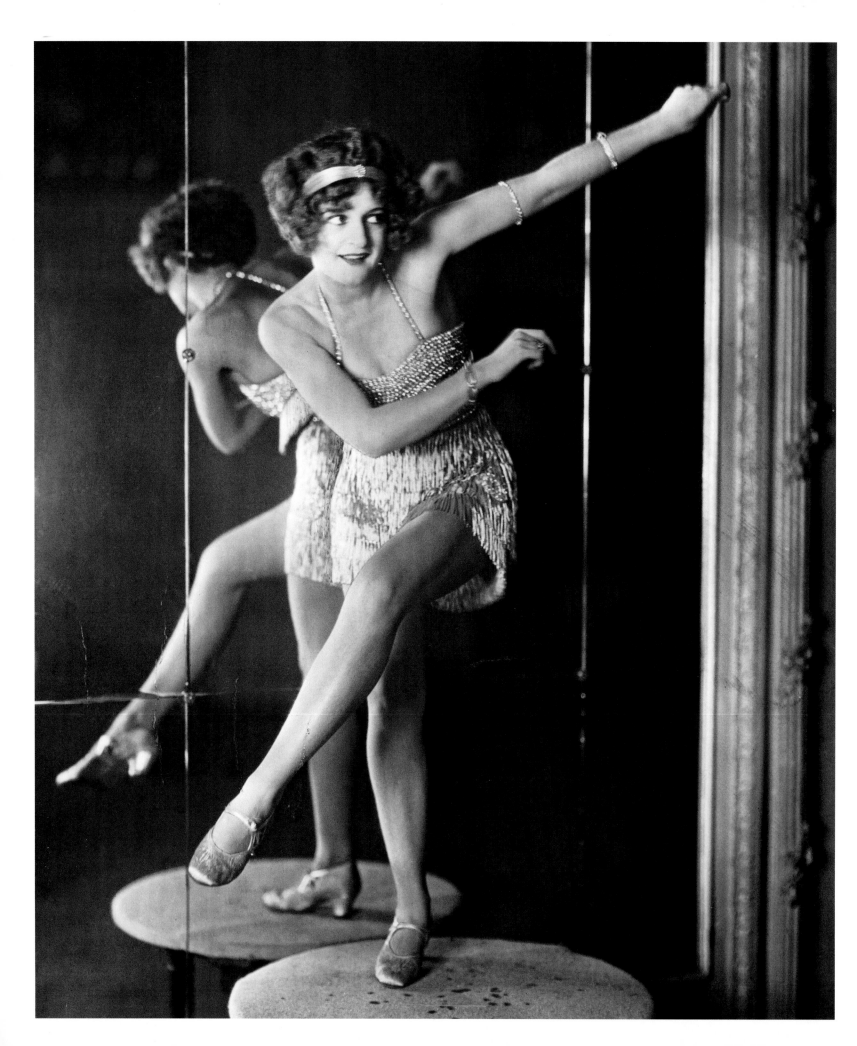

A vogue for Chinese and Japanese art also emerged. The simple geometric forms of Japanese decorative arts and architecture were particularly influential, but most distinctive was the fashion for black-and-red colour combinations, eggshell, and silver leaf, alongside plain and decorated lacquered furniture, screens, metalwork, and other objects. The exotic designs produced by Leon Bakst for the Ballets Russes in the 1910s also had an impact on the popularity of so-called "Oriental" taste. African art was widely collected and imported into Europe, especially from the French colonies, and provided a rich sources of inspiration. The geometric marks, circles, and triangles of African textiles, shields and sculptures also became part of the repertory of Art Deco. African-American culture was also regarded as epitomizing the vitality of modern urban life. Perhaps its most famous exponent was Josephine Baker, whose erotically charged "Danse Sauvage", first performed in Paris in 1925, combined a fascination with the "primitive" with modern black American music and dance.

Modernism
Art Deco was not simply a luxury style catering for an elite market. Modernist and industrial designers, especially in the United States, turned to new materials such as aluminium, chromium, and tubular steel, as well as cheaper metals such as copper and brass, not just for furniture but also for large-scale interiors, especially cinemas. Glass and concrete became the dominant elements of modern architecture, while the invention of versatile new plastics such as Bakelite and Catalin helped to meet the massive demand for consumer goods such as vacuum cleaners, desk accessories, and radios, especially in the 1930s.

The Wall Street Crash of 1929 and the ensuing Depression years led to a dramatic downturn in the demand for luxury goods. Parallel to this was the development of a more austere aesthetic promoted by avant-garde designers who advocated good-quality design for all and an ethos of "form follows function". The best-known of these was the Bauhaus school

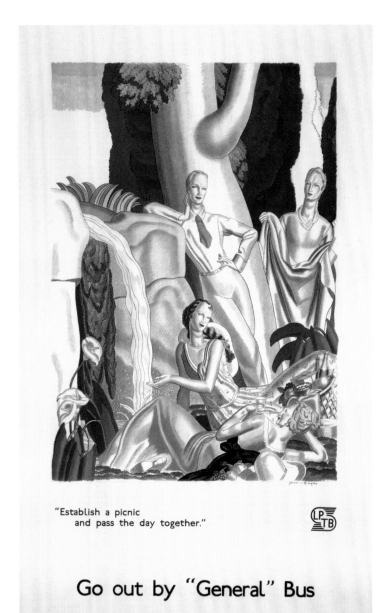

"Establish a picnic and pass the day together."

Go out by "General" Bus

OPPOSITE
With her bobbed hair, beaded dress, and carefree attitude, Charleston dancer Bee Jackson was the embodiment of the flapper in 1925 – although her fringed hemline was higher than those usually worn off-stage by her contemporaries.

RIGHT
This 1933 poster by Jean Dupas encouraged Londoners to travel by bus and "establish a picnic". As well as producing illustrations for London Transport and Vogue, Dupas worked on the decor of the Normandie and other ocean liners.

founded in Weimar, Germany, in 1919. Its aim was to train artists to work with industry, an approach that proved highly influential, especially as many Bauhaus designers went on to teach in American universities. The Bauhaus was known for starkly geometric tubular-steel furniture, lighting, and textiles, designed by Marcel Breuer, Ludwig Mies van der Rohe, and Marianne Brandt, among others.

Art Deco around the World

In the 1920s, Art Deco became a global phenomenon – the 1925 Paris *Exposition* was widely covered in the press and many designers from other countries visited it, while exhibitions of French decorative arts toured the world, and department stores promoted the style to consumers. Stylized and abstract motifs with local and regional meanings were widely assimilated into the new style. In the 1930s, with the rise of Fascism, many European designers emigrated to the United States, while Hollywood film was an important medium for transmitting the style across popular culture.

One of the main reasons for Art Deco's popularity was its association with "modernity", commerce, and new technologies. Nowhere was this more apparent than in the United States, where the symbolism of the modern metropolis adopted by Art Deco designers included skyscraper motifs, angular decoration suggestive of the rhythms of jazz, and the development of the purely American idiom of "streamlining". Representing the vogue for travel and derived from the aerodynamic forms of cars, trains, and planes, it was characterized by soft curving, elongated forms and horizontal banding, particularly in the designs of Raymond Loewy and Norman Bel Geddes.

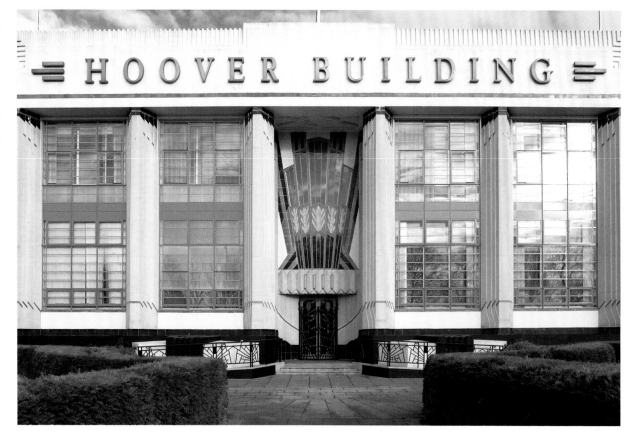

RIGHT
Set on a busy road on the western outskirts of London, the Hoover Building was designed in 1933 by Wallis, Gilbert & Partners to be a "modern palace of industry". The vacuum-cleaner factory's Egyptian-inspired facade was floodlit at night, serving as a glamorous beacon for passing motorists.

The Art Deco revival

Art Deco fell out of fashion after the Second World War, but renewed interest in the decorative arts of the interwar years first began to emerge in the 1960s, another period of tumultuous political, cultural, technological, and social change. Art Deco designers were rediscovered, long-neglected buildings of the period protected and restored, and exhibitions on the subject presented, and books published. The most influential of these publications was Bevis Hillier's *Art Deco of the 20s and 30s* (1968), which gave the "Art Deco" label widespread currency. Since that time the style's popularity among collectors and dealers has increased enormously. With their clean lines, bright colours, bold motifs, and innovative techniques, Art Deco pieces continue to evoke the glamour, glitter, and optimism of the Jazz Age.

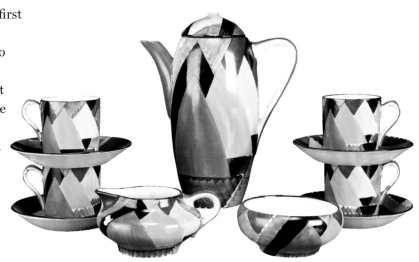

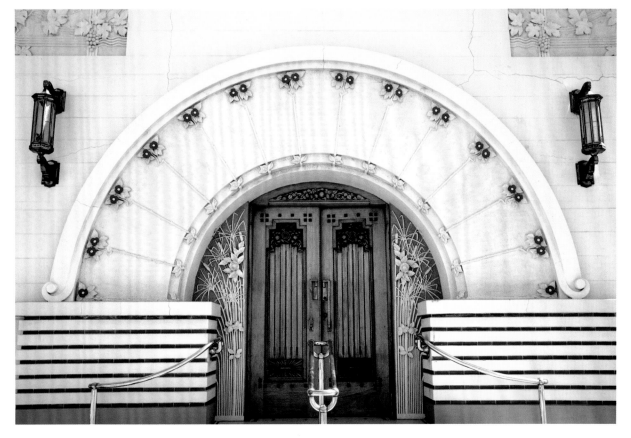

ABOVE
Susie Cooper's "Cubist" pattern, as seen on this coffee service manufactured by Gray's Pottery in the late 1920s, displays the bold colour combinations and geometric shapes typical of the Jazz Age.

LEFT
With its flamboyant pink-and-gold arched entrance framing carved wooden doors, the National Tobacco Company Building is one of the Art Deco jewels of Napier, New Zealand. In 1931, the town was devastated by the Hawke's Bay earthquake and subsequently rebuilt in the fashionable style of the day.

FURNITURE

THE CLASSICAL INFLUENCE

In France, Art Deco furniture owed its origins to the elegant, Neo-classical designs of the Louis XVI era (1754–93). These pieces were characterized by the use of the finest materials and high standards of craftsmanship to create sleek, refined objects that relied on wood veneers, delicate carving, and inlays for decoration. This style dominated the 1925 *Exposition Internationale des Arts Décoratifs et Industriels Modernes* and is epitomized by the rooms designed by Émile-Jacques Ruhlmann, which were the fair's most admired attraction.

While for many Ruhlmann was the greatest designer of his era, he was not the only one creating furniture with a classical influence. Paul Follot's designs from the 1920s also used exotic woods, complex carpentry, and expensive materials. Historical styles also influenced the work of Léon and Maurice Jallot, Maurice Dufrène and Louis Süe, and André Mare. Their contemporary Jules Leleu created similarly elegant pieces with minimal surface decoration, which evolved from a Louis XVI style to an angular, Cubist-influenced look.

This classic influence was also seen in Belgium, where the De Coene Frères factory produced pieces that combined an Art Deco elegance with a traditional Belgian aspect. In Italy, Gio Ponti created elegant modern furniture that was enhanced by Neo-classical-style decoration.

These designers used traditional materials and skills to reimagine historical designs for the modern world. Many well-known Art Deco designers began their careers as architects and went on to be celebrated as *artistes décorateurs* – offering a complete interiors scheme with the furniture, carpets, wallpaper, curtains, and accessories designed or chosen to enhance the room. Department stores in Paris offered a similar service, installing room sets that showed how pieces could be displayed in the home. Dufrène even went on to run the La Maîtrise interiors department at the Galeries Lafayette.

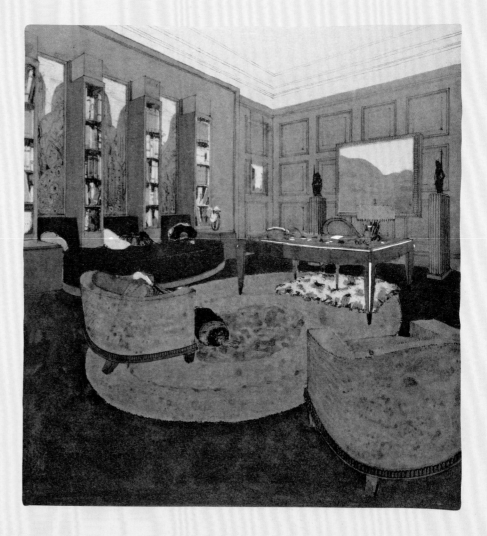

RIGHT
The clean lines and elegant curves of the armchairs, bookshelves, and desk in this 1929 design exemplify the design ideals of Émile-Jacques Ruhlmann.

OPPOSITE
An illustration of a small salon featuring furniture designed by Ruhlmann, dating from the mid 1920s. The careful balance of luxurious materials, colour combinations, and elegant stylistic details create a distinctly modern interior.

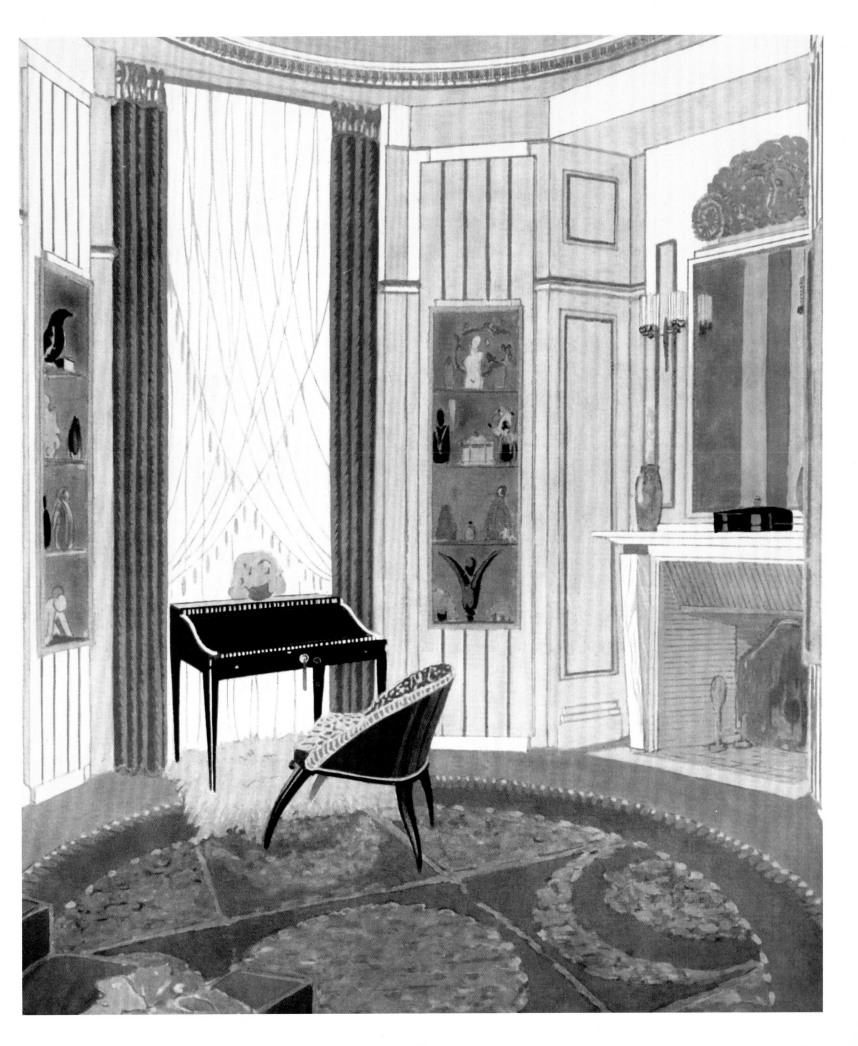

ÉMILE-JACQUES RUHLMANN

The luxurious creations of Émile-Jacques Ruhlmann (1879–1933) mark him out as one of the most revered names of the Art Deco Movement and among the finest furniture makers and designers of the 20th century.

It is perhaps no surprise that Ruhlmann grew up to create stylish furniture made from exotic, luxurious, and expensive materials. After completing his military service in 1901, he began to work for his father François at the Parisian interior design company Société Ruhlmann, which sold elegant mirrors, paintings, and wallpapers of the highest quality. It was there that Émile-Jacques' talent as a draughtsman and designer was first noticed. He took over the running of the firm following his father's death in 1907.

Ruhlmann's first designs, which included exquisite furniture, lamps, and fabric, were shown at the 1913 Salon d'Automne in Paris. In 1919, his firm merged with that of builder and remodeller Pierre Laurent to become REL (Ruhlmann et Laurent). It went on to become one of the largest firms of its type in Paris, employing more than 600 people at its peak.

The 1920s saw Ruhlmann at the height of his success – marked by a spectacular display of typically sophisticated rooms designed for the *Exposition Internationale des Arts Décoratifs et Industriels Modernes*, held in Paris in 1925. These were typical of the celebrated interiors he designed for his wealthy clients.

Like his other designs, the pieces he created for the Paris Exposition show meticulous attention to detail: carefully chosen woods with inlays of mother-of-pearl, metal, or ivory are crafted with incredible precision. The carved patterns on his earlier work are subtle and finely executed: details such as escutcheons and keys usually match.

As well as REL, in 1923 Ruhlmann opened his own cabinetmaking company, employing the finest craftsmen and draughtsmen.

Such was his success, Ruhlmann was able to live the elegant lifestyle he created for others. His showroom was furnished

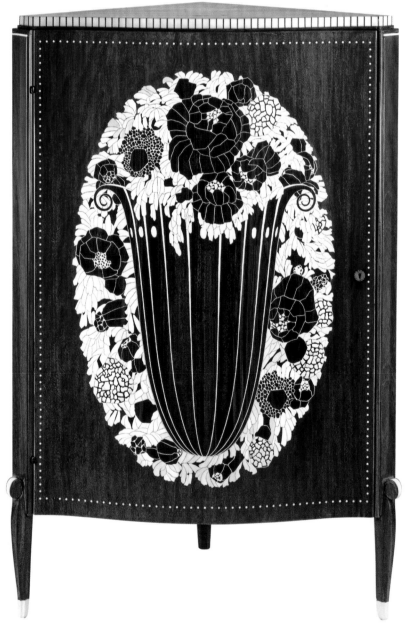

RIGHT
A Ruhlmann corner cabinet, kingwood veneer on mahogany with ivory inlay.
c1923, 50in (127cm) high, **NPA**

with fine antiques mixed with examples of his own work, while the tackle box he designed to take on fishing trips – he was a keen angler – was made from macassar ebony.

The hallmarks of Ruhlmann's furniture are elegant lines, typical of the French Goût Grec (Greek style) or Louis XVI style, but with a clean, modern feel, made from rich, exotic woods and other materials and to exceptionally high standards of craftsmanship similar to the work of the 18th-century royal *ébénistes* (cabinetmakers). Some people referred to him as "the Riesener of the 20th century", comparing him to Jean-Henri Riesener (1734–1806), Louis XVI's celebrated cabinetmaker, and this made his work all the more appealing to his clients who considered themselves to be modern French royalty.

Business declined between the Depression in 1929 and Ruhlmann's death in 1933. After his death his furniture designs were made under the direction of his nephew, Alfred Porteneuve (1896–1949).

BELOW MIDDLE
This low fireside table is typical of Ruhlmann's extravagant furniture designs. Every surface is veneered in amboyna – one of the most expensive burl woods – with exotic ivory inlays. The circular top rotates and the table has a stepped base. These are not the only features that make it as desirable today as it was when it was made: the base is marked with the "Ruhlmann Atelier A" signature. c1930, 29¼in (74cm) wide, **NPA**

BELOW LEFT AND RIGHT
These dining chairs were part of a set of 18 exhibited at Ruhlmann's pavilion at the 1925 Paris *Exposition Internationale*. He designed the pavilion, called the Hôtel du Collectionneur, as the imaginary villa of a rich and discerning collector. The burl walnut chairs are upholstered in red leather and set with metal mounts. c1925, 36in (91.5cm) high, **NPA**

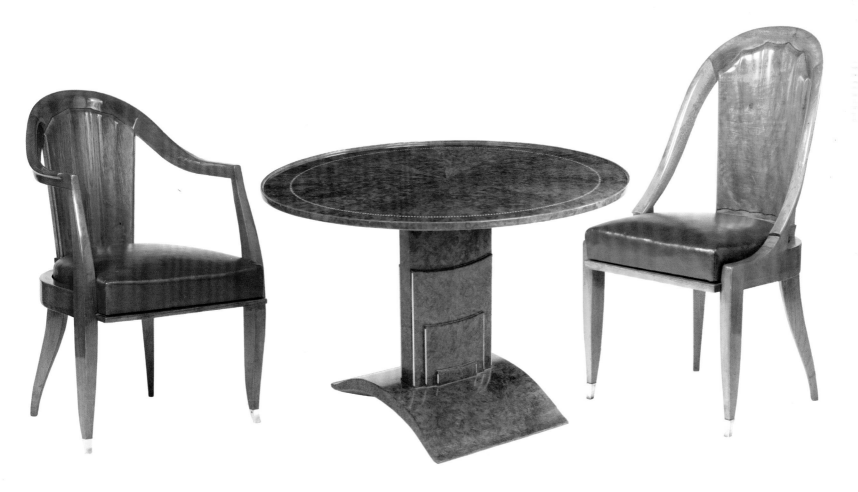

PAUL FOLLOT

P aul Follot (1877–1941) was one of the leaders of the Art Deco Movement in France and his work influenced other designers around the world.

Although he is mostly remembered for his beautifully voluptuous upholstered Art Deco furniture, Follot originally trained as a sculptor and was an interior designer for much of his career, which began in Paris before 1900. His work was soon picked up by La Maison Moderne, a short-lived gallery of modern design that had been founded in the city in 1899 by German dealer Julius Meier-Graefe (1867–1935) and which competed with the better-known Maison de l'Art Nouveau, a gallery established by the influential German-born art dealer Siegfried "Samuel" Bing (1838–1905) in 1895.

Follot became a member of the Société des artistes décorateurs in 1901 and by 1920 he was creating furniture that recalled the early Louis XVI style. Like the pieces from that era, his elegant, luxurious work featured exotic woods, expensive inlays, and complex woodwork. The "Follot style" was copied around the world and the term is still used today.

From 1923 Follot was the artistic director of Pomone, the interior and furniture design studio that was part of the Le Bon Marché department store in Paris. He also designed all the rooms for the store's pavilion at the 1925 Paris *Exposition Internationale*, as well as a vestibule for the pavilion showcasing ideas for a modern French embassy, organized by the Société des artistes décorateurs.

Follot's style evolved throughout his career: from Art Nouveau in the early years, to Neo-Rococo in the mid 1920s, Cubist by the late 1920s, and resolutely Modernist by 1930. He remained active until the mid 1930s.

As well as furniture, Follot designed carpets for Savonnerie, textiles for Cornille et Cie, ceramics for Wedgwood, and glass and silver for Christofle, exhibiting his work at the Paris salons. As his pieces were not signed, the best way to identify them is from exhibition documents.

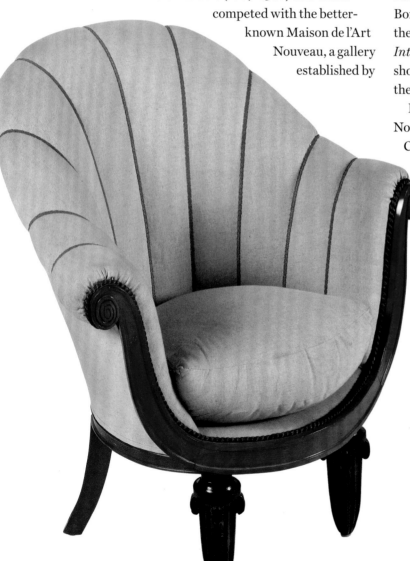

LEFT
One of a pair of rare bergère chairs by Paul Follot. The U-shaped seat rail has carved scroll terminals and frames an arched, ribbed, upholstered back. It is supported on outswept rear legs and ebonized, fluted, tapering feet at the front. c1920, 32¼in (81.5cm) high, **F**

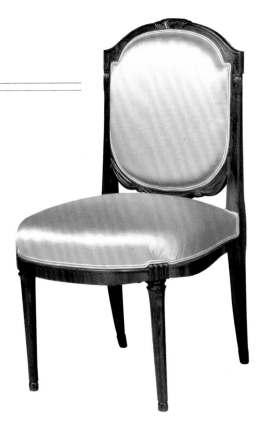 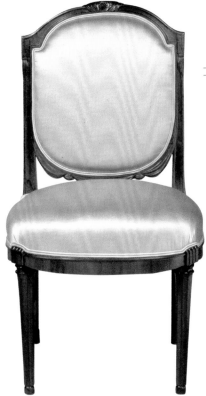

LEFT
A pair of solid rosewood upholstered dining chairs by Paul Follot. The bases of the chairbacks are hand-carved with swags of fabric and the tops with flowers and swags. The carved, tapering legs finish with carved feet. c1920, 37in (94cm) high, **I**

CLOSER LOOK

The hallmarks of Paul Follot's designs are a refined, classical style featuring restrained carved details and the finest materials. He valued the work of traditional craftsmen and in 1903 cofounded L'Art dans Tout, a group of artists who fought for the French crafts tradition against industrialization.

The chair is made from luxurious macassar ebony and rosewood, which were used in many of Follot's designs.

The elegant legs have been carved into a square-section form with fluting where they join the frame of the drop-in seat.

One of a set of four macassar ebony and rosewood chairs by Paul Follot with drop-in seats. c1920, 32in (81cm) high, **F**

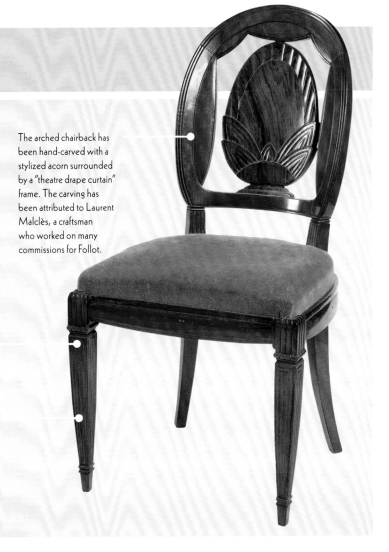

The arched chairback has been hand-carved with a stylized acorn surrounded by a "theatre drape curtain" frame. The carving has been attributed to Laurent Malclès, a craftsman who worked on many commissions for Follot.

SÜE ET MARE

The Art Deco form known as the "1925 style" was the creation of design duo Louis Süe (1875–1968) and André Mare (1887–1932). Their luxurious modern interpretation of the French Rococo style brought elegance – and sometimes extravagance – to the 1925 Paris *Exposition Internationale*.

Mare began his career as a Cubist painter, and used his skills to help to develop military camouflage. Süe was an architect and interior designer and set up an interior design firm, Atelier Français, in 1912. After working for the couturier Paul Poiret (1879–1944), he produced furniture, textiles, and ceramics, as well as perfume bottles for Jean Patou (1887–1936).

Süe and Mare met at the Academie Julian but did not work together until after the First World War, in which they had both taken part. After designing a war memorial in 1919 they formed an interior design firm, the Compagnie des Arts Français.

Their success came quickly but did not last. By 1925 – when they were asked to design several buildings and interiors for the Paris *Exposition* – they had created their signature style: furniture made from mahogany or pale-coloured woods, shaped into sweeping curves, and often highlighted with gilding or inlaid with ivory or mother-of-pearl. Motifs included twisted rope carving, delicate scrolls, swags, fruit, flowers, and birds.

At the Paris *Exposition* their pavilion, *Un Musée d'Art Contemporain* (A Museum of Contemporary Art), rivalled that of Ruhlmann, and their furniture was featured in the *Une Ambassade Française* (A French Embassy) pavilion and the Parfums d'Orsay boutique among others.

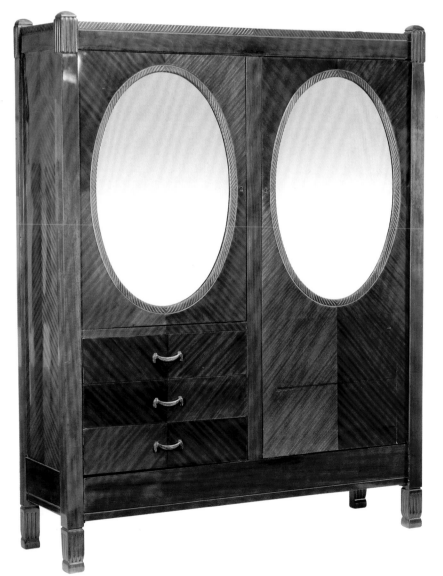

LEFT
A two-door armoire by Süe et Mare, with oval mirrors and three graduated drawers with silvered handles. Much of the decoration is supplied by the grain of the mahogany, but the mirrors are surrounded by typical twisted rope carving. c1918–20, 80in (203cm) high, I

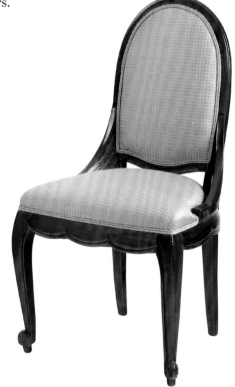

RIGHT
A rosewood side chair by Süe et Mare, with an elegant arched back above a padded seat and the frame carved with feather details. The cabriole legs end in scroll feet. c1925, 39in (99cm) high, I

JULES LELEU

After the First World War, Jules Leleu (1883–1961) turned his talents from sculpture to furniture design. Large numbers of his pieces were produced – including some commercial commissions and items for French ocean liners – all featuring simple, elegant lines.

Leleu exhibited his work regularly through the Société des artistes décorateurs and his unadorned pieces can appear plain when compared to the work of designers such as Süe et Mare or Paul Follot. The mastery of line shown in his designs is reminiscent of furniture from the French Directoire period (1795–99) rather than the Louis XV (1710–74) and Louis XVI styles favoured by some of his contemporaries. By the late 1920s his style had evolved into an angular Cubist Modernism.

Not all of Leleu's early pieces were signed but they can be verified through contemporary interior design schemes and catalogues. He generally used dark woods with little surface decoration and plain or nickel-plated brass mounts. The result was practical forms that were popular with commercial clients. This means that much of his work consists of desks, chairs, and side tables suitable for offices, hotels, and ocean liners. Later Leleu designs are Modernist and architectural in style and tend to use more metal.

As a rule, Leleu's work compares with that of Émile-Jacques Ruhlmann and is sometimes unjustly called "poor man's Ruhlmann". Most of his furniture was made between 1919 and the outbreak of the Second World War. Leleu also designed rugs for his interiors.

BELOW LEFT
A sycamore table-bar by Jules Leleu. The rectangular top overhangs a rectangular section column, which in turn sits on a rectangular base that is fitted with drawers and a fall-front bar compartment. The interior is veneered with contrasting mahogany. c1930, 24in (61cm) high, **G**

BELOW RIGHT
A mahogany secretaire by Jules Leleu, inlaid with rosewood and ivory and with ivory handles and escutcheon, on tapering octagonal legs that finish in capped feet. c1930, 47½in (121cm) wide, **F**

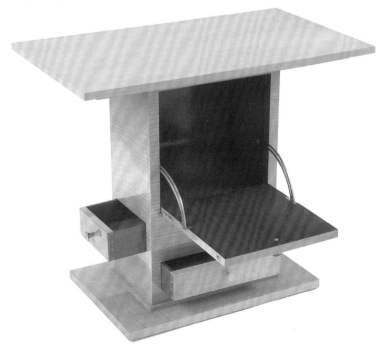

LÉON & MAURICE JALLOT

The furniture of father and son Léon and Maurice Jallot developed from pieces made in the 18th-century French provincial style to refined, modern styles that echoed the latest fashions.

Like many of his contemporaries, Léon Jallot (1874–1967) worked as a furniture designer, interior designer, architect, and craftsman. He is possibly best known for his Art Nouveau designs and from 1899 he managed the furniture workshop at Siegfried Bing's Maison de l'Art Nouveau, leaving just before it closed in 1904. Before he started to collaborate with his son Maurice (1900–71), Léon produced accomplished pieces in a traditional style that relied on the beauty of the wood and carved details, as well as large, complex designs that required challenging cabinetry skills. Between the wars, he continued to produced these ambitious pieces, but in the Art Deco style.

Before the mid 1920s Léon's furniture tended to be made from oak or veneered with fruitwood or sycamore. He also used traditional woods such as palisander, amboyna, and camphor.

In 1921, once Maurice joined him, his work started to use more refined techniques, sometimes with leather, shagreen, or parchment applied to the surfaces. Father and son worked together, and alone, throughout this time. Maurice received acclaim for his design for the Hôtel Radio in Chamalières.

After 1925 the Jallots started to work in a more Modernist style, which suited the fashion of the time. Some of their work was exhibited at the 1925 Paris *Exposition Internationale*. By the 1930s they had transformed their output again, to feature sleek lines and metal and even plastic elements. Their modern designs included steel card tables, mirrored cabinets, and cabinets with lacquered doors.

Maurice's 1940s designs are considered to be Art Deco and he continued to design furniture after the Second World War.

BELOW
A wooden desk by Jallot, with ring-turned legs designed for the Cité Internationale Universitaire in Paris. The top is inlaid with a leather writing surface and the lower level features a drawer with open shelves on both sides, which create a cantilevered architectural effect. c1931, 47in (119cm) wide, I

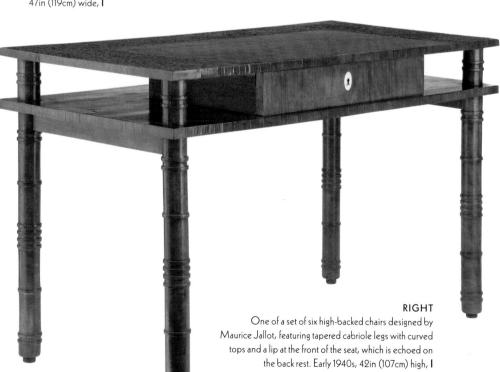

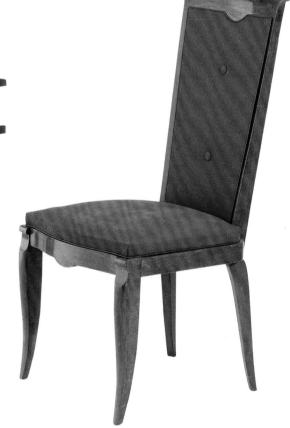

RIGHT
One of a set of six high-backed chairs designed by Maurice Jallot, featuring tapered cabriole legs with curved tops and a lip at the front of the seat, which is echoed on the back rest. Early 1940s, 42in (107cm) high, I

DE CŒNE FRÈRES

During the 1920s the Belgian De Coene Frères company transformed its output from simple, provincial furniture to high-quality and high-style Art Deco that was as good as anything found in France.

In 1888 brothers Jozef (1875–1950) and Adolphe de Coene had taken over the family wallpaper and interior design business – Kortrijk Kunstwerkstede Gebroeders De Coene – in Kortrijk, Flanders, following the death of their father. They worked with their mother and sisters to continue the business and by 1900 were producing furniture.

Early De Coene Frères furniture was made in the Art Nouveau style, influenced by Henry Van de Velde (1863–1957), as well as modern versions of traditional Flemish furniture. The furniture was a commercial success and enabled the company to expand its interior design service to include specially designed lighting, fabrics, stained glass, and carpets. By the 1920s the company was Belgium's largest furniture manufacturer. Their high level of craftsmanship and use of quality materials resulted in a number of international awards for their work.

The company exhibited at the 1925 Paris *Exposition Internationale* in the "Section Belge" but these pieces were mainly in the traditional style – albeit with an Art Deco twist – highlighted by the fact that they were shown alongside the work of Belgian Modernist designers Victor Servranckx (1897–1965) and Marcel Baugniet (1896–1995). Encouraged by the commercial success of the Art Deco designs they had seen, the brothers began to create furniture in the new French style and received international commissions for their work.

De Coene Frères' Art Deco furniture is often made from exotic materials such as lacquer and macassar ebony and resembles the work of Léon and Maurice Jallot. Some pieces may be signed with a label or ink stamp.

BELOW
A desk by De Coene Frères. The macassar ebony body of the desk is set with chrome and leather, and its convex sides contain drawers and shelves. c1930, 90½in (230cm) long, l

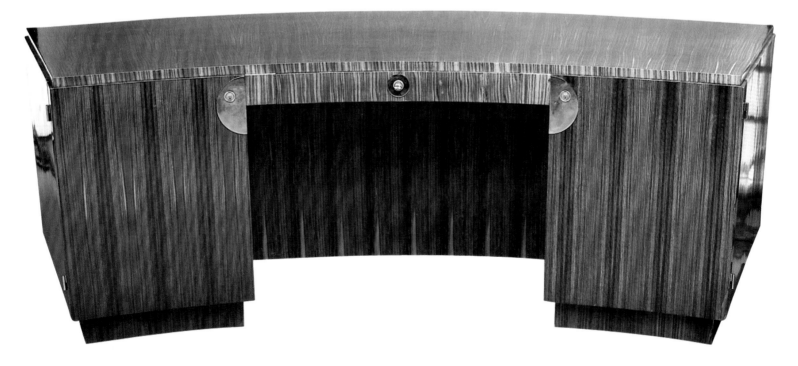

MAURICE DUFRÈNE

Maurice Dufrène (1876–1955) brought a mature sensibility to the world of Art Deco design. Like many of his contemporaries, he worked as an interior designer, or *artiste décorateur*, furnishing the homes of the Parisian elite.

After studying at the École des Art Décoratifs, Dufrène began working for Julius Meier-Graefe in 1899. Before long he was made the director and manager of La Maison Moderne, a group of artists who collaborated on designs that could be produced in multiples.

Dufrène was soon working at the forefront of modern design and, in 1904, became a founding member of the Salon des Artistes Décorateurs, with whom he exhibited for 30 years. Dufrène taught at the École Boulle in Paris from 1912 until 1923. By 1919 he was working in the Art Deco style and in 1921 became responsible for the recently opened La Maîtrise studio at the Galeries Lafayette department store in Paris. The shop, like many of its rivals, helped to popularize the Art Deco style by showing customers the new furnishings in room settings.

In 1925 he designed the interior of the La Maîtrise pavilion at the Paris *Exposition Internationale* as well as luxury boutiques and the living room of the *Une Ambassade Française* (A French Embassy) pavilion.

Dufrène is best known for his furniture designs, but he also created rugs, fabrics, metalware, pottery, and whole interiors. Throughout his career, his furniture designs referenced an austere, Neo-classical style, which owed much to the ever-popular Louis XVI style. He typically used dark mahogany, although some pieces were made from exotic woods or featured ebonized details. His designs use little carved ornament – his early furniture was often decorated with carved scrolls rather than traditional Art Nouveau motifs – and by the 1930s were angular and even simpler in style. Pieces may be marked with a "La Maîtrise" label.

RIGHT
The sparse style of Maurice Dufrène's designs can be seen in this tub chair (one of a pair), which has an arched, padded back and sides, and scrolled arm terminals. The padded seat has an additional squab cushion above the short, splayed, square-section legs. c1930, 31in (79cm) high, **H**

GIO PONTI

Giovanni "Gio" Ponti (1891–1979) worked was a furniture and ceramics designer, architect, and journalist from the 1920s until his death. His influential oeuvre was at the forefront of design for all of the eras through which he worked through – from Art Deco to mid-century Modernism and beyond.

Ponti was born in Milan and studied architecture before starting work as a designer at the Richard Ginori porcelain factory. While there, he developed his interest in clean, modern forms adorned with elegant Neo-classical-style decoration, which can be seen in his furniture. His work won a prize at the 1925 Paris *Exposition Internationale*, after which he wrote: "Industry is the style of the 20th century, its mode of creation."

In 1928 he founded *Domus* magazine as a vehicle for his beliefs. In 1941, he left to found another magazine, *Stile*, which he edited until 1947 when he returned to *Domus*.

Despite his success at Ginori, turning it into a role model of industrial design, Ponti wanted to expand his work and by the mid 1930s was also taking on architectural commissions.

Before the Second World War, Ponti's designs featured Neo-classical motifs, such as details on his furniture that echo arches or the signature diamond pattern seen in updated form on much of his later work, that are essentially Art Deco. His furniture at this time used materials including burled walnut and marble. Ponti believed that furniture was an integral part of the interiors of the buildings he designed and this concept reached its logical conclusion in his "organized walls", which consisted of in-built shelving, lighting, and furniture.

CLOSER LOOK

Gio Ponti's furniture was often produced to complement the interior of the buildings he designed. This sideboard is unmarked but was from an apartment building Ponti designed in Via Goldoni, Milan, and appeared in the July 1938 issue of *Domus* magazine. The applied latticework on this piece creates a diamond pattern that is a typical feature of his work.

The interior of the sideboard is fitted with drawers and shelves to aid in the organization of the contents.

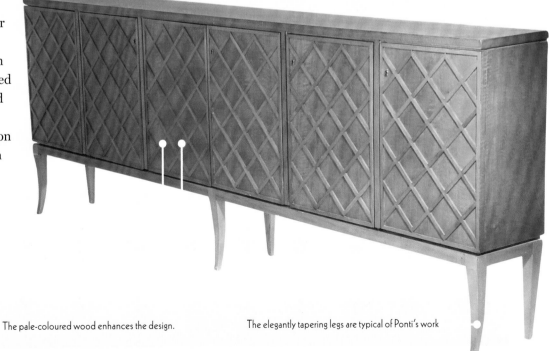

A six-door sideboard by Gio Ponti, c1938, 98½in (250cm) wide, **F**

The pale-coloured wood enhances the design.

The elegantly tapering legs are typical of Ponti's work

EUROPEAN GALLERY

AUSTRIA ◊ FRANCE ◊ GERMANY ◊ ITALY ◊ SWEDEN

In France, many cabinetmakers and retailers created elegant Art Deco furniture in the style of Émile-Jacques Ruhlmann, Paul Follot, and others. These pieces are often unsigned, or may bear only a retailer's mark, but the best show all the distinctive features of the finest Art Deco style although they are made from less expensive materials and may exhibit more limited skilled craftsmanship.

Before the mid 1930s, pieces such as these were generally made with exotic woods and inlays or with carefully chosen veneers. Later items feature native woods and metal inlays, and tend to be larger and simpler in concept.

Among the designers making better-quality pieces were Dominique – a joint venture between André Domin (1883–1962) and Marcel Genévrière (1885–1967) – which was active from 1922, René Herbst (1891–1982) who had a unique style and founded the Union des Artistes Modernes (Union of Modern Artists, or UAM) in 1930, Eric Bagge (1890–1978) who designed the jewellery hall for the 1925 Paris *Exposition Internationale*, and the Modernist Francisque Chaleyssin (1872–1951).

Elsewhere in Europe, Art Deco furniture often reflects national styles and, again, is rarely marked. German and Austrian designers tended to use dark or stained woods to create austere furniture, some of it a development of the Wiener Werkstätte style. Later pieces may show the influence of Bauhaus designs.

Swedish designers – in particular Axel Larsson (1898–1975), Bruno Mathsson (1907–88), and Sven Markelius (1889–1972) – used native birch and other blond woods to create high quality, practical furniture, some featuring wood inlays that may be ebonized. Examples made after the 1930 Stockholm *International Exhibition* tended to have a Modernist edge.

In Eastern Europe, folk traditions can be seen in the colours and styles of decoration used. Italian manufacturers created great quantities of Art Deco furniture, much of which was exported to the USA. Pieces are often large and extravagant and many of them were inspired by French style. They may feature inlays of exotic woods, parchment, and ivory.

RIGHT
An elegant French coffee table of circular geometric form. The top is supported by four curved square-section uprights secured by a carved disc and joined to four splayed, conical feet. 1940s, 23½in (59.5cm) diam, **J**

A pair of French oak lounge chairs with trapezoid backs with rounded tops over the plank seats, which are covered by deep upholstery. The arms and skirts are veneered with rounded, diagonal slats. c1940, 34¼in (87cm) high, **K**

A rectilinear Swedish birch-wood dressing table, on bracket feet. The three drawers feature ebonized wood handles and the rectangular top is piano-hinged at the back so that it lifts to access the storage space beneath. c1920, 35¾in (91cm) wide, **K**

A dining chair designed by Maxime Old (1910–91) and with the original red leather upholstery. Old worked for Émile-Jacques Ruhlmann but went on to create his own designs. Unlike that of his mentor, his work is sleek, modern, and usually devoid of ornamentation but features subtle angles. He used expensive woods such as oak, cherry, ash, and walnut, sometimes enhanced with bronze accents or fittings. 1930s, 27in (68.5cm) high, **J**

A pair of burl-wood classical-inspired backless chairs in the style of Jules Leleu. The paleness of the wood of the seats and pedestal bases contrasts with the black velvet upholstery, unmarked. c1925, 27¾in (70.5cm) high, **J**

A French burl-wood-veneered sideboard, with a rectangular top over two doors and raised on a plinth base. The simple architectural shape is enhanced by the grain of the wood rather than any other surface decoration. c1940, 55½in (141cm) wide, **K**

A Swedish birch-wood side table. The rectangular top has a black glass insert and is raised on bracket feet. There is a central partition between the open shelves and two drawers, which have ebonized handles. c1930, 26in (66cm) wide, **K**

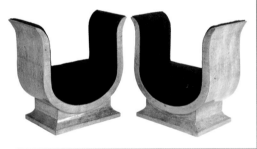
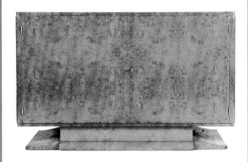

A macassar ebony dining table with faux ivory inlay. The circular top is designed as four sections with the wood grain at right angles. It is set on four solid curved supports above a square, stepped pedestal base. c1940, 55¼in (140cm) diam, **J**

An Italian burl-wood buffet, with a mirror and asymmetrical shelf structure on an ebonized plinth. The case section contains four small drawers and a cupboard with twin doors. c1930, 70in (178.5cm) wide, **K**

A pair of Italian burr-wood lounge chairs, with rounded backs. The backs, sides, and seats are upholstered in ochre suede. Both chairs sit on contrasting dark wood square-section feet. c1930, 29in (73.5cm) high, **J**

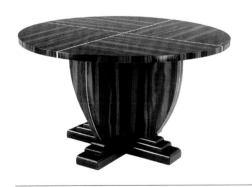
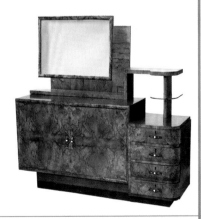
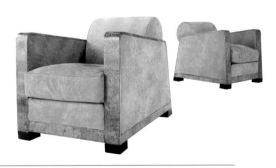

EUGENE SCHOEN

New York architect and designer Eugene Schoen (1880–1957) created high-quality Art Deco furniture with a heavy French influence.

Schoen studied architecture at Columbia University, graduating in 1901, and won a scholarship to Europe, which he used to study architecture in Vienna with Otto Wagner (1841–1918) and Josef Hoffmann (1870–1956), who influenced his design aesthetic. Schoen set up his own architectural practice in New York in 1905. Between the First and Second World Wars, he continued to work as an architect and also ran an art gallery.

After visiting the 1925 Paris *Exposition Internationale*, Schoen set up an interior design business and his furniture and rug designs reflected the French Art Deco style that dominated the displays. However, his inventive use of new materials such as Fabrikoid, Flexwood, and Monel, combined with more luxurious materials such as exotic woods, set his designs apart.

He decorated his furniture with dark, exotic wood veneers and parquetry as well as subtle carved detail.

During the 1930s, Schoen designed furniture for the retailer Schmieg & Kotzian (which also traded as Schmieg, Hungate & Kotzian). The firm sold high-quality reproductions of 18th-century formal furniture as well as more fashionable designs, all made with the best materials and using traditional techniques. This combination of materials, craftsmanship, and high standards of manufacture suited Schoen.

Most of Schoen's Art Deco pieces date from after the Depression, when only the very wealthy could afford to buy them. Much of his furniture was, and is, promoted as "one of a kind". In the late 1930s he produced avant-garde pieces made from nickel and glass, but stopped designing furniture in the mid 1940s. Schoenwork is rarely found outside the USA and not all of it is signed.

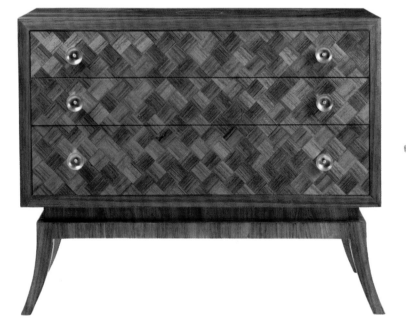

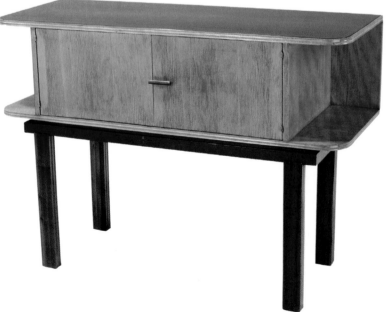

BELOW
A Brazilian rosewood and sycamore console designed by Eugene Schoen for Schmieg, Hungate & Kotzian, with a simple wooden door handle. c1930, 52in (132cm) wide, **J**

ABOVE
A three-drawer chest-on-stand with splayed legs designed by Eugene Schoen for Schmieg, Hungate & Kotzian. The body and stand are made from solid and veneered mahogany, while the drawer fronts are set with cross-hatched parquetry. The circular handles have faux pearl centres. c1935, 45in (114cm) wide, **H**

GILBERT ROHDE

Gilbert Rohde (1894–1944) designed practical and elegant furniture that was popular in homes and offices across America. He founded his New York design studio in 1927, and soon became known for his avant-garde ideas. He had visited Germany and many of his pieces were inspired by the Bauhaus. The influence of Walter Gropius (1883–1969), in particular, can be seen in Rohde's modular and sectional furniture, which Rohde is credited with making popular in the USA.

Rohde's furniture was typically made from natural materials, including American maple and exotic hardwood veneers. He sometimes used sparse metal hardware, but more often his work features wooden drawer handles in a characteristic mushroom shape and decorated with incised wavy lines.

Much of Rohde's solid, heavy, and reliable furniture was designed for corporate manufacturers, such as Herman Miller, Heywood-Wakefield (from 1929), and John Widdicomb. He is credited with introducing Herman Miller to modern design and encouraging the firm to make the industrial office furniture for which it is renowned today.

Rohde designed innovative children's furniture for Kroehler and a range of tubular steel seating furniture for Troy Sunshade Co. in 1933. The latter is in the Bauhaus style and includes a widely reproduced Z-bar stool, which consists of a single piece of tubular steel bent into the support and seat. He also contributed designs to the 1939 New York World's Fair.

Rohde's furniture is typically marked. Some custom furniture bears a paper label.

LEFT
A walnut-veneered two-door dresser by Gilbert Rohde, designed for Herman Miller. The doors, with vertical semi-circular handles and three horizontal chrome bands, conceal six drawers. The dresser is accompanied by a freestanding circular mirror on a square base. c1930, chest 44in (112cm) high, **I**

RIGHT
A "Cloud" table by Gilbert Rohde, designed for Herman Miller. The distinctive trefoil top is veneered with acacia burl wood while the tapered legs are wrapped in leatherette. c1940, 27in (68.5cm) wide, **J**

HILLE

London-based furniture manufacturer Hille began to make Art Deco furniture after Ray Hille (1900–86), the daughter of its founder, was dismayed by the reaction to the British furniture shown at the 1925 Paris *Exposition Internationale*. The British exhibits were acknowledged as being generally sparse in quantity and conservative in taste. One critic even complained of the "dullness and aloofness, and the absence of the spirit of adventure in many of the British displays" at the exhibition.

The Hille furniture company was founded in 1906 by Russian émigré Salomon Hille (1875–1940) in the East End of London. He began as a furniture restorer and went on to create quality reproduction furniture, mainly of 18th-century designs, as well as custom-made pieces. In the early years the firm supplied stores including Waring & Gillow and Maples.

Ray Hille had travelled frequently to Paris and was convinced that the modern designs she had seen there had commercial potential in Britain. As a result she created her own furniture designs, which interpreted the work of Paul Follot and his contemporaries using blond woods or exotic veneers. Ray designed Art Deco furniture from the mid 1920s until the Second World War, although the company continued to produce reproduction pieces as well. She took over the running of the company from her father in 1932.

After the war, the company created more innovative designs, particularly mid-century modern commercial interiors by designers Robin (1915–2010) and Lucienne Day (1917–2010). Robin Day became design director at Hille in 1950 and his best-known designs include the 1950 Hillestak chair and the 1963 Polyprop stacking chair. The company is still in operation today.

BELOW
A bird's-eye maple and walnut crossbanded dining table and six dining chairs attributed to Hille, of classic Art Deco form, the table with rectangular leg supports and the chairs with rounded backs and splayed legs. c1930, table 71¾in (180cm) long, I

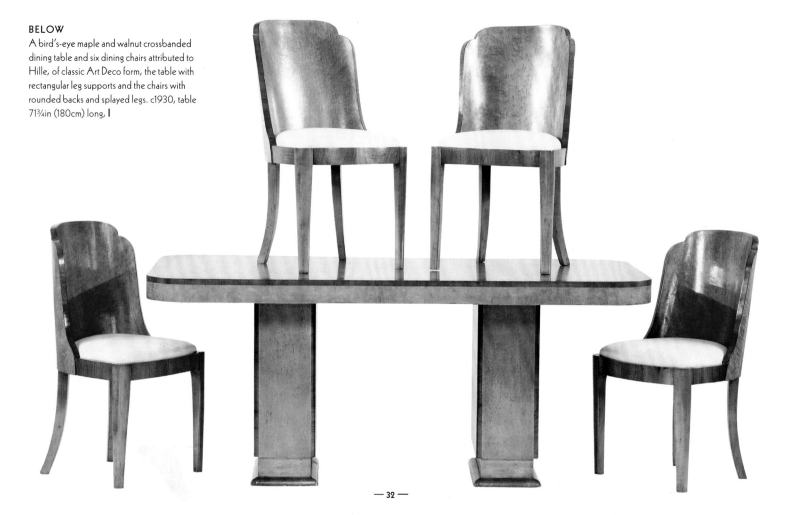

WHYTOCK & REID

Whytock & Reid was among the leading cabinetmakers and upholsterers in Edinburgh. The company was renowned for its high-quality workmanship and its workshops added furniture in the Art Deco style to its output from the mid 1920s onwards.

The company was founded in 1807, when Richard Whytock began selling fabrics in the city. In 1827 John Reid, a master cabinetmaker and upholsterer, started his own company in Ayrshire. The two businesses were joined in 1876 to create Whytock, Reid & Co. based in George Street, Edinburgh. The business moved to Belford Mews in 1885 and remained there until the company closed in 2004. Work by the company's craftsmen furnished some of Scotland's most famous houses, including the Palace of Holyroodhouse in Edinburgh, as well as the Royal Yacht *Britannia*.

Whytock & Reid was famed for its quality furniture and even seasoned wood in large Baltic pine timber stores for 20 years before using it. Its Art Deco items featured luxurious finishes such as lacquer and gilding, exotic woods like coromandel, and expensive veneers including burr walnut. Pieces were also decorated with carving and exotic wood inlays, but in general decoration was kept to a minimum.

The Art Deco pieces produced by Whytock & Reid are often substantial, with a rectilinear style that is similar to that of the French designers.

BELOW
A lacquered mirror, by Whytock & Reid. The rectangular red lacquer frame has cresting moulded with stylized plant forms and painted in gilt. c1930, 39¾in (101cm) high, **M**

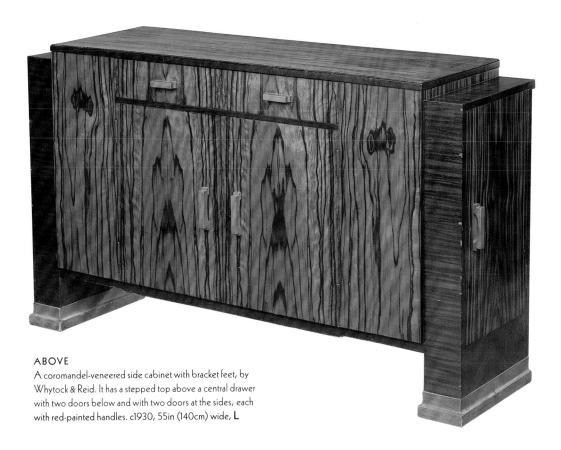
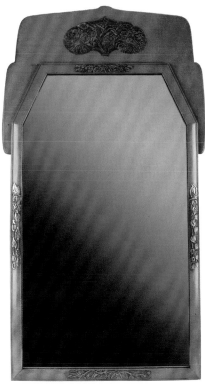

ABOVE
A coromandel-veneered side cabinet with bracket feet, by Whytock & Reid. It has a stepped top above a central drawer with two doors below and with two doors at the sides, each with red-painted handles. c1930, 55in (140cm) wide, **L**

THE BEGINNINGS OF MODERNISM

While the Art Deco Movement may have started with a modern interpretation of classical French style, for many it evolved into a Modernist Movement.

The journey towards simpler forms, design for mass-production, and the influence of architects can all be seen in the early years of the 20th century at the Wiener Werkstätte, and grew as the world recovered from the First World War. By the time the 1925 Paris *Exposition Internationale* opened, the designers at the Bauhaus in Germany, Warren McArthur in the USA, and Le Corbusier in France were among those who had been experimenting with "modern" ideas for some time.

During an interview at the Paris exhibition, Le Corbusier said that the future of design was forward-looking and not rooted in the past. He foresaw that the designs of Émile-Jacques Ruhlmann, Paul Follot, Louis Süe and André Mare, and others, which, despite their "modernism", were based on 18th-century designs and methods of manufacture, would be replaced by something new. He explained it as "the end of an era of antique lovers and the beginning of the modern age".

In many ways Le Corbusier was right. The controversial designs housed in his avant-garde *Pavilion de l'Esprit Nouveau* (Pavilion of the New Spirit) included modular units and tubular steel furniture created by him or the Bauhaus designers and which were to become the forerunners of the Modern Movement.

Ultimately the success of these modern pieces was not just down to the perception of one man. The Depression meant that finding ways to mass-produce inexpensive furniture became paramount. And in 1925 the respect given in the near future to Marcel Breuer, Ludwig Mies van der Rohe, Walter Gropius, Erich Dieckmann, and other modern designers at the Bauhaus was not certain. However, the prototypes they developed went on to inspire designers around the world.

The move towards something "new" also had room for designers such as Eileen Gray in France and Alvar Aalto in Finland, who were not easily grouped with others.

LEFT
In 1927, Charlotte Perriand designed a small, revolving armchair for her apartment in Paris, and the LC7 is still in production today. This version was made c1940.

OPPOSITE
A dining room designed by Charlotte Perriand for the Salon des Artistes Décorateurs in Paris, 1928. The extendable table is paired with LC7 chairs.

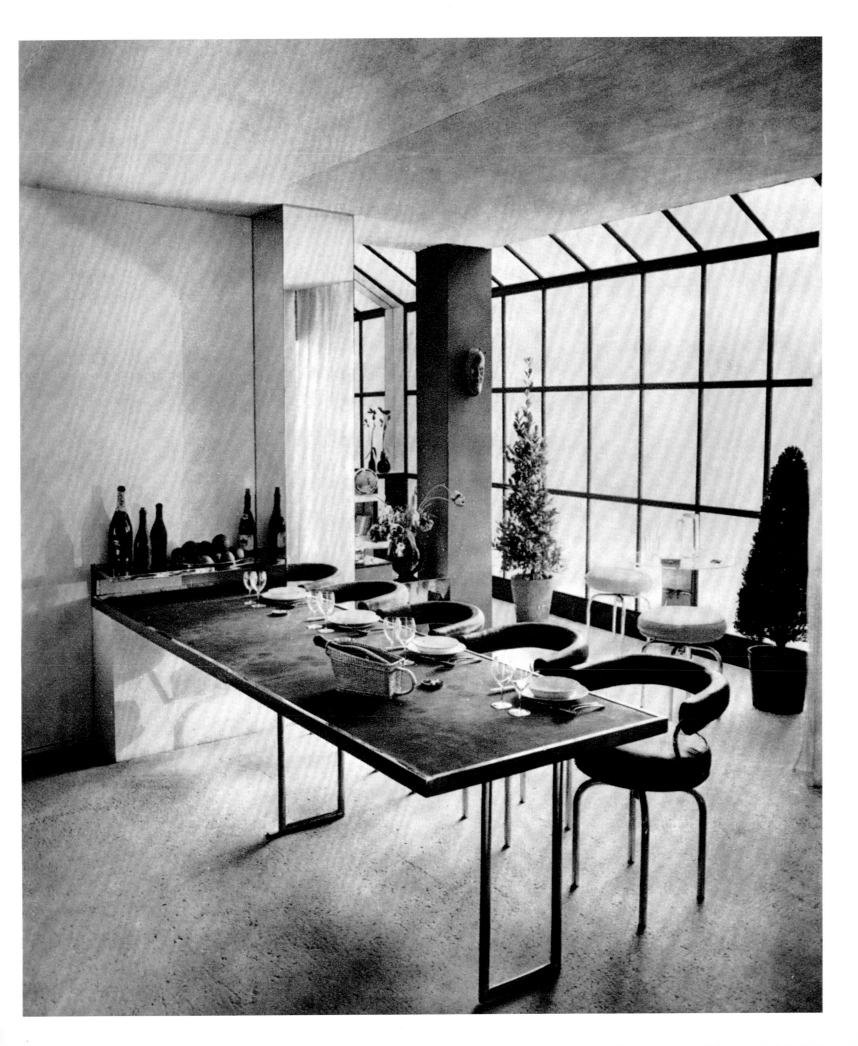

LUDWIG MIES VAN DER ROHE

Ludwig Mies van der Rohe (1886–1969) was a German architect and designer who created some of the 20th century's most iconic buildings and furniture. He is also responsible for the famous statement "less is more".

In his early years as an architect Mies worked for Peter Behrens (1868–1940) in Berlin. In 1930, he was made director of the Bauhaus, a post he held until the school was dissolved in 1933. Some of Mies's most enduring designs are the revolutionary tubular steel cantilevered items of furniture, especially chairs, made by the firm of Berliner Metallgewerbe from 1927 to 1931. These are considered modern classics, as are the Barcelona chair of 1929 (based on a classical Roman form and created for the king of Spain) and the Brno chair of 1930 (designed for Mies's renowned Tugendhat House in Brno, Czech Republic). It is notable that these pieces were developed while Mies was working as an architect in Berlin rather than during his time at the famous design school. This is likely to be because he used only the best-quality materials and relied on high-cost production techniques, while the Bauhaus focused on low-cost designs that could be mass-produced.

Mies's furniture combines a graceful form with a groundbreaking simplicity and a meticulous detail. He saw designing chairs and skyscrapers as equally challenging, as chair design brought with it "endless possibilities and many problems". In 1929, when the German government commissioned him to design the German pavilion for the Barcelona *International Exposition*, he devoted as much time to the furnishings as he did to the building itself.

Mies emigrated to America in 1937 to escape the Nazis, and became head of the Chicago School of Architecture in 1938. At this time he almost stopped designing furniture, but did create two of America's most celebrated Modern buildings: the Farnsworth House in Illinois (1946–50) and the Seagram Building in New York City (1951–8). Mies's work greatly influenced the Modern Movement and the International Style of architecture.

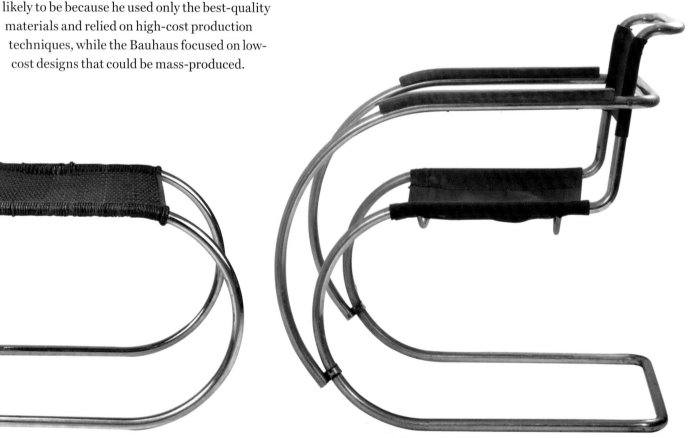

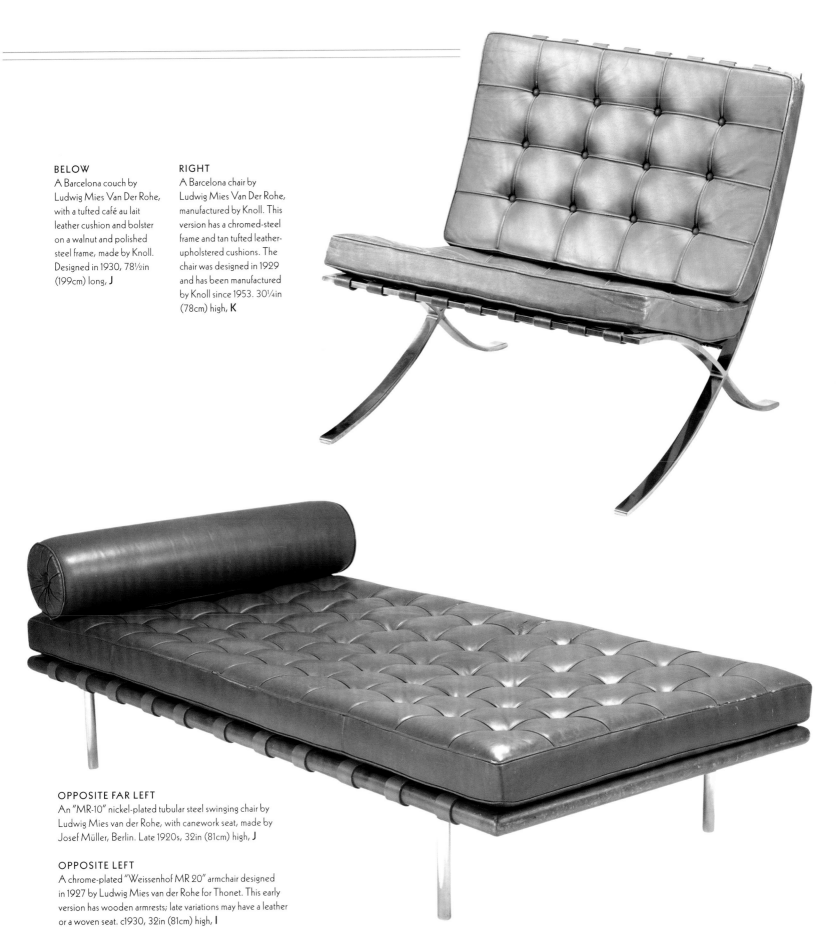

BELOW
A Barcelona couch by
Ludwig Mies Van Der Rohe,
with a tufted café au lait
leather cushion and bolster
on a walnut and polished
steel frame, made by Knoll.
Designed in 1930, 78½in
(199cm) long, **J**

RIGHT
A Barcelona chair by
Ludwig Mies Van Der Rohe,
manufactured by Knoll. This
version has a chromed-steel
frame and tan tufted leather-
upholstered cushions. The
chair was designed in 1929
and has been manufactured
by Knoll since 1953. 30¼in
(78cm) high, **K**

OPPOSITE FAR LEFT
An "MR-10" nickel-plated tubular steel swinging chair by
Ludwig Mies van der Rohe, with canework seat, made by
Josef Müller, Berlin. Late 1920s, 32in (81cm) high, **J**

OPPOSITE LEFT
A chrome-plated "Weissenhof MR 20" armchair designed
in 1927 by Ludwig Mies van der Rohe for Thonet. This early
version has wooden armrests; late variations may have a leather
or a woven seat. c1930, 32in (81cm) high, **I**

MARCEL BREUER

For many, the designs that Marcel Breuer (1902–81) created at the Bauhaus School of Architecture and Design in Germany changed the course of 20th-century design. He saw the role of the designer as "civilizing technology", but when he showed his work at the 1925 Paris *Exposition Internationale* it was considered radical, despite being exhibited alongside similar pieces in Le Corbusier's *Pavilion de l'Esprit Nouveau* (Pavilion of the New Spirit).

Born in Hungary, Breuer joined the Bauhaus at Weimar in Germany in 1920, where he was a protégé of the school's founder, Walter Gropius. Breuer specialized in furniture design, headed the cabinetmaking workshops from 1924 to 1929, and had become a Master of Interiors by 1926. However, he found the debates that inspired many of his contemporaries frustrating and preferred to design "without having to philosophize before every move".

Breuer's 1925 tubular steel "B3" club chair – better known as the "Wassily" chair – revealed the possibilities of this new material. Two years later he exhibited one of the first tubular steel cantilevered chairs, which was allegedly inspired by bicycle frames. The revolutionary chair used non-reinforced steel tubing to create an inexpensive and springy seat. Much of his steel furniture was manufactured by Thonet.

After leaving the Bauhaus, Breuer set up his own architectural practice in Berlin but he left Germany in 1931 because of the economic slump. After working in France, Greece, Morocco, Spain, and Switzerland, he finally moved to London in 1935, where some of his laminated-wood furniture designs were manufactured by Isokon.

In 1937 Breuer moved to the USA and from 1946 he lived in New York, where he worked as an architect and industrial designer. The Whitney Museum, completed in 1966, is one of his New York architecture projects.

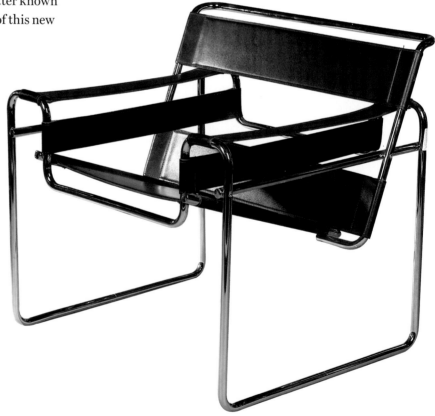

RIGHT
A "Wassily" or "B3" armchair by Marcel Breuer. It has a chrome-plated tubular metal frame, with a leather seat, back, and armrests. The chair was nicknamed "Wassily" after the painter Wassily Kandinsky (1866–1944), who was working at the Bauhaus at the time it was designed and admired its design.
c1925, 31in (79cm) wide, **L**

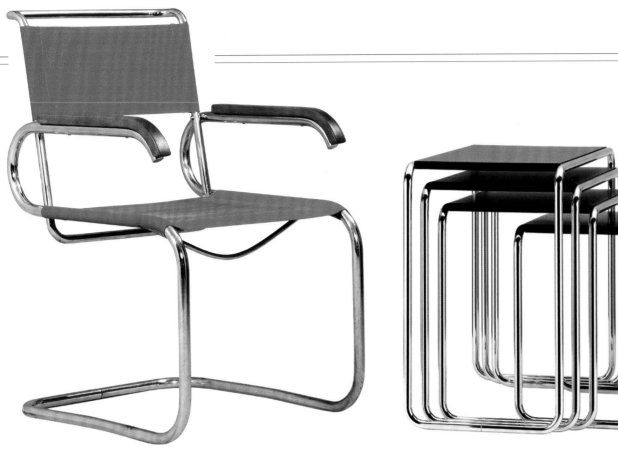

ABOVE
A model "B 55" armchair, designed by Marcel Breuer and manufactured by Thonet. It has a chromium-plated tubular steel frame, with lacquered beech armrests and original red fabric seat and back. Designed 1928–9 and manufactured c1932, 34in (86cm) high, **J**

ABOVE RIGHT
A three-tier shelving unit by Marcel Breuer, with bent chromed-metal frame and black lacquer shelves, manufactured by Thonet, unmarked. c1930, 24½in (62cm) high, **J**

BELOW
A laminated plywood chaise lounge by Marcel Breuer, with undulated seat and coral-coloured leather upholstery. The original of this model was made from plywood by Isokon in the 1930s. This example was manufactured by Knoll in the late 1950s and is unmarked. 51in (130cm) wide, **J**

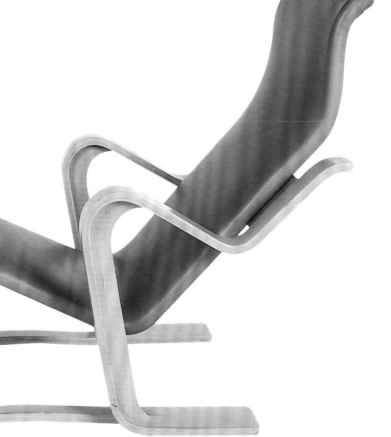

LE CORBUSIER, PIERRE JEANNERET & CHARLOTTE PERRIAND

A pioneer of Modernism, Le Corbusier (1887–1965) produced some of the most celebrated furniture of the 20th century – as well as some of the most controversial buildings. Born Charles-Édouard Jeanneret in Switzerland, he spent most of his working life in France, using the name he created for himself. Largely self-taught, Le Corbusier designed his first house in 1905. His philosophy was to see the house as a "machine for living", as encapsulated in his work designing high-rise apartment blocks and interiors. In his 1925 book *L'Art Decoratif d'aujourd-hui* (Decorative Art Today), he stated that furniture designers should create objects that operated as an extension of the human body.

He set up a company in 1922 with his cousin, Pierre Jeanneret (1896–1967), and in 1927 invited Charlotte Perriand (1903–99) to join his studio. She designed industrial-inspired furniture with him for almost a decade, using materials such as chrome, steel, and leather. In 1928 Le Corbusier and Perriand set themselves the task of designing three different chairs –

for conversation, for sleeping, and for relaxation (the "Model LC2 Grand Confort" club chair) – for the Maison la Roche in Paris, which Le Corbusier had designed with Jeanneret. All three chairs brought an unexpected level of comfort to the hard, tubular steel-framed designs, thanks to leather upholstery. Perriand said of the designs that "the smallest pencil stroke had to...fulfil a need, or respond to a gesture or posture, and to be achieved at mass-production prices."

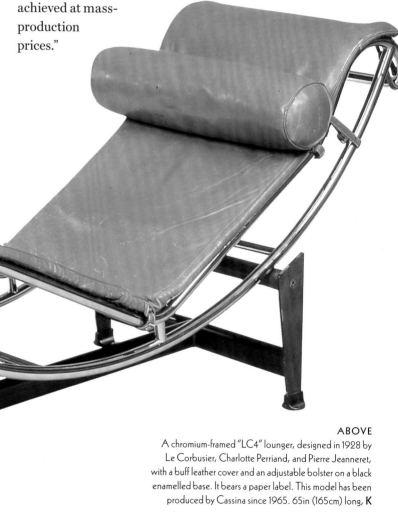

ABOVE
A chromium-framed "LC4" lounger, designed in 1928 by Le Corbusier, Charlotte Perriand, and Pierre Jeanneret, with a buff leather cover and an adjustable bolster on a black enamelled base. It bears a paper label. This model has been produced by Cassina since 1965. 65in (165cm) long, **K**

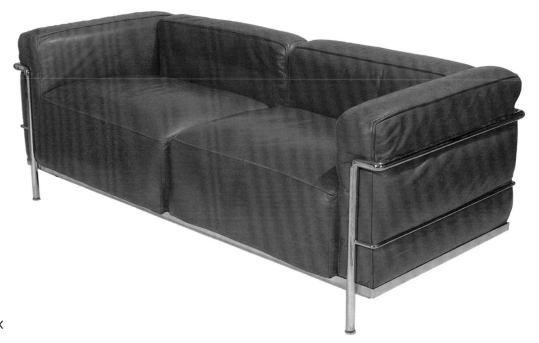

RIGHT
The "LC2" loveseat by Le Corbusier was also known as the "Petit Confort". Designed in 1929, it did not go into production until 1959. The back legs are set in closer together than the front legs, so that the sofa appears to float. This example, which has a polished chromed-steel frame and burgundy leather cushions, was made under licence by Cassina, Italy. 66in (168cm) wide, **K**

CLOSER LOOK

The "basculant" armchair chair, model "B301", was designed by Le Corbusier, Pierre Jeanneret, and Charlotte Perriand, in 1928, and initially manufactured by Thonet. The designers reduced the form of the chair to its essentials, while the industrial materials reflect Le Corbusier's concept of furniture as equipment. This model was used to furnish several of Le Corbusier's houses, including the Villa Savoye. Le Corbusier produced three versions of this chair: one for the Salon d'Automne in 1929, another for Villa Church in 1928, and a third for the 1930 *Union des Artistes Modernes* (UAM) exhibition. Later examples were manufactured by Cassina and Aram.

The design is compact and lightweight when compared to the "Grand Confort" sofa and armchair.

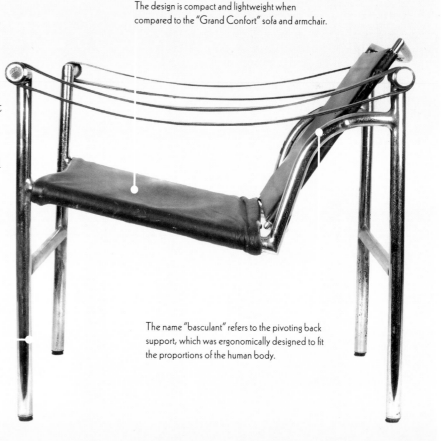

This economical design used the bare minimum of materials.

The name "basculant" refers to the pivoting back support, which was ergonomically designed to fit the proportions of the human body.

A "basculant" armchair chair, with a chromium-plated bent tubular steel frame with a black leather back rest, seat, and armrests. c1928, 24½in (62cm) high, **H**

EILEEN GRAY

The work of Eileen Gray (1878–1976) inspired Modernist and Art Deco designers, yet for much of the 20th century her name and her work were forgotten.

Gray was born in Ireland and was one of the first female students at the Slade School of Art in London. In 1907 she moved to Paris, where she learned the art of lacquering with a Japanese craftsman, Seizo Sugawara. The techniques she discovered there heavily influenced her early furniture designs, which combined Art Deco elements with traditional Japanese design. In 1922 she opened a gallery in Paris – Galerie Jean Desert – to show her work. While her pieces became popular with intellectuals, she soon tired of creating exclusive furniture and became interested in architecture.

Gray was introduced to the work of Le Corbusier and other Modernists by her friend Jean Badovici (1893–1956), a Romanian architect. Badovici and Gray worked on a number of architectural commissions together, including a house in the south of France named "E1027": E is for Eileen, 10 for J as it is the tenth letter of the alphabet, 2 for B (Badovici) and 7 for G (Gray). The building was considered revolutionary at the time, thanks to its open-plan interior, and the project also gave Gray the chance to reappraise her furniture designs. She focused on furniture as elements in the "machine" of the house, and the result was a new, practical style of furniture, which allowed form to follow function. Pieces in this Reductionist style included the "Transat" chair, which was inspired by the deckchairs on transatlantic ships, and the height-adjustable "E1027" side table.

Gray continued to create simple furniture designs, including a folding S-chair and a double-sided chest of drawers, and in 1937 she contributed plans for a holiday centre to Le Corbusier's pavilion at that year's Paris *Exposition Internationale*.

After the Second World War Gray's work was forgotten while that of Le Corbusier and others was celebrated. However, a 1968 magazine article and an auction of some of her work in 1972 brought her to public attention again and the London-based furniture company Aram began to reproduce some of her designs, including the "Bibendum" chair and" E1027" table.

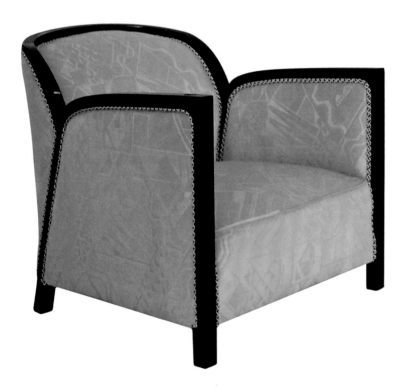
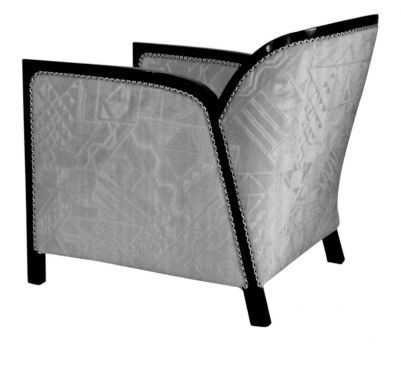

OPPOSITE

A pair of French Art Deco boudoir chairs by Eileen Gray, of Cubist angular design, with a lacquered wood frame and upholstered with a Modernist-design fabric. c1930, 25½in (65cm) high, **I**

BELOW

One of a pair of "Bibendum" chairs by Eileen Gray, with chrome frame and grey leather upholstery. Designed in 1926, the chair was named after the Michelin Man logo of the Michelin Group, whose body rolls mimic tyres, and was a response to Le Corbusier's "Grand Confort" armchair. It was designed to be equally comfortable but more feminine, thanks to its softer, rounder form. 36in (91.5cm) wide, **J**

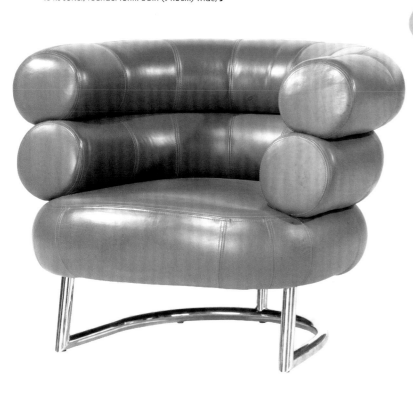

ABOVE

A pair of "E1027" adjustable glass and chrome tables by Eileen Gray. These were designed in 1927 as bedside tables, as the ring at the base can be pushed under the bed while the top can be moved up or down to accommodate a thick quilt. The tubular steel frame is reminiscent of the cantilevered chairs designed by her contemporaries and contradicts the conventional notion of a table with four legs. 24¾in (63cm) high, **K**

ALVAR AALTO

T he Finnish designer and architect Alvar Aalto (1898–1976) was a leading figure in 20th-century design. He managed to combine the ideals of the Modern Movement with a strong humanist streak, which convinced him to use natural materials such as laminated birch plywood rather than the tubular steel favoured by many of his contemporaries. The result was furniture and buildings that appealed to the psychological as well as the physical needs of humans – a concept he described as "psychophysical".

Aalto studied architecture in Helsinki from 1916 to 1921 and married the designer Aino Marsio (1894–1949) in 1924. For five years the couple experimented with bending native birch wood, the results of which enabled Aalto to create his revolutionary chair designs in the 1930s.

The house Aalto designed in Turku in 1927 is among the finest examples of Scandinavian Modernism, but it is one of his other architectural projects that is perhaps his masterpiece. As well as designing the building

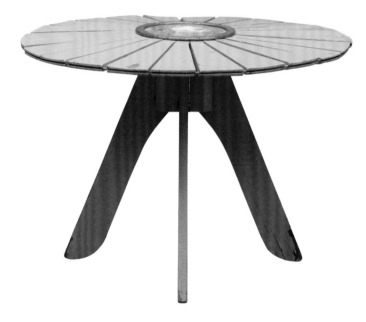

LEFT
Alvar Aalto's "Tank" armchair for Artek – originally called "Easy Chair 400" – was the first wooden chair to echo the cantilevered tubular steel designs being created by other designers. It features Aalto's trademark legs, which curve underneath the seat. It was shown at the 1936 Milan *Triennale* and has an upholstered and padded seat and a curved birch-plywood frame. 1940s, 29½in (75cm) high, **J**

ABOVE
A birch-wood garden table by Alvar Aalto, with a circular sunburst top set around a metal centre and on a wooden tripod base, no. 330. c1938–9, 31½in (80cm) diam, **I**

for the Paimio Sanitorium for Tuberculosis (1929–33), Aalto was responsible for the interior furnishings, including the "Model No.41 Paimio" bent-wood chair and the cantilevered "No. 31" chair. International acclaim followed, boosted by his design for the Finnish Pavilion at the 1939 New York World's Fair, which followed an exhibition of his furniture at Fortnum & Mason, London, in 1933.

In 1935, Alvar and Aino Aalto, Harry Gullichsen (1902–54), and Nils Hahl (1904–41) established Artek, the company that continues to manufacture his designs today. Two further export companies followed: Finmar, which brought his work to Britain, and Wohnbedarf in Switzerland, which supplied other European markets.

Aino Aalto created celebrated glassware, and Alvar joined her in working with glass in 1938, when he designed the "Savoy" vase for Finnish firm Iittala. This classic piece shows how his signature asymmetrical, fluid, and organic design style could be translated from one medium to another.

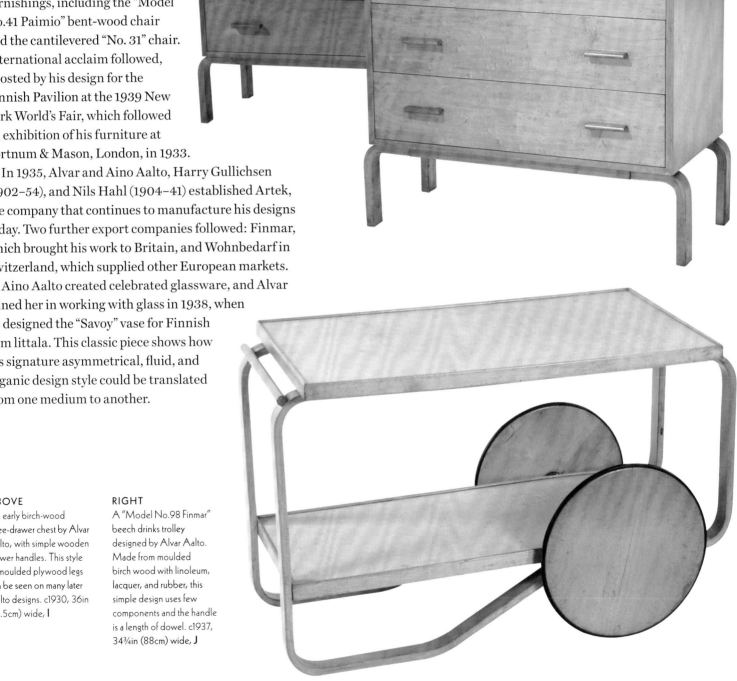

ABOVE
An early birch-wood three-drawer chest by Alvar Aalto, with simple wooden drawer handles. This style of moulded plywood legs can be seen on many later Aalto designs. c1930, 36in (91.5cm) wide, **I**

RIGHT
A "Model No.98 Finmar" beech drinks trolley designed by Alvar Aalto. Made from moulded birch wood with linoleum, lacquer, and rubber, this simple design uses few components and the handle is a length of dowel. c1937, 34¾in (88cm) wide, **J**

ERICH DIECKMANN

Erich Dieckmann (1896–1944) was one of the most important furniture designers of the Bauhaus. Having first studied architecture at Danzig Polytechnic, followed by painting and drawing in Dresden, in 1921 he began a four-year carpentry apprenticeship at the Weimar Bauhaus. When the school moved to Dessau in 1925, Dieckmann remained in Weimar, where he headed the furniture workshop at the renamed Bauhochschule from 1925 until 1930 (he had been deputy head of the furniture workshop after Marcel Breuer's departure). From 1931 until 1933 – when he was dismissed from his post by the National Socialists – he was head of the carpentry workshop at the Kunstgewerbeschule Burg Giebichenstein in Halle. He lived in Berlin after 1939.

At the Bauhaus, Dieckmann developed ranges of furniture designed to be mass-produced at low prices. These pieces were destined for the new, compact workers' housing that was being built in several German cities.

Although Dieckmann also experimented with tubular steel, he is best known for the standardized wooden furniture he created, which shows the influence of Breuer. The designs are strictly geometric: the frames are based on right angles and most of the wood has a square cross-section or is flat. Another common feature is chair legs and armrests linked using a runner construction. However, the geometry of these pieces is softened by his use of hardwoods such as beech, cherry, oak, and ash, as well as cane matting. These modular items were designed to be manufactured with standard machine-made components. Dieckmann also designed a range of garden furniture. These rattan pieces could be folded for storage and had adjustable back and foot rests, and some had integrated cup and book holders.

His work was exhibited at the ambitious 1929 *Die Wohnung* (The Dwelling) exhibition in Stuttgart, alongside the work of Peter Behrens, Le Corbusier, and Ludwig Mies van der Rohe.

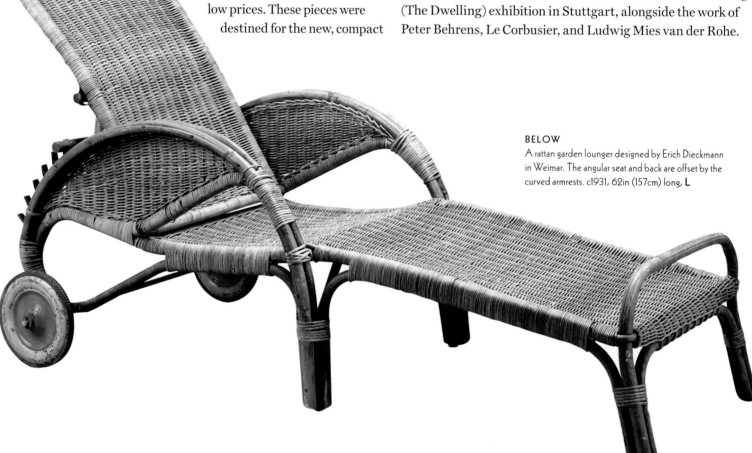

BELOW
A rattan garden lounger designed by Erich Dieckmann in Weimar. The angular seat and back are offset by the curved armrests. c1931, 62in (157cm) long, **L**

WOLFGANG HOFFMANN

Wolfgang Hoffmann (1900–1969) was the son of Josef Hoffmann, co-founder of the Wiener Werkstätte. He was born in Vienna and studied architecture and design before going on to work for his father.

In 1925, the Austrian-born Joseph Urban (1872–1933), who was a friend of Wolfgang's father, was looking for an assistant at his architectural practice in New York. Josef recommended Wolfgang and he set sail for the USA with his wife Pola (1902–84), having sold the first-class ticket Urban had sent him so he could buy two steerage tickets instead.

After Wolfgang had worked with Urban for nine months, the Hoffmanns started their own design business on Madison Avenue in New York. They designed custom furniture for stores, apartments, and theatres in the city, and their work was shown at the *American Designers Gallery* exhibitions in 1928 and 1929.

In 1932 Urban asked Wolfgang Hoffmann to help develop the colour scheme for the 1933 Chicago World's Fair and design the interior and furniture for the Lumber Industries house. There, Hoffmann's work was seen by the Howell Company, of Geneva, Illinois (later, St Charles, Illinois) and he became the firm's resident designer from 1934 until 1942, designing chromed-steel furniture.

Hoffmann's designs for the Howell Company combined tubular or flat chromium-plated steel with vinyl, leather, linoleum, lacquer, glass, wood, and Bakelite to create elegant chairs, desks, tables, and storage furniture for homes and offices in the European Modernist style. Pieces may be labelled. Hoffmann moved to Chicago to supervise the production of his designs. While they were modern, he did not think of them as being streamlined. He is reported to have said: "[The style] has been employed only in aircraft design and it has nothing to do with the clean cut architecture of either a tubular chair or a table".

After the Hoffmanns divorced in 1932, Pola married the mystery writer Rex Stout (1886–1975) and had a successful career as as textile designer. Wolfgang left the Howell Company in the early 1940s when it began to produce items for the war effort. He worked as a professional photographer in Chicago until his death.

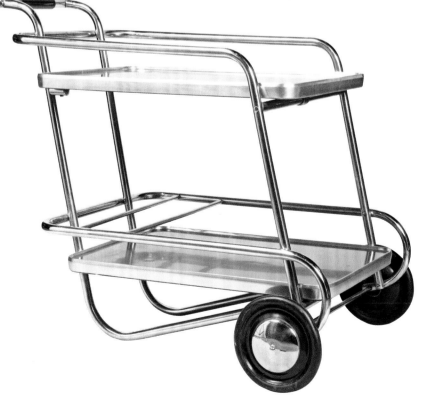

RIGHT
An early prototype for a tubular steel serving cart designed by Wolfgang Hoffmann for the Howell Company in Chicago, with two green Formica trays and rubber wheels. A similar model went into prodcution and became one of the company's best-selling items. c1935, 27in (68.5cm) high, **NPA**

MODERNIST GALLERY

BAGGE ◊ BRANDT ◊ CHALEYSSIN ◊ CHANLER ◊ FRANK ◊
GIUDICI ◊ HERBST ◊ SAARINEN ◊ ULRICH ◊ WRIGHT

During the 1920s and 1930s Modernist furniture designs relied on pared-back silhouettes and plain surfaces to mark their difference from extravagant Art Deco and traditional furniture styles.

In France, the Union des Artistes Modernes (UAM) was founded in 1929 to promote the new style. Members included Le Corbuser, Eileen Gray, René Herbst, and Charlotte Perriand. Herbst (1891–1982) was a keen supporter of ow-cost mass-production but also created pieces for the top end of the market.

Francisque Chaleyssin (1872–1951) began his career making traditional furniture, but received praise for a curved sideboard used as a writing desk at the 1925 Paris *Exposition Internationale* and his exhibit at the 1927 *Modern Decorative Art Exhibition*.

French architect and decorator Eric Bagge (1890–1978) created stylish interiors for exhibitions including the *Salon d'Automne* and the 1925 Paris *Exposition Internationale*. Metalworker Edgar Brandt (1880–1960) also exhibited pieces at the Paris *Exposition* and collaborated with several designers and architects. He designed a small number of pieces of wooden furniture.

Finnish-born Eliel Saarinen (1873–1950) emigrated to the USA in 1922 and helped establish the Cranbrook Academy, Michigan. He designed a small number of Art Deco furnishings for the school and private clients, as well as pieces that were produced commercially by Johnson Furniture.

American industrial designer Russel Wright (1904–76) designed several furniture lines from the 1930s until the 1950s, including the "American Modern" wooden furniture produced by the Conant-Ball company of Gardner, Massachusetts.

Austrian-born Josef Frank (1885–1967) created furniture in an economical, modern style. He worked in Vienna, Sweden, and the USA.

In Italy, Guglielmo Ulrich (1904–77) created Modern furniture using exotic woods, while Battista and Gino Giudici used tubular steel for a range of seating furniture.

RIGHT
A small dark oak freestanding shelf unit by Francisque Chaleyssin, featuring intersecting asymmetrical plates and based on a drawing by his son-in-law, André Ducaroy. c1930, 30½in (77cm) high, **K**

A rosewood and rosewood-veneer pedestal table by René Herbst, with a circular top over a Cubist circular stepped geometric base. 1920s, 30in (76cm) high, **I**

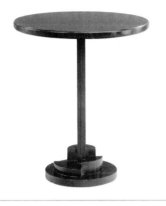

A bent-wood easy chair designed by Josef Frank and manufactured by Thonet. The wood has been stained and the chair bears a Thonet mark. 1929, 36in (91.5cm) high, **K**

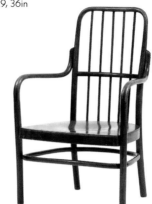

An early and rare asymmetric server designed by Russel Wright for Heywood-Wakefield. It is covered with a burl-wood veneer and black lacquer finish and the drawer and cupboard doors have horizontal handles. c1930, 42in (107cm) wide, **J**

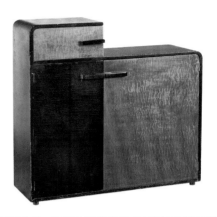

A pair of walnut and mohair lounge chairs by Guglielmo Ulrich. The arms and front legs are shaped with elegant curves. c1930, 31in (79cm) high, **I**

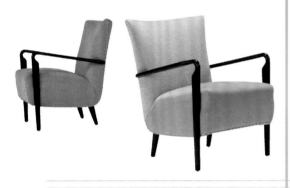

A two-tier coffee table designed by Eric Bagge. The circular top, undershelf, and column support are veneered in walnut. The support has an illuminated glass insert at the top and a chrome collar at the base. c1930, 35in (90cm) diam, **I**

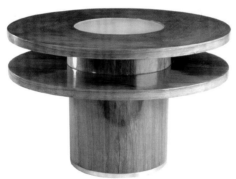

A chaise longue designed by Battista and Gino Giudici and manufactured by Fratelli Giudici of Locarno, Switzerland. The brothers spent 12 years and required three patents to design their ideal chair, which combined an ambitious geometric vision with a refined functionality. The tubular steel frame is hung with a cotton and linen fabric and can be converted to a rocking chair. c1935, 44½in (113cm) long, **I**

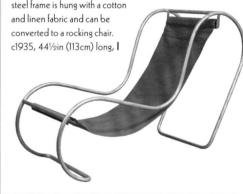

A three-panel screen by Robert Winthrop Chanler (1872–1930), painted with two zebras on one side in black and tan on an ivory ground, the back decorated with diagonal stripes in black with silver foil. 1928, 78in (198cm) high, **H**

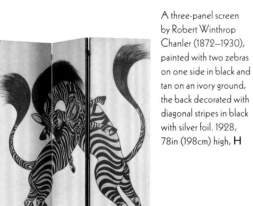

A rare solid rosewood office chair by Edgar Brandt, designed to be used in his offices. The high arched back is complemented by scrolled J-shaped arms, a stuff over seat, and tapering legs with gilt sabots. 1920s, 43½in (110cm) high, **H**

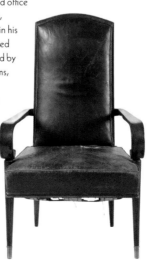

A pedestal dining table designed by Eliel Saarinen for Johnson Furniture. The circular tables, which sits on a circular base surrounded by a series of pillars, was part of the "Flexible Home Arrangements" collection. c1941, 52in (132cm) diam, **J**

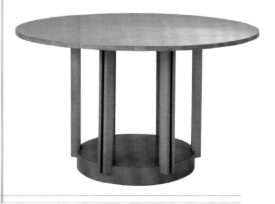

SKYSCRAPER STYLE

The skyline of New York in the 1920s and 1930s, with its soaring skyscrapers, inspired furniture designers to create elegant, stepped pieces that reflected the geometry of the city. For many, the new buildings reflected the optimism of the time and a faith in the future and modern industry. By 1926, although the tallest buildings of their age – the Chrysler Building and the Empire State Building – were still under construction, skyscrapers dominated the skies.

It was a particularly American view of Art Deco design. The designer Paul Frankl once claimed that the 1925 Paris *Exposition Internationale* would have looked a lot different if America had exhibited a skyscraper or two. Frankl was probably the most accomplished exponent of the skyscraper style – in fact he created an entire range under the "Skyscraper Furniture" label. The stepped designs have a geometric, architectural form, which is devoid of embellishment apart from plain, lacquered finishes and simple trims and handles.

This modern, American style was echoed in the work of the industrial designer Donald Deskey and the furniture designer Warren McArthur. Deskey used Bakelite, chrome, and aluminium to trim his wooden furniture, and created blocks of colour with paint and lacquer panels. McArthur led the way with tubular aluminium furniture in the USA. His work differs from comparable designs made in Europe in that the joints are an important part of the visual appeal of the design. European designers produced similar items using a seamless construction.

The streamlined pieces these designers and their contemporaries produced were echoed in the obsession with speed created by the latest cars and trains, and the same sleek designs can also be seen in many household objects – from radios to Bakelite desk sets.

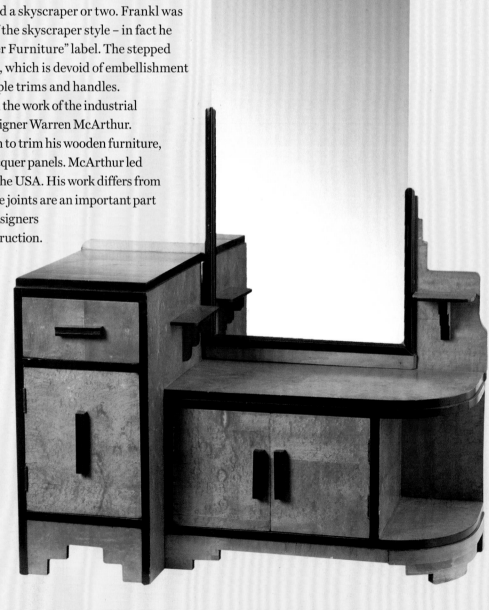

RIGHT
This "Skyscraper" vanity unit by an unknown designer has all the hallmarks of the style: the cupboards and mirror are at different levels and, like the handles, each section is trimmed with black lacquer. 1930s, 61in (155cm) high, **J**

OPPOSITE
Built in 1929, the New York Central Building on Park Avenue is now known as the Helmsley Building. It was designed by Warren & Wetmore, the architects of New York's iconic Grand Central Terminal.

NEW YORK CENTRAL BUILDING

PARK AVENUE, NEW YORK

AT · THE · GATEWAY · TO · A · CONTINENT

PAUL FRANKL

The furniture designed by Paul Frankl (1886–1958) epitomizes the architecture, culture, and glamour of Jazz Age New York. His work, which was primarily designed for chic Manhattan apartments, is unique to the city where it was made and rarely seen outside the USA.

Frankl was born in Prague, Czechoslovakia, and trained as an architect in Vienna, Paris, Munich, Berlin, and Copenhagen before emigrating to America in 1914. He became a US citizen in 1925. Not long after arriving in the New World, Frankl was a leading member of the New York Modern Movement, together with Donald Deskey and the Viennese architect Joseph Urban.

Frankl's work celebrated the new, modern way of life he found in New York. He initially designed buildings and furniture, but focused on the latter from the mid 1920s. In 1922

he set up Frankl Galleries and four years later produced the first pieces in his signature "Skyscraper Furniture" line, which was inspired by the stepped skyline of New York City. This custom-made line was sold through Frankl Galleries.

Despite being made from Californian redwood and nickel-plated steel with rudimentary black lacquered surfaces, pieces of "Skyscraper Furniture" are among the most sought after of all American Art Deco furniture.

These pieces represent the optimism of 1920s New York, which Frankl discussed in his 1928 book, *New Dimensions*. The lack of ornament in his designs is unsurprising, given his belief that "ornament equals crime".

As well as making "Skyscraper Furniture" in the 1920s, Frankl designed lacquered Chinese-style furniture, but this

proved to be less popular. After 1930, most of Frankl's furniture was made from metal. He continued to design after the Second World War, working with manufacturers including Brown & Salzman and Johnson Furniture. His designs were also sold by Barker Brothers in Los Angeles. He died in New York City.

OPPOSITE
A walnut sofa designed by Paul Frankl, with nickelled brass mounts. This piece was exhibited at the Chicago World's Fair in 1933. c1933, 72in (183cm) wide, **H**

LEFT
A "Skyscraper Furniture" dressing table by Paul Frankl, made from black lacquered wood with chromed-steel trim, handles, and stretchers, and a mirror-glass oval back and rectangular top. c1930, 44in (112cm) wide, **I**

BELOW
A rare "Skyscraper Furniture" chest by Paul Frankl, asymmetrically configured with drawers, single cabinet with red interior and shelves, and a pull-out shelf enamelled in black and red with pyramidal and horizontal brass handles. 1920s, 56in (142cm) high, **H**

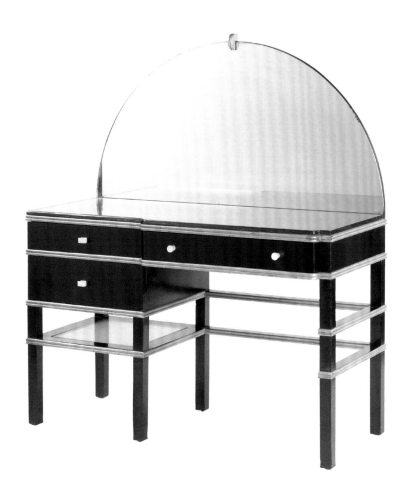

DONALD DESKEY

Donald Deskey (1894–1989) was an American Modern industrial designer who created pieces in an unmistakable Art Deco style. As well as furniture he designed interiors, lighting, fabrics, wallpaper, and packaging, and frequently used modern materials including chromium, Bakelite, and aluminium. His work was influenced by Cubism and – following a visit to the 1925 Paris *Exposition Internationale* – French Art Deco. During the 1920s and 1930s his designs progressed from Art Deco to Streamline Moderne.

Deskey was born in Blue Earth, Minnesota, and studied architecture at the University of California, but did not go on to design buildings; instead he worked as an artist and designer.

In 1927 he founded the design consultancy Deskey Vollmer Inc. in partnership with designer Phillip Vollmer, which specialized in furniture and textile design.

Deskey won the competition to design the interiors for Radio City Music Hall, part of the Rockefeller Center in Midtown Manhattan. The work was completed in 1932 and is probably his best-known work. The interior was the subject of sympathetic restoration in 1999 and, although some pieces were sold and replaced, the result is an Art Deco landmark, which has changed very little and gives visitors the chance to see Deskey's work as he intended.

From around 1930 until 1934 Deskey designed hundreds of pieces of economical furniture for mass-production using Bakelite, aluminium, steel, and cork for companies including John Widdicomb, S. Karpen of Chicago, and Ypsilanti Reed.

In the 1940s he set up Donald Deskey Associates, which became one of the leading design practices in the USA after the Second World War, designing interiors of houses, restaurants, clubs, and hotels throughout the country.

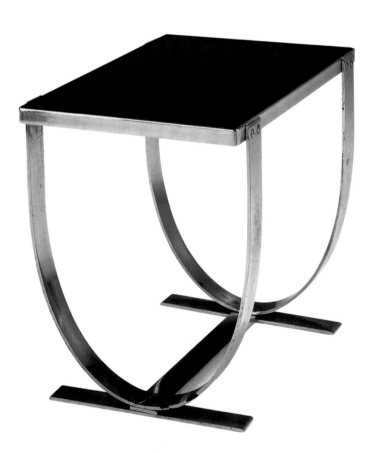

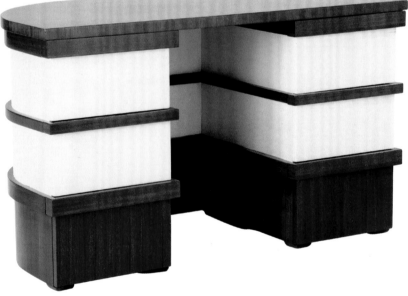

LEFT
A side table by Donald Deskey, with a black glass top above U-shaped banded and chromed-steel uprights and an I-shaped base. c1930, 22¼in (56.5cm) wide, **J**

ABOVE
A six-drawer D-shaped knee-hole desk by Donald Deskey, made from mahogany with white-painted and lacquered sides and drawers. c1930, 50in (127cm) wide, **I**

WARREN MCARTHUR

Born in Chicago, Warren McArthur (1885–1961) was brought up surrounded by the latest technological advances. His father was one of the first people in the city to own a car and, in 1892, he commissioned Frank Lloyd Wright (1867–1959) to design the family's new home.

McArthur studied mechanical engineering at Cornell University, New York, graduating in 1908. He soon started developing his interest in product design: between 1911 and 1914, he filed ten patents for lamps. In 1913 he moved to Phoenix, Arizona, to work with his brother Charles. Their father had given each son $100,000 to get started in business. The brothers prospered, opening car dealerships and starting the first radio station in Arizona.

Warren began designing furniture in 1924 when his oldest brother, architect Albert Chase McArthur (1881–1951), started to run out of money for a house he was building for their father. To save money, Warren offered to design the furniture and have it made locally. Like Marcel Breuer, Le Corbusier, and Ludwig Mies van der Rohe, he used tubular metal for his designs.

Following the 1929 Stock Market Crash, McArthur moved to Los Angeles to concentrate on manufacturing furniture. He moved his company east in 1932, first to Rome, New York, then to Bantam, Connecticut, in 1936. Between 1929 and 1940 he created a collection of chairs, tables, and sofas that furnished the most sophisticated homes, stores, and offices in the country. He started making custom pieces but soon began to work on new methods of joining sections, to make aluminium hard and prevent it from tarnishing. However, the cost of the materials and construction process meant that McArthur furniture was never made in large quantities.

The clever engineering, sleek design, lightness of construction, and materials he used resulted in McArthur being asked to design bomber seats during the Second World War.

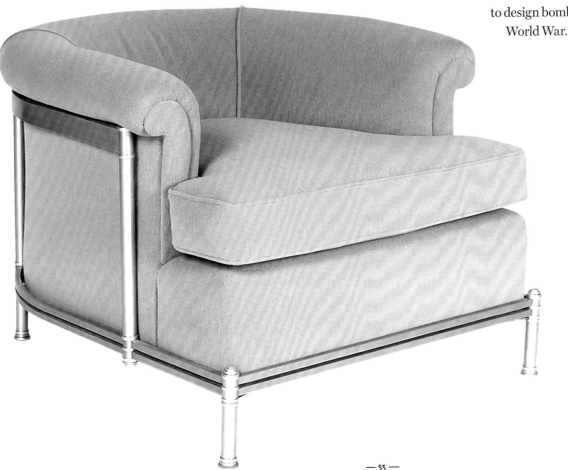

LEFT
An "Old Point Comfort" club chair by Warren McArthur, with typical tubular aluminium frame and taupe fabric upholstery. c1930, 30in (76cm) high, I

BRITISH FURNITURE GALLERY

HARRY & LOU EPSTEIN ◊ BETTY JOEL ◊ GORDON RUSSELL

Most British Art Deco furniture was made in London and was designed to appeal to middle-class families who had relatively little space or money but wanted the latest designs in their homes. The result is furniture with few of the elegant details seen in French pieces – or the drama used by American designers. Instead, economy of design and manufacture were key. Most pieces were designed to be practical and are generally box-shaped chests or cabinets.

However, some designers were able to bring elements of the French style to their work. Ray Hille interpreted it for British budgets and interiors, while brothers Harry and Lou Epstein created a distinctly British Art Deco style of suite furniture and elegant cocktail bars alongside French-inspired pieces. In Edinburgh, Whytock & Reid combined traditional cabinetmaking skills with high-quality materials to create substantial Art Deco designs.

Betty Joel (1896–1985) was in the privileged position of being one of a small group of designers who made modern furniture for the British social elite. During the 1930s, from her premises in London's exclusive Knightsbridge, she used English woods such as sycamore and exotic timbers to veneer her geometric forms.

Gordon Russell (1892–1980) created a unique form of Art Deco furniture imbued with an Arts and Crafts aesthetic. These designs, produced in his Cotswolds workshops, used local woods and traditional cabinetmaking skills.

Other Art Deco British furniture of note includes wicker pieces by Lloyd Loom, and some aluminium pieces made by PEL (Practical Equipment Limited) during the 1930s in Birmingham, influenced by the work of Marcel Breuer. Retailers such as Heal & Co. also promoted the style.

RIGHT
A quartetto nest of tables by Harry and Lou Epstein, veneered in burr maple with serpentine-cut rims to the under shelves and tops. The tops have later ebony stringing. The Epsteins' furniture was typically veneered with burr maple, sycamore, or walnut. Like most pieces, it was probably custom-made and is not marked. c1930, 30in (76cm) diam, **K**

A pair of bookcases by Betty Joel, in Australian silky oak, each of asymmetric form with open shelves and two cupboard doors on fluted square feet. Like many of Joel's pieces they were made by J. Emery at Token Works Portsmouth and they have a "Token Hand-Made Furniture by Betty Joel" label, dated. 1932, 36in (91.5cm) wide, **J**

A cherry wood and English walnut corner desk "No. 705" by Gordon Russell, made at his workshop in Broadway, Worcestershire. The piece displays the combination of geometric and traditional styles that is typical of the Art Deco style he employed in the 1930s. 1930, 45½in (116cm) wide, **J**

A "Cloudback" carver chair by the Epsteins, upholstered in a cow patch fabric. Brothers Harry and Lou Epstein are credited with having created the iconic Art Deco "Cloud" seat furniture – which included armchairs and sofas as well as dining chairs – in the mid 1930s. Their work is always of a high quality. 1928, 33½in (85cm) high, **J**

A pair of geometric Queensland silky oak bedside cabinets by Betty Joel, with chrome disk handles that are typical of her style. They were made by the Token Works and retailed by J.C. Penney. They have the applied Token Works labels on the reverse. 1934, 36in (91.5cm) high, **J**

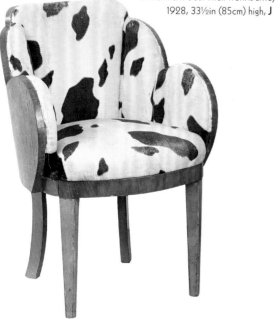

LIGHTING GALLERY

BRANDT ◊ CLIFF ◊ DAUM ◊ FAYRAL ◊ MULLER FRÈRES ◊ SUBES

Some designers used the possibilities offered by electric lighting to create lamps that emphasized their design skills and blurred the lines between practicality and decoration. Others, such as Émile-Jacques Ruhlmann, saw lighting as an integral part of a design for an interior.

Figurative lamps with brass or spelter (a cheap zinc alloy) bases and glass shades were very popular. Classic designs feature a naked dancing girl holding up a globe of light. Many of these pieces are unmarked.

Glass manufacturers, particularly the French firms of Daum, Schneider, and Muller Frères, had been making glass lampshades since the 1900s. In the 1920s they started to use etched glass with elegant designs that were enhanced when the light was switched on. The shades were generally a simple shape decorated with geometric patterns, stylized flowers, or Egyptian motifs, and the glass itself might be mottled, marbled, or textured.

René Lalique (1860–1945) created many designs for domestic glass light fittings and was commissioned to produce shades for the French ocean liner SS *Normandie*, as well as for shops, restaurants, and offices around the world.

Many leading metalworkers, including Edgar Brandt, Paul Kiss (1885–1962), Raymond Subes (1891–1970), and Albert Simonet, created ceiling and floor lamps in their signature styles. Brandt worked with Daum to produce a variety of lighting and his "La Tentation" floor lamp of a cobra coiling up to a marbled glass shade is one of his best-known designs. Floor lamps were often supplied in pairs.

Pottery manufacturers also made lamp bases, decorating them with the latest stylized or geometric designs.

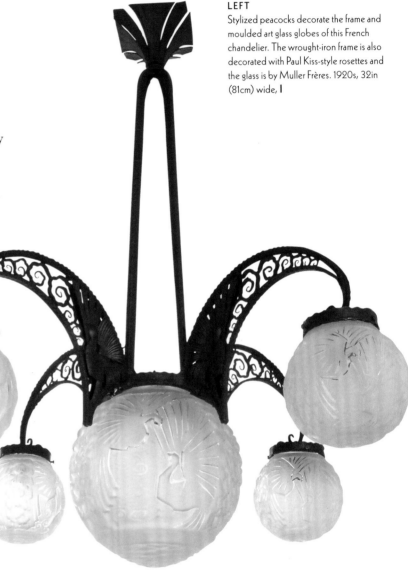

LEFT
Stylized peacocks decorate the frame and moulded art glass globes of this French chandelier. The wrought-iron frame is also decorated with Paul Kiss-style rosettes and the glass is by Muller Frères. 1920s, 32in (81cm) wide, I

An American Art Deco chandelier consisting of two frosted glass discs separated by a frosted glass cylinder, with metal supports and with a fluted central boss. c1935, 23in (58.5cm) diam, **I**

A acid-etched chandelier by Daum, the domed diffuser decorated with scrolls on a chipped ice ground, the central standard with internal gilt decoration, signed "Daum Nancy France" with the cross of Lorraine. c1930, 35in (90cm) high, **I**

A "La Tentation" lamp by Edgar Brandt and Daum, of a cobra supporting a glass shade. The gilt-bronze base is stamped "E.BRANDT" and the internally decorated glass shade is engraved "Daum, Nancy" with the cross of Lorraine. c1925, 19in (48cm) high, **G**

A French table lamp base, probably a Clarice Cliff (1899–1972) design, featuring a stylized floral motif in black and grey on a cream pottery ground, signed "Gray's Pottery" on the base. 1930s, 6in (15cm) diam, **K**

An etched glass lamp by Daum, the base and shade made from clear glass with a frosted and textured surface. The shade is supported by wrought-iron arms. Both sections are signed. c1925, 18in (45.5cm) high, **I**

A pair of organic table lamps. The ebonized wood bases are shaped as stylized branches on a domed, stepped base and support petal shades in peach, amber, and white, unmarked. c1925, 18in (45.5cm) high, **M**

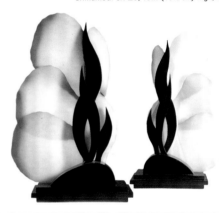

A bronze patinated alloy table lamp on a marble base, in the form of a female athlete naked except for a belt with pendants, balanced on one foot and holding aloft a spherical milk glass shade, unsigned. c1925, 28in (71cm) high, **J**

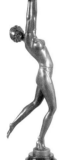

A French wrought-iron chandelier in the style of Raymond Subes. The geometric skyscraper-style arms radiate from a stepped central column and terminate in cylindrical alabaster glass shades. 1920s, 31½in (80cm) diam, **I**

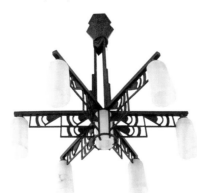

A spelter table lamp modelled by Fayral (a pseudonum for Pierre Le Faguays, 1892–1956), of an exotic dancer naked to the waist and wearing a draped skirt, holding aloft a crackled glass globe shade. She stands on a stepped marble base. Signed "Fayral" and "Paris France". c1925, 20½in (52cm) high, **M**

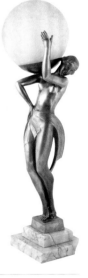

DESK & FLOOR LAMP GALLERY

JACQUES ADNET ◊ ANGLEPOISE ◊ NORMAN BEL GEDDES ◊ BREVETTE ◊ CHRISTIAN DELL ◊ MARC EROL & CHARLES GOETZ ◊ LA MAISON DESNY ◊ GIO PONTI

The challenge for designers working in a Modern aesthetic was to create lighting that fully utilized the latest materials – Bakelite and chrome – as well as the more traditional glass and wood. The result was some of the most distinctive and exciting modern lighting of its time.

At the Bauhaus in Germany, designers created lamps that were pared down to the basics and could be mass-produced. Many of these designs were to become the basis of all modern desk lamps: a simple base and shade joined by a metal stem. Christian Dell (1893–1974), who was head of the Bauhaus school's metal workshop from 1922 until 1925, went on to design many functional, classic lamps for German companies throughout the 1930s and 1940s.

The iconic Anglepoise desk lamp was also developed at this time. The 1932 brainchild of George Carwardine (1887–1947), an English automotive engineer, it featured an articulated spring that allowed the lamp to be moved in any direction, directing the beam of light where it was needed, and yet remain stable. Similar Bakelite lamps were made by companies including Brevette in France.

Modernist designers elsewhere in Europe, including Jacques Adnet (1900–84) and Marc Erol in France and Gio Ponti in Italy, created lamps with a minimal, classical aesthetic that had a more decorative style than their German equivalents.

The style was taken to another level by La Maison Desny in Paris, where a series of abstract geometric lights was developed.

In the USA, Modern and Machine Age designers, including the industrial designer Norman Bel Geddes (1893–1958), Walter Dorwin Teague (1883–1960), and Donald Deskey, created sleek, abstract lights for both the home and the office.

RIGHT
George Carwardine's Anglepoise lamp had a huge impact on lighting. Originally designed for use in factories, it proved essential in offices too. The black lacquered lamp with equipoise springs was first introduced in 1932, and has been in production ever since.

ANOTHER Anglepoise LAMP
OF 1001 ANGLES · 1001 USES
MANUFACTURED BY
HERBERT TERRY & SONS LTD. REDDITCH, ENGLAND.
U.K. PATENT NO. 404615

A Modernist floor lamp by Jacques Adnet. The base consists of three glass rods and terminates in a glass sphere finial and ribbed chrome torchère uplighter shade with two side beehive downlights. 1930, 70½in (179cm) high, **H**

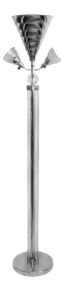

An American Machine Age "mushroom" table lamp with a chrome and black enamelled domed shade secured to the stem with a ball finial. The knopped stem is joined to a stepped chrome base. 1930s, 18in (45.5cm) high, **K**

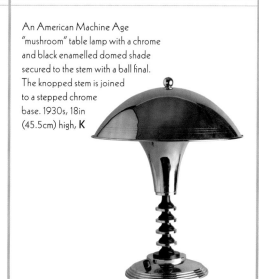

A French "Jumo" streamlined Bakelite desk lamp designed for Brevette. The black and brown Bakelite case contains an internal extendable arm and has the factory stamp to the base. c1940, 17½in (44.5cm) high, **L**

A table lamp designed by Gio Ponti for the science department at Padua University. The brown-painted metal shade sits over a matte glass shade, chrome-plated stem, and brown-painted metal base. 1936–41, 16in (40.5cm) high, **K**

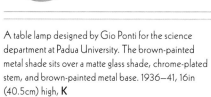

A table lamp consisting of a frosted glass stepped shade supported by a pair of rearing chromed gazelles and all set on a stepped black vitriolite glass base. 1930s, 8¾in (22cm) high, **L**

A Bauhaus table lamp designed by Christian Dell. The green shade is designed to rotate in all directions and is joined to a green enamelled base by a curved brass arm. 1920s, 17in (43cm) high, **K**

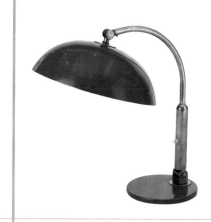

A glass and metal "Fleur" table lamp by Marc Erol and Charles Goetz for La Crémaillère. The conical frosted glass and chromed metal shade sits above a chrome metal stem with two stylized leaves. c1925, 15¾in (40cm) high, **J**

A Modernist geometric chrome and glass table lamp by La Maison Desny consisting of a series of stacked square, salmon-coloured glass plates set on a chrome base. The glass plates create a diffused light. c1925, 5in (12.5cm) high, **J**

An American streamlined Art Moderne floor lamp, attributed to Norman Bel Geddes. It has a domed shade, which is joined to the off-centre chrome and copper stepped circular base by straight rods that are set at a right angle. 1930s, 53in (135cm) high, **J**

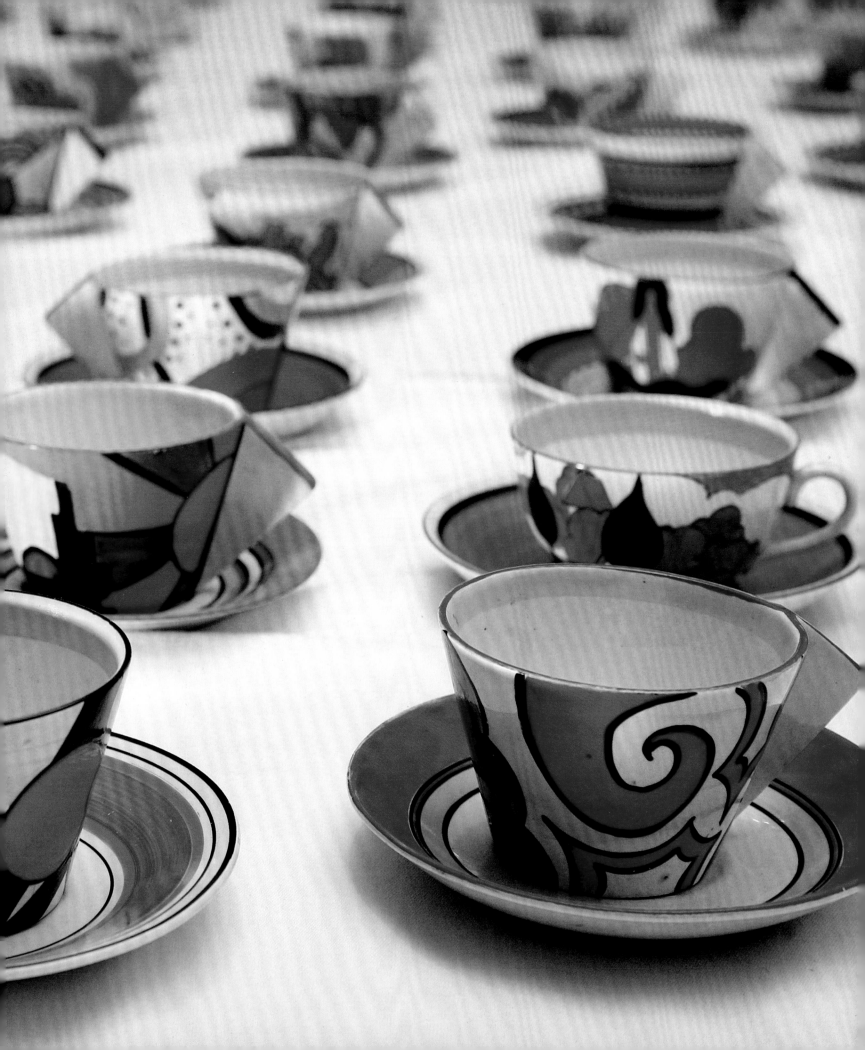

— CHAPTER TWO —

CERAMICS

GEOMETRIC GRAPHIC

Leading designers used geometric and graphic designs to introduce modernity to ceramic forms and inspired factories to mass-produce wares in a similar style. Some decorated traditional forms such as vases and bowls with Art Deco patterns, others created novel shapes on which to base their modern decoration, while a third group used the new style to depict motifs including the human form and classical themes in a graphic way.

One of those who combined traditional ceramic forms with geometric patterns was Charles Catteau at the Belgian pottery, Boch Frères. He transformed large vases using hand-painted bold designs, which contrasted a cream or grey background with bright, primary colours depicting the geometric or stylized animal motifs popular at the time.

Similarly bold designs were produced by Clarice Cliff in Staffordshire, England. The introduction of the innovative "Bizarre" range brought colourful, geometric designs into many homes. Susie Cooper worked in the Staffordshire potteries too, creating stylized and geometric patterns on decorative and useful ceramic wares. Her patterns tend to be more sophisticated and European than those of Cliff.

Colourful artistic wares were also made at the Poole Pottery in Dorset. Many established factories made Art Deco wares alongside their traditional lines. As well as dinner services and other domestic wares, a number of firms such as Longwy and Sèvres in France commissioned designers, including Édouard Cazaux and Émile-Jacques Ruhlmann, to create artistic wares. Wedgwood in the UK employed Keith Murray, Daisy Makeig-Jones, and John Skeaping to produce designs.

In the USA, Roseville, Cowan, and Rookwood were among the factories that developed Art Deco ranges to meet the growing demand. Cowan's "Jazz" bowl and "Danse Moderne" platter and Roseville's "Futura Tank" vase are considered to be icons of American Art Deco design.

Ceramic designers often reinterpreted the female form as a modern, liberated person. Goldscheider, Lenci, and Rosenthal were some of the firms that produced wares depicting women in fashionable dress – or fashionably undressed – in exquisite detail.

Ceramics were also made in Modernist Art Deco forms. The French factory Mougin Frères produced vases decorated with stylized landscapes, while in the USA industrial designer Russel Wright and potter Frederick Hurten Rhead created popular modern ranges for the home.

LEFT
A pottery vase designed by Charles Catteau for Boch Frères, decorated in blue, yellow, and green with repeating segments of stylized sunbursts, signed on base. c1923, 6¼in (16cm) high, **L**

OPPOSITE
A selection of brightly coloured pieces by Clarice Cliffe, including musicians and dancers from the "Jazz" series, designed in 1930. These flat, cut-out ceramic figures were tricky to produce and did not sell well at the time, making them very rare today.

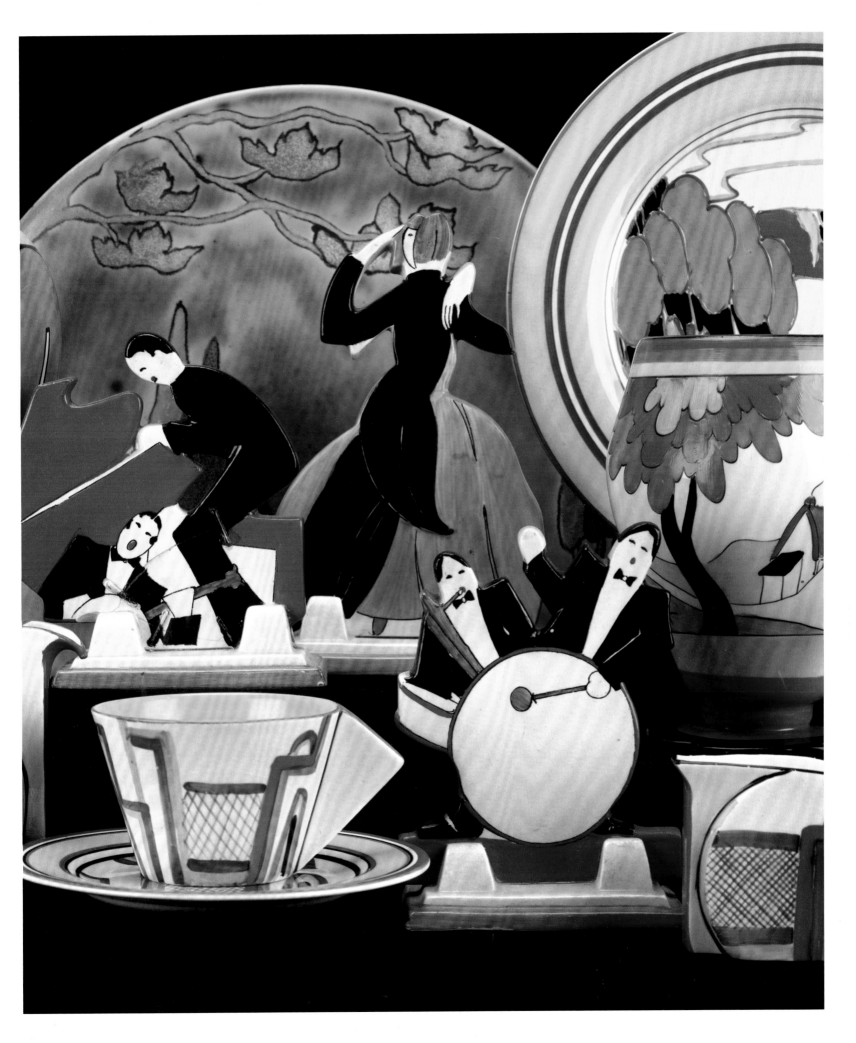

CLARICE CLIFF

Having started her career as a young girl in 1916 as a lithographer, applying transfer designs to ceramics at Wilkinson's Royal Staffordshire Pottery, Clarice Cliff (1899–1972) was an internationally respected designer by the 1930s.

At Wilkinson's Cliff's talent for design was spotted by John Butler and Fred Ridgway, the factory's artistic team. However, it was Colley Shorter (1882–1963), the owner's son – whom she married in 1940 – who gave her the most encouragement. He made sure she received formal training and helped her to set up a studio at his father's Newport Pottery.

Cliff's initial success came in 1928 with the first pieces in the "Bizarre" range. It went on to include hand-painted colourful, geometric patterns such as "Banded" and "Abstract" in its signature palette of orange, green, yellow, and black. As with the majority of Cliff's pieces, these patterns were painted over a "honey" glaze on Wilkinson's affordable, standard earthenware. Her most popular designs were still being manufactured in the 1960s, but less successful ones, such as "Butterfly" (1930), had a short production run and are rare today. All the decoration on Cliff's pieces was created by hand – although she tended to supervise the work rather than carry it out herself – and remained the same throughout the Art Deco years. She employed young "painteresses" with a taste for modern design and varying artistic ability.

Cliff became artistic director in 1931 but the factory closed in 1940. After the war she continued to work for Wilkinson's, mainly as an administrator.

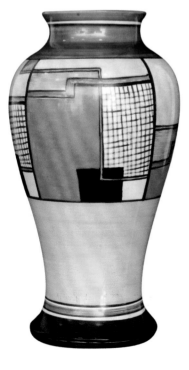

FAR LEFT
A "Football" pattern Mei Ping vase by Clarice Cliff, with hand-painted graphic design, shape no.14, signed with the "Bizarre" mark. c1930, 14in (35.5cm) high, I

LEFT
A "Butterfly" pattern vase by Clarice Cliff, the square stepped vase hand-painted with a semi-naturalistic butterfly on a striped ground, signed with the "Fantasque" mark. c1930, 8in (20cm) high, J

ABOVE
An "Orange Lucerne" vase by Clarice Cliff, shape no.204, hand-painted with a stylized scene of a castle within a forest, signed with printed marks and painted "Applique" mark. c1930, 8¾in (22cm) high, J

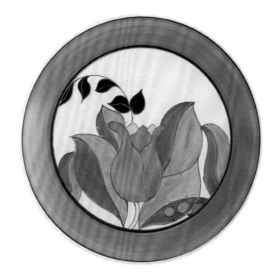

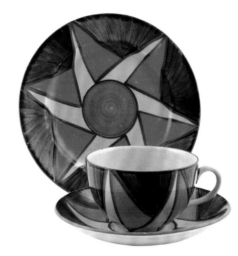

LEFT
A "The Laughing Cat" "Bizarre" figure by Clarice Cliff, the cream ground painted with black, green, and orange dots and an orange bow, with printed mark. c1930, 4¾in (12cm) high, **K**

ABOVE
A "Red Tulip" "Fantasque Bizarre" wall plaque by Clarice Cliff, decorated with a stylized tulip and leaves, with printed mark. c1932, 13½in (34cm) diam, **J**

ABOVE
An "Original Bizarre" "Globe" teacup, saucer, and side plate by Clarice Cliff, the sunburst pattern painted in shades of orange, green, and purple, with printed factory marks. c1930, 7in (18cm) diam, **M**

CLOSER LOOK

The "Bizarre" range began as a means of decorating old pottery blanks, but in 1929 Clarice Cliff began to design her own forms. Her innovations included conical sugar shakers, a honeycomb teapot, and an inverted conical bowl on a cruciform support. By 1940 Cliff had conceived or overseen the production of more than 500 shapes and 2,000 patterns, many with evocative names such as "Sunrise" (1929), "Gayday" (1930), and "Tennis" (1931).

The conical sugar sifter is typical of Cliff's range and was decorated with a number of patterns. Here the "Orange Trees & House" design combines an Art Deco pattern with an Art Deco shape. The sifter is printed with the factory marks on the base.

This conical shape does not show the pattern well in comparison to chargers and lotus jugs, and was therefore less common.

Like many of Cliff's designs, the pattern is framed by striped borders.

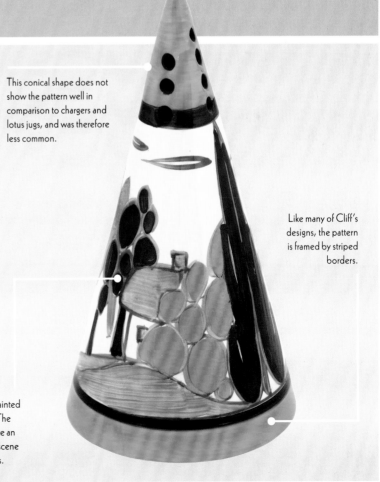

A Clarice Cliff "Orange Trees & House" conical sugar sifter, with printed factory marks. c1930, 5½in (14cm) high, **K**

The trees and house have been painted with Cliff's typical, bold palette. The design uses simple shapes to create an evocative image of a rural English scene with a cottage hidden among trees.

SUSIE COOPER

With her sophisticated designs influenced by modern art movements including Cubism, the Viennese Secession, and French Art Deco Modernism, Susie Cooper (1902–95) brought subtle style and modern European taste to the Staffordshire potteries and peoples' daily lives: the majority of her output was useful tableware.

After taking evening classes at Burslem Art School, Cooper started work as a decorator for A.E. Gray & Co. in Stoke-on-Trent in 1922 where her mentor was the factory's principal designer, Gordon Forsyth (1879–1952). However, the majority of her Art Deco wares were created at the Susie Cooper Pottery, which she founded in Tunstall in 1929 and which moved to Burslem in 1930.

Working with a team of six female painters, Cooper decorated earthenware blanks of her own design with patterns that by the mid 1930s had become increasingly geometric and sparse. After 1935 some of her pieces were embellished with transfer-printing rather than being painted by hand. These later wares included breakfast services comprising cups and saucers, toast racks, and egg cups.

As well as artistic flair, Cooper displayed a particular talent for commercial promotion. During the Depression of the 1930s she produced up to 200 designs a year, selling them through fashionable London showrooms and promoting them at British industrial fairs with the slogan "No Home is Complete without Susie Cooper". She found particular success at the 1932 British Industries Fair and the 1935 *British Art in Industry* Exhibition.

The pottery closed during the Second World War and no Art Deco wares were made after 1950. The Susie Cooper Pottery became part of the Wedgwood Group in 1966 and Cooper continued working for the company until she was in her eighties.

LEFT
A "Seagull" side plate by Susie Cooper, decorated with a flying gull hovering above stylized waves, with printed marks on the base. c1930, 6¾in (17cm) diam, **M**

ABOVE
A "Pottery Paris" milk jug by Susie Cooper for Gray's, painted with the geometric '"Cubist"' pattern, no.8071, printed with the ocean liner mark on the base. c1930, 5¼ in (13cm) high, **M**

POOLE

After the First World War, the pottery in Poole, Dorset, began to make colourful, artistic wares to meet the new demand for Art Deco pieces. In 1921, its owners, brothers Owen and Charles Carter, formed a partnership with former goldsmith Harold Stabler and husband and wife John and Truda Adams to create Carter, Stabler & Adams; the business was renamed Poole Pottery in 1963. Stabler's wife Phoebe, who had worked for Royal Doulton, also worked for the pottery as a designer.

By the mid 1920s the Poole Art Deco style was defined by the vibrant painting of Truda Adams (1890–1958), which was influenced by her background in embroidery. Typical pieces feature stylized flowers and leaves, sometimes incorporating zigzags, birds, and deer, in a form reminiscent of contemporary French designs. She was awarded two gold medals at the 1925 Paris *Exposition*. The result was noteworthy Modernist ceramics created by a combination of traditional hand-throwing techniques and modern decoration, which were sold through fashionable boutiques including Liberty's and Heal's in London. In 1930, Truda married Charles Carter's son, Cyril.

As well as vases and tableware, Harold and Phoebe Stabler created lively figures and plaques, including the "The Bull" group: two children sitting on a bull and surrounded by floral garlands. Pieces in the "Handcraft" range, made after 1920, feature white or pale grounds. Most vases consist of simple forms decorated with Japanese-inspired designs in bright, hand-painted colours. Other styles include figures and bookends decorated with monochrome or mottled glazes by John Adams; pots marketed under the name "Picotee", which featured horizontal bands of muted colours that were sprayed onto the surface; and Adams's "Streamline" tablewares.

LEFT
A "Leaping Gazelle" or TZ pattern shouldered ovoid vase by Truda Carter for Poole Pottery, with impressed marks to base. The highly stylized design is enclosed by two striped borders.
c1930, 6¾in (17cm) diam, **M**

RIGHT
A "Tea" tile from the walls of the Poole Pottery tea room. The graphic design was produced by illustrator Edward Bawden (1903–1989), who created a number of tile panels for the pottery.
1930s, 6in (15cm) square, **M**

GEOMETRIC GALLERY

BURLEIGH WARE ◊ MYOTT ◊ ROYAL DOULTON ◊ ROYAL WINTON ◊ SHELLEY

The success of geometric designs pioneered by designers including Clarice Cliff and Susie Cooper encouraged many Staffordshire factories to follow their lead. Soon, potteries created inexpensive utilitarian and decorative wares in innovative new shapes and decorated with strong, geometric patterns or stylized landscapes. Many of these pieces are unmarked and of poor quality, but the best examples show the excitement and boldness of the Art Deco style.

Shelley and Royal Doulton were among those who produced tablewares in the new style. Cups, jugs, and teapots were created with angular handles – sometimes fashionable yet impractical – and decorated with striking patterns or stylized rural scenes. Shelley was unrivalled for its tableware, with patterns designed by its artistic director Eric Slater (1896–1963).

Many eye-catching designs were made by Myott and Royal Winton. Notable pieces from these potteries are in the style of Clarice Cliff with a jazzy feel, such as fan-shaped vases hand-painted with bold, repeating patterns. Royal Winton was another Staffordshire pottery noted for its domestic wares decorated with bright colours and lustre glazes.

Burleigh Ware is also best known for its Art Deco ceramics. It made vividly coloured pieces, in particular yellow jugs decorated with birds or with animal- and human-shaped handles.

RIGHT
The asymmetrical "Fan" vase designed by Royal Winton is hand-painted with stylized sunflower motifs using yellow, green, and red on a white ground. The architectural stepped base is painted in shades of brown. c1930, 9in (23cm) high, **M**

The rare "Beaky" jug by Myott combines an exaggerated faceted body and angular handle with hand-painted decoration of geometric bands in a bold palette of orange, green, blue, and black. There are printed marks and "BG62" on the base. 1930s, 9in (23cm) high, **M**

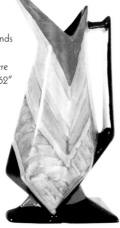

A hand-painted Art Deco geometric pattern decorates this square tazza by Grimwades Royal Winton. The design is continued onto the flared pedestal base. The bottom has printed "Ivory England" and painted "Handcraft 10024" marks. c1930, 3¾in (9.5cm) high, **M**

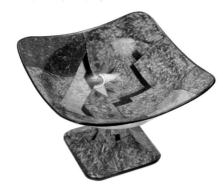

The "Mode" teapot was designed by Eric Slater for Shelley and produced from 1930 to 1933. Thanks to its angular handle, it is one of the factory's strongest Art Deco forms and here it is decorated in classic Art Deco colours: green with gold and black details. Pattern no.P11754, with printed and painted marks. c1930, 5in (12.5cm) high, **L**

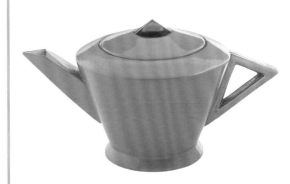

The geometric "Fan" vase by Myott, pattern no.6888. Here it is hand-painted with semi-naturalistic flowers and a mottled sky background but it was also decorated with a geometric design and in an autumnal orange colourway. c1930, 8½in (21.5cm) high, **M**

A Queen Anne shape trio (cup, saucer, and side plate) by Shelley, decorated with the Art Deco "Tall Trees and Sunrise" pattern. The octagonal shapes create simple broad and narrow panels that do not interfere with the decoration. c1929, saucer 6¼in (16cm) diam, **M**

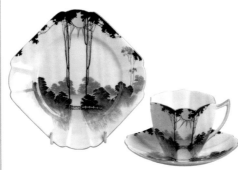

A hand-painted "Bow tie" jug, pattern no.9747 by Myott, hand-painted with bold swathes of colour. Like many of Myott's pieces, the decoration on this piece was inspired by the work of Clarice Cliff. c1930, 8½in (21.5cm) high, **M**

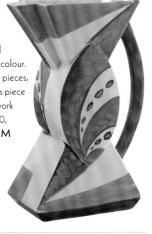

A 1930s Burleigh Ware water jug, moulded with an angular handle and decorated with a stylized flamingo in flight beside bulrush and water grasses, printed marks. This piece was part of the pottery's "Flower" range. 1930s, 9in (23cm) high, **M**

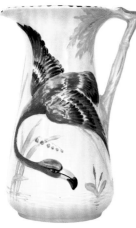

An Art Deco tea set by Royal Doulton, decorated with the "De Luxe" pattern, a geometric Art Deco design featuring green and white glaze sections divided by a black and silver arc. The set comprises: sandwich plate, sugar bowl, milk jug, six teacups, saucers, and tea plates, with impressed dates. c1936, cup 2¾in (7cm) high, **M**

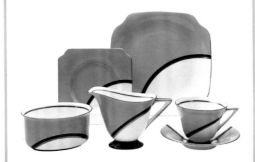

A ginger jar and cover by Royal Winton, decorated with a fantasy landscape with a castle in an iridescent finish over a ruby lustre ground. Items such as this are not typical of the factory's Art Deco output, which focused on chintz ware: ceramics decorated with all-over floral designs. 1930s, 12in (30cm) high, **M**

COWAN

The majority of the wares made by the Cowan Pottery were mass-produced, inexpensive, and useful. Today it is renowned for a small number of artistic, Art Deco pieces, which include some of the most valuable American ceramics of the period.

The pottery was founded in 1913 in Lakewood, Ohio, by Reginald Guy Cowan (1884–1957), who went on to create many of the pottery's figural designs. In 1920 the pottery moved to larger premises in Rocky Road, near Cleveland, Ohio, and by 1929 employed more than 40 people and used nine kilns. As well as tiles, garden ornaments, and doorknobs, the factory made a range of figural vases, figures, and other decorative pieces, including the innovative figural "flower frogs": figures designed to stand in water and hold flowers.

However, it is for the Art Deco pieces created by Viktor Schreckengost (1906–2008) that Cowan is celebrated today. His "Danse Moderne" figural plaque and "Jazz" punchbowl (which is officially titled "New Year's Eve in New York City") – decorated with stylized figures and views of Manhattan – are among the most famous and valuable American Art Deco ceramics.

Schreckengost was one of a group of about 20 artists, which also included A. Drexler Jacobson, Alexander Blazys, Margaret Postgate, and Waylande De Santis Gregory, who were commissioned by Cowan to create pieces for the pottery. The first were produced in 1927 but their success was short-lived; the pottery closed in 1931 as a result of the Depression. Ceramics attributed to this group of designers include bookends, figures, vases, and wall plaques in the Art Deco style.

RIGHT
The "Danse Moderne" wall plaque, designed by Viktor Schreckengost for Cowan, features an iconic Jazz Age design of a stylized couple dancing, surrounded by cocktail glasses and stars. The glazed earthenware is impressed with stamps on the back. 1931, 11¼in (28.5cm) diam, **D**

BOCH FRÈRES

The Art Deco wares produced by the Belgian Boch Frères factory were mass-produced and designed to appeal to stylish buyers. It is a tribute to the French-trained artists who designed them that they are now considered to be progressive for their time and valued accordingly. These pieces, which are usually marked "Keramis", consist of slip-cast bodies hand-painted with eye-catching patterns, which made them appealing to the patrons of the fashionable galleries and department stores around the world that sold them.

Charles Catteau (1880–1966) was one of the main designers. He was born into a family of ceramic workers in Sèvres, France, and was employed at the porcelain factory in Nymphenburg, Germany, before joining Boch Frères in 1906. The factory had been established in 1841 by the Boch family at La Louvière and was known for its utilitarian wares as well as decorative wares designed by Alfred William Finch(1854–1930), which featured faience with thick, opaque glazes embellished with incised patterns. When

Catteau was made artistic director in 1907 he continued this tradition to a small degree, as well as making pieces in the Art Nouveau style.

By the mid 1920s Catteau had introduced pieces decorated with vibrant cloisonné enamels, which transformed the factory's output. These bold pieces feature an off-white craquelure ground adorned with yellow and azure blue designs. Subject matter includes large, human figural pieces, stylized animals, birds, and flowers, often depicted within repeating friezes.

He also designed matt stoneware vases in muted colours, with Modernist forms and decoration. These pieces are usually marked "Grès Keramics" and may feature designs influenced by Cubism or Abstract Expressionism, including exotic flowers and animals.

Catteau was employed at the Boch Frères factory until 1945. Other designers who worked there included Paul Follot (1877–1941) and Marcel Goupy (1886–1954).

ABOVE
A "Keramis" pottery charger designed by Charles Catteau for Boch Frères, decorated with a grazing deer surrounded by a geometric border, with Persian blue and turquoise glazes on a cream crackled ground, with printed marks and facsimile signature to the base. c1930, 14½in (37cm) diam, **L**

ABOVE
An ovoid fayence vase by Boch Frères. This important piece is decorated with stylized flying pelicans and craquelé decoration in blue, yellow, and beige. Signed "Boch Fres La Louvière Made in Belgium". 13¾in (35cm) high, **J**

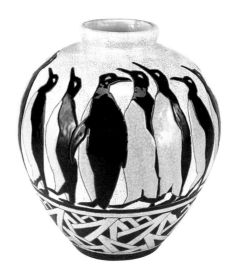

ABOVE
A large spherical crackleware vase by Boch Frères, decorated with stylized penguins depicted in black and mint glazes and set on a white ground. "Made in Belgium/Boch Fes/Alfred/976" stamp on the base. c1930, 14½in (37cm) high, **I**

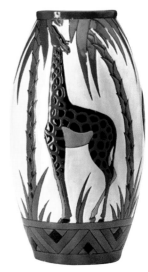

ABOVE
A "Keramis" ovoid vase designed by Charles Catteau for Boch Frères, enamel-decorated with semi-naturalistic giraffes in different poses on a pale yellow ground, the base with black "KERAMIS MADE IN BELGIUM" stamp, numbered "D.1451" and incised "895". c1931, 12in (30cm) high, **I**

WIENER WERKSTÄTTE

When Josef Hoffmann (1870–1956), Koloman Moser (1868–1918), and Fritz Wärndorfer (1868–1939) founded the Wiener Werkstätte (1903–32) in Vienna, their aim was to form an association of craftsmen. They were inspired by the Guild of Handicraft, a British Arts and Crafts organization established by Charles Robert Ashbee (1863–1942). However, while Ashbee wanted to re-create a medieval guild, Hoffman and his colleagues hoped to initiate a group of forward-thinking workshops.

In 1905 the Werkstätte explained its programme: "The limitless harm done in the arts and crafts field by low quality mass production on the one hand and by the unthinking imitation of old styles on the other is affecting the whole world like some gigantic flood…It would be madness to swim against this tide. Nevertheless we have founded our workshop. Where appropriate we shall try to be decorative without compulsion and not at any price."

By 1910 Hoffmann and his co-founders had been joined by Joseph Olbrich (1867–1908), Gustav Klimt (1862–1918), Dagobert Peche (1887–1923), and Otto Prutscher (1880–1949), among others. In all, a hundred workers (including 40 "masters" who had their own individual marks) made ceramics, furniture, metalwork, and glass of progressive design in a range of styles for the organization.

The Werkstätte's central philosophy was that household objects should be aesthetically pleasing. As a result, ceramics designed by members of the group tend to be imaginative and distinctive as well as functional. Pieces were usually marked "WW" and with the artist's monogram. The group was led by Hoffman until the end of the First World War, when Peche became its guiding influence. Peche brought a playful style to the group's work, which had previously been dominated by a rectilinear simplicity, and used colourful geometric decoration that fitted with the emerging Art Deco style, sometimes combining it with naturalistic elements.

While the group's members agreed to turn their backs on tradition, rejecting the historical and romantic styles of the 19th

LEFT
A stylized earthenware bust of a woman's head, designed by Lotte Calm for the Wiener Werkstätte, the brick-red body is decorated with a white glaze with polychrome details. The interior is marked "WW, Made in Austria, 960". c1930, 9½in (24cm) high, **l**

century and Art Nouveau, they looked to geometric and naturalistic forms and types of decoration. They intended to develop a unified, modern style of design, but the ways in which each member expressed this differed. Gudrun Baudisch (1907–1982) added asymmetrical handles to geometric vases, while Hilda Jesser (1894–1985) fused organic and geometric shapes; and Ernst Böhm (1890–1963) embellished geometric forms with repeating geometric patterns, while Lotte Calm (1897–1927) and Michael Powolny (1871–1954) created lifelike figures.

The result was modern but could not survive the economic crises of the early 1930s.

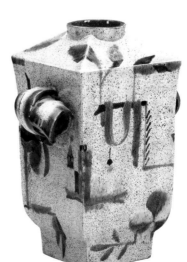

BELOW LEFT
A vase with an ovoid body, elongated trumpet-shaped neck, asymmetric loop handles, and painted with a graphic design by Gudrun Baudisch for the Wiener Werkstätte. c1920, 10in (25.5cm) high, **L**

BELOW
A cruet set depicting a dancing couple flanked by two bowls, designed by Susi Singer (1895–1955) for the Wiener Werkstätte. The stylized form is decorated with typically colourful glazes. Signed "733" on base. c1925, 4¾in (12cm) high, **R**

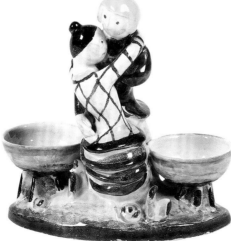

ABOVE
A ceramic figure of a female dancer wearing a dress painted with an all-over geometric design of clouds, leaves, and stars, designed for the Wiener Werkstätte. c1930, 16¼in (41cm) high, **K**

LEFT
A rectangular ceramic vase with enclosed rim and stepped foot and coiled handles designed by Hilda Jesser for the Wiener Werkstätte. The white ground is decorated with stylized flowers and leaves. c1920, 9in (23cm) high, **J**

EUROPEAN CERAMICS

BOCH FRÈRES ◊ BIANCINI ◊ BÖHM ◊ CATTEAU ◊ CAZAUX ◊ FONTAINE ◊ HAVILAND ◊
RUHLMANN ◊ SANDOZ ◊ SAVIN ◊ SÈVRES ◊ SOCIETÀ CERAMICA ITALIANA

Many European factories believed that it made commercial sense to create pieces to meet the demand for the new Art Deco style as well as satisfying the existing market for more traditional designs.

Georges Lechevallier-Chevignard (1878–1945), the director of the Sèvres factory, commissioned furniture designer Émile-Jacques Ruhlmann (1879–1933) to create several ornamental pieces and animal sculptor François Pompon (1855–1933) to make versions of his stylized bronzes – in particular his renowned polar bear – in ceramic form. Other collaborators included Édouard Cazaux (1898–1974), Jean Dupas (1882–1964), Raoul Dufy (1877–1953), Anne-Marie Fontaine, and Marcel Goupy. The success of these pieces encouraged other potteries, such as Théodore Haviland of Limoges, Longwy, and others, to follow suit.

The fashion for depicting Greek and Roman mythological scenes using stylized figurative decoration can be seen in the work of Charles Catteau at Boch Frères as well as in pieces made at the studio of Jean Mayodon (1893–1967).

Longwy and Boch Frères sold their designs through upmarket galleries and department stores. The majority of Longwy's pieces were retailed by Primavera, the fashionable homewares section of the Printemps department store in Paris. Longwy developed a distinctive method of using saturated colours and crackled glazes that made new vases look like antiquities. Some of the modern designs that adorned the hand-finished stoneware and earthenware were derived from Egyptian, Greek, and Roman artefacts and featured stylized floral, animal, and human motifs.

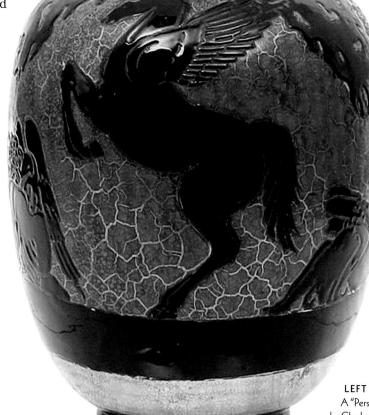

LEFT
A "Perseus and the Gorgons" "Keramis" vase designed by Charles Catteau for Boch Frères, the stylized classical design of warriors fighting the gorgon enamelled in black on a red and gold crackled ground and set between striped bands, with printed and painted marks. c1930, 14in (35.5cm) high, **J**

An earthenware vase designed by Édouard Cazaux for Sèvres and decorated with a frieze of stylized gazelles bordered by narrow bands with a green glaze on a crackled ivory ground. c1925, 12½in (31.5cm) high, **J**

An Angelo Biancini earthenware vase, made by Società Ceramica Italiana, Italy, depicting a colourful circus tent, with manufacturer's mark. The other side of the vase is painted with a young woman holding a horse. 1938 12¼in (30.5cm) high, **K**

The form of this porcelain vase was designed by Émile-Jacques Ruhlmann for Sèvres around 1928. The body of this example is decorated with figures in a rural summer landscape. The gilded bands around the foot and rim are typical of Sèvres's wares. 1937, 15¾in (40cm) high, **I**

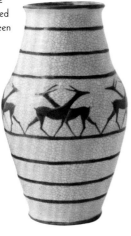

A Théodore Haviland Limoges porcelain parrot, designed by sculptor Édouard-Marcel Sandoz (1881–1971), in shades of green, pink, and white, with printed factory marks. Sandoz worked with the Haviland factory for 30 years and this piece is typical of the geometric forms covered with bright glazes that he created there. c1930, 7½in (19cm) high, **M**

The design of this porcelain fish by Sèvres was influenced by Cubism. This decorative item is glazed in tones of pink and mustard, and the "DN" mark on the base shows that it is made from *pâte dure nouvelle*, a custom ceramic mix. 1925, 17in (43cm) long, **K**

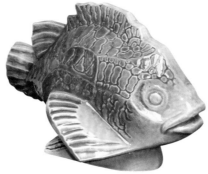

Figures of stylized animals were a popular Art Deco decoration. This pottery model of a polar bear was produced by Sèvres Vinsare, and is covered in a white "faience crispée" glaze, with green printed mark. 1930s, 17¼in (44cm) long, **M**

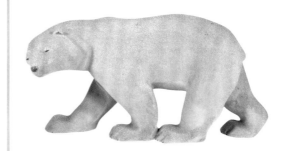

The decoration and form of this porcelain vase, designed by Anne-Marie Fontaine for Sèvres, work in harmony: the simple base exploits the ivory porcelain form while the highly decorated top shows the stylized flower and stripe decoration to great effect. 1927, 8¼in (21cm) high, **L**

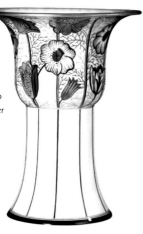

A striking vase by Ernst Böhm, Berlin, decorated with contrasting shades. The white-glazed porcelain is overlayed with orange-red, leaving a white border that cleverly emphasizes the shape of the vase. c1928 12¾in (32cm) high, **L**

A vase decorated by artist Maurice Savin (1894–1973) for Sèvres with a rural scene. Savin began work with Sèvres after a visit to the factory in 1933. He designed more than 300 ceramics, including figures of women and animals. c1933, 12¼in (31cm) high, **J**

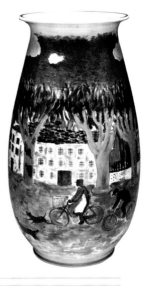

WEDGWOOD

During the Art Deco period, the Wedgwood Pottery employed a number of innovative designers to produce new lines alongside the wares for which it had long been known. The pottery, founded by Josiah Wedgwood (1730–1795) in Burslem, Staffordshire, in 1759, was renowned during the 18th and 19th centuries for its creamware and pearlware, as well as its blue-and-white jasperware.

In the 1920s and 1930s Wedgwood continued to produce copies of these table and decorative wares alongside the new ranges that were versions of the latest Art Deco designs. For example, the factory's traditional painting and gilding techniques were used to decorate tea sets with geometric handles or embellished with stylized flowers, or dinner services with Egyptian-style motif borders and stepped handles, all of which were designed to appeal to fashionable buyers. Wedgwood employed many innovative designers to produce these ranges, including Keith Murray, John Skeaping, and Daisy Makeig-Jones.

Murray (1892–1981) designed dozens of items for Wedgwood, which met with great commercial success. His best work was slip-glazed and lathe-turned to create a two-colour effect.

Skeaping (1901–81) trained as a sculptor and was hired as a freelance modeller in 1927. He created 14 animal and bird designs for the company.

During the 1920s, Makeig-Jones (1881–1945) created decorative pieces decorated with magical landscapes featuring fairies, goblins, and pixies. Known as "Fairyland Lustre", they were painted and printed in gold and lustre glazes. While not Art Deco in style they are emblematic of the innovative ceramics being made at the time.

RIGHT
An "Etruscan" vase by Keith Murray for Wedgwood. The Modernist graphic, linear design was created by cutting into the celadon glaze to reveal the white glaze beneath it. c1934, 8in (20cm) high, **L**

JOHN SKEAPING

The geometrically stylized animal figures and bookends that Skeaping designed for Wedgwood were inspired by sketches and models he made at London Zoo. They were ideal for mass-production as they could be slip-moulded in one piece. The range included a fallow deer, sea lion, kangaroo, and monkeys. The majority of these were covered with matt, monochrome glazes. Examples covered with black basalt or the semi-matt glazes developed by Norman Wilson are considered to be his best.

A "Fallow Deer" sculpture by John Skeaping for Wedgwood. The deer is shown standing by semi-naturalistic vegetation and is covered in a glossy ochre glaze, impressed "Wedgwood J. Skeaping" to the base. c1930, 7in (18cm) high, **M**

KEITH MURRAY

Keith Murray was an outstanding Modernist designer. He was born in New Zealand but trained in London and was a pilot during the First World War. He trained as an architect in 1919 and worked as a graphic designer and illustrator before joining Wedgwood in 1933. His distinctive pieces are predominantly glazed in green, straw yellow, or moonstone white. Black basalt, brown, or grey glazes are much rarer. Murray's ceramic forms are typically simple, bold, and clean, and glazed in matt, semi-matt, or celadon stain glazes.

A matt green shoulder vase by Wedgwood, of flared cylindrical form with a shallow collar neck and horizontal banded body, designed by Keith Murray, shape no.3805, printed mark to the base. c1930, 11¼in (28.5cm) high, **M**

EGYPTIAN STYLE

The magnificent riches that Howard Carter (1874–1939) uncovered in Tutankhamun's tomb captured the imagination of the public and began a craze for all things Egyptian. Photographs of the opening of the tomb, on 4 November 1922, fascinated people around the world. The discovery of the tomb was supposed to be a curse – a belief reinforced to some by the untimely death of Carter's sponsor Lord Carnarvon (1866–1923) – but it was a blessing to the designers and manufacturers who fulfilled the ensuing demand for Egypt-inspired goods.

In February 1923 the *New York Times* reported that "businessmen all over the world are pleading for Tut-Ankh-Amen designs for gloves, sandals, and fabrics". Their requests were met by objects embellished with scarabs, sphinxes, lotus flowers, pharaoh's heads, cobras, eagles, and pyramids, as well as hieroglyphics and interpretations of the wall paintings found in the tomb. Everything from vases to covered boxes, perfume bottles to shawls, and brooches to the walls of cinemas were decorated in the Egyptian style.

Of particular interest was the number and variety of gold objects found. This inspired designers to use gold decoration wherever possible, and it was combined with colours associated with the young pharaoh's tomb: earth red, white, ultramarine, turquoise, and a blue that mimicked lapis lazuli.

The artefacts also encouraged ceramics designers to produce new glazes and to use existing ones in innovative ways. At Sèvres, Jean Mayodon worked with metallic oxides highlighted with gold. Lustred glazes were employed at Carlton Ware and by Daisy Makeig-Jones at Wedgwood. René Buthard used lustred glazes and developed a faux snakeskin finish. At Gustavsberg in Sweden, Wilhelm Kåge (1889–1960) created the "Argenta" range of decorative pieces covered with a green mottled glaze and decorated with a silver stylized female, flower, or animal.

Among the funerary goods discovered at the tomb were chariots, furniture, mummy cases, gold jewellery, and the pharaoh's spectacular gold mask. As a result, covered ceramic jars were designed to resemble the canopic jars employed as part of the mummification process and high-end jewellers used gold and precious stones, including diamonds, rubies, and sapphires, to create exquisite Egyptian jewellery.

The obsession with Egyptomania could be found everywhere and often went to extremes: the layered bindings of the ancient mummies inspired the "Mummy Wrap" dress that was all the rage in the 1920s.

RIGHT
Egyptian-style decoration was popular with decorators at Sèvres during the 1920s and 1930s. This box and cover are decorated with a gilt odeonesque-style plaque, which contrasts with the mottled blue glaze, printed mark "M.P. Sevres". c1925, 6½in (16.5cm) diam, **L**

OPPOSITE
Tutankhamun died in 1323 BC, aged about 18. The young pharaoh's funerary mask, made of beaten gold inlaid with semi-precious stones, was found in 1922, when his long-forgotten tomb was discovered in Egypt's Valley of the Kings, its contents completely intact.

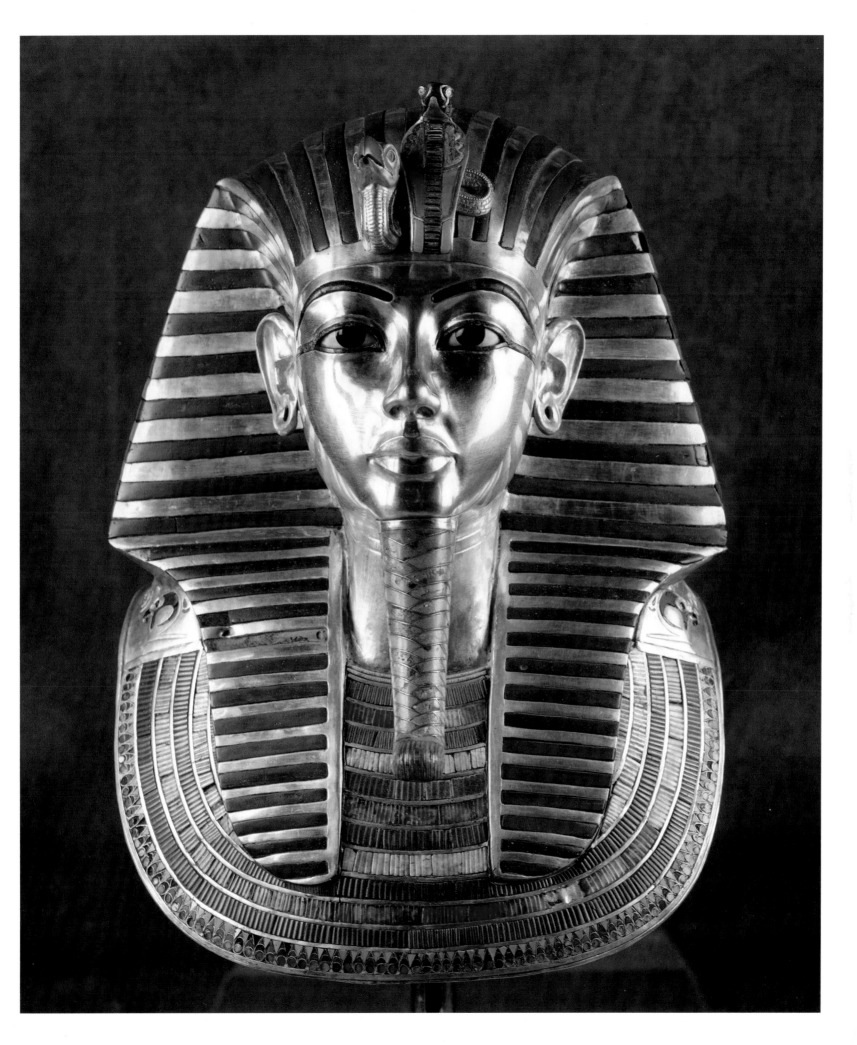

CARLTON WARE

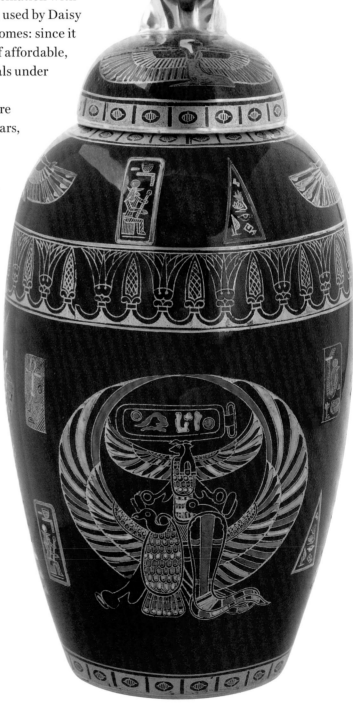

Many of the highly decorative wares produced by Wiltshaw & Robinson Ltd at the Carlton Works in Stoke-on-Trent, Staffordshire, in the 1920s and 1930s feature exotic designs influenced by the public's fascination with ancient Egypt. The bold colours and lustre glazes (inspired by those used by Daisy Makeig-Jones at Wedgwood) brought fashionable design to many homes: since it began in 1890 the factory had specialized in the mass-production of affordable, low-quality copies of the table and decorative wares made by its rivals under the Carlton Ware trademark.

Many of these designs were used to decorate traditional earthenware forms. For example, Carlton's most inexpensive items, such as ginger jars, were adapted by the addition of pharaoh or sphinx knops to simulate canopic jars and finished with hand-painted hieroglyphs and lotus-leaf borders. This range was given the name "Tutankhamun" and sold throughout the 1920s.

Other conventional forms, such as jugs, ovoid- and trumpet-shaped vases, and simple bowls were also given an Art Deco finish. Some of the designs particularly suited the factory's large plates where they were shown to their advantage. A range of 12 lustrous background colours was used to create a speckled or "powder" finish and then embellished with popular Art Deco motifs such as fans with repeating geometric patterns and stylized flowers and trees. By the mid 1920s its trademark pieces were decorated with

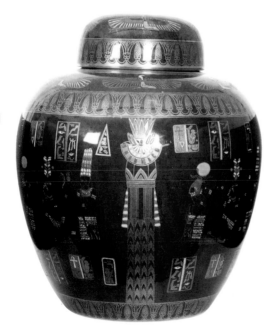

FAR RIGHT
A Carlton Ware "Tutankhamun" jar and cover, the finial of the cover shaped as a pharaoh's mask, decorated with hieroglyphics over a blue ground, the base with "Tutankhamun" marks. 1920s, 10½in (26.5cm) high, **J**

RIGHT
A Carlton Ware "Tutankhamun" ginger jar, decorated with Egyptian scenes and motifs over a royal blue ground, with gilt highlights, the base with printed marks. 1920s, 13½in (34cm) high, **K**

a combination of gilding and hand-applied overglaze enamels. However, these were less prevalent during the 1930s.

The factory also made some Art Deco forms, including bowls with displaced segments, bowls raised on an X-form foot, and jars with geometric feet and handles. The company's range of wares was ambitious, encompassing decorative jars, bowls, and vases as well as tablewares and large toilet sets for the washstand. Designs were also inspired by the work of Clarice Cliff, Susie Cooper, and Wedgwood's "Art Pottery" range.

The company was renamed Carlton Ware Ltd in 1958 and various manufacturers now make limited edition pieces under licence. Although it went on to make novelty and other wares, it is the Art Deco pieces for which it is best known today. While few pieces can truly be said to be pure Art Deco in their design, the majority of those made during the 1920s and 1930s show its influence. The most collectable pieces feature geometric forms decorated with bold motifs.

After 1929 similar designs were produced at S. Fielding & Co. after Carlton's designer Enoch Boulton left to work at the pottery.

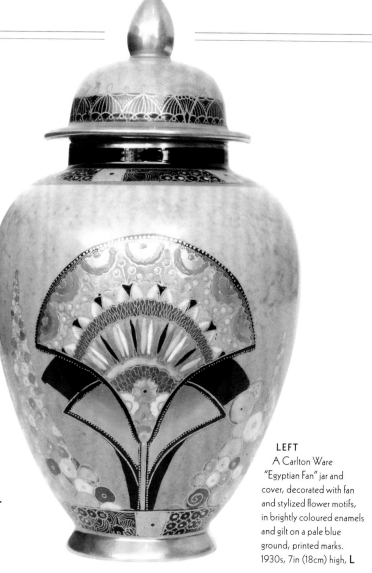

LEFT
A Carlton Ware "Egyptian Fan" jar and cover, decorated with fan and stylized flower motifs, in brightly coloured enamels and gilt on a pale blue ground, printed marks. 1930s, 7in (18cm) high, **L**

ABOVE
A Carlton Ware "Tutankhamun" footed bowl, decorated inside and out with hieroglyphics in gilt and enamel colours over a blue ground, the rim decorated with a geometric design, the base with printed marks. c1930, 4in (10cm) diam, **M**

ABOVE
A Carlton Ware "Egyptian Fan" single-handled flower jug, decorated with fan and stylized flower motifs, in brightly coloured enamels and gilt on a red ground, with gilded handle, foot, and rim, printed marks. 1930s, 7¼in (18.5cm) high, **L**

ABOVE
A Carlton Ware "Egyptian Fan" circular plaque, decorated with fan and stylized flower motifs within a geometric border, in brightly coloured enamels and gilt on a pale blue ground, printed marks and painted "O/3283 3697". 1930s, 13in (33cm) diam, **K**

FIGURAL CERAMICS

The First World War had given women many new freedoms, from joining the workforce to wearing make-up in public. The daring fashions worn by Flapper girls in the 1920s called for short haircuts and even shorter dresses.

These newly liberated women were celebrated in some of the most eye-catching ceramic figures of the Art Deco Movement. Gone were the historical poses of the Victorian era and the languid women of the Art Nouveau years. In their place was a modern woman who drove a car, participated in sports, smoked cigarettes, and danced the Charleston.

Some of the finest figures were made by the Goldscheider factory in Vienna. The best examples were modelled by leading sculptors including Josef Lorenzl, Stefan Dakon, Paul Philippe (1870–1930), Michael Powolny, Vally Wieselthier (1895–1945), and Ida Meisinger. Their work exhibits great attention to detail: the clothing, accessories, and make-up are faithful copies of modern couture. The figures wore flowing, bias-cut dresses, hats, fans, and scarves, and had exceptionally narrow waists, long, elegant limbs, and inscrutable faces. All of this allowed the designers to show off their modelling skills

and make the most of the stylish outfits of the time. In contrast, figures showing dancers feature revealing stage costumes, often based on exotic styles. The Italian Lenci factory went one step further and depicted many of its young women naked. Rosenthal, in Bavaria, produced Art Deco figures of dancers or fashionable women, using the factory's white and cream glazes. Established factories such as Meissen in Germany and Royal Doulton in England concentrated on their traditional output but also introduced some Art Deco figures. At Meissen, modellers including Paul Scheurich (1883–1945) (who also worked for Nymphenburg and Berlin) created exceptionally detailed female figures decorated with subtle colouring, while Max Esser (1885–1945) produced charming animal figurines. At Royal Doulton, Leslie Harradine (1887–1965) added some Art Deco figures to the range of traditional, crinoline ladies he created.

Elegant figures of dancers and fashionable women were also made by Katzhütte, Goebel and Hutschenreuther in Germany, the Wiener Werkstätte, Robj in Paris, and Noritake in Japan. The figures made by Royal Dux in Czechoslovakia included everything from snake dancers to Hollywood heartthrob Rudolph Valentino (1895–1926).

RIGHT
A "Lady With Fan" figure, designed by Paul Scheurich for Meissen, modelled in porcelain to depict a fashionable woman and painted in shades of brown, pink, and blue with gilt highlights, dated 1929 and produced throughout the 1930s. 1929, 18½in (47cm) high, I

OPPOSITE
Two smartly dressed young Flappers dancing on the roof of a Chicago hotel.

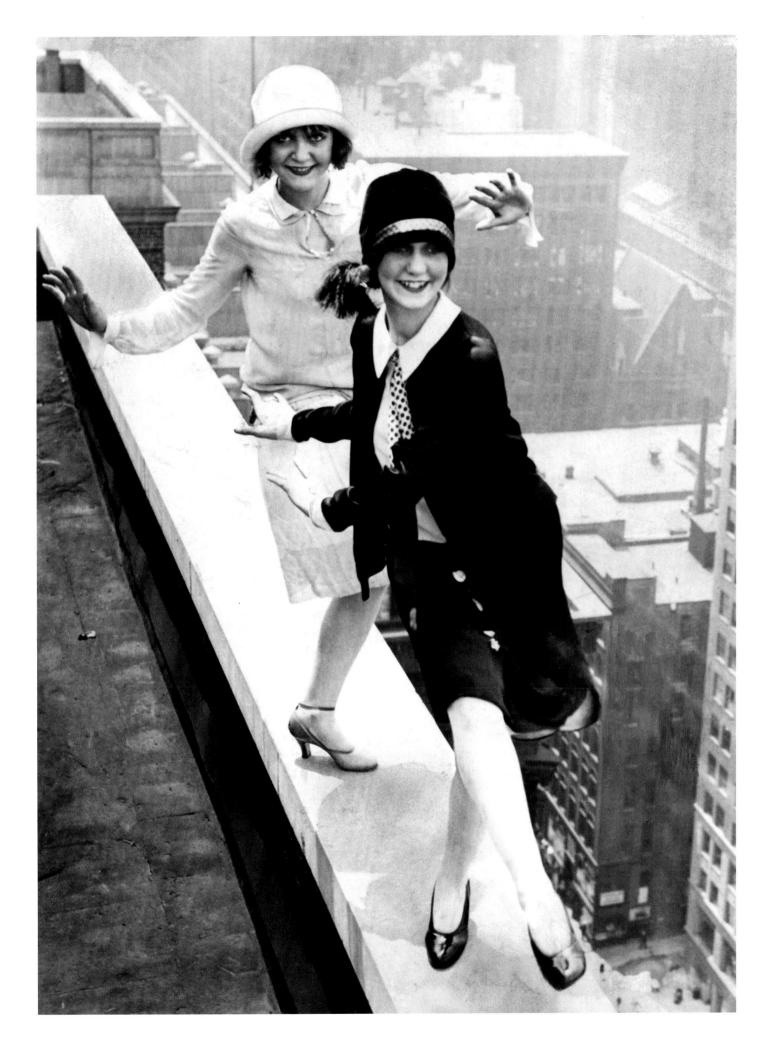

GOLDSCHEIDER

One of the most influential potters of the period, Friedrich Goldscheider (1845–1897) moved from his native Bohemia to Vienna, where he established the Goldscheider Manufactory & Majolica Factory in 1885.

His ceramic figures made in interwar Vienna are among the most striking and finely detailed of the 20th century. Goldscheider's unrivalled range of wares included statues, tobacco jars, jardinières, and wall masks made in unglazed red earthenware and painted to resemble Vienna bronze.

Well-known sculptors such as Josef Lorenzl (1892–1950) and Stefan Dakon (1904–92) modelled some of the company's best Art Deco figures. Recognizable for the way they portray fashionable, carefree women or avant-garde dancers using vivid colours and fine details, these are highly collectable. Dakon's signature appears on dozens of models, including those featuring women as exotic dancers, wearing cascading robes, or walking with borzoi hounds. Most of these pieces were made between 1922 and 1935.

Thanks to the factory's success, Goldscheider opened retail outlets in Paris, Leipzig, and Florence. The factory closed in 1953 but Art Deco pieces have been reproduced in recent years.

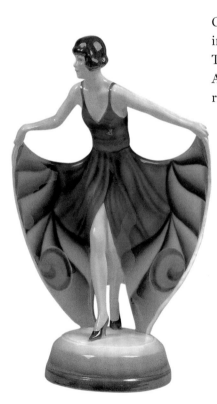

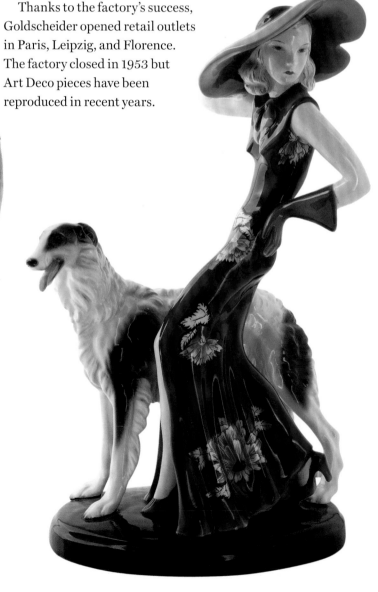

ABOVE LEFT
A figure of a dancer designed by Josph Lorenzl for Goldscheider, modelled with a fashionable, strapless dress, which she holds out to display the Art Deco design of the fabric. Black company stamp, model no.5822/337/15. c1922, 18½in (46cm) high, **J**

ABOVE
A Josph Lorenzl figure of a dancer, based on one of the designer's bronze figures, the ceramic body painted in naturalistic colours and with a "butterfly wing" dress decorated with a symmetrical geometric pattern, model no.5715/49/8. c1930, 15¾in (40cm) high, **K**

RIGHT
An Art Deco Goldscheider figure by Claire Herczeg (1906–97), modelled as a lady wearing a fashionable Art Deco outfit. She is accompanied by a Borzoi — the dog breed of choice for the period. c1925, 17in (43cm) high, **J**

CLOSER LOOK

Goldscheider produced many ceramic figures inspired by avant-garde ballets, like this "Caged Bird", also known as a "Butterfly Girl", by Josef Lorenzl. The pieces were time-consuming to make, but the attention to detail and technical process employed meant they were impossible for competitors to copy. Elaborate moulds were used to slip-cast sections of the figures, which were then assembled by hand before being decorated. Any imperfections were removed before firing; an example with visible seam lines is likely to be an inferior copy. Goldscheider is one of the most collectible ceramicists of the Art Deco period.

A Josef Lorenzl painted figurine, entitled "Caged Bird" signed to the back, the underside with a black manufacturer's stamp and model no. '5230/1860/8'. c1923, 18¼in (46cm) high, **J**

ABOVE
A figure by Stefan Dakon for Goldscheider, depicting a woman covering her naked figure with an ostrich feather fan and a garment made from a floral Art Deco fabric, and wearing fashionable shoes, with impressed and painted marks, facsimile signature, and model no.5876. c1930, 19in (48cm) high, **I**

THE GOLDSCHEIDER MARK
This founder's mark can be found stamped on the base of the figures produced by Goldscheider.

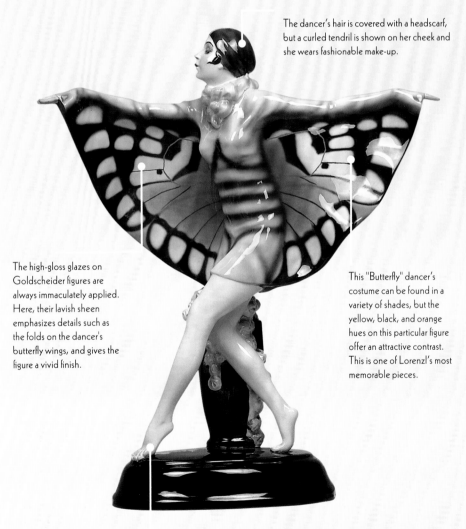

The dancer's hair is covered with a headscarf, but a curled tendril is shown on her cheek and she wears fashionable make-up.

The high-gloss glazes on Goldscheider figures are always immaculately applied. Here, their lavish sheen emphasizes details such as the folds on the dancer's butterfly wings, and gives the figure a vivid finish.

This "Butterfly" dancer's costume can be found in a variety of shades, but the yellow, black, and orange hues on this particular figure offer an attractive contrast. This is one of Lorenzl's most memorable pieces.

Goldscheider's moulds incorporated lots of detail, from the delicate facial profile down to the toes.

LENCI

The Lenci Pottery was one of the first to depict the modern woman in its figurines. Founded in Turin, Italy, in 1919 by Enrico Scavini and his wife Helen (Elena) König Scavini (1886–1974), it initially manufactured hand-painted dolls. These were commercially successful, but in 1920 it began producing ceramics. Elena, who had trained as an artist before her marriage, designed many of the best figurines. Other designers included Abele Jacopi (1882–1957), Sandro Vacchetti (1889–1976), Giovanni Grande (1887–1937), and Gigi Chessa (1898–1935).

The typical Lenci woman was tall and thin, with long legs, a slim waist, and often had a characteristic pale yellow hair. However, unlike its rival Goldscheider, which produced female figures dressed in the latest fashions, many Lenci women frequently wore nothing at all. Elena's "Nudino" range is particularly sought after.

The company was named after the nickname by which Elena König Scavini was known, but "Lenci" also served as an acronym for the Latin motto *Ludus Est Nobis Constanter Industria*, meaning "play is our constant work". This ideal permeates the factory's designs, which are among some of the most playful, evocative pieces of their time. One figure, "Nella", by Elena König Scavini, features a fashionably dressed young woman sitting on a bench with a frog on the back rest; another, called "Primo Romanzo", shows a girl sitting in her armchair with a book at her side while she thinks about her boyfriend. Scavini's "Nudo Sul Mondo" is of a girl wearing nothing but a hat

BELOW
A "Nella" figure designed by Elena König Scavini for Lenci, modelled as a fashionable young woman wearing a black dress and red beret seated on a bench with a frog on the back rest, painted marks and dated 11-XI-33. c1933, 9in (23cm) high, **J**

RIGHT
A "Sul Mondo" earthenware figure, designed by Mario Sturani (1906–1978) and Elena König Scavini for Lenci, modelled as a naked girl seated with a small dog on top of a globe, painted mark "Lenci, Torino, MADE IN ITALY, M". c1930, 19in (48cm) high, **H**

kneeling on a globe and with a book and her pet dog at her side.

As well as figures, Lenci produced vases, face masks, and covered vessels. All wares are usually decorated in the bright palette of provincial northern Italy, while the modelling shows a Germanic influence. Some pieces featuring stylized figures were inspired by the Wiener Werkstätte.

It is said that Walt Disney (1901–1966) was so impressed by Elena's designs that he based the look of his films *Bambi* and *Fantasia* on the 1920s and 1930s Lenci style and even tried, unsuccessfully, to persuade Elena to work for him. In the 1950s, the factory produced licensed Disney figures, including Bambi, Thumper, Peter Pan, Dumbo, and Pinocchio.

In 1964 the Lenci factory returned to exclusively producing dolls. In 1999, a limited number of ceramic pieces were re-created to celebrate the 80th anniversary.

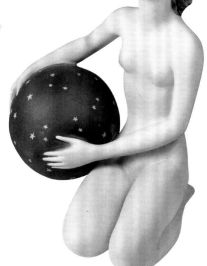

LEFT
A figural dish, attributed to Elena König Scavini for Lenci, modelled as a naked girl riding on the back of a semi-naturalistic fish and raised on a circular dished tray, moulded mark "ICNEL" to body. c1930, 17½in (44.5cm) high, **I**

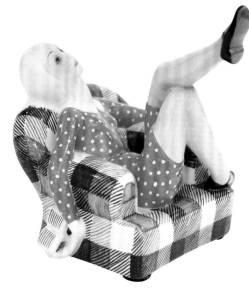

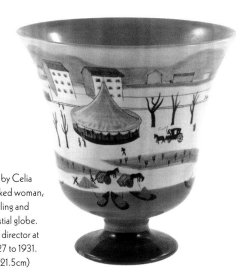

ABOVE
A Lenci figure by Elena König Scavini, "Primo Romanzo", modelled as a fashionably dressed young lady, daydreaming in a tartan-print armchair with a book by her side. Signed and dated "11/11/36". 1936, 9¾in (25cm) high, **I**

RIGHT
An earthenware pedestal vase by Lenci, painted with a Surrealist landscape of vehicles by a pitched big-top tent, beside a river, painted mark "LH" monogram. c1930, 11in (28cm) high, **J**

FAR RIGHT
A Lenci figure by Celia Bertelli of a naked woman, depicted kneeling and holding a celestial globe. Bertelli was art director at Lenci from 1927 to 1931. c1930, 8½in (21.5cm) high, **L**

WALL MASKS GALLERY

BESWICK ◊ CLARICE CLIFF ◊ ESSEVI POTTERY ◊ GOLDSCHEIDER

Brightly coloured wall masks featuring the faces of fashionable women brightened many homes from the late 1920s until the 1950s. Porcelain wall pockets filled with fresh flowers had been common in grand houses in Georgian England, but these purely decorative items caught the imagination of those living in modest homes across Britain, the Commonwealth, and the USA.

Such masks usually feature women with fashionable short hairstyles or contemporary headwear, and recall the everyday glamour of the time. As well as the colourful appearance, the appeal of these faces lies in the simple lines and bold moulding of Art Deco stylization.

In general, wall masks were mass-produced by British and some Continental potteries as an inexpensive way to bring a piece of modern design into the home.

The Staffordshire potteries were among those who took advantage of the trend. Makers include John Beswick of Longton and J.H. Cope of the Wellington China Works, also in Longton, which used the marks "C. & Company" and "C. Ltd". Clarice Cliff also made wall masks but they formed only a small part of her range. Most examples were created in an exotic, French style or were designed to resemble contemporary fashion icons such as Marlene Dietrich (1901–1992).

In contrast, in Austria the Wiener Werkstätte created unique masks that command a premium today. Goldscheider was one of the few Austrian factories to produce affordable wall masks in the style of the Werkstätte

before the outbreak of the Second World War. These are more commonly found today and are characterized by elongated faces and bold colours as well as hair styled in ringlets made from individual ceramic curls. Goldscheider masks made in Britain after the war by Myott & Son and marked "Goldscheider made in England" are less popular with collectors.

Unusual motifs are generally more valuable than common examples, as are those featuring religious themes or Spanish ladies. Modern copies of Viennese masks and cheaply made Japanese copies of the period can be found.

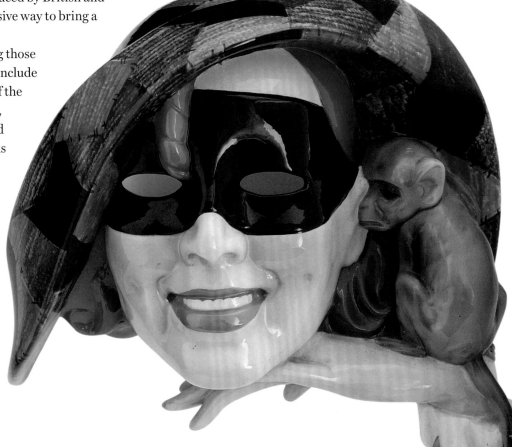

RIGHT
A wall mask by Essevi Pottery of a girl dressed for a carnival, wearing a face mask, and with a large hat over her blue hair and a monkey on her wrist. 1930s, 10½in (26.5cm) high, **L**

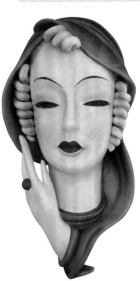

A pottery wall mask by Goldscheider of a woman with stylized curled hair wearing a green headscarf and ring, printed mark and impressed "7813" and "F.D." 1930s, 12¾in (32cm) high, **L**

A Czech Goldscheider-style pottery wall mask of a woman wearing a blue scarf over her stylized orange hair. The success of companies such as Goldscheider led to many imitators. 1930s, 11½in (29cm) high, **M**

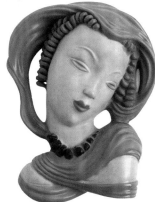

A pottery wall mask by Goldscheider, depicting a woman in a yellow hat, with sleek hair and make-up, model no.6429, incised and printed marks. c1930, 9in (23cm) high, **K**

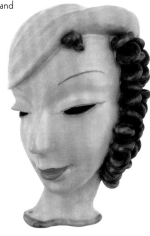

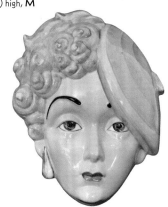

A pottery wall mask by Goldscheider of a woman's sculptural head, her hand holding a "Tragedy" mask, model no.6787, the reverse with printed and painted marks. 1930s, 8¾in (22cm), **K**

A face mask by Beswick modelled as a fashionable young woman wearing a beret over her cropped blonde hair, printed marks. 1930s, 9½in (24cm) high, **M**

A pottery wall mask by Goldscheider of a woman wearing a headscarf over her stylized curled hair, designed by Kurt Goebel (1906–1991), model no.7813, the reverse with printed and painted marks. 1930s, 8¾in (22cm) high, **L**

A pottery wall mask by Goldscheider modelled as a woman with a stylized face, curled blue hair and wearing bright red lipstick, with a tulip flower, model no.6859. c1933, 8¼in (21cm) high, **M**

A "Marlene" face mask by Clarice Cliff, depicting a stylized woman's face wearing an ornate headdress and earrings, highlighted with red and green enamels, "Bizarre" mark. c1933, 7½in (19cm) high, **M**

A pottery wall mask by Goldscheider of a woman with blue hair, wearing a flowing orange scarf and stylized make-up, model no.7784, impressed and printed marks. c1930, 10¼in (26cm) high, **M**

FIGURAL GALLERY

GRES MOUGIN ◊ KATZHÜTTE ◊ GIO PONTI ◊ ROSENTHAL ◊ ROYAL DOULTON ◊ ROYAL DUX

The exceptional detail shown in many Art Deco figurines makes them the equivalent of three-dimensional fashion plates. The most sought after figures depict the ideal modern woman, dressed in the latest fashions: bias-cut gowns or daringly short skirts, bathing suits, or exotic dance costumes designed to flatter and perhaps to shock. Animal figures were created with the same silhouette in mind: stylized, energetic, elegant, and exceptional.

Royal Doulton is known for the traditional crinoline ladies first produced in 1913. Leslie Harradine, one of their leading designers, rejoined the pottery in 1920 after serving in the First World War and created figures in this style, as well as figures that depicted women in contemporary poses and roles. His "Sunshine Girl" wears a bathing suit, while "Marietta" and "Harlequinade" show Flapper girls ready for a fancy-dress ball. They are, however, demure when compared to similar figures produced on the Continent.

Factories in the German town of Katzhütte, including Hertwig & Co., produced thinly cast porcelain figures in the 1920s and 1930s. The quality of the figures of stylized animals and fashionable women produced there compares well to those made at Goldscheider. The designers decorated the figures using naturalistic colours. The best pieces are signed by the modeller and many were made by Stefan Dakon, who also worked for Goldscheider and Keramos.

The Rosenthal factory in Selb, Bavaria, made Art Deco figures from 1924 to 1939, with some popular figures kept in production after the Second World War. Its stylish models were based on modern subjects or dancers but used a more restrained palette than similar figures by Goldscheider.

After the war brothers Joseph (1876–1961) and Pierre (1880–1955) Mougin worked with the ceramics factory at Lunéville, France. Having made their names with the Art Nouveau style, they became fascinated by the possibilities of Art Deco. They produced vases and other items embellished with geometric designs, as well as stylized figures of animals and birds.

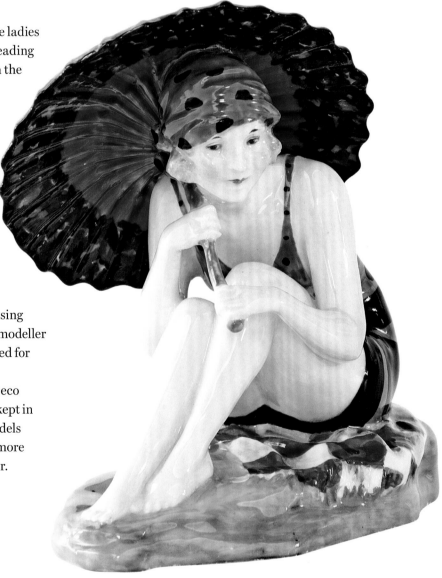

RIGHT
A "Sunshine Girl" figure by Royal Doulton, modelled by Leslie Harradine as a young girl with fashionably cropped hair sitting dressed in a bathing suit beneath a parasol. c1929, 5in (12.5cm) high, **J**

A figure of an elegant woman by Katzhütte, wearing a large-brimmed hat and a long, flowing dress decorated with graduated pinks, blues, and greens, printed marks. c1930, 17in (43cm) high, **L**

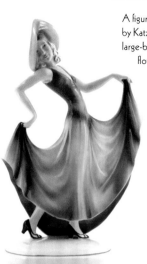

A "Marietta" figure by Royal Doulton, depicting a young woman dressed as a devil for a fancy-dress ball, model no.HN1341, printed marks. 1930s, 8¼in (21cm) high, **L**

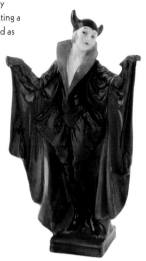

A porcelain figure by Royal Dux of a scantily clad erotic dancer on a lotus flower base, painted in blue with gilt highlights, applied pink triangle, and printed and impressed marks. c1930, 15¾in (40cm) high, **L**

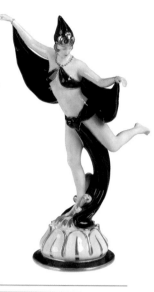

A figure by Katzhütte of a fashionable woman holding out the flowing skirt of her long pink and blue dress, printed mark and impressed no.67. c1930, 13in (33cm) high, **L**

A "Negligee" figure by Royal Doulton, depicting a young woman wearing a nightdress and kneeling on a cushion decorated with stylized Art Deco flowers, model no.HN1228, printed marks. 1929–36, 5in (12.5cm) high, **K**

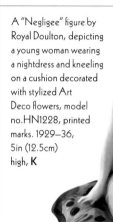

A figure by Katzhütte of a woman in an elegant pose, holding the hem of her flowing, pink dress and the crown of her hat, printed mark. c1930, 8in (20cm) high, **M**

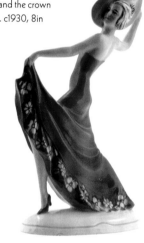

A Rosenthal white glazed porcelain figure of a faun delicately licking its hind foot, its body creating an elegant arch. It is marked with a green factory stamp "L. OTTO", model no.311. 1927 4¾in (12cm) high, **M**

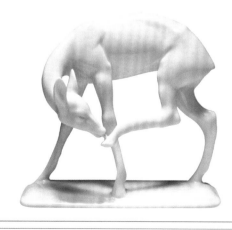

A figure by Katzhütte of a fashionable yet demurely dressed woman wearing a shawl suit with tied scarf belt and broad-brimmed hat, printed marks. c1930, 11in (28cm) high, **M**

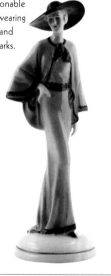

A porcelain figure by Gio Ponti (1891–1979) for Richard Ginori of a stylized leaping gazelle, covered with a white, glossy glaze, signed "Richard Ginori" in green. c1930, 9¾in (25cm) long, **L**

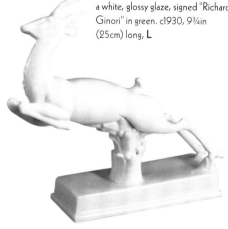

WAYLANDE GREGORY

Recognized as a leading American Modernist, Waylande Gregory (1905–1971) created decorative Art Deco ceramics for the Cowan Pottery as well as sculptures, including the "Fountain of the Atom" for the 1939–40 New York World's Fair.

After attending the Kansas City Art Institute, Gregory moved to Chicago in 1924 when he became the assistant to Lorado Taft (1860–1936) at his Midway Studios. He was active in the Cleveland School, a flourishing arts community in Ohio, and in 1928 was the chief designer and lead sculptor at Cowan Pottery. During his time at Cowan Gregory created limited edition figures, including "Salome", in which he combines the horror of the beheading of St John the Baptist with the rhythm and motion of Salome's veil dance. It won first prize at the 1929 Cleveland Museum of Art May Show. His figures "Nautch Dancer" and "Burlesque Dancer" were inspired by Gilda Gray (1901–1959), a well-known entertainer from the Ziegfeld Follies. These pieces show the influence of the Cleveland School on his work and exhibit a smooth, linear, flowing style form through which he hoped to express an American style of sculpture.

In 1932, following the closure of Cowan as a result of the Depression, Gregory became artist-in-residence of ceramics at Cranbrook Academy in Bloomfield Hills, Michigan. During his 18 months there he produced several well-known sculptures, including "Kansas Madonna" and "Girl with Olive". Gregory then moved to New Jersey, where he was director of sculpture of the New Jersey Works Progress Administration (WPA), a work-relief project created to help artists during the Great Depression. Throughout the 1940s he worked in the studio glass movement.

LEFT
"Kneeling Nude", an early glazed terracotta sculpture by Waylande Gregory, of typical smooth, linear form, inscribed "W. Gregory" on the base and with American Arists Inc. label. c1934, 18in (45.5cm) high, **I**

BELOW
A pair of unicorn bookends, designed by Waylande Gregory for Cowan, of streamlined, architectural form, covered in mottled ochre and mahogany glassy glaze, stamped with a flower mark. c1930, 7¼in (18.5cm) high, **L**

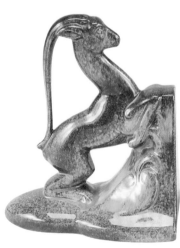

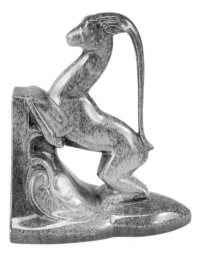

RØSENTHAL

Rosenthal was established as a decorating studio by Philipp Rosenthal (1855–1937) in Selb, Bavaria, in 1879. Ten years later he opened a factory to manufacture his own ceramics for decoration. He employed well-known designers and modellers, and from around 1907 the company made porcelain figures its speciality, starting with Art Nouveau pieces. Art Deco designs were made from 1924 to 1939 and were at the cutting edge of modern taste. The company had opened its retail headquarters in Berlin in 1917 and began to sell delicate figures and finely painted porcelain vases, jars, and tablewares. Unlike older, more established factories, Rosenthal figures depicted fashionable modern subjects or dancers from the tales of *The Arabian Nights*. In the 1920s some of the factory's exotic dancers were modelled by Dorothea Charol (1889–1963), while Claire Weiss (1906–97) created an Art Deco series of the "Four Seasons" in 1932.

Its best tablewares feature thinly potted, stark white or ivory porcelain with hand-painted decoration and signed with the company's mark of a crown and letters. Some figurines simulate ivory and others have a signature moulded into the base.

The factory continued to produce Art Deco designs after the Second World War; modern reproductions have been made of a number of these. Some Bavarian factories copied its designs and style. The company continues today, making mostly modern pieces.

BELOW
A Egyptianesque porcelain figure by Rosenthal of a woman snake charmer, printed factory marks. The factory produced several snake-charmer figures. c1930, 8¼in (21cm) high, **M**

RIGHT
A porcelain figure of the German dancer Lo Hesse by Constantin Holzer-Defanti (1881–1951) for Rosenthal, with green company stamp and "53/00" on the base. Hesse (1889–1983?) was renowned for wearing exotic costumes such as the one shown here. c1923, 8¾in (22cm) high, **L**

BELOW
A porcelain figure by Wolfgang Schwarzkopf for Rosenthal of a fashionably dressed young woman seated on a pedestal, with artist's and maker's mark to base. c1930, 10¾in (27cm) high, **K**

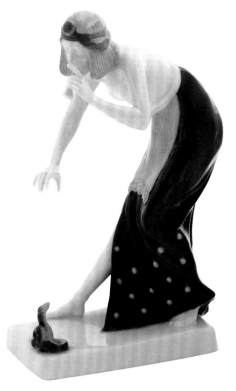

ROOKWOOD

The Art Deco period saw the Rookwood Pottery creating simple, economical designs that reflected the fashions of the day and the economic downturn that caused the Depression. During the factory's Arts and Crafts heyday it had become known for its extraordinary glazes. It was founded by Maria Longworth Nichols (1849–1932) in 1880 in Cincinnati, Ohio, a woman with a passion for ceramics, Japonisme, and the Arts and Crafts ethic. She employed some of the finest artists in the USA and Europe, and by the outbreak of the Second World War her factory was thriving thanks to its comprehensive range of useful and decorative wares, many of them decorated with the pottery's shiny Standard Glaze, introduced in 1883. The 1920s and the Depression brought a change of fortune and the company went into receivership in 1941.

Typical pieces made during this time include slip-cast vases decorated with monochrome matt green, pink, or blue glazes, and desk accessories such as bookends and paperweights. Mottled glazes were used around 1940.

The late 1920s did see Rookwood produce some pieces in the artist tradition of its early days. Danish designer Jens Jensen (1895–1978) and his wife Elizabeth Jarrett created modern, European-inspired vases featuring floral and figurative decoration. Louise Abel (1894–?), a German-born sculptor who emigrated to America and worked in Cincinnati, produced some designs for Rookwood, including vases with friezes of male nudes and figures of animals inspired by visits to Cincinnati Zoo.

The pottery reopened after the Second World War with new owners but made fewer art wares. After 1971, various owners tried revivals using old moulds, and in 1982 Arthur Townley (1926–2011) of Michigan Center bought Rookwood, and made a limited number of pieces from old moulds.

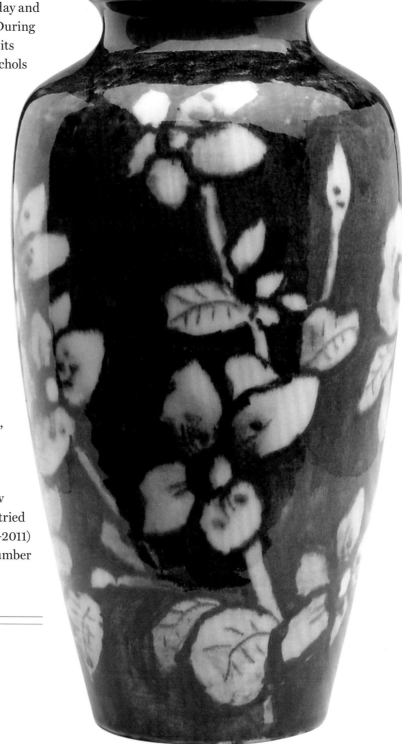

RIGHT
A tall "Jewel" porcelain Art Deco vase, painted by Jens Jensen for Rookwood with stylized ivory hibiscus blossoms and leaves on a grey-brown butterfat ground, with flame mark, "XXXI/614C" and artist's cipher to base. 1931, 12½in (31.5cm) high, **J**

WELLER

By 1904 the Weller Pottery was the largest art pottery in the world, having made its name by taking advantage of the growing demand for art pottery.

Its founder, Samuel Weller (1851–1925), set up the pottery in Fultonham, Ohio, in 1872, and moved to Zanesville in 1888. Like many other factories, it initially produced utilitarian wares. Weller bought the Lonhuda Pottery in 1894 and within a year had mastered the company's glazing techniques, which had been developed by former Rookwood decorator Laura Fry (1857–1943). The "Lonhuda" range was similar to Rookwood's Standard Glazed pieces and featured hand-painted natural motifs on a brown glossy background; it was re-launched by Weller as "Louwelsa", named after his daughter Louise.

By 1925 Weller had three factories employing 600 people. However, even a company like Weller, which had prospered in the face of strong competition, struggled during the Depression. It introduced the "Tutone" range: a collection of vases, planters, and other decorative pieces that could be produced cheaply by moulding the bodies and decorating them with two coloured glazes. Stylized Art Deco figurines of owls were cost-effective to mould, fire, and glaze.

The "Cretone" collection was launched in 1934 and was one of the final ranges to require freehand decoration. Pieces feature a sparse, stylized design that is typical of the Art Deco period and which also displays the hand-painted decoration effectively. Motifs include leaping gazelles – a popular Art Deco motif. The pottery closed in 1948.

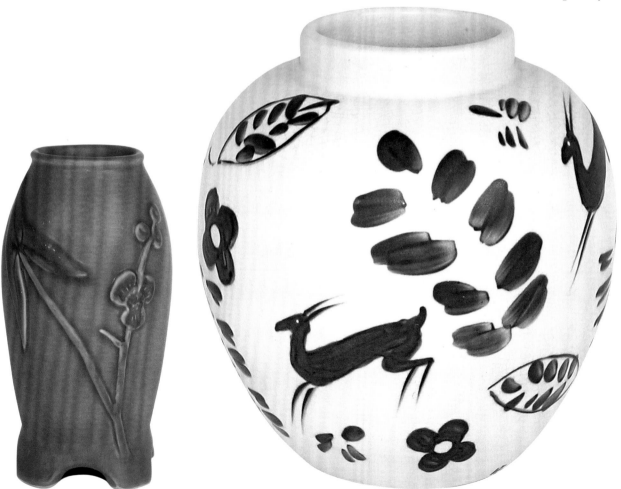

FAR LEFT
A "Tutone" vase by Weller, moulded with a stepped base and semi-naturalistic flowers, covered in a purple glaze with green highlights, marked with Weller kiln stamp. Late 1920s, 6¾in (17cm) high, **L**

LEFT
A "Cretone" vase, hand-decorated by Hester Pillsbury for Weller with sparse, stylized leaves, flowers, and four gazelle, signed "HP" at the base and impressed "WELLER". c1934, 5½in (14cm) high, **M**

MODERNIST

For many the Art Deco Movement was an opportunity to look to the future and define what modernity would look like. How they achieved this varied. Some designers re-created classical themes in a modern style. These artistic pieces used traditional craftsmanship to create modern designs. The French sculptor André Legrand (1902–47) decorated vases for Mougin Frères in Nancy with bas relief depictions of subjects such as a frieze of athletic women or a stylized landscape featuring fauns and bathing women.

Others used the new obsession with speed and streamlining as the inspiration to create revolutionary forms. In general, these rejected surface decoration or just used simple moulded shapes for their visual appeal. The benefit of this was that it also made them suitable for mass-production. Prime examples include the plain geometric vases and bowls designed by Keith Murray for Wedgwood. The simple forms are enhanced by the matt and semi-matt glazes used to decorate them.

Pieces from the Roseville "Futura" range – in particular the "Tank" vase – also met the demand for architectural designs that owed their visual appeal to the striking shape rather than any designs moulded or painted onto the vessel's surface.

The true success of Art Deco Modernist ceramics can be seen in two collections of tableware that have graced American tables for decades. The "American Modern" line designed by Russel Wright in 1937 and produced by the Steubenville Pottery Company of Steubenville, Ohio, in sold some 250 million pieces between its introduction to the market in 1939 and the end of the 1950s, making it the biggest selling dinner service ever.

In 1936 the British potter Frederick Hurten Rhead designed the "Fiesta" dinner service for the Homer Laughlin Pottery in East Virginia where he was artistic director. It was so successful that by its second year of production more than one million pieces had been made.

RIGHT
A vase by Mougin Frères of Nancy, France, decorated by André Legrand with shallow incised decoration of a faun and bathing women highlighted in blue on a white ground. c1925, 11½in (29cm), **J**

RUSSEL WRIGHT

Russel Wright (1904–76) was a prolific industrial designer who applied the streamlined aesthetic to everything from furniture to metalware and ceramics. The "American Modern" line made by the Steubenville Pottery Company is significant for its restrained, fluid, organic shapes – the jugs and teapots resemble buds – rather than the angular forms seen in Art Deco designs. It was sold in a range of progressive, contemporary colours such as Coral (pink) and Seafoam (green) and buyers could mix and match colours. Today it is made by the Bauer Pottery of Southern California.

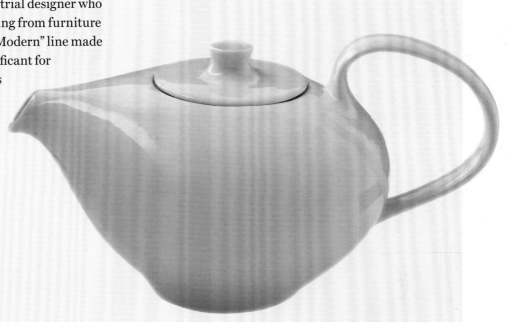

An "Iroquois Casual" teapot, designed by Russel Wright, in lemon yellow glaze, with red printed mark to base. This was Wright's next range after the success of "American Modern". The organic, streamlined shapes were made from durable, high-fired china. 1947–67, 10in (25.5cm) wide, **M**

HOMER LAUGHLIN (FIESTAWARE)

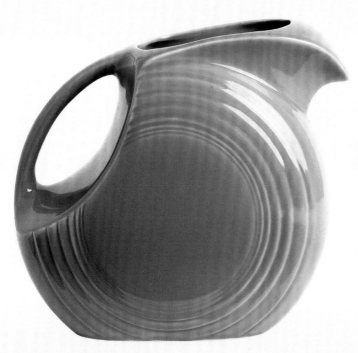

The "Fiesta" range that Frederick Hurten Rhead (1880–1942) designed for the Homer Laughlin China Company features circular forms that are reminiscent of Bauhaus designs. The pieces are decorated with moulded concentric circles with unusual design elements such as a cut-out handle on the pitchers. It was originally made in red, yellow, cobalt blue, green, and ivory. Turquoise was added in 1937. Softer pastel colours were introduced in the 1950s, with a return to brighter shades in the 1960s. Production ceased in 1972 but was revived in 1986.

A "Fiesta" pitcher, designed by Frederick Rhead for the Homer Laughlin China Company, with a streamlined, aerodynamic shape enhanced by moulded concentric circles and a cut-out handle. c1936, 7in (18cm) high, **M**

ROSEVILLE

By 1930, Roseville was one of the largest potteries in the USA, making everything from decorative vases to garden ornaments. The company began in 1892 when a group of businessmen took over the J.B. Owens Pottery in Zanesville, Ohio. Owens had made its name making copies of Rookwood's Standard Glaze wares, and Roseville continued this tradition with a range it named "Rozane".

The pottery's Art Deco lines were led by "Futura", a range of modern forms – primarily vases but also bowls, flower blocks, candlesticks, and jardinères – decorated with geometric patterns. It was introduced in 1924 and made until 1928. The matt glazes were blended to create vivid contrasts, typically combining pink with grey or blue, burnt orange, and grey, or shades of green and blue. An early advertisement for the "Futura" range said: "This delightful new pattern by Roseville – Futura – brings into your home the charm and the exhilarating tang of the modern." Another extolled "the modernistic beauty of Futura…the dashing lines…the fearless spirit that Roseville craftsmen have so artfully given them."

In the mid-1930s Roseville added the "Moderne" and "Pinecone" lines. As the name suggests, pieces in the latter series are decorated with moulded pinecones. Designed by the pottery's art director Frank Ferrell (1871–1961), it includes vases, wall pockets, and jardinières. "Pinecone" was made in a range of colours, which determine value today. Before the Second World War typical pieces were decorated with brown and orange merging into russet; after the war, blue and pink were more usual. Popular with buyers, the series continued until the pottery closed in 1954. Said to have been the highest selling art pottery line ever, it has even been credited with saving the company from bankruptcy.

The "Moderne" series was introduced in 1936 and featured vases, bowls, and candlesticks decorated with blue, turquoise, and pink glazes. Today, both "Pinecone" and "Moderne" are less desirable than "Futura" pieces.

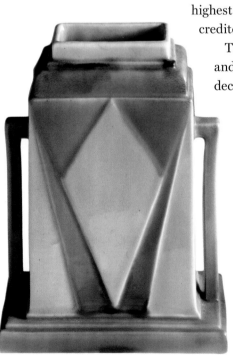

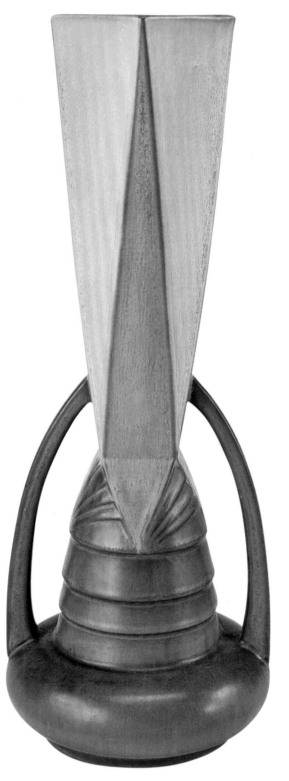

LEFT
A "Futura" rectangular vase by Roseville, with stepped base and rim and buttressed handles, the moulded, geometric design enhanced by pink and green glazes, with paper label. 1920s–1930s, 8¼in (21cm) high, **L**

RIGHT
A "Futura" faceted vase by Roseville, with arched handles over a stepped, bulbous lower section and supporting a geometric, flared upper section, glazed in brown and grey, with Roseville silver paper label to base. 1920s–1930s, 14in (35.5cm), **J**

CLOSER LOOK

More experimental than any of the other 78 patterns in the "Futura" range, the "Tank" vase is one of the most progressive American Modernist Art Deco ceramic forms and revolutionary when compared to the traditional wares Roseville had produced. Like other "Futura" designs, examples are finished in a mottled, matt glaze of two colours, which merge across the body. As the vase is rare and desirable, examples command a higher price than any of the other "Futura" pieces. The unusual, multi-sided shape features plenty of corners but no curved lines.

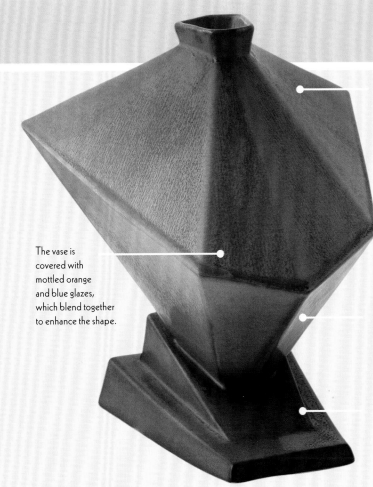

The "Tank" is the rarest and most sought after of the "Futura" range, which consisted of 78 different Art Deco shapes. The overall effect was advanced for its time.

The vase is covered with mottled orange and blue glazes, which blend together to enhance the shape.

The asymmetrical shape features no curved lines: even the neck has straight lines and corners.

The base consists of two stepped wedges that support the tilted body of the vase.

An exceptional and rare "Futura" "Tank" vase by Roseville in orange to blue mottled glaze, partial paper label. 1920s–1930s, 9½in (23.5cm) high, **I**

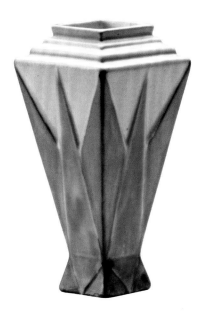

ABOVE
A "Futura" four-sided vase by Roseville, with stepped neck, decorated with a geometric foliate design in green and dark grey on a light grey ground, unmarked. 1920s–1930s, 6in (15cm) high, **L**

ABOVE
A "Futura" vase by Roseville, of slim rectangular form, with moulded handles and on a stepped base, with radiating blue design on a pale blue ground, unmarked. 1920s–1930s, 8in (20cm), **M**

ABOVE
A "Futura" bamboo leaf ball vase by Roseville, on a sloping base, glazed in blue with dark blue and green stylized leaves, unmarked. 1920s–1930s, 7½in (19cm) high, **L**

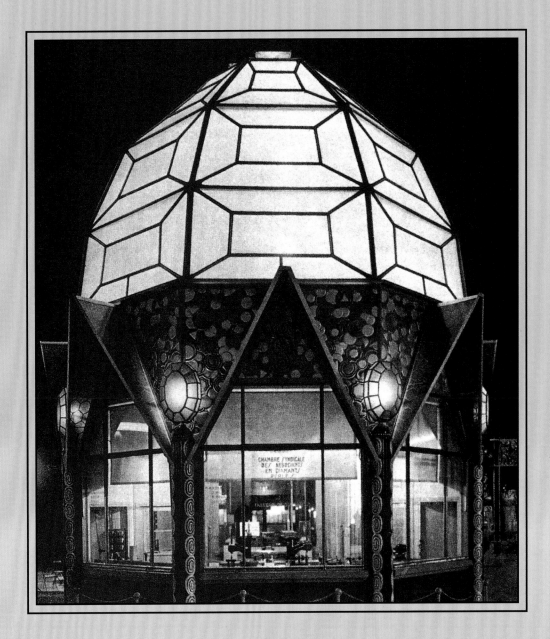

— CHAPTER THREE —

GLASS

PRESSED AND MOULD-BLOWN GLASS

Moulds are often used to shape glass, particularly sculptural objects or vessels with relief-patterned decoration. The two most common ways of moulding glass are pressing and mould-blowing.

Pressed glass is made by placing molten glass in the bottom of a two-part mould, then pressing the other half (known as the mandrel) downwards so that the glass is squeezed into the contours of the mould. In the case of flared vases or bowls, the mandrel acts as a plunger, shaping the smooth inside wall. Mould-blown glass is similar but in this case a bubble of molten glass is blown into the mould. With narrow-necked vessels, the glass is blown into a two-part mould, which is separated to release the vessel.

Originally developed in the USA in the 1830s as a cheaper way of emulating the appearance of cut glass, pressed glass was widely used in Britain during the late 19th century to produce low-cost everyday domestic glassware and ornaments. It enjoyed a second wave of popularity during the 1920s and 1930s as it was ideal for the type of deep-relief ornamentation associated with the Art Deco style. British companies such as James Jobling and George Davidson took full advantage of its potential, creating colourful vessels and statuettes at affordable prices.

Meanwhile, in France, René Lalique used press-moulding and mould-blowing techniques extensively for his decorative bowls, vases, and sculptures. Decorated with dynamic deep-relief patterns of animals and flowers, his ravishing Art Deco designs raised this hitherto lowly technique to the highest artistic level.

Often made from milky opalescent glass, Lalique's pieces were highly sophisticated in colouring and design. Such was Lalique's skill in designing moulds that he could even transform a humble perfume bottle into a miniature work of art, adorning the vessel and the stopper with exquisite floral motifs and textural patterns.

LEFT
As shapes become more geometric and flowers more stylized, the beginnings of what was to become the Art Deco style can be seen in this watercolour design for a perfume bottle by René Lalique. c1905, 8½in (22cm) high, **K**

OPPOSITE
Dating from 1930, this illustration from the brochure for the SS *Atlantique* shows the ocean liner's elegant Salon Ovale, which featured a crystal chandelier, rosewood panelling, and a frieze of laquered panels by Jean Dunand.

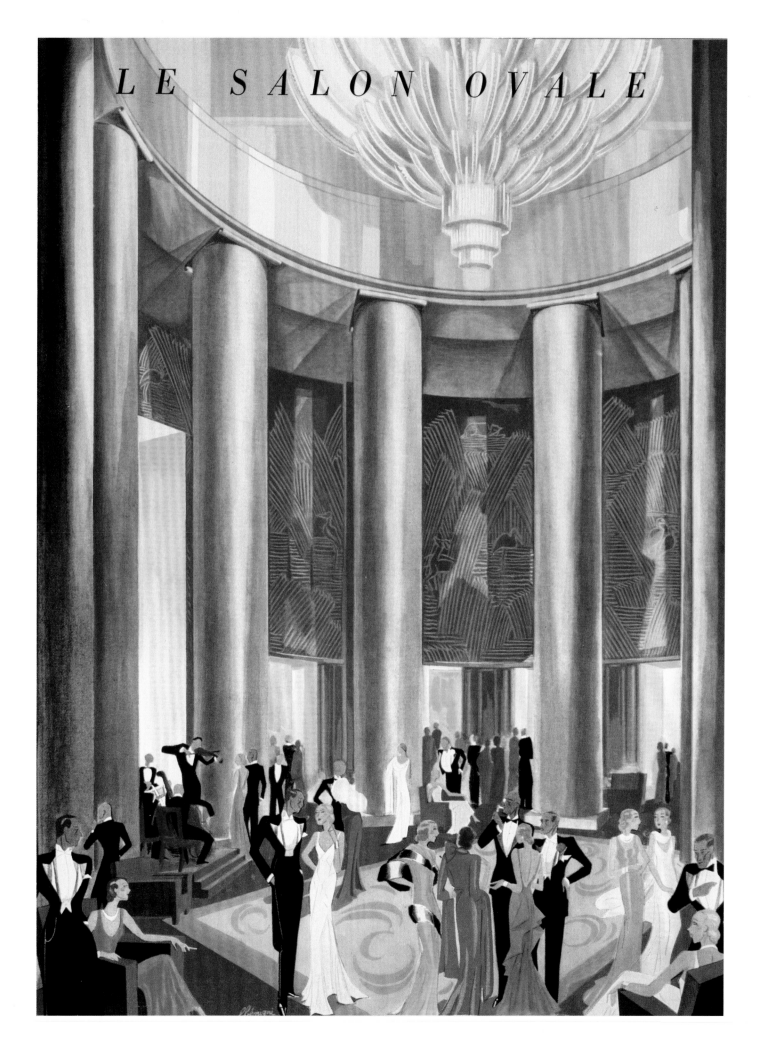

LALIQUE

Best known for his glass, René Lalique (1860–1945) originally rose to fame as a jeweller after setting up a workshop in 1885. He began incorporating glass into his jewellery in the 1890s and subsequently experimented with one-off vessels and sculptures moulded using the *cire perdue* (lost-wax) technique. In 1907 Lalique was invited to design a bottle for the perfume manufacturer François Coty (1874–1934). He became so interested in glass as a consequence that he ended up buying a glassworks at Combs-la-Ville near Fontainbleau in 1909, after renting the factory for a year. Lalique's new venture proved so engrossing that he stopped making jewellery in 1911 in order to concentrate on glass, acquiring an additional factory at Wingen-sur-Moder in Alsace in 1918.

Although Lalique's glass was manufactured using mass-production press-moulding and mould-blowing techniques, he insisted on the highest standards and remained personally involved on a creative level throughout the interwar years. The relief patterns he created were so crisply modelled that the glass appeared to have been sand blasted or acid etched, rather than moulded. Although two-part moulds were often employed, the joint lines on the glass were carefully removed by fire-polishing.

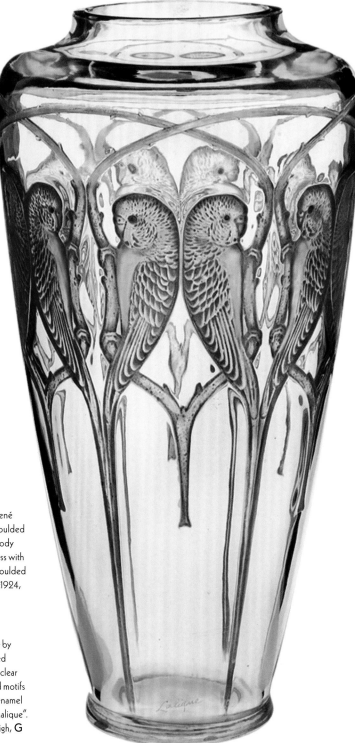

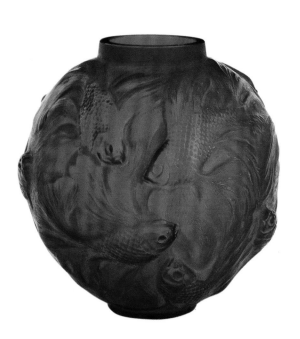

LEFT
A "Formose" vase by René Lalique, with a relief-moulded fish pattern, spherical body mould-blown in red glass with white enamel patina, moulded mark "R. LALIQUE". c1924, 6½in (16.5cm) high, **I**

RIGHT
An "Inséparables" vase by René Lalique, decorated with pairs of lovebirds, clear colourless glass, frosted motifs highlighted with sepia enamel atina, engraved mark "Lalique". c1919, 13½in (34cm) high, **G**

Lalique used a type of glass known as demi-cristal, which was better suited to moulding than lead crystal, being more malleable and less fragile. Many of his pieces were in opalescent glass, often tinted pale blue. Opalescent glass is heat reactive, so the intensity of the milkiness varies

RIGHT
An "Orly" vase by René Lalique, clear colourless glass with four semi-circular projecting ribs impressed with radiating indentations, stencilled mark "R. LALIQUE FRANCE". c1935, 6½in (16.5cm) high, **J**

CIRE PERDUE

Cire perdue, or the lost-wax process as it is known, is a technique for casting one-off glass vessels or sculptures. A wax or wax-coated model is cased in clay. When fired, the wax melts, leaving a cavity inside. Molten glass is poured into the mould and left to cool. The outer casing is then broken to release the object. Because the mould is destroyed in the process, the resulting piece is unique.

Lalique adopted *cire perdue* for his earliest creations and continued to use the technique later on for special pieces. These rare objects are very finely modelled and the detailing is more delicate and nuanced than on his press-moulded or mould-blown production wares.

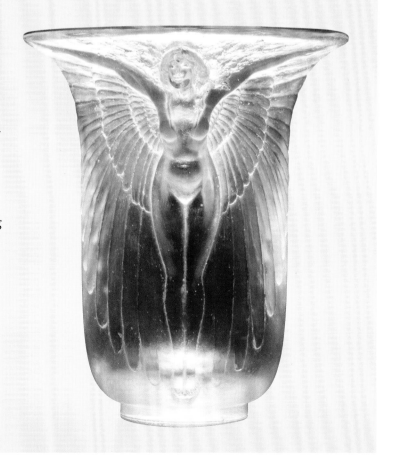

RIGHT
A "Deux Figures Femme Aillées" vase by René Lalique, featuring two winged females, clear colourless glass moulded using *cire perdue* technique, inscribed "No 1/4 415-22", engraved "R. Lalique". 1922, 6¼in (16cm) high, **A**

depending on localized temperature differences within the mould. Lalique exploited these effects and added translucent or opaque enamels in sepia and other colours to create surface patinas highlighting the contours of the form or details of the pattern.

As a designer, Lalique was a master of nature imagery, conjuring up fish, insects, flowers, and birds in a vivid and imaginative way. Figurative designs, especially nymphs,

featured prominently in many pieces, harking back to *fin-de-siècle* Art Nouveau, but the depth of his relief patterns and the stylization of motifs place him firmly at the forefront of Art Deco. By the end of the 1920s Lalique had developed a wide-ranging collection of glassware, including tableware, bowls, and vases, as well as lighting and accessories, such as ashtrays, mirrors, and clocks. He also created spectacular large-scale architectural features for buildings, railway carriages, and ocean liners, including decorative panels and light fittings for celebrated ships such as the *Normandie* and the *Île de France*.

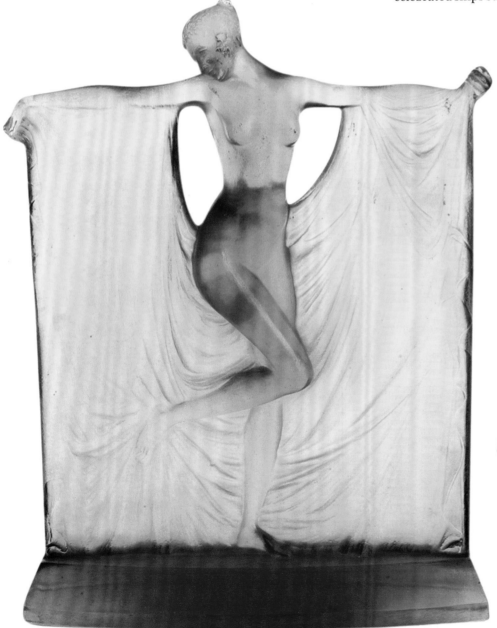

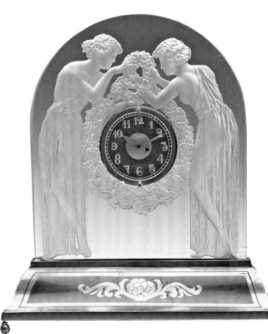

LEFT
A "Suzanne" statuette by René Lalique, depicting a dancing female with drapery over her outstretched arms, press-moulded opalescent amber glass, moulded mark "R. LALIQUE". c1925, 9in (23cm) high, **G**

ABOVE
A "Deux Figurines" clock by René Lalique, featuring two female figures clasping a wreath, clear colourless glass with frosted decoration, metal base with ball feet. c1926, 15¼in (38.5cm) high, **I**

LALIQUE & HIS IMITATORS

Because Lalique was so successful commercially, his work attracted numerous copyists. As well as French firms such as Sabino, who created watered-down versions of Lalique's designs, Lalique-style pieces were also produced by Bohemian manufacturers. A comparison of Lalique's "Bacchantes" vase with a Czechoslovakian lookalike reveals some key differences.

Lalique's opalescent glass was also widely copied, notably by the British firm Jobling in its "Opalique" range, but the two could hardly be mistaken as Jobling's designs were much more prosaic.

BELOW LEFT
A "Bacchantes" vase by René Lalique, decorated with dancing female figures, moulded opalescent glass with bluish iridescence, mounted on a bronze base, wheel-cut mark "R. LALIQUE". c1927, 9½in (24cm) high, **E**

BELOW RIGHT
A Czechoslovakian "Bacchantes" vase in the style of René Lalique, press-moulded clear colourless glass. c1930, **N**

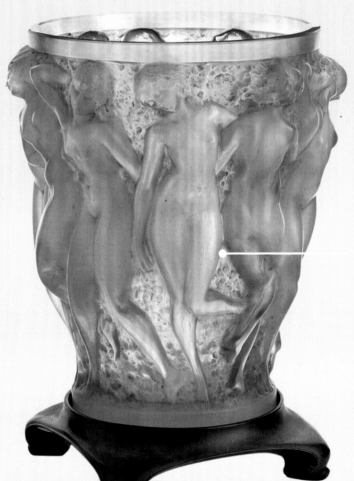

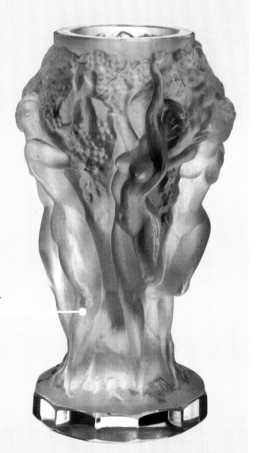

The Lalique piece is well proportioned and sensitively modelled, with subtle blue iridescence.

Compared to the Lalique original, the Czech vessel is crude in design with exaggeratedly muscular figures.

PRESSED & MOULD-BLOWN GLASS GALLERY

BOHEMIA GLASS ◊ CHANCE GLASS ◊ ETLING ◊ DAVIDSON ◊ GOODDEN ◊ GRAFFART ◊ JOBLING ◊ SABINO ◊ VAL SAINT-LAMBERT

Using a mould to shape glass – either by press-moulding or mould-blowing – has many advantages, both technical and commercial. As well as speeding up production, it means that designs can be standardized and unit costs are reduced. Moulded glass is highly adaptable, lending itself equally to high-end luxury goods, such as those as created by Lalique and Sabino, and affordable mass-market products of the kind produced by the British firms James Jobling and George Davidson. Even elite companies such as the Belgian firm Val Saint-Lambert ventured into the field of moulded glass during the Depression years of the 1930s when the market for their expensive cut-glass pieces contracted.

The more angular and geometric Art Deco forms that came into vogue following the Paris *Exposition Internationale* of 1925 were ideal for pressed glass. Winged vases with flat handles, as pioneered by Lalique and popularized by Jobling, were well suited to press moulding, as were the faceted forms of Davidson's "Chippendale" range (1930) and the geometicized shapes of Chance Glass's "Orlak" range (1929). Statuettes of animals and birds, intended for the mantelpiece or sideboard, were also extremely popular during the 1930s. These small sculptures with their quasi-Moderne aesthetic could be cheaply produced in the medium of pressed glass. Several firms, including Etling, Sabino, Jobling, and Val Saint-Lambert, followed Lalique's lead by adopting opalescent glass. Pastel shades such as pale green and pink were desirable during the interwar period, often with a satin finish created by sand blasting or acid etching.

RIGHT
A vase by Sabino, decorated with foliage, mould-blown opalescent glass, satin finish, marked "Sabino Paris". Founded by Italian-born Marius Ernest Sabino (1878–1961), this French was strongly influenced by Lalique. c1930, 5in (12.5cm) high, **M**

A pair of French "Black Amethyst" vases decorated with birds, horses, and scrolls, mould-blown in purplish-black glass, marked "MADE IN FRANCE 153". The deep-relief pattern on this vase is very striking. 1930s, 6¼in (16cm) high, **M**

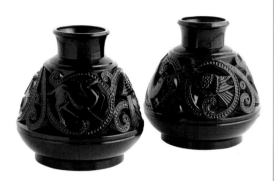

A "Danse de Lumière" lamp by Sabino, featuring a female figure with outstretched arms, press-moulded pink glass with satin finish, lightfitting in base, moulded mark "PAT APPLD". This design is heavily indebted to Lalique's "Suzanne" statuette. 1920s, 11½in (29cm) high, **J**

An "Orlak" ashtray (ID13) by Chance Glass, designed by Robert Goodden (1909–2002), press-moulded pale blue heat-resistant borosilicate glass, moulded mark "ORLAK". The "Orlak" range also included octagonal heat-proof casseroles by Harold Stabler (1872–1945). c1929–33, 5¾in (14.5cm) wide, **N**

A celery vase by James Jobling, with cloud-shaped handles, pattern no. 11700, design registration no. 795462 (8 August 1934), press-moulded amber glass. Sunderland-based Jobling enjoyed great commercial success during the interwar years. 1934, 7¾in (19.5cm) high, **N**

A "Femme avec Chien" statuette by Etling, press-moulded opalescent glass with satin finish, moulded mark "Etling France 108". Founded by Edmond Laurent Etling in 1909, this firm sold ceramics, glass, and bronze through their Paris shop. c1925, 7in (18cm) high, **L**

A "Carlshutte" sailing boat centrepiece by Bohemia Glass, press-moulded pink glass with satin finish, registration no. 812 656 (3 June 1936). Based at Teplice in Czechoslovakia, Bohemia Glass was the trade name of C. Slanina & Co. 1936, 11in (28cm) wide, **N**

An "Opalique" elephant by James Jobling, press-moulded opalescent glass, pattern number 10700, moulded diamond registration mark. Other "Opalique" novelties included lovebirds, fish, and carver rests in the form of squirrels and hares. c1934, 6in (15cm) wide, **L**

A "Chippendale" vase by George Davidson, with faceted body, press-moulded marbled amber "Cloud Glass". Tortoiseshell effects were created by trailing dark glass onto lighter coloured glass before it was poured into the mould. c1930–40, 5½in (14cm) high, **N**

A "Luxval" bird sculpture by Val Saint-Lambert, probably designed by Charles Graffart, press-moulded green opalescent glass. Inspired by Lalique's opalescent glass, "Luxval" was Val Saint-Lambert's range of cheaper press-moulded ornaments. 1930s, 8in (20cm) high, **L**

PERFUME BOTTLES GALLERY

BACCARAT ◊ DEVILBISS ◊ D'ORSAY ◊ HOFFMANN ◊ LALIQUE ◊ SCHIAPARELLI ◊ STEUBEN

During the early 20th century perfume companies began to commission eye-catching scent bottle designs from leading glassmakers, such as Lalique and Baccarat, in an attempt to attract more consumers. The trend for highly decorative perfume bottles was already well established before the First World War, which saw the rise of the American firm DeVilbiss, whose bejewelled vessels with ornate metal mounts were custom-made by elite glassmakers in Europe and the USA.

Lalique's designs for scent bottles were miniature works of art, with vessels in unusual shapes, such as moths or fossils, and elaborate press-moulded stoppers. Lalique's "Leurs Âmes" perfume bottle for D'Orsay embodied the lingering spirit of Art Nouveau, its stopper decorated with languorous female figures encircling the vessel like a halo. The international pre-eminence of the French perfume industry was affirmed by the magnificent Perfume Pavilion at the Paris *Exposition Internationale* in 1925 designed by Lalique.

What is striking about perfume bottles during the interwar years is their sheer diversity and inventiveness. The fashion for Art Deco encouraged flamboyant and playful designs, such as Schiaparelli's "Shocking" perfume bottle in the form of a naked female torso. Labels often disappeared altogether, the name of the perfume being either discreetly moulded into the glass, as in Lalique's moth-shaped bottle for Heraud's "Phalène", or incorporated within the design, as in Baccarat's "Ming Toy" bottle for Forest, where the title appears on a fan.

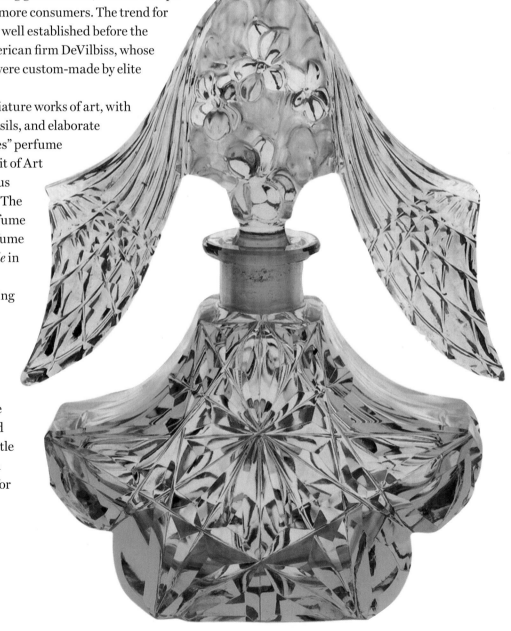

RIGHT
A Czechoslovakian "Tiara" perfume bottle, pale blue crystal, stencilled mark "MADE in CZECHOSLOVAKIA". The unusual stopper, with its dynamic sweeping wings, is made even more arresting by the decorative swags. 1930s, 5¾in (14.5cm) high, **L**

An "Imperial" perfume bottle by DeVilbiss, yellow glass shading to opal, metal filigree mount with glass jewels. Based in Toledo, Ohio, DeVilbiss commissioned unusual-coloured bottles from specialist glassmakers in the USA and Europe. c1920s, 7¾in (19.5cm) high, I

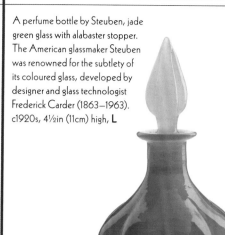

A perfume bottle by Steuben, jade green glass with alabaster stopper. The American glassmaker Steuben was renowned for the subtlety of its coloured glass, developed by designer and glass technologist Frederick Carder (1863–1963). c1920s, 4½in (11cm) high, L

A perfume bottle by Heinrich Hoffman, yellow vaseline glass, moulded mark "HOFFMAN". The mould-blown cylindrical bottle by this Czech firm features dancing female figures in classical dress. The press-moulded stopper is decorated with flowers. c1920s, 6½in (16.5cm) high, K

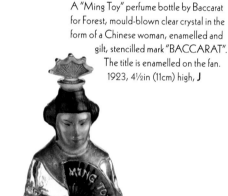

A "Leurs Âmes" perfume bottle by René Lalique for D'Orsay, clear and frosted glass with sepia enamel patina, moulded mark "LALIQUE". Launched in 1912, "Leurs Âmes ("Their Souls") is evoked by two female figures suspended from branches. 5¼in (13cm) high, I

A "Ming Toy" perfume bottle by Baccarat for Forest, mould-blown clear crystal in the form of a Chinese woman, enamelled and gilt, stencilled mark "BACCARAT". The title is enamelled on the fan. 1923, 4½in (11cm) high, J

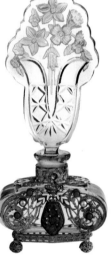

A Czechoslovakian perfume bottle, blue crystal body with metal filigree mounts set with jewels, press-moulded stopper in clear glass with frosted floral motifs, stencilled oval mark "MADE IN CZECHOSLOVAKIA", label "MORLEE". c1920s, 6¼in (16cm) high, L

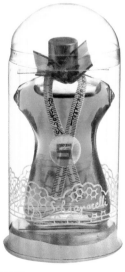

A Schiaparelli "Shocking" miniature perfume bottle in the form of a naked female torso, clear and amber glass with paper tape measure around neck, plastic domed cover. This bottle for French couturier Elsa Schiaparelli (1890–1973) is deliberately provocative. 1936, 2in (5cm) high, L

An "Amphitrite" perfume bottle by René Lalique, mould-blown green glass in the form of an ammonite, press-moulded stopper depicting a kneeling female figure, engraved mark "R. Lalique France". Sea goddess Amphitrite was the wife of Poseidon. c1920, 3½in (9cm) high, I

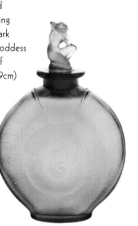

A "La Phalène" perfume bottle by René Lalique for D'Heraud, mould-blown amber glass in the form of a moth with a woman's body, press-moulded stopper, moulded marks "LALIQUE" and "PHALENE", gilt label "Mona Lisa". c1923, 3½in (9cm) high, I

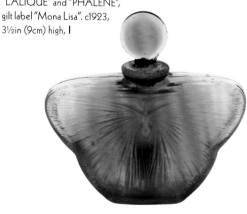

MULLER FRÈRES

enri Muller, who established the glass-decorating workshop of Muller Frères at Lunéville in France in 1895, was a highly skilled glass engraver and carver. He and his four brothers, Désire, Eugène, Pierre, and Victor, had learnt their craft at the Gallé factory at Nancy, hence their preference for cameo glass and organic imagery in the Gallé style. They were later joined by their sister Camille and three other brothers, so the company was very much a family affair. Using custom-made cased glass blanks blown to their specifications by Gobeleterie Hinzelin at Croismare near Nancy, Muller Frères employed a combination of acid-etching and wheel-carving to create elaborate patterns depicting flowers, birds, insects, and animals. By cutting through multiple layers of coloured glass, they were able to fashion designs of remarkable subtlety and tonal richness.

Although Muller Frères was forced to close during the First World War, the family regrouped in 1919 and purchased the Hinzelin glassworks. From this date onwards until its closure in 1936, the company was known as Grandes Verreries de Croismare et Verreries d'Art Muller Frères Réunies. A sizeable operation employing 300 people at its peak, the reincarnated Muller Frères was run on more commercial lines during the 1920s, producing large quantities of lamps, often with mottled colouring and a matt finish. Cameo vases remained an important part of the firm's output and floral imagery in the late Art Nouveau style continued to flourish throughout the 1920s. Designs became simpler and more standardized during this period, however, and the decoration was mostly acid-etched, rather than wheel-carved.

Stylized landscapes were popular during the interwar years, including exotic locations such as South America and North Africa, as well as generic pastoral scenes. In the mid 1920s Muller Frères consciously sought to expand its repertoire by adopting modish Art Deco features, such as metallic inclusions of silver, gold, or platinum leaf. The Stock Market Crash of 1929 and the ensuing Depression had a catastrophic impact on the market for luxury glass. This badly affected Muller Frères, which ceased production in 1933 and shut down completely three years later.

RIGHT
A cameo vase by Muller Frères, decorated with crocuses, acid-etched in red glass over a yellow ground, needle-etched mark "MULLER FRES LUNEVILLE". c1920, 11½in (29cm) high, **K**

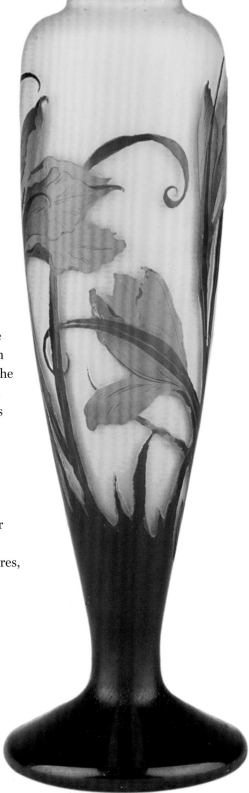

D'ARGENTAL

The Compagnie des Cristalleries de Saint Louis adopted the trade name D'Argental for a range of cameo glass produced between 1919 and 1925. Based in Lorraine, close to the German border, Saint Louis was one of the oldest glassworks in France, dating back to the mid 18th century. D'Argental was the French name for Münzthal, where the factory was located.

Although Saint Louis is best known for its cut lead crystal, during the 19th century the firm developed a range of faux cameo glassware decorated with acid-etching. However, its offerings were eclipsed at the Paris *Exposition Universelle* of 1900 by the ultra-sophisticated Art Nouveau cameo glass produced by the glassworks of Émile Gallé at Nancy, which combined wheel-engraving with acid-etching to create patterns of extraordinary naturalistic detail and depth. In order to harness the full potential of cameo glass, Saint Louis recruited Gallé's protégé Paul Nicolas. Nicolas had been chief designer at the Gallé glassworks since 1895 and continued to work for the firm until 1914, before being headhunted by Saint Louis after the First World War

The main task assigned to Nicolas was to develop a new range of cameo glass, which was marketed under the name "D'Argental". As well as designing the shapes and patterns, Nicolas personally decorated some pieces, which are marked with the Cross of Lorraine. In recognition of his status and experience, he was also given permission to use the firm's facilities to make cameo glass under his own name. These pieces were signed "P. Nicolas", whereas the Saint Louis range was marked "St Louis Nancy" or "D'Argental". Drawing on his lengthy experience at Gallé, Nicolas created strikingly naturalistic designs composed of flowers and leaves. His patterns are notable for their realism and for the delicacy of their fine detailing. The other genre in which Nicolas excelled was landscapes, often composed of trees silhouetted against the sky. Although most of these scenes were generic, he occasionally depicted specific views, such as the island of Mont Saint Michel.

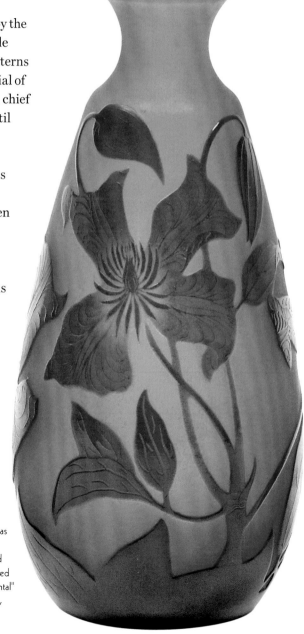

RIGHT
A "D'Argental" cameo glass box designed and decorated by Paul Nicolas, with a pattern of flowers and leaves, white glass cased with ruby, acid-etched, wheel-carved, and fire-polished, signed "St Louis Nancy". c1922, 5in (12.5cm) diam, **K**

RIGHT
A "D'Argental" cameo-glass vase designed and decorated by Paul Nicolas with clematis, colourless glass overlaid in blue and violet, etched, with frosted ground, signed "D'Argental" within the design. c1925, 7½in (17.5cm) high, **K**

DAUM FRÈRES

Originally established by Jean Daum (1825–85) in 1878 as a manufacturer of watch covers and table glass, Daum Frères later evolved into a renowned art glass manufacturer after being inherited by Jean's sons, Auguste (1853–1909) and Antonin (1864–1931) Daum, in 1885. The glassworks was based at Nancy in north-east France, not far from that of Émile Gallé. It was the latter's extraordinary creations that inspired Daum Frères to set up a decorating workshop producing cameo glass during the early 1890s, with Antonin Daum as head of design. Early Daum pieces were strongly influence by Gallé, both in their imagery and style, although the company also developed distinctive techniques of its own, including *pâte de verre* and vitrification (mottled effects created by picking up enamel particles on the marver). Lighting was an important area from the outset and Daum frequently collaborated with the metalwork designer Louis Majorelle (1859–1926), a partnership that continued until the 1930s.

After the First World War, Antonin's nephew Paul Daum emerged as the creative driving force after taking over the running of the factory in 1909, introducing new lines, such as vessels made of bubbled glass with gold or silver inclusions, decorated on the surface with trailed coloured glass. Responding to Cubism, Daum Frères became the leading exponent of Art Deco glass during the 1920s. Acid-etching, a staple technique in cameo glass, was now co-opted as a creative effect in its own right for shaping the glass. Paul Daum was heavily influenced by the powerful sculptural

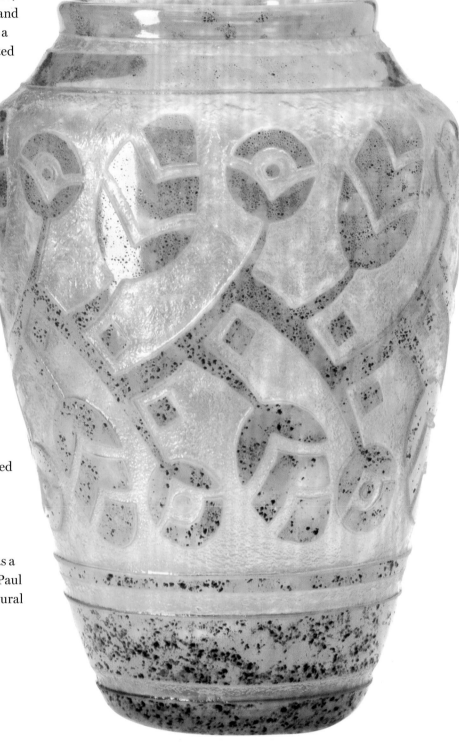

RIGHT
A vase by Daum, acid-etched in deep relief with geometricized leaves and flowers, amber glass with speckled and mottled ground, wheel-cut mark "Daum Nancy France". c1925, 10in (25.5cm) high, **J**

art glass of Maurice Marinot (1882–1960), which spurred him to create simple, robust, thick-walled vessels with deep-relief acid-etched patterns, contrasting polished shiny surfaces with matt textures. Patterns became increasingly abstract, composed of dynamic arrangements of circles, stripes, and diamonds. Colour became less important, especially after lead crystal was adopted in the 1930s, with increasing emphasis on monumental pieces with bold Modernist shapes and patterns.

LEFT & RIGHT
A floor lamp by Daum, with cupped shade in amber glass acid-etched with an abstract geometric pattern in the Art Deco style, signed "Daum Nancy France". Elaborate metal stand, possibly made by Louis Majorelle, cast stem entwined with ivy, three branches with oak leaves and birds supporting the shade, domed foot in beaten metal. 16in (40.5cm) wide, 64in (163cm) high, **I**

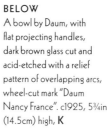

BELOW
A bowl by Daum, with flat projecting handles, dark brown glass cut and acid-etched with a relief pattern of overlapping arcs, wheel-cut mark "Daum Nancy France". c1925, 5¾in (14.5cm) high, **K**

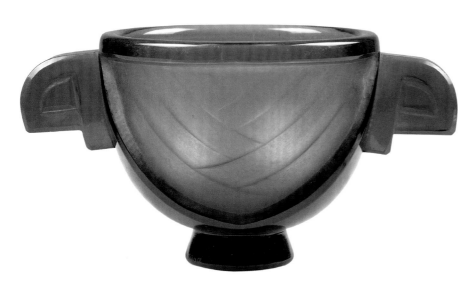

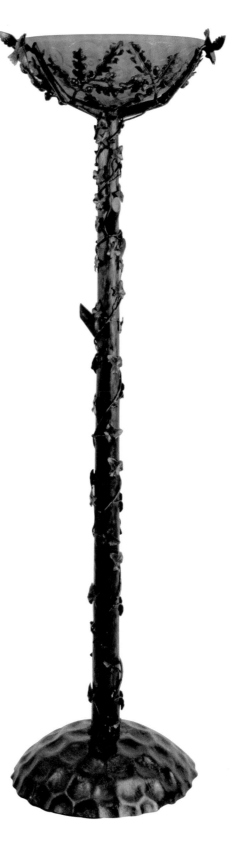

CHARLES SCHNEIDER

Charles Schneider (1881–1953) had previously worked as a designer at Daum Frères before joining forces with his brother Ernest Schneider (1877–1937) and Henri Wolf to establish his own glassworks, Schneider Frères & Wolf, at Épinay-sur-Seine near Paris in 1913. The enterprise had barely got going before the outbreak of the First World War brought a halt to production. Afterwards it was relaunched as Société Anonyme des Verreries Schneider, with Charles as technical and artistic director and Ernest in charge of business affairs.

Although the company specialized in cameo glass and recruited glassmakers from Daum and Muller Frères, Verreries Schneider made a conscious decision to embrace the emergent Art Deco style, rather than falling back on the established Art Nouveau aesthetic associated with Gallé and the School of Nancy. Adopting simpler designs with stylized angular motifs, mostly created by Charles Schneider, vessels were often decorated with banded patterns or borders encircling the vessel. The firm's ranges were divided into two distinct categories, with luxury items sold under the name "Schneider", and less expensive pieces marketed as "Le Verre Français", a trade name registered in 1918, including some moulded glass.

Distinctive Schneider characteristics included mottled effects in the glass, sometimes graduated in colouring, created by picking up ground

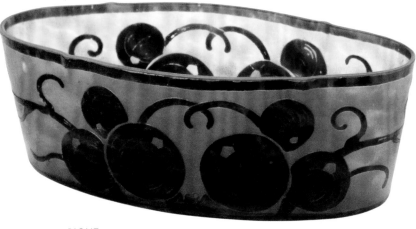

ABOVE
A Le Verre Français bowl designed by Charles Schneider, acid-etched cameo glass with stylized fruit in magenta over mottled orange ground, engraved mark. 1920s, 10in (25.5cm) diam, **L**

RIGHT
A Le Verre Français lamp, designed by Charles Schneider, acid-etched cameo glass with large beetles in tortoiseshell over orange ground, wrought-iron mounts, engraved mark "Le Verre Francais". 1920s, 20¼in (51.5cm) high, **K**

enamels from the marver. Handles and feet were often in a contrasting opaque colour and some pieces were decorated on the surface with coloured trails or blobs of glass, known as cabochons, wheel-carved into floral motifs. Furnace-worked reliefs in the form of plants and insects were also sometimes added. A new range called "Luxor", made of streaky or bubbled glass with deep acid-etched Egyptian-inspired patterns, was introduced during the late 1920s.

Although Verreries Schneider was extremely successful, it was badly hit by the Stock Market Crash, which damaged its hitherto lucrative American export market. This, combined with a costly long-running legal battle with a rival factory called Verrerie de Compiegne, which blatantly plagiarized Schneider's designs under the name "Degué", forced the closure of the glassworks in 1931. Verreries Schneider was eventually wound up after being declared bankrupt in 1938.

BELOW LEFT
A Le Verre Français vase, designed by Charles Schneider, acid-etched cameo glass with enamel, stylized pansies in orange and blue on yellow ground, engraved mark "Le Verre Francais". 1920s, 14¾in (37.5cm) high, **J**

BELOW
A Le Verre Français vase, pink mottled glass with black pedestal foot, acid-etched with a pattern of curved bands, marked "Le Verre Francais". c1925, 9in (23cm) high, 8in (20cm) diam, **I**

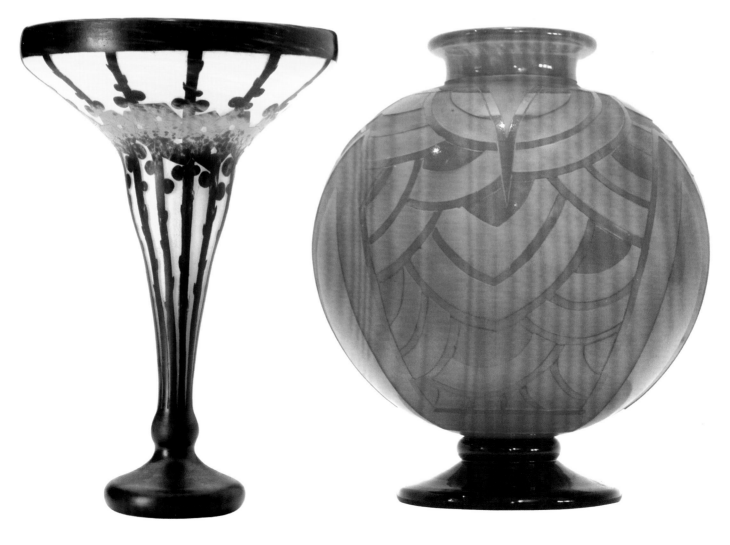

SAINT LOUIS

Founded in Lorraine in 1767 with a patent from Louis XV (1710–74), Verrerie Royale de Saint Louis is one of the oldest and most distinguished glassworks in France. Later known as Compagnie des Verreries et Cristalleries de Saint Louis, the firm took off after developing its own recipe for lead crystal in 1781, following the fashion for this material set by English and Irish firms. Because of its purity of colour and its excellent refractive properties, lead crystal is ideal for cutting. Like its rival Baccarat, Saint Louis prided itself on the skilfulness of its cutting, developing an international reputation for its high-quality cut-glass tableware, ornamental glass, and chandeliers.

During the mid 19th century Saint Louis became renowned for its opaline glass, which was produced in colours such as pale blue, green, yellow, and turquoise. The company also produced *millefiori* paperweights decorated with coloured canes and Venetian-inspired *latticinio* vessels with spiralling filigree patterns created from canes of pink, white, or blue cased in clear glass. Another form of decoration adopted by Saint Louis during

the 19th century was acid-etched cameo glass, known as faux cameo. Saint Louis later commissioned Gallé's former designer Paul Nicolas to develop a special range of cameo glass, marketed under the name "D'Argental" between 1919 and 1925.

Overlay crystal, in which a layer of colour was applied to the surface and then cut through, had been introduced at Saint Louis in 1844. By the early 20th century the company was producing monumental thick-walled lead crystal and overlay crystal vases in colours such as red and green. Saint Louis's designers, Jean Sala (1895–1976) and Jean Luce (1895–1964), excelled in bold Art Deco patterns using broad, deep mitre-cutting. Geometric patterns predominated, including designs composed of criss-crossing vertical and horizontal lines and curved upright blade motifs.

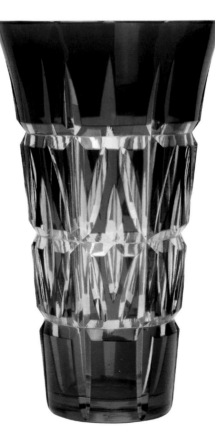

RIGHT
An overlay crystal vase by Saint Louis, clear colourless lead crystal cased with green glass, mitre-cut with horizontal and vertical lines. Early 20th century, 11¾in (29.5cm) high, **L**

FAR RIGHT
A vase by Saint Louis, clear colourless lead crystal, mitre-cut with grid pattern on the foot and overlapping vertical blades on the body, signed. Early 20th century, 11¾in (29.5cm) high, **M**

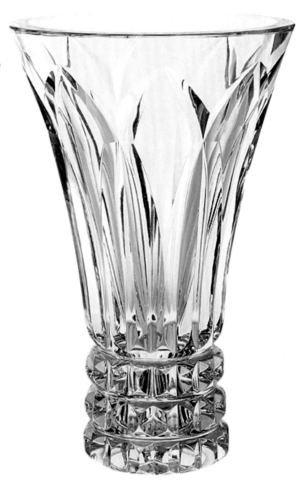

VAL SAINT-LAMBERT

Les Verreries et Établissements du Val Saint-Lambert was founded at Meuse, near Liège, in 1825. Originally in the Netherlands, this area became part of Belgium in 1830. Although the company initially produced basic utilitarian table glass, it soon moved into the luxury glass market after switching to lead crystal. Val Saint-Lambert later merged with several other glassworks, greatly expanding its output and producing lighting, optical glass, and stained glass as well as ornamental glass and tableware.

By the turn of the 19th century Val Saint-Lambert had adopted the prevailing Art Nouveau style and was collaborating with the celebrated *fin-de-siècle* Belgian architects Henry van de Velde (1863–1957) and Victor Horta (1861–1947). Van de Velde's vases and stained glass panel, created between 1895 and 1910, featured scrolling vegetation, while Horta designed flamboyant light fittings with petal-shaped lampshades. Léon Ledru, who was head of design at Val Saint-Lambert from 1888 to1926, was heavily influenced by Van de Velde, creating vessels with undulating cut necks. Many from the early 20th century were in overlay crystal, with clear colourless glass sandwiched between two different colours on the inside and outside of the vessel.

During the 1930s Val Saint-Lambert's most significant designer was Charles Graffart, a master engraver who had joined the company in 1906 at the age of 12 and subsequently became a designer in 1929. Monumental thick-walled vases in overlay crystal were one of his specialities, often faceted and deeply cut with bold abstract patterns in the Art Deco style. Graffart also designed a range of low-cost moulded vases and ornaments called "Luxval" in pastel or opalescent demi-crystal, inspired by Lalique. An innovative range of art glass produced at Val Saint-Lambert's Jemeppe branch from 1909 onwards and throughout the 1920s was designed by Romain and Jeanne Gevaert. Particularly striking were their opaque glass vessels in contrasting colours with "hammered" cut surfaces (a technique known as *battuto*).

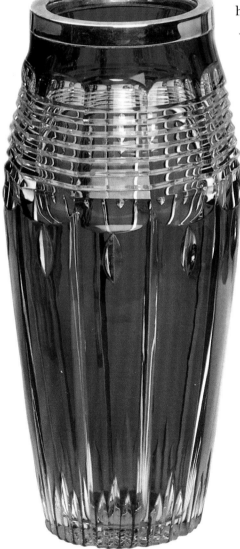

LEFT
An overlay crystal vase by Val Saint-Lambert, clear colourless lead crystal cased with red glass, decorated with horizontal and vertical cutting, silver band on rim with 800 Belgian silver mark. 1930s, 10in (25.5cm) high, **J**

RIGHT
An overlay crystal bowl by Val Saint-Lambert, clear colourless lead crystal cased with red on the exterior and glass on the interior, the rim cut with waves. c1904, 4in (10cm) high, **I**

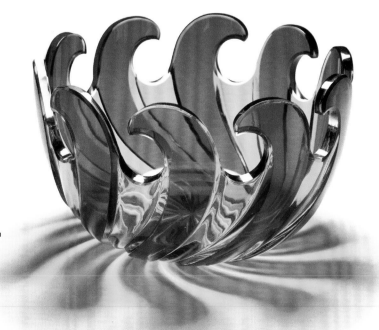

CUT & ENGRAVED GLASS GALLERY

LUDWIG MOSER & SONS ◊ ORREFORS ◊ ROYAL BRIERLEY ◊ RICHARDSON ◊ STEVENS & WILLIAMS ◊ STUART & SONS ◊ JOHN WALSH WALSH ◊ WEBB CORBETT ◊ WHITEFRIARS

Made from a recipe combining lead oxide, silica, and sodium or potassium, lead crystal is ideally suited to cutting and engraving, being perfectly clear and colourless, with excellent refractive properties, but soft enough to decorate with the wheel. As it was an English glassmaker, George Ravenscroft (1632–83), who originally invented lead crystal in the 17th century, it is hardly surprising that British manufacturers should excel in using this material. Although lead crystal was later adopted by Continental manufacturers, such as Val Saint-Lambert in Belgium, Saint Louis in France, and Orrefors in Sweden, some of the most outstanding Art Deco cut glass was made by English firms in the traditional glassmaking region of the West Midlands. London glassmakers James Powell & Sons (Whitefriars Glass) also created some impressive thick-walled cut lead crystal bowls and vases in vivid colours such as sea green and emerald.

Whereas during the 19th century the tendency had been to apply as much decoration as possible, Modernist designers developed simpler forms and patterns that highlighted the intrinsic beauty of the glass. Keith Murray (1892–1981), an architect who designed for Stevens & Williams during the 1930s, created pared-down vessels with arresting cut or engraved designs. Cut glass tableware was also injected with new dynamism by Art Deco, with firms such as Stuart & Sons, Thomas Webb, and Webb Corbett creating innovative modern patterns. Also noteworthy are the elegant calligraphic designs of William Clyne Farquharson (1906–72) for the Birmingham firm of John Walsh Walsh Ltd, who used shallow cutting for his delicate cursive patterns.

RIGHT
A vase by Richardson, clear colourless lead crystal with mitre-cut crescents and vertical flutes, marked "Richardson". Webb's Crystal Glass Company, which acquired H.G. Richardson in 1930, continued producing designs under the Richardson name for several years. c1933, 8in (20cm) high, **M**

A bowl with tapered sides and V-cuts to the rim by Royal Brierley, clear colourless glass decorated with a geometric patteren of mitre, lens, and flute cutting, pattern number 68449 and 50. 1937–8, 8¾in (22cm) high, **M**

A bowl by Stuart & Sons, designed by Ludwig Kny (1869–1937), clear colourless lead crystal with fluted mitre-cutting, etched mark "Stuart". The pattern on this bowl is very dynamic, suggesting splashing water. 1935, 11¾in (29.5cm) diam, **L**

A decanter with a flat stopper by Webb Cobett, probably designed by Herbert Webb, decorated with a cut leaf design. Mid 1930s, 11¾in (30cm) high, **M**

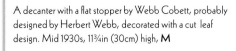

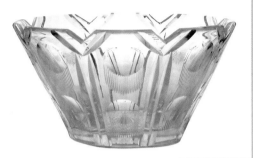

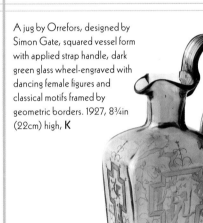

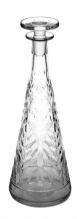

A "Streamline" vase by Stevens & Williams (Royal Brierley), designed by Keith Murray, clear colourless lead crystal with undulating cut rim and wavy horizontal mitre-cut pattern. c1932–9, 10¼in (26cm) high, **M**

A jug by Orrefors, designed by Simon Gate, squared vessel form with applied strap handle, dark green glass wheel-engraved with dancing female figures and classical motifs framed by geometric borders. 1927, 8¾in (22cm) high, **K**

A vase by Webb Corbett, clear colourless lead crystal with mitre-cut pattern of stylized leaves, etched mark "WEBB CORBETT MADE IN ENGLAND". The motifs derive from a vase designed by Freda Coleburn in 1938. c1938–9, 9¼in (23.5cm) high, **M**

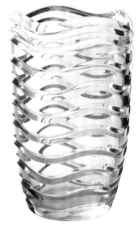

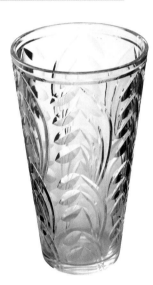

A vase by John Walsh Walsh, clear colourless lead crystal with shallow-cut Neo-classical decoration, including scale pattern around rim and oval motifs and vertical flutes on body, marked "Walsh Birmingham". 1930s, 6½in (16.5cm) high, **M**

A "Oroplastic" lidded vase by Ludwig Moser & Sons, dark purple glass with acid-etched and gilded patterns, including a frieze depicting classical musicians on the body and floral motifs on the lid. c1920, 12¼in (31cm) high, **L**

A bowl by James Powell & Sons (Whitefriars Glass), designed by William Wilson, emerald lead crystal with comet design (pattern number 8988), composed of lens-polished circles and mitre-cut horizontal lines. 1934, 11in (28cm) diam, **L**

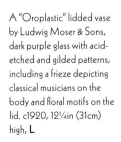

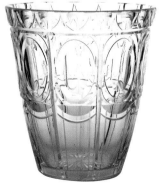

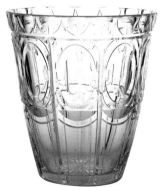

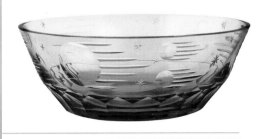

BLØWN GLASS GALLERY

BIMINI ◊ CONSOLIDATED LAMP & GLASS COMPANY ◊ HARTLEY WOOD ◊ LEGRAS ◊ LOETZ ◊ MONART ◊ LUDWIG MOSER & SONS ◊ JAMES POWELL & SONS ◊ POWOLNY ◊ VERRERIES SAINT-DENIS ◊ WHITEFRIARS GLASS

Because glass becomes viscous when heated, its plasticity means that it can be blown and pulled into a variety of shapes. Glass-blowing is a highly skilled process requiring both dexterity and strength. The larger the vessel and the thicker its walls, the heavier it will be. Blowing glass

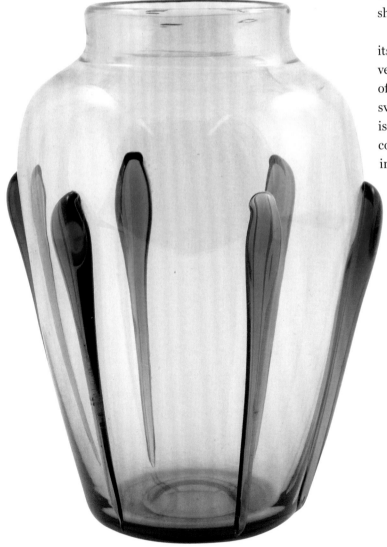

finely with thin walls also requires considerable expertise. Glassmakers use a variety of metal tools and cupped wooden formers to shape the vessel during the blowing process, spinning the blowing iron so that the glass does not stick. Metal moulds are also used, either to impress a relief pattern on the gather of molten glass before it is blown (a process known as dip-moulding or optic-moulding), or to determine its final shape as the glass is blown into the mould (mould-blowing).

Other decorative effects can be created within the glass itself or by applying hot glass to the surface. While some vessels are blown from glass of a single colour, others consist of multiple layers of coloured glass or several different colours swirled together in the pot to create streaky effects. Threading is a common form of decoration on blown glass. Trails of coloured glass can be applied to the surface at various stages in the blowing process. If added at the beginning, they will be incorporated into the walls of the vessel, as in the blue and white striped Loetz vase shown in the middle row opposite. If applied at the end, they will be in relief on the surface, as in the Whitefriars "Tear" vase on this page.

LEFT
A "Tear" vase by James Powell & Sons (Whitefriars Glass), designed by Barnaby Powell, sea green lead crystal with blue trailed tears, polished pontil mark. A larger variant of a design by Harry Powell (1853–1922) from 1901. 1932, 10in (25.5cm) high, **L**

A vase by Legras, designed by August Jean-François Legras for Verreries et Cristalleries de Saint-Denis et Pantin Réunies, dark green glass acid-etched with linear geometric relief pattern evoking draped fabric, signed "Legras". Late 1920s, 8½in (21.5cm) high, 5in (12.5cm) diam, **K**

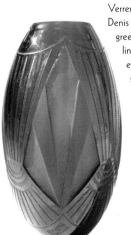

An "Antique Glass" vase by Hartley Wood, clear glass streaked with transparent red, yellow, blue, purple, and green, broken pontil mark. This Sunderland-based stained-glass firm produced decorative blown vessels as a sideline. 1930s, 8in (20cm) high, **M**

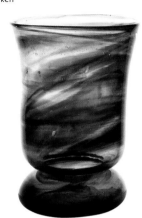

A chalice-shaped bowl by Ludwig Moser & Sons, designed by Josef Hoffmann for the Wiener Werkstätte, purple glass with lobed and ribbed form and trumpet-shaped foot, probably mould-blown in two parts using wire formers. c1922, 5½in (14cm) high, **K**

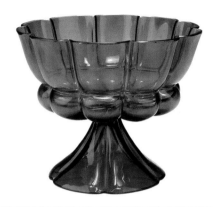

A lamp base by Whitefriars designed by Barnaby Powell in 1935, golden amber ribbon-trailed glass, pattern number 9055. 1938–40, 13in (32cm) high, **M**

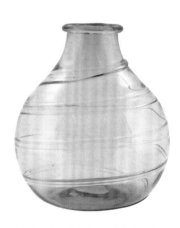

A bud vase by Bimini, trumpet-shaped vessel of clear colourless glass with threaded yellow trails and applied press-moulded green leaves, figure of a fox in hot-worked pale-brown glass with black ears and eyes. c1930s, 4in (10cm) high, **N**

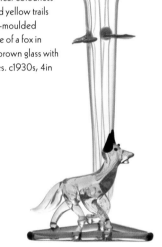

A chalice-shaped vase by Loetz, designed by Michael Powolny (1871–1954), bowl and foot made of opal glass with linear pattern of blue threaded trails, clear colourless glass knop, engraved mark "PROF POWOLNY LOETZ". c1930s, 5in (12.5cm) high, **K**

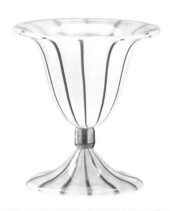

A "Cloisonné" vase by Monart, designed by Paul Ysart (1904–1991), red glass cased in clear glass with iridescent crackle, shape D, size IX, colour code 64. The crackle was produced by applying white enamel to the hot glass, then dipping it in water. c1930s, 6½in (16.5cm) high, **L**

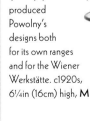

A vase by Loetz, designed by Michael Powolny, translucent amber glass with black rim and ball feet. Czech glassmaker Johann Lötz Witwe (Loetz) (1778–1844) produced Powolny's designs both for its own ranges and for the Wiener Werkstätte. c1920s, 6¼in (16cm) high, **M**

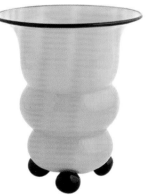

A "Ruba Rombic" vase by Consolidated Lamp & Glass Company, mould-blown angular vessel in cloudy, streaky green glass with satin finish. Part of a range of Art Deco glass and tableware by this Pennsylvania-based firm. c1928–32, 9¼in (23.5cm) high, **K**

STEUBEN

The Steuben Glass Works was established in 1903 by Thomas Hawkes (1846–1913) and Frederick Carder (1863–1963) at Corning in upstate New York. Carder was an English glass designer and glass technologist who had previously worked for the Stourbridge firm of Stevens & Williams. Inspired by Tiffany's "Favrile" glass, he developed a velvety iridescent glass called "Aurene" in 1904, which was used for vases and lampshades. Produced in gold or blue, some "Aurene" pieces were left plain while others were decorated with feathered effects, created by pulling fine threads on the surface of the molten glass.

Carder went on to develop numerous other colours at Steuben over the next few decades, including an ivory glass called "Calcite" (1915) and a translucent white glass called "Ivrene" (1920s). In his acid-etched cameo vases, patterns were cut through multiple layers of glass to reveal contrasting colours below. For the "Intarsia" range, designs were acid-etched on a cased blank, which was then reheated and coated in clear crystal before being blown. Other decorative effects exploited by Carder included air-trap patterns, metallic inclusions, and *millefiori* canes.

In 1918 Steuben was taken over by Corning Glass Works, a large industrial and scientific glass manufacturer, the name Steuben Glass being adopted in 1933. From this date onwards, coloured glass was phased out in favour of clear colourless glass, using a new lead crystal of exceptional purity developed by Corning's scientists. Steuben's artistic policy changed dramatically as a consequence, spearheaded by the firm's newly appointed managing director

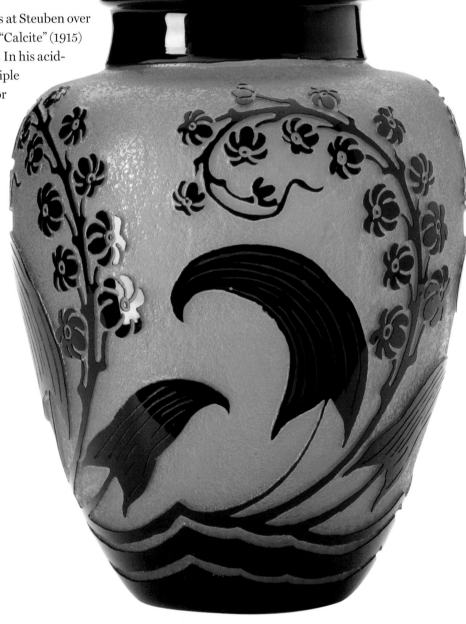

RIGHT
A cameo vase by Steuben, decorated with heart-shaped leaves and sprigs of flowers, acid-etched through black glass over a jade green ground. c1920s, 10in (25.5cm) high, l

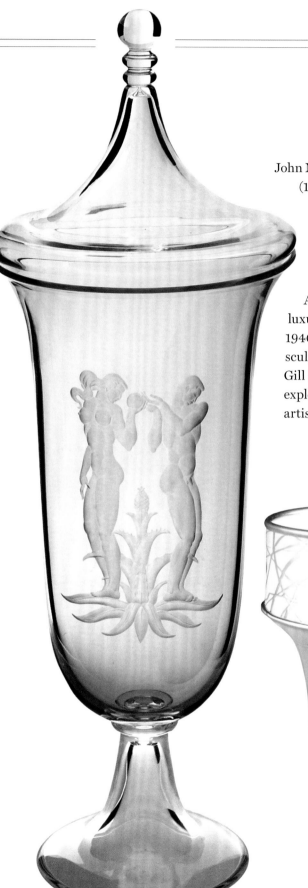

John Monteith Gates (1905–79), who enlisted sculptor Sidney Waugh (1904–63) as designer. Thick-walled lead crystal vessels on plinth-like bases in restrained Art Deco shapes became the hallmark of the new Steuben aesthetic. Decorated with copper wheel engraving, the main focus of these vessels was on stylized figurative designs, typified by Waugh's "Adam and Eve" vase (1938).

Following the opening of a new showroom and design studio on Fifth Avenue in New York in 1934, Steuben concentrated exclusively on high-end luxury glass. An exhibition called *Twenty-Seven Artists in Crystal*, mounted in 1940, featuring limited edition designs by leading international painters and sculptors, including Jean Cocteau (1889–1963), Salvador Dalí (1904–89), Eric Gill (1882–1940), Henri Matisse (1869–1954), and Georgia O'Keeffe (1887–1986), exploited Steuben's engraving expertise and heralded a growing emphasis on artists' designs.

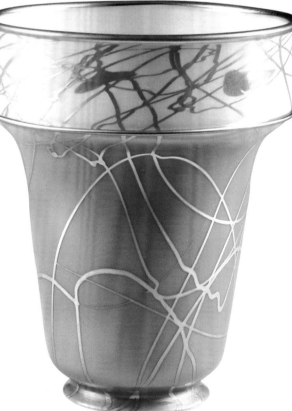

FAR LEFT
An "Adam and Eve" lidded vase by Steuben, designed by Sidney Waugh, clear colourless lead crystal wheel-engraved with a figurative design of Eve giving an apple to Adam in the Garden of Eden. 1938, 16in (40.5cm) high, **I**

LEFT
A "Aurene" lampshade by Steuben, decorated with a scribbly pattern in platinum on a brown iridescent ground with a gold and white border. Early 20th century, 5¾in (14.5cm) high, **J**

CARLO SCARPA

The Italian architect Carlo Scarpa (1906–78) was one of the most innovative glass designers of the 20th century. The vases and bowls he created during the 1930s still look incredibly modern and were decades ahead of their time. Scarpa initially worked for Maestri Vetrai Muranesi Cappellin & C. (MVM Cappellin), a short-lived Murano company run by Giacomo Cappellin from 1925 to 1932. He then embarked on a highly productive partnership with Vetri Soffiati Muranesi Venini & C., established by Cappellin's former business partner Paolo Venini (1895–1959) in 1925. Initially Scarpa worked on a freelance basis, but in 1934 he was appointed artistic director for Venini, continuing in this role until 1947.

A master of form and an inspired colourist, Scarpa created simple but beautifully proportioned vessels with unusual textures and striking patterns, produced in arresting colour combinations, such as red and black, or green, white, and black. Underpinning his skill as a designer was his respect for the material and his understanding of glassmaking processes, which enabled him to exploit the creative potential of glass to the full. Drawing on techniques that had been used in the Venetian glass industry for centuries, such as sliced *millefiori* canes, Scarpa created a new aesthetic that was rooted in history but forward-looking and contemporary, as demonstrated by his mosaic-like "Murrine Opache" bowls (1934).

In addition to colour and pattern, Scarpa also exploited the tactility of glass, both in the making of the vessel and the finishing processes. In his "Sommerso" vessels (1934), cased bubbled glass was combined with gold leaf, for example, while his "Coroso" pieces (1934) were acid-etched through a crackled resist to create iridescent textural effects.

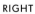

RIGHT
A "Incamitiato" vase by Maestri Vetrai Muranesi Cappellin, designed by Carlo Scarpa, red glass on the interior, black glass on the exterior, marked "MVM Cappellin". c1930, 6in (15cm) high, **H**

Many of the techniques championed by Scarpa would become hallmarks of Venini glass for decades to come, as in "Battuto" (1938), imitating the appearance of beaten metal through small, shallow, matt, unpolished cuts covering the surface of the vessel. Another decorative effect championed by Scarpa was "Tessuto" (1940), finely striped patterns resembling woven textiles created from transverse sections of coloured canes in the glass. Combining a painter's eye with a sculptor's feeling for materials and an architect's sense of form, Scarpa raised glass to new heights. In his hands, Art Deco glass was elevated to the highest echelons of fine art.

BELOW
A bowl by Venini, designed by Carlo Scarpa, transparent sepia bubbled glass body, clear colourless handles with matt "hammered" finish. c1935, 9½in (24cm) diam, **K**

RIGHT
A "Tessuto" vase by Venini, designed by Carlo Scarpa, fine stripes in black/ green and green/white, engraved mark "venini italia 80 100/26". 1940 (date of design), 1980 (date of reissue), 13½in (34cm) high, **K**

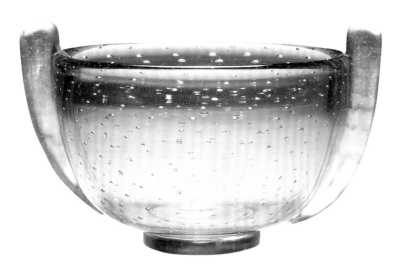

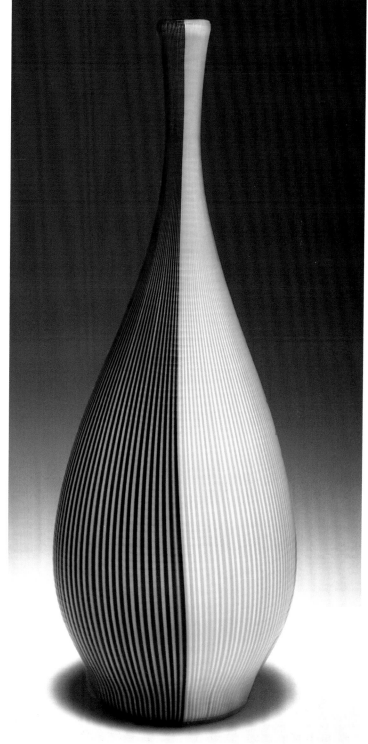

MURANO GALLERY

BAROVIER ◊ BAROVIER SEGUSO & FERRO ◊ FERRO TOSO ◊ MARTINUZZI ◊ VENINI

Italian Art Deco glass has a very distinctive character because of the close-knit glass community on the Venetian island of Murano, with its centuries-old glassmaking traditions. Family firms predominated, often dating back for generations, such as Vetreria Artistica Barovier and Ferro Toso, both run by groups of brothers. Although fiercely independent, these companies were linked by a complex network of interconnections, with frequent schisms, mergers, and alliances.

History and modernity were equally important influences on Murano glass from a stylistic point of view. Many Murano vessels drew on classical forms, for example, resembling urns or amphoras with looped or scrolling handles, but rigorously simplified and pared down. Whereas Scandinavian glassmakers adopted a purist approach, the Italians were more extravagant and exuberant, creating vessels with a joyful quality and playful character. Brightly coloured glass canes were sliced vertically and horizontally to create vessels with ribbon-striped and mosaic patterns within their walls.

Coloured glass was the norm on Murano and most blown vessels were enhanced by additional decoration, such as the densely bubbled effects in Venini's "Vetro Pulegoso" and the gold inclusions and multicoloured swags in Barovier & Toso's "Oriente" range. Because Murano glassmakers were so highly skilled, this acted as a spur for the inventiveness of designers, who created exciting new applications for traditional techniques. While some designers emerged from within the ranks of the Murano glassmaking firms, the industry was also invigorated by designers from other professions, including painters such as Tomaso Buzzi (1900–81), sculptors such as Napoleone Martinuzzi (1892–1977), and architects such as Carlo Scarpa.

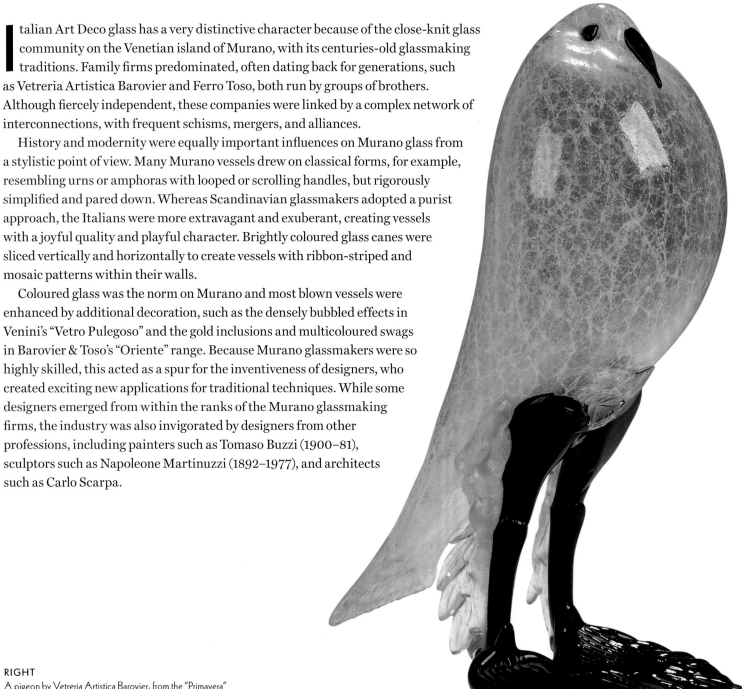

RIGHT
A pigeon by Vetreria Artistica Barovier, from the "Primavera" series designed by Ercole Barovier (1889–1972), grey body in cased crackled glass with applied black beak, eyes, and legs with pressed feet. c1929, 12½in (31.5cm) high, **C**

An "Opalino" vase by Venini, designed by Tomaso Buzzi, blue glass with white lattimo rim and foot, circular label "Venini Murano". Buzzi was artistic director at Vetri Soffiato Muranese Venini & C. from 1932 to 1934. c1932, 8½in (21.5cm) high, **J**

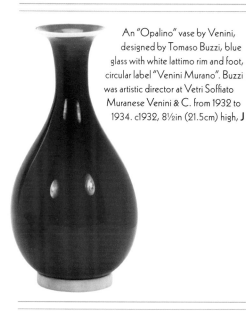

A vase by Vetreria Artistica Barovier, designed by Ercole Barovier, transparent ruby glass cased with bubbled colourless glass, with applied hot-worked trailed ribs in clear glass on either side. c1930–6, 11in (28cm) high, **J**

A "Vetro Pulegoso" vase by Venini, designed by Napoleone Martinuzzi, urn-shaped vessel in bubbled dark green foam glass with scalloped handles in hot-worked glass. A sculptor by profession, Martinuzzi was Venini's art director from 1925 to 1931. c1930, 14in (35.5cm) high, **I**

A "Nero e Rosso" vase attributed to Napoleone Martinuzzi for Vetri Artistici e Mosaici Zecchin Martinuzzi, black glass with crackle pattern, applied red foot and rim. Martinuzzi joined forces with painter Vittorio Zecchin (1878–1947) to establish this firm. c1932–6, 6¼in (16cm) high, **K**

A "Vetro Mosaico" vase by Ferro Toso (Barovier & Toso), designed by Ercole Barovier, mosaic-patterned vessel created from opaque yellow, brown, and black murrhines (slices of coloured canes), black rim and foot. c1936–48, 8½in (21.5cm) high, **I**

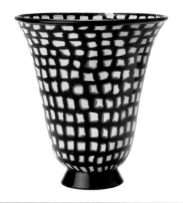

An "Oriente" vase by Ferro Toso (Barovier & Toso), designed by Ercole Barovier, honey-coloured glass with silver foil inclusions, swagged pattern created from multicoloured rods. Although Ferro Toso and Vetreria Artistica Barovier merged in 1936, the name Barovier & Toso was not adopted until 1942. 1940, 7¼in (18.5cm) high, **I**

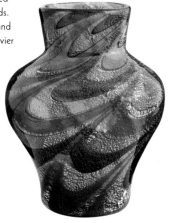

A "Vetro Pulegoso" vase Venini, designed by Napoleone Martinuzzi, bubbled dark green foam glass, gold inclusions in applied collar on the shoulder, and trailed tears on lower part of vessel towards the foot. 1929, 9½in (24cm) high, **J**

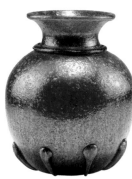

A "Laguna" vase by Venini, designed by Tomaso Buzzi, bell-shaped vessel in milky pink glass with gold foil inclusions. A subtly coloured vessel created by an architect-designer who was also a painter. 1932, 6¼in (16cm) high, **J**

A "Pulegoso" vase by Barovier Seguso & Ferro, light blue foam glass with scroll handles on shoulder. Artistica Soffiera e Vetreria Barovier Seguso & Ferro was formed in 1933 by glassblowers from Vetreria Artistica Barovier. 1935–40, 11in (28cm) high, **J**

ENAMELLED GLASS GALLERY

MARCEL GOUPY ◊ HAIDA ◊ JEAN LUCE ◊ STEINSCHÖNAU

Enamelled glass was extremely popular during the 1920s and 1930s, as it was the perfect vehicle for dynamic brightly coloured Art Deco patterns. Two of the chief exponents of this specialized art form were the French designers Marcel Goupy (1886–1980) and Jean Luce (1895–1964). Goupy's designs, created for a Paris shop called Maison Rouard, were executed on his behalf by a skilled enameller called Auguste Heiligenstein (1891–1976). Most of his patterns were outlined in black enamel or gilding, in-filled with a mixture of clear and opaque enamels in vivid colours. Patterns ranged from stylized landscapes and deer (a classic Art Deco motif) to oriental dancers inspired by the Ballets Russes. Ceramics and glass designer Luce, who ran his own Paris shop from 1931, also adopted enamelling as his favoured medium for a while, before moving on to other forms of glass decoration such as engraving and sand blasting.

Bohemian glassworks had a long tradition of glass painting with enamels, which continued during the early 20th century, with many specialist decorating firms based in and around the towns of Steinschönau and Haida (now Kamenický Šenov and Nový Bor in the Czech Republic). Adapting their style to suit prevailing Art Deco fashions, they drew on an eclectic range of sources from folk art to Neo-classicism.

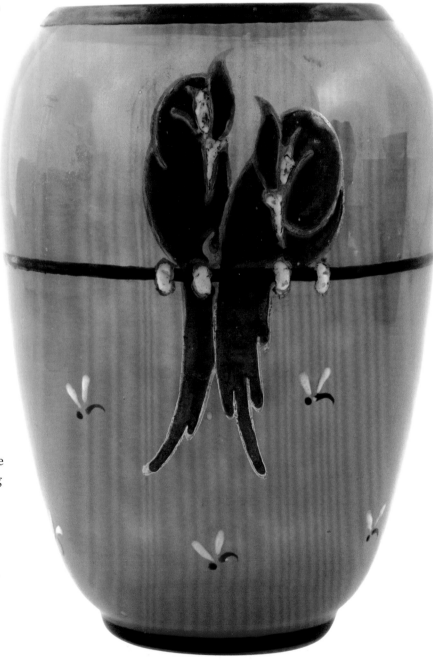

RIGHT
A vase by Marcel Goupy, enamelled in orange on the interior, painted with a design of birds and dragonflies in black and white enamels outlined with gilding on the exterior, foot, and rim banded in black, enamelled signature on base. c1925, 7½in (19cm) high, **K**

A lidded bowl by Steinschönau (Kamenický Šenov), clear colourless glass enamelled with black lines on a cylindrical bowl and in polychrome on the lid with a silhouette of a naked woman playing with a dog in a garden. c1920, 3¾in (9.5cm) diam, **M**

A vase by Marcel Goupy, clear colourless glass enamelled in turquoise, purple, orange, and green with a stylized landscape of geometricized trees, black enamelled signature on base. 1920s, 6in (15cm) high, **M**

A vase by Marcel Goupy, with prunts on the neck, mottled colouring on the interior, painted with dots, circles, and lines in orange, red, and black enamels on the exterior, enamelled signature "M. Goupy". c1925, 5¼in (13cm) high, **M**

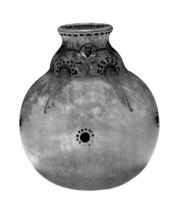

A vase by Jean Luce, clear colourless glass with applied trails on the foot, painted in blue and white enamels and gilding with floral motifs, stripes, dots, and lozenges, artist's monogram on base. c1928, 5¼in (13cm) high, **M**

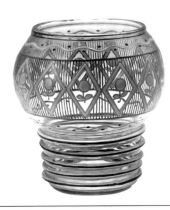

A pair of vases by Haida (Nový Bor), clear colourless glass enamelled in black, yellow, red, and green with small birds in cartouches, rosettes, and stylized flowers in Wiener Werkstätte style. 1930s, 5½in (14cm) high, **M**

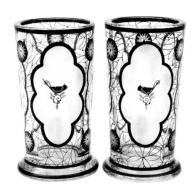

A vase by Haida (Nový Bor), with a domed lid, clear colourless glass enamelled in green, blue, and transparent yellow over-painted in black with a tessellated pattern incorporating stylized floral motifs. c1920, 10½in (26.5cm) high, **K**

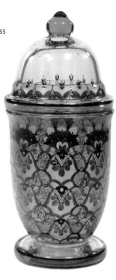

A vase by Marcel Goupy, clear colourless glass, neck enamelled in mottled brown on the interior, painted in turquoise, green, and black enamels and gilding with deer and trees on the exterior, black rim and foot. 1920s–1930s, 10in (25.5cm) high, **I**

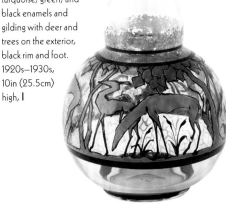

A bowl by Marcel Goupy, clear colourless glass painted in red and black enamels and gilding with stylized berries running around the rim and cascading downwards, black rim and foot, enamelled signature "M. Goupy". 1920s, 2½in (6cm) high, **K**

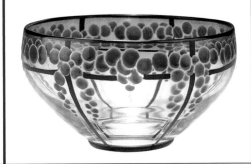

A vase by Marcel Goupy, clear colourless glass painted with a stylized landscape in turquoise, blue, green, grey, and brown enamels, outlined in gilding, black enamelled rim and foot. 1920s–1930s, 7in (18cm) high, **I**

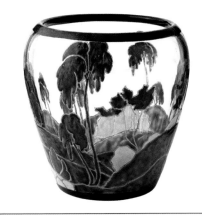

PÂTE DE VERRE GALLERY

GABRIEL ARGY-ROUSSEAU ◊ FRANÇOIS-ÉMILE DÉCORCHEMENT ◊ AMALRIC WALTER

A special type of moulded glass used to create decorative vessels and small sculptural objects is known as *pâte de verre*, which means "glass paste". Made from finely crushed glass and metallic oxides mixed with a binding agent, the glass paste is placed in a refractory mould and fired in a kiln. As the glass particles melt and vitrify, they fuse with the oxides. The moulds are removed from the kiln before the glass becomes too viscous, thereby preserving localized areas of colour.

Pioneered in France during the 1880s and 1890s by artist Henri Cros (1840–1907), *pâte de verre* was disseminated and promoted by his son Jean Cros (1884–1932), who studied at the École Nationale de Céramique at Sèvres with Gabriel Argy-Rousseau (1885–1953). Having adopted the medium, Argy-Rousseau exhibited his work at the Salon des Artistes in 1914. He subsequently established a small factory in Paris called Les Pâtes de Verres d'Argy-Rousseau in 1921. Although initially used for Art Nouveau designs, *pâte de verre* was equally well suited to Art Deco. The vivid colours and stylized patterns created by Argy-Rousseau demonstrated its aesthetic potential.

Another key figure in the development of *pâte de verre* was Amalric Walter (1869–1959). Initially based at Daum Frères in Nancy from 1906 to 1914, he later established his own workshop, collaborating with designer Henri Bergé (1870–1937), who had previously worked alongside him as chief decorator at Daum. Artist and potter François-Émile Décorchement (1880–1971) was another distinguished pioneer. Using a material called *pâte de cristal*, made from powdered lead crystal, Décorchemen created gem-like vessels that were crystalline and translucent rather than semi-opaque.

RIGHT
A *pâte de cristal* "Conches" vase by François-Émile Décorchement, ovoid form with flared rim in creamy-orange glass with streaky violet and brown marbled effects, horizontal grooves on lower half of the body. Relief-decorated masks in purple on the shoulder feature a bearded man's head, with three tear-shaped motifs between each mask. Moulded semi-circular mark "DÉCORCHEMENT". c1925, 5½in (14cm) high, **H**

A *pâte de cristal* bowl by François-Émile Décorchement, faceted body with stepped handles, moulded in translucent amber glass with streaky brown tortoiseshell effects. An artist who originally practised as a potter before adopting the medium of glass, Décorchement spent many years perfecting his glassmaking techniques. The material he developed, known as *pâte de cristal*, was much more translucent than *pâte de verre* and bore a striking resemblance to gemstones in colour and texture. 1920s, 4¾in (12cm) wide, **H**

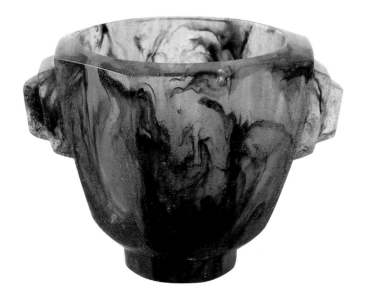

A *pâte de verre* vase by Gabriel Argy-Rousseau, moulded around the rim and foot with stylized chrysanthemums, moulded signature "G. Argy-Rousseau", moulded mark "France" on base. The colouring of this piece is very subtle, ranging from soft pastels to vivid reds. c1925–30, 6in (15cm) high, **I**

A *pâte de verre* clock by Amalric Walter, moulded in relief with two bees and an orchid, signed "Bergé SC A WALTER NANCY". This piece was created in Walter's workshop after the First World War. Designed by his long-time associate Henri Bergé, with whom he had previously collaborated at Daum, this attractive clock, with its striking colouring and naturalistic motifs, captures the visual appeal of this technically demanding medium. 4½in (11cm) high, **J**

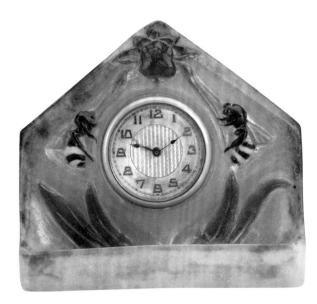

A *pâte de verre* table lamp by Gabriel Argy-Rousseau, in the form of a fan, moulded in relief with stylized flowers in purple, red, and black, mounted on a later iron stand, stamped mark "FRANCE G. ARGY-ROUSSEAU". This piece was made at Les Pâtes de Verres d'Argy-Rousseau, a small factory established by the artist in 1921. Lighting was an important part of the range and objects were serial-produced in reusable composite moulds. c1925–30, 7¾in (19.5cm) high, **I**

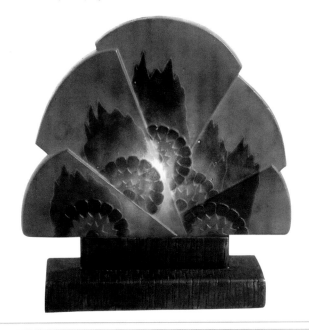

IRIDESCENT GALLERY

VICTOR DURAND ◊ STEUBEN ◊ WMF

Although iridescent glass is primarily associated with Art Nouveau, it remained extremely popular until the end of the 1920s and forms part of the story of Art Deco glass. The vogue for iridescent glass was initially triggered by the success of the "Favrile" range by Louis Comfort Tiffany (1848–1933), produced by the Stourbridge Glass Company of Corona, Long Island, New York, from 1894 (renamed Tiffany Furnaces in 1902). Iridescent lustres were created by spraying molten glass with metallic salts. Decorative effects such as feathering were produced by manipulating fine threads of glass trailed on the surface.

Given the popularity of Tiffany's "Favrile" glass, it is hardly surprising that it prompted so many copyists, particularly in the USA. Frederick Carder's "Gold Aurene" glass for Steuben, launched in 1904, was clearly indebted to Tiffany, the name "Aurene" being derived from the Latin word *aurum*, meaning gold. Its enduring appeal is indicated by the fact that "Aurene" variants were still being produced by Steuben during the 1920s. Victor Durand's "King Tut" range, made by the Vineland Flint Glass Works in New Jersey from around 1925, was another late descendant of Tiffany's "Favrile".

The long-lasting fashion for iridescent glass and its renaissance during the 1920s under the aegis of Art Deco is indicated by the success of Wüttembergische Metallwaren fabrik's (WMF) "Myra-Kristall". Launched in 1925, this range was created in Germany three decades after "Favrile" using similar techniques. Significantly, the vessels were much simpler and plainer, reflecting the fact that Modernism was on the rise.

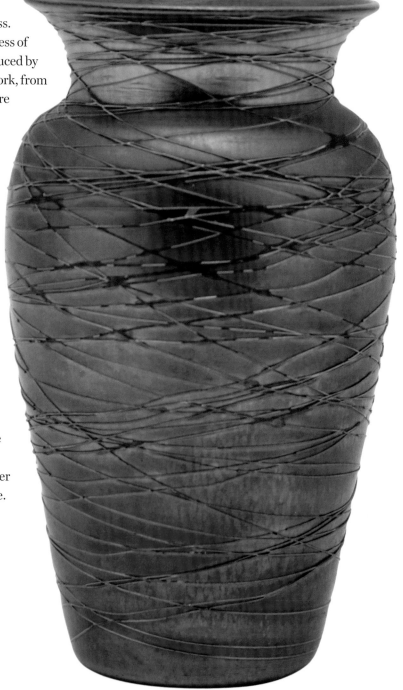

BELOW
A baluster-shaped vase by Victor Durand, blown glass with kingfisher blue iridescent finish, decorated with fine trails of glass with gold iridescence. Part of a range of Tiffany-style iridescent glass produced by the Vineland Flint Glass Works, New Jersey, following the recruitment of Martin Bach Jr in 1924. Bach had previously worked for the art glass firm of Quezal and his father had been employed as a chemist by Louis Comfort Tiffany. c1925, 7¼in (18.5cm) high, **L**

A "Blue Aurene" vase by Steuben, designed by Frederick Carder, ovoid vessel with dark purplish-blue iridescence. Following Tiffany's example, Carder patented his first iridescent glass colour, "Gold Aurene", at Steuben in 1904. "Blue Aurene" was launched the following year and proved so successful that it remained in production for several decades. Although "Blue Aurene" pieces are not uncommon, this vase is an unusual shape, so it has added rarity value. c1925, 5in (12.5cm) high, **K**

A "Gold Aurene" bowl by Steuben, designed by Frederick Carder, translucent ivory-coloured "Calcite" glass body with ribbed pattern and wavy-edged rim, white on the exterior with gold iridescent finish on the interior of the broad flared neck. "Gold Aurene" was first produced in 1904 whereas "Calcite" dates from 1915. This rare piece, combining both types of glass, dates from the following decade and reflects the move towards greater classical simplicity in response to Art Deco. c1925, 11¼in (25.5cm) diam, **K**

A "Myra-Kristall" vase by WMF, ribbed gourd-shaped mould-blown body, amber glass with iridescent matt gold finish. Based at Geislingen in southern Germany, WMF was the acronym for Wüttembergische Metallwarenfabrik. Although the company originally specialized in metalwork, particularly pewter and silver plate, it later branched out into glass from 1883. Its "Myra-Kristall" art glass, produced from 1925, was sprayed with metallic salts while the glass was hot to produce an iridescent lustre. c1928, 6 in (15.5cm) high, **M**

A "King Tut" vase by Victor Durand, iridescent glass with a pattern of waves and swirls. "King Tut" alludes to the pharaoh Tutankhamun, whose treasure-filled tomb was excavated by the British archaeologist Howard Carter in Egypt's Valley of the Kings in 1922. The discovery prompted a wave of Tut-inspired designs, from glassware to jewellery and architecture. c1925, 6½in (16.5cm) high. **M**

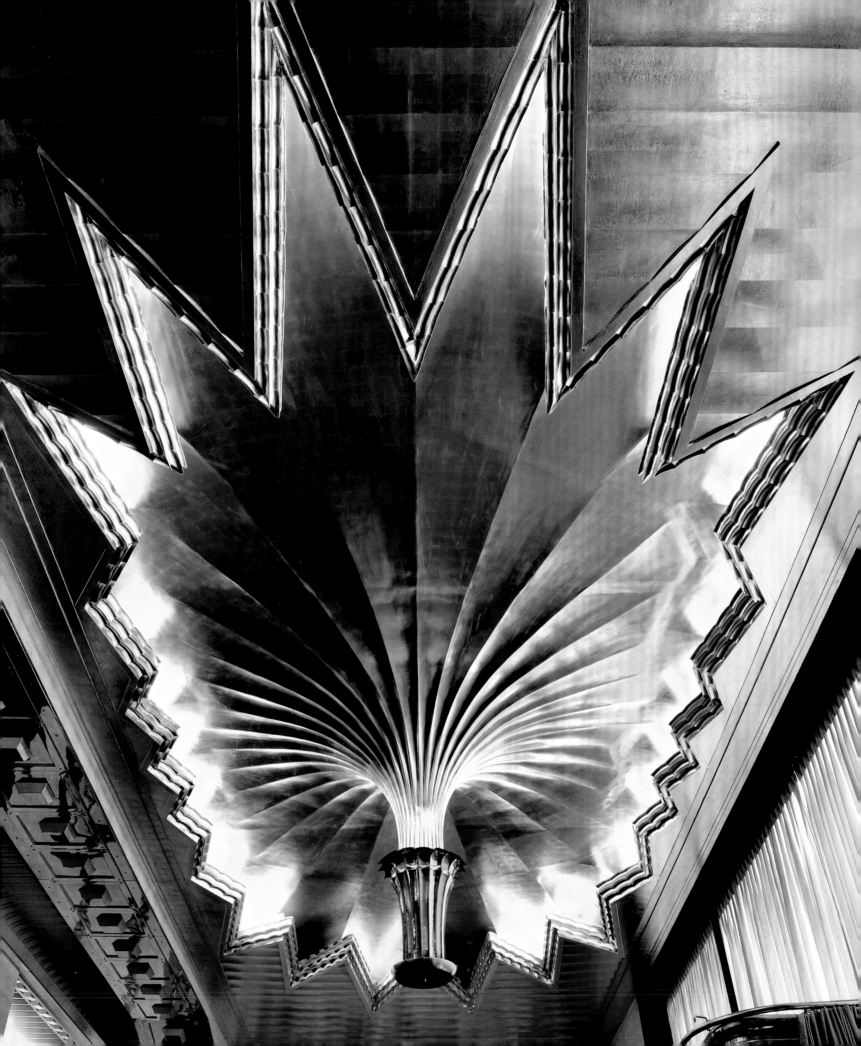

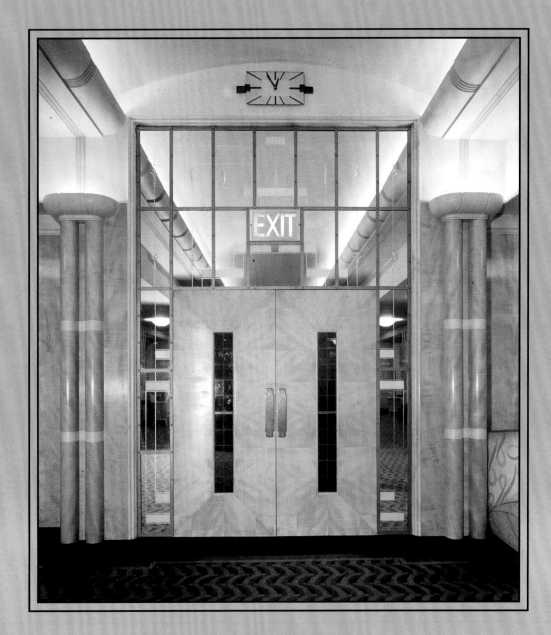

— CHAPTER FOUR —

SILVER, METALWARE, CLOCKS & PLASTIC

CHRISTOFLE

Christofle & Cie has been one of France's most renowned silver and metalware manufacturers since the early 19th century. In the Art Deco period it is particularly associated with commissioning designs from many of the leading architects, sculptors, and industrial designers of the day.

Charles Christofle (1805–63), founder of the family firm, began work as a jeweller but turned to the manufacture of silver and household plate by the late 1830s. In 1842 he bought the French rights to the electroplating patents of G.R. Elkington, enabling him to expand the firm's production such that its annual turnover by 1847 exceeded two million francs. By the time of his death in 1863 the firm had become an industrial leader in the manufacture of silver and plate, with its main factory at Saint-Denis, near Paris, but with retail outlets and branches at Karlsruhe, Vienna, and Brussels. At the 1900 Paris *Exposition Universelle* the firm introduced a new type of plate called "Gallia metal", similar to but more durable than pewter, and less expensive to manufacture, leading to production during the early 20th century of a line of high-quality wares at more affordable prices.

Christofle experienced a decline during the economic Depression of the early 20th century but a revival began under the leadership from 1932 of Tony Bouilhet (1897–1984), great-grand-nephew of the founder. The firm commissioned work from many notable designers of the Art Deco period, including Maurice Daurat (1880–1960), Maurice Dufrène (1876–1955), Paul Follot (1877–1941), André Groult (1884–1966), Jean Serrière (1893–1965), Louis Süe (1875–1968), and André Mare (1887–1932), the Dane Carl Christian Fjerdingstad (1891–1968), and the Italian Gio Ponti (1892–1979).

In 1935 the firm produced much of the Art Deco silver and electroplate for the SS *Normandie*, a large, sleek and lavishly appointed French ocean liner.

Christofle pieces are typified by simple, geometric designs with plain surfaces, and hardstone,

RIGHT
A covered vessel by Christofle & Cie. Simple forms and clean lines are typical of Art Deco pieces by the firm. 1920s, 4in (10cm) high, **M**

ivory, or wooden handles and knobs, although its output also included revivalist, florid, and streamlined objects, as well as unusual pieces such as Süe's Cubist squirrel sweetmeat dish and automobile ashtray, and Fjerdingstad's swan-form gravy boat. Pieces are usually stamped with the name on the base. After the Second World War the firm continued to employ Gio Ponti as well as other well-known designers and makers such as Tapio Wirkkala (1915–85) and Lino Sabattini.

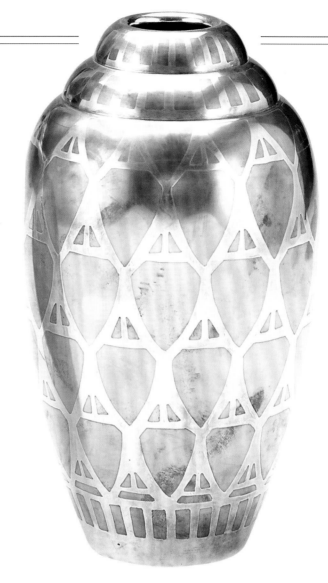

RIGHT
An "Ecailles" dinanderie mixed-metal vase of copper and silver by Christofle & Cie, designed by Luc Lanel (1893–1965), factory stamped, and with the mark "B1G". c1920, 10in (25.5cm) high, **K**

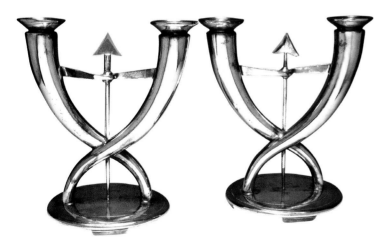

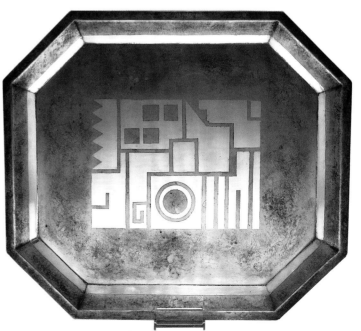

ABOVE
A pair of flame candlesticks, designed by Gio Ponti for Christofle & Cie, made of silver-plated "Gallia metal", in the shape of two intertwined cornucopias, stamped "O. GALLIA" and with the model no. "6055". c1931, 8¼in (21cm) high, **I**

RIGHT
A silver-plated octagonal copper tray by Christofle & Cie, with etched geometrical decoration to the centre. Signed "Christofle B 199 G". 1930s, 18½in (46.5cm) wide, **M**

GEORG JENSEN

Georg Jensen (1866–1935) was one of Denmark's most renowned silversmiths in the 20th century, and the work of the firm that he established in Copenhagen is highly collectable today. Jensen wares – both hand-made and mass-manufactured – were arguably the most influential of all European silver during the Art Deco period, and were widely imitated throughout the Continent and in North America.

Jensen began his career as an apprentice goldsmith at the age of 14. He later studied sculpture and worked as a porcelain modeller, but at the turn of the century returned to silversmithing. In 1904 he established his own workshop in Copenhagen, Georg Jensen Sølvsmedie. His early work in the Art Nouveau style drew on his training in the fine arts, with abstract, rounded forms to which he added bunches of fruit or flowers. From 1906 Jensen also made silver designed by the painter Johan Rohde (1856–1935), whose style was strikingly functional and restrained and helped to cement the international reputation of the firm through the 1920s and 1930s.

Heavily influenced by the British Arts and Crafts Movement, Jensen Art Deco wares are characterized by highly polished, clean outlines and stylized organic forms, often with handles, knops, stems, and feet in the form of naturalistic or abstract scrolls, tendrils, berries, pods, and flowers. Some pieces incorporate semi-precious stones or amber. Its output of domestic wares, designed by Henning Koppel (1917–82) and Sigvard Bernadotte (1907–2002), among others, included tureens, candelabra, cigar boxes, and coffee and tea services. Dating from the mid 1930s were elegant centrepieces and smaller shallow bowls by

RIGHT
A water jug by Georg Jensen, designed by Johan Rohde, design no. 432. Versions of this jug were produced in various sizes. c1925, 8in (20cm) high, I

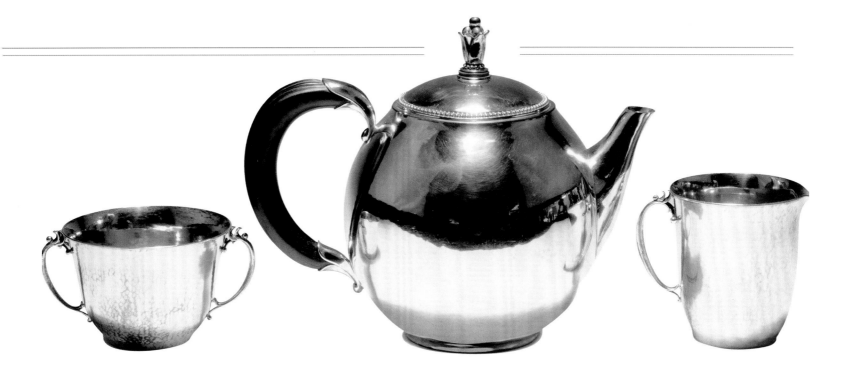

Harald Nielsen (1892–1977), which have simple curled handles and plain surfaces. The typically Jensen hammered finishes, short-bladed knives, and round-bowled spoons were widely imitated.

Marks on Jensen silver are well documented and can include the design number or the initials of the designer. Today the firm has branches worldwide, and remains renowned throughout Europe and North America for the quality of its workmanship, both in hand-made and mass-manufactured domestic objects, jewellery, and flatware.

ABOVE
A silver tea service "456" by Georg Jensen, designed by Harald Nielsen. Jensen vessels made in the Art Deco period often have plain, satin-like surfaces produced by annealing the piece, immersing it in sulphuric acid, and then buffing it to allow slight oxidization to remain. 1927, teapot 6in (15cm) high, **J**

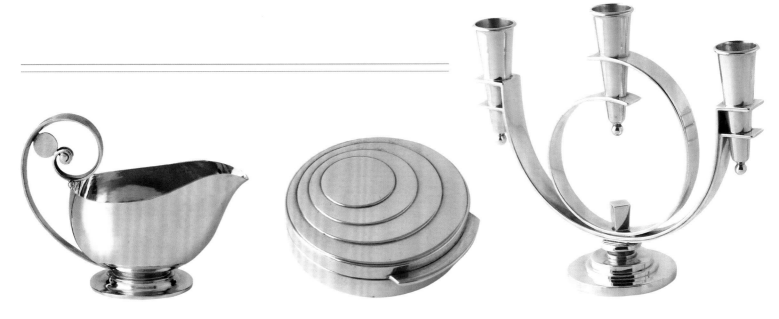

ABOVE
A jug by Georg Jensen, designed by Johan Rohde, design no. 321, with the characteristic scrolling tendril handle found on Jensen wares. c1920s, 4in (10cm) high, **K**

ABOVE
A silver pill box by Georg Jensen. The plain geometric repeating circles on the lid are a typical motif of the period. c1930, 1¾in (4.5cm) high, **K**

ABOVE
A pair of silver candelabra by Georg Jensen. Jensen's international reputation depended on the simple elegance of his designs and their crafted appearance. c1933, 6½in (16.5cm) high, **G**

SILVER GALLERY

ADIE BROTHERS ◊ HERMANN BEHRND ◊ BRUCKMANN UND SÖHNE ◊ GEBRÜDER DEYHLE ◊ PAUL FOLLOT ◊ SAUNDERS AND SHEPHERD ◊ TÉTARD FRÈRES ◊ WOLFERS FRÈRES

The Art Deco style was as popular in silver as it was in other decorative arts and reflected the eclectic mix of styles prevalent in the period, from the pure lines and geometric forms of the Modern Movement to conspicuous opulence in the use of exotic materials, such as ebony and ivory, and contemporary reworkings and inspiration from past styles, such as French Baroque and Rococo. The finest silver continued to be hand-made, but companies such as the International Silver Company in the USA and Adie Brothers and Walker & Hall in Britain mass-produced more affordable pieces for a wider market.

France was undoubtedly the leader in the most sophisticated and highly crafted Art Deco designs, most notably through the work of Jean Puiforcat (1897–1945), characterized by austere and pure geometric forms, seen in a range of tea services, candlesticks, clocks, bowls, and other tableware. Other well-known Paris silversmithing firms included Maison Cardeilhac, Maison Christofle, and Tétard Frères. In Austria the Wiener Werkstätte produced highly wrought decorative silver in an ornate, Baroque

style often in swirling and fluted forms, while in Britain the the work of H.G. Murphy (1884–1939), Harold Stabler (1872–1945), and R.M.Y. Gleadowe (1888–1944) featured rectilinear forms and engraved or smooth polished surfaces. Other major European makers included Wolfers Frères and Delheid Frères in Belgium, in streamlined and geometric styles with ivory handles and finials, Württembergische Metallwarenfabrik (WMF) in Germany, and Georg Jensen in Denmark, and in the USA the Gorham Manufacturing Company in Rhode Island.

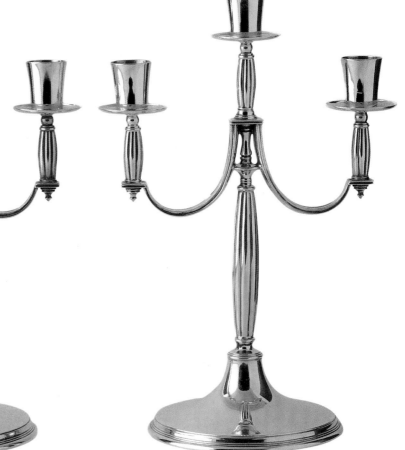

RIGHT
A pair of English candelabra, designed by Harold Stabler for Adie Brothers. Many Art Deco silver pieces drew inspiration from Neo-classical design, and the slightly bulbous, tapering forms here are reminiscent of 18th-century Georgian silver. 1936, 11¾in (30cm) high, I

A five-part silver "Janine" service by Wolfers Frères, Brussels, with rosewood handles, and with the manufacturer's mark and "8005", and the model no. "4487–4490". The service was named after a daughter of its designer, Marcel Wolfers (1886–1976). c1925, coffee pot 5¾in (14.5cm) high, **H**

A large cast and hammered centrepiece on an oval stand made by Gebrüder Deyhle in Schwäbisch Gmünd, Germany. The bulbous form and stylized shell handles make reference to the style of 18th-century Rococo silver. 1920, 7 x 15½ x 10½in (20 x 39 x 26.5cm), **K**

A fine silver-plated teapot and creamer by Paul Follot, both pieces marked "Pfollot". The sweeping fluted design and angular forms show the continued influence of Art Nouveau during the Art Deco period. 11½in (29cm) high, **J**

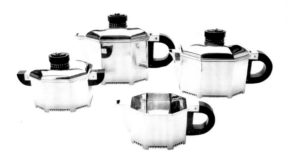

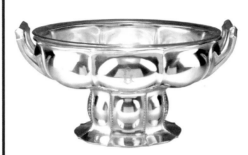

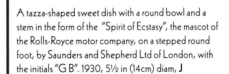

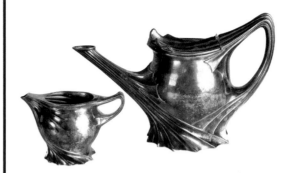

A silver tin by Hermann Behrnd, chased, hammered, and soldered, with carved amber finial, maker's mark, and "MENNER, STUTTGART". Handles and finials in exotic materials such as amber, ebony, and ivory are distinctive features of Art Deco silver. c1930, 7¼in (18.5cm) high, **L**

A tazza-shaped sweet dish with a round bowl and a stem in the form of the "Spirit of Ecstasy", the mascot of the Rolls-Royce motor company, on a stepped round foot, by Saunders and Shepherd Ltd of London, with the initials "G B". 1930, 5½ in (14cm) diam, **J**

A five-part silver coffee and tea service by Bruckmann und Söhne in Heilbronn, Germany, with macassar wood handles and knobs, the undersides stamped with the master's mark, half moon, crown, "835" (denoting the purity of the silver) and partly with the model no. "13636". 1932, coffee pot 8in (20cm) high, **K**

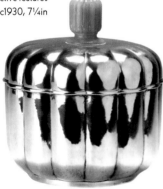

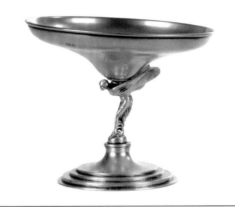

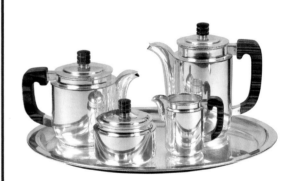

A silver tea service by Wolfers Frères, with stained ebony handles and knobs, comprising a teapot with a hinged lid, milk jug, and sugar bowl. The geometric, ribbed ball-shaped bodies are a typical element of the Art Deco style. c1927, teapot 6½in (16.5cm) high, **K**

A pair of French Art Deco silver tureens, cover, and stand, with the maker's mark of Tétard Frères. Tétard produced some of the most outstanding French silver of the Art Deco period, especially geometric pieces. c1930, 13¾in (35cm) long, **F**

A hexagonal part engine-turned table lighter in the form of a petrol pump surmounted with a model of the "Spirit of Ecstasy", by Saunders and Shepherd Ltd of London, with the initials "G B". Novelty silver items from the period are particularly collectable today. 1934, **I**

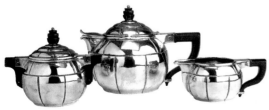

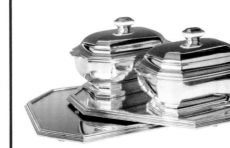

MODERNIST GALLERY

EDWARD BARNARD & SONS ◊ DOLE VALVE CO ◊ H.G. MURPHY ◊
REVERE COPPER AND BRASS CO. ◊ GENE THEOBALD ◊ WMF

Silver and other metals – capable of being cast, moulded, and highly polished – provided the perfect medium for Modernist designers to express one of the key design ideals of the age: that form should follow function. Starkly geometric forms, including cylinders, spheres, rectangles, and triangles with minimal decoration such as banding, began to appear in the work of both European and American silversmiths. In the USA especially, manufacturers like the Chase Brass and Copper Co., Kensington Ware, and the Revere Copper and Brass Co. exploited less expensive metals such as aluminium, pewter, and chrome to produce attractively priced domestic wares styled by leading designers, including Russel Wright and Norman Bel Geddes.

Among the most renowned and influential silver and metalwork designers in Europe were Marianne Brandt (1893–1983), whose hemispherical teapot (1924) built of circles and semi-circles is one of the most celebrated pieces produced at the Bauhaus school of design in Dessau. In France, Jean Puiforcat's tablewares exploited the interplay of light, reflection, and shadow on starkly geometric and austere forms. In the USA stepped cylindrical and rectilinear forms evoked the shapes of Modernist skyscrapers, especially in cocktail sets, while the influence of abstract art movements such as Cubism and Futurism is seen in such pieces as the "Cubic" tea service of multifaceted forms made in contrasting plain and oxidized silver and gilt, designed by the Dane Erik Magnussen for Gorham Manufacturing Co. in 1927 and dubbed "The Lights and Shadows of Manhattan" by the *New York Times*.

LEFT
An English chrome and Bakelite kettle and urn, stamped "Regd 849217". This kettle and urn epitomize the Art Deco fascination with geometric and angular forms and plain surfaces that embodied the ideals of the Machine Age. 1940s, 16½in (42cm) high, **L**

A pair of U-shaped candlesticks by Dole Valve Co. of Chicago, in Bakelite and chrome, exhibited at the 1939 World's Fair in New York, which provided visitors with a glimpse of "the world of tomorrow". c1939, 8in (20cm) wide, **K**

A pair of solid brass and wrought-iron andirons, from the Washington, DC, estate of the original owners, the interior of which was designed by the artist and decorator Madame Yna Majeska in 1934, unmarked. c1934, 14½ x 9 x 15in (37 x 23 x 38cm), **K**

A silver drum-shaped cigarette box and cover by H.G. Murphy, made in London at the Falcon Works, with turned band decoration and the cover with a typically Art Deco ivory finial, with stamped marks. 1934, 5in (12.5cm) high, **I**

A nickel silver over brass four-piece tea set by Gene Theobald, with Bakelite handles, made by the Wilcox Silver Plate Co. This unusual geometric design typifies the ingenuity of American Art Deco metalwork. c1928, 8½in (21.5cm) wide, **I**

A silver and ivory vase and cover, with stamped marks "D&P Birmingham 1936". English silver of the 1920s and 1930s was more influenced by traditional Arts and Crafts forms, as seen in the tapering shape of this vase. 1936, 12¼in (31cm) high, **M**

A nickel silver-plated bowl and cover by Fritz August Breuhaus (1883–60), made by Württembergische Metallwarenfabrik (WMF), Geislingen. WMF was Germany's largest manufacturer of silver plate during the 1920s and 1930s. 1929, 6 in (15cm) high, **K**

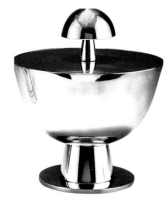

A silver sugar caster by Edward Barnard & Sons, with a stepped and pierced cover with flared geometric finial, stamped with the maker's mark, London hallmarks for 1934, and with the King's Jubilee mark for 1935. c1934, 5¾in (14.5cm) high, **M**

A pair of chrome "face" lamps, by the Revere Copper and Brass Co., possibly designed by Helen Dreyfuss, the wife of designer Henry Dreyfuss (1904–72). The stylized faces recall the African tribal masks that widely inspired painters, sculptors, and designers in this period. 1930s, 10in (25.5cm) high, **L**

A French silver-plated box, with hinged lid and Bakelite handles. Functional pieces with plain forms and elegant handles such as this are particularly collectable today. It is important to check the condition of Bakelite for any cracking or damage. 1930s, 10¾in (27cm) wide, **J**

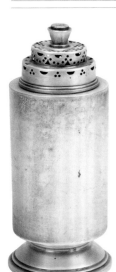

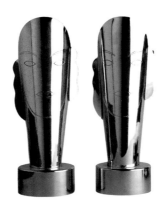

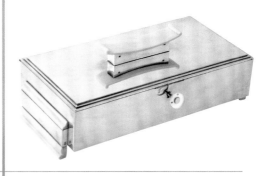

RUSSEL WRIGHT

One of the foremost American industrial designers, Russel Wright (1904–76), described his approach as "humanizing functional design". He championed a simpler, more organic style in contrast to the harder geometric lines and forms of International Modern.

Born in Lebanon, Ohio, Wright originally studied law at Princeton University, but after his first year spent the summer in the art colony at Woodstock, New York, where he met his future wife and collaborator, Mary (1905–52). He left Princeton to study architecture, art, and sculpture, and began work as an assistant on theatre set design for Norman Bel Geddes.

In 1930 Wright exhibited his design of an aluminium cocktail shaker in Manhattan. It was so successful that he began a business in New York with Mary in 1930, designing and making spun-aluminium domestic items such as pitchers, urns, and other kitchenware, all exploiting the aesthetic qualities of the material itself through elegant, modern forms enhanced by finely brushed horizontal lines. In 1932 *A Design for Machine* exhibition in Philadelphia featured an all-aluminium breakfast room by Wright, showing lamps, tables, accessories, cutlery, and mugs in aluminium.

Wright is also known for his designs in other media. He designed a collection of solid bleached maple furniture under the name "Modern Living", manufactured for the Macy's department store for the Conant Ball Company (1935); chrome pieces for the Chase Brass and Copper Co.; and an early table model radio. He is perhaps best known for his ceramic designs, especially "American Modern", made from 1939 to the 1950s at the Steubenville Pottery, and "Casual China", porcelain tableware with indentations rather than handles, made in the 1940s and the 1950s. Wright established his own design office in 1939 and in December 1940 launched a nationwide craft, design, and merchandizing consortium of 100 designers called "The American Way" to promote low-cost American style to industry, although this was later abandoned owing to the Second World War.

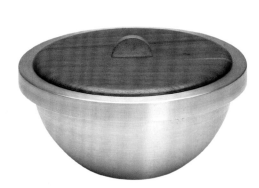

ABOVE
A spun-aluminium bowl by Russel Wright, with walnut lid, stamped "Russel Wright". Wright is credited as being one of the first designers to explore the design potential of aluminium. c1930, 8½in (21.5cm) diam, **J**

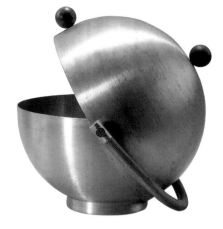

ABOVE
A "Wright Accessories" spun-aluminium bun warmer, designed and made by Russel and Mary Wright in New York City, stamped "RUSSEL WRIGHT", with wood and cane fittings. Early 1930s, 14in (35.5cm) high, **L**

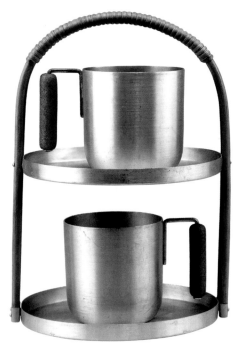

ABOVE
A "Wright Accessories" spun-aluminium table etagère, designed and made by Russel and Mary Wright, with two mugs or handled pots, stamped "RUSSEL WRIGHT", with cork and cane fittings. Early 1930s, 14in (35.5cm) high, **L**

NORMAN BEL GEDDES

Norman Bel Geddes (1893–1958) was among the most important exponents of the streamlined style, a characteristically American strand of Art Deco. Born in Michigan, he studied briefly at the Art Institute of Chicago and then worked in theatre design, shop window display, and advertising in New York. In 1927 he opened his own industrial design studio.

Alongside metalware, Bel Geddes designed furniture, textiles, interiors, and household items such as a 1933 stove for the Standard Gas Equipment Corporation, which used sheet metal clipped onto a tubular frame to produce clean lines and continuous surfaces. He was a leading designer in new metals such as chrome and aluminium, and aimed to bring modern designs to a wider audience through the use of materials that were less expensive than silver. Particularly notable are his designs for barware, including the "Skyscraper" cocktail set and "Normandie" water pitcher. His "Manhattan" service (1937), made by the Revere Copper and Brass Co., consists of a tall, cylindrical cocktail shaker and simple stemmed cups on a stepped tray, evoking the forms of skyscrapers and Modernist buildings.

Bel Geddes's vision of a streamlined Machine-Age industrial art was made popular by his book *Horizons* (1932) – with its futuristic designs for trains, planes, and cars – by his floating restaurant in steel, glass, and aluminium at the *Century of Progress* Exhibition in Chicago (1933), and by his General Motors pavilion for the New York World's Fair (1939). After the Second World War his consultancy went into liquidation as a result of a lack of commissions.

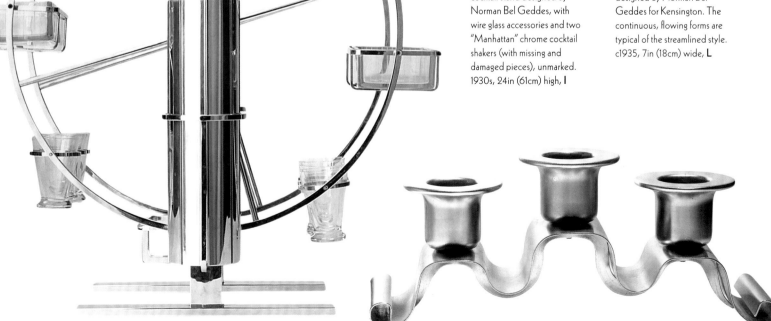

LEFT
A Ferris-wheel-shaped chrome cocktail stand designed by Norman Bel Geddes, with wire glass accessories and two "Manhattan" chrome cocktail shakers (with missing and damaged pieces), unmarked. 1930s, 24in (61cm) high, **I**

BELOW
A pair of aluminium candlesticks designed by Norman Bel Geddes for Kensington. The continuous, flowing forms are typical of the streamlined style. c1935, 7in (18cm) wide, **L**

CHASE BRASS & COPPER COMPANY

During the 1920s and 1930s mass-produced domestic wares in aluminium, pewter, brass, copper, and chrome grew in popularity as they were less expensive and easier to clean and maintain than silver and silver-plate.

Chromium, or chrome especially, was particularly appropriate for the Machine Age aesthetic as it had a brilliant, hard surface resistant to corrosion that required no polishing – ideal for households where the numbers of servants had

been much reduced after the First World War. The largest manufacturer of chrome in the USA during this period was the Chase Brass and Copper Co. It had been established in 1876 in Waterbury, Connecticut, and established its reputation as a brass manufacturer, especially for munitions in the First World War; by 1918 the US government was its largest customer. The company continued to grow during the 1920s, and by 1929 had become a leading supplier of brass parts to the fast-expanding automobile industry.

From 1930 to 1941 Chase focused on the consumer market, manufacturing a popular and now highly collectable series of Art Deco-inspired metal houseware. These were produced in six general categories classified by the company as "Specialties": table electrics, buffet service articles, decorative items,

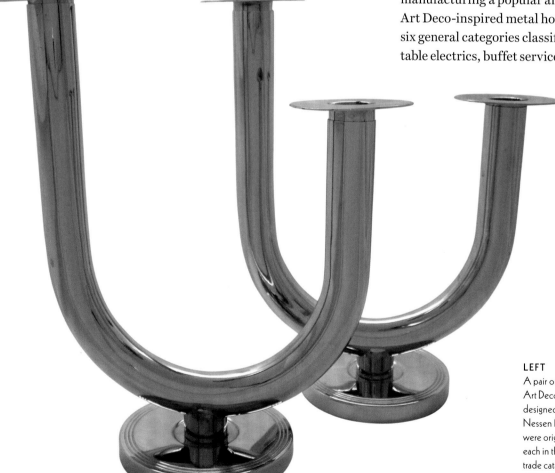

LEFT
A pair of "Taurex Uneven" Art Deco candlesticks, designed by Walter von Nessen for Chase. These were originally priced at $3 each in the 1930s Chase trade catalogue. 1934, 9¾in (25cm) high, **L**

OPPOSITE TOP RIGHT
A pair of copper and brass bookends in the form of spheres and circles by Walter von Nessen for Chase. c1933, 5¼in (13cm) wide, **L**

drinking accessories, smokers' articles, and miscellaneous. More than 500 types of objects were made, alongside an equal number of different lamps and lighting fixtures. All items are marked on the base with the distinctive centaur mark. Particularly sought after today are those by commissioned designers including Russel Wright, Rockwell Kent (1882–1971), and the German émigré Walter von Nessen (1889–1943), particularly known for his table and floor lamp designs. During the early 1940s the firm discontinued these lines, turning its attention to the wartime production of shell casings, gun barrel casings, and timing devices.

ABOVE
A "Pretzelman" in polished chrome by Chase. Novelty Art Deco tableware is among the most collectable today, but look out for dents and other damage. 1930s, 9in (23cm) high, **M**

ABOVE
A "Constellation" accent lamp designed by Walter von Nessen for Chase in 1933, in English bronze finish with a helmet shade pierced with stars and a white milk glass dome on a flared base, stamped "Chase". 8¾in (22cm) high , **L**

ABOVE
A four-piece tea service by Chase, of polished chrome with ribbed white plastic handles, comprising an electric tea kettle with original cord, creamer, and covered sugar bowl, and a circular tray, all marked. 1930s, 8 x 8in (20 x 20cm), **L**

COCKTAIL EQUIPMENT GALLERY

ASPREY & CO. ◊ E. & J. BASS ◊ CHASE ◊ GULDSMEDSAKTIEBOLAGET ◊ NAPIER ◊ REVERE

The craze for cocktails in the 1920s and 1930s represents the euphoric and frenzied party-going that countered the devastation and losses of the First World War. Cocktails surged in popularity in the early 20th century as the "cocktail party" emerged as a way to pass the time enjoyably and sociably between afternoon tea and dinner. The cocktail shaker was invented when an innkeeper realized that it was much easier to mix a drink by using a slightly larger glass over the top of a smaller one. It became a must-have bar accessory, and thousands of patented designs began to appear as people sought the perfect mixer.

In the 1920s' Prohibition era in the USA the cocktail became a way to stretch out a supply of illicit alcohol. In England, legendary barman Harry Craddock (1876–1963) popularized the dry martini at the Savoy Hotel, London, while cocktail shakers soon became a standard item in every home as well as in every bar. Companies such as the International Silver Corporation made luxury silver and silver-plated pieces for a wealthy elite. To meet wider demand, manufacturers mass-produced chrome-plated and Bakelite shakers and cocktail sets, advertised as needing "no polishing", often with brilliantly coloured ruby or cobalt glasses. Russel Wright, Norman Bel Geddes, and Lurelle Guild (1898–1986) were among the leading industrial designers creating streamlined modern forms, many inspired by the skyscraper. Novelty shakers, however, are among the most popular and collectable items today. These can be found in a huge variety of forms, from golf bags, bowling pins, and bells through to roosters, penguins, and other animals to aeroplanes and airships.

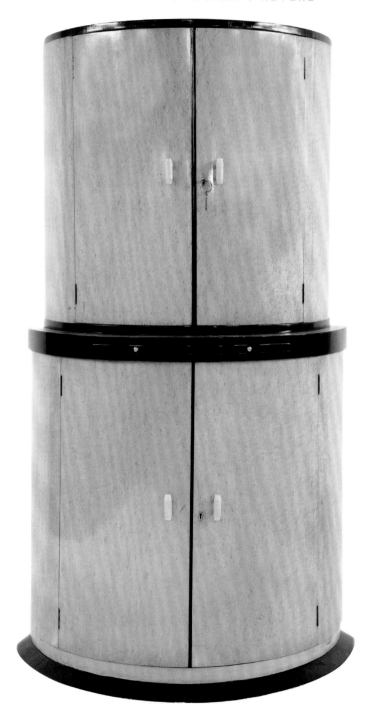

RIGHT
A bird's-eye maple cocktail cabinet, the top opening to reveal glass shelves and a mirrored back, with a fitted cupboard below. The fashion for cocktail parties influenced furniture and interior design as well as tableware and barware, and cabinets like this became essential for storing and displaying cocktail sets and drinks. 66in (168cm) high, **J**

A chrome "Empire" cocktail shaker by Revere, with hemispheric handle, and butterscotch Bakelite finial and stopper, with a stamped mark. This make of cocktail shaker is particularly rare today and difficult to find in good condition. c1938, 11in (28cm) high, **L**

A novelty "Zeppelin" cocktail shaker, the design attributed to A.J.A. Henckels, Germany, comprising various measures, a flask, and a strainer, stamped "made in Germany" (missing some pieces). The form of this shaker was inspired by the German airship *Graf Zeppelin*, the first commercial aircraft to cross the Atlantic (1928). 1920s, 12¼in (31cm) high, **L**

"The Thirst Extinguisher", a silver-plated cocktail shaker by Asprey & Co., with recipes for eight cocktails on the base of the shaker, stamped "A & Co., Asprey, London, Made in England 3212, regd no. 833773". c1932, 15in (38cm) high, **J**

An American "Blue Moon" cocktail set, designed by Howard Reichen for Chase, comprising 11 goblets with blue glass bowls, a cocktail shaker, matching tray, and four bottle coasters. The clean geometric lines and bold blue glass are typical of Art Deco cocktail sets. 1930s, **L**

An unusual and rare "Polar Bear" silver-plated metal cocktail shaker. Novelty pieces like this with angular lines and simple detailing are especially collectable today. The head removes and has a separate internal strainer. c1930s, 10in (25.5cm) high, **J**

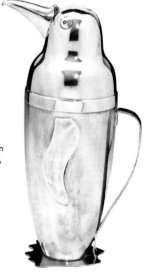

A silver-plated Art Deco cocktail shaker by Napier, in the form of a penguin. Mid 20th-century Modern reproductions of this highly sought after design can be identified by the lack of a hinged beak and the presence of a screw-on metal stopper at the end of the beak. c1936, 12½in (32cm) high, **K**

Harry Craddock, *The Savoy Cocktail Book*, first edition, published by Constable and Company, London. Craddock left Prohibition America to join the Savoy Hotel and became world renowned for his cocktails. This book has never gone out of print but a first edition is especially collectable. 1930, 7¾in (19.5cm) high, **M**

A cocktail shaker designed by Folke Arström (1907–97) for Guldsmedsaktiebolaget (GAB), Sweden, marked on the base "PRIMA NS". The austere forms of this shaker are particularly associated with Scandinavian design of the 1930s. 1935, 8¾in (22cm) high, **L**

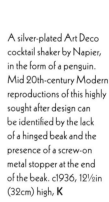

A rare Art Deco silver-plate nine-piece cocktail set by Elsa Tennhardt for E. & J. Bass Company, comprising six glasses, a shaker, ice bucket, and tray, marked "E.&J.B Pat. Apld For". c1928, tray 23¼in (59cm) wide, **E**

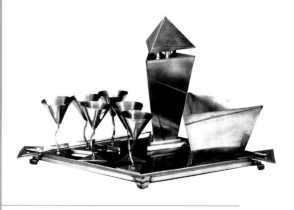

DESIGN MOVEMENTS GALLERY

HERMANN BAUER ◊ EDGAR BRANDT ◊ JEAN DUNAND ◊ LURELLE GUILD

The 1920s and 1930s were a period of experimentation for silversmiths and metalworkers in Europe and the USA as they sought to respond to consumer demand for fashionable wares. In the USA the vogue for streamlining, representing the vogue for travel and fascination with speed, appeared in soft curving or angular and elongated forms and horizontal banding, seen for example in the missile-shaped designs of Raymond Loewy (1893–1986) for desk accessories and Norman Bel Geddes for soda siphons, as well as futuristic-looking orb-shaped tea and coffee urns in silver and brass designed by Finnish-born architect Eliel Saarinen (1873–1950). Silver streamlined designs were produced by American manufacturers including Reed & Barton, International Silver, and Towle Silversmiths. Streamlined chrome pieces are generally widely available today and often at affordable prices, although hand-made studio pieces are more sought after than those made commercially.

Another trend of the period, especially in France, was for decorative work in non-precious metals, known as "dinanderie". Copper or brass vases and other wares with inlaid silver or with coloured lacquering in abstract and geometric patterns of diamonds and lozenges were a specialism of the Swiss designer Jean Dunand (1877–1942) and his apprentice Claudius Linossier (1893–1955). Dunand's techniques drew inspiration from Asian art, while other exotic motifs such as snakes – as, for example, on the floor lamp by Edgar Brandt (1880–1960), which has a stem in the form of an extended cobra – and sphinxes reflected the craze for African and ancient Egyptian art.

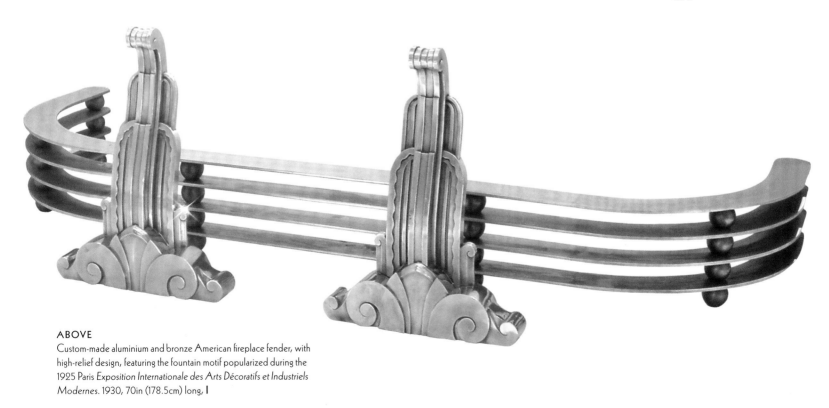

ABOVE
Custom-made aluminium and bronze American fireplace fender, with high-relief design, featuring the fountain motif popularized during the 1925 Paris *Exposition Internationale des Arts Décoratifs et Industriels Modernes*. 1930, 70in (178.5cm) long, I

A rare American coffee set designed by Lurelle Guild (1898–1986) for International Silver, silver-plated with ebonized handles and sleek profile with decorative finial. Guild was one of the pioneering American industrial designers to translate French Art Deco designs into American consumer products. He also designed a number of streamlined aluminium household items, manufactured from 1934. c1934, coffee pot 12in (30cm) high, tray 13in (33cm) diam, I

A silver mocca service by Hermann Bauer, with an original circular wooden tray, made by the Silver Ware Manufactory of Schwäbisch Gmünd, Germany. Characteristically for Art Deco silver, the handles are of cambered ebony-coloured plastic and the angular forms recognize the influence of streamlining. c1928, jug 8¼in (21cm) high, J

A lacquered brass vase by Jean Dunand, with a basketweave decoration and silver-plated ring at the mouth. Pieces by Dunand are especially in demand among collectors today, and the textured surfaces and rich tones of brown and red are particularly associated with his work. 1920s, 8½in (21.5cm) high, I

A pair of hand-wrought-iron paperweights by Edgar Brandt. Brandt is best known for his wrought-iron gates, grilles, and other architectural pieces, and these paperweights, in the form of a sculpted coiled cobra, are a particularly unusual design. Original pieces can be identified by the rich patina and weighty feel. c1925, 4¾in (12cm) high, I

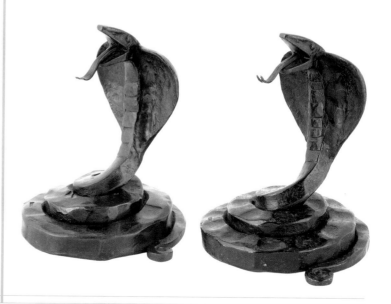

CAR MASCØTS GALLERY

BENTLEY ◊ BUICK ◊ FREDERICK BAZIN ◊ GEORGE COLIN ◊ JAGUAR ◊ RENÉ LALIQUE ◊ ROLLS-ROYCE ◊ R. VARNIER

Few objects better epitomize the sense of elegance, style, and luxury of the Art Deco era than the car mascot or hood ornament. The rapid expansion of travel by motor car, as well as by train, ship, and bus, was a feature of the 1920s and 1930s, but equally important was the image of the motor car as the embodiment of modernity, one that was propagated by the rise of highly sophisticated marketing techniques. Car mascots, often attached to the radiator cap, were a characteristic styling element of car design and were often used to represent the automobile company brand. Today these pieces are widely collected not just as representations of a marque but as works of sculpture in their own right.

The forms of car mascots are generally figurative – whether human figures, birds, or animals – and are of two main forms. A "factory mascot" is one that is fitted as standard by manufacturers of a particular vehicle, or a mascot approved by them and sold through their agents, for example the 1931 Buick figure of "Mercury", the leaping form of the eponymous Jaguar, or the famous "Spirit of Ecstasy" of Rolls-Royce. "Accessory mascots", on the other hand, were produced and fitted separately. Many accessory mascots were one-off ornaments designed and/or made by leading artists and designers, and are considered more collectable than factory pieces. Most ornaments were of nickel or chrome-plated zinc, but can also be found in brass, bronze, glass, pewter, and aluminium. Glass mascots were produced by Red-Ashay and Warren-Kessler in Britain and the Corning Glass Co., New York, but the best-known and by far the most valuable are the 29 different glass mascot types by René Lalique (1860–1945).

RIGHT
An "Archer" car mascot by René Lalique, of clear and frosted glass, with the moulded mark "R. LALIQUE". Lalique was responsible for designing and producing the first glass car mascot for the French Citroën company in 1925.
c1926, 4¾in (12cm) high, **J**

A "Sirene" mascot by George Colin, depicting a graceful nude with long hair rising from waves, her hands outstretched. This French nickel-bronze mascot is complete with its original green veined marble base display mount, which adds value. 1922–5, 7in (18cm) high, **K**

A rare "Tête de Paon no. 1140" clear and frosted glass car mascot by René Lalique. Lalique's glass mascots were made in a number of variations, with tinted and coloured examples being the rarest. This design of a peacock's head can also be found in an even rarer blue. c1928, 7in (18cm) high, **H**

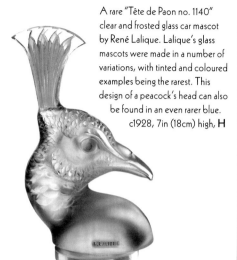

A Rolls-Royce Phantom 2/Silver Dawn car mascot. The famous "Spirit of Ecstasy" has been the mascot of Rolls-Royce since it was designed by the sculptor Charles Robinson Sykes (1875–1950) around 1910. Kneeling versions of the figure were also produced from 1934 to 1939. 1930s, 5¾in (14.5cm) high, **K**

A leaping gazelle car mascot, chrome zinc die cast, on radiator cap. This mascot is similar to those used on Chrysler cars. Chrome mascots are prone to denting, corrosion, and pitting, so examples in good condition command a premium. 6¼in (16cm) long, **M**

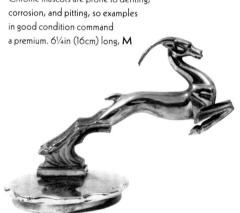

An American chrome-plated moulded angel car mascot, with red Lucite wings, from a Buick 48. This example unusually combines the characteristic synthetic plastics of the period, in this case the acrylic Lucite made by DuPont, with metal. c1950s, 7in (18cm) long, **L**

A Jaguar chrome-plated brass "Leaping Cat" car mascot, designed by Gordon Crosby (1885–1943), for small Mk10 and 2.4G Jaguar cars, stamped "7'24265'2WP". The form of a leaping jaguar caught in motion symbolizes the Art Deco fascination with speed. c1937, 5in (12.5cm) long, **N**

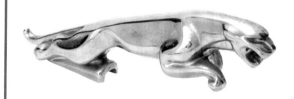

A "Bravoure du Chief Indien" French car mascot in the form of a Native American with a snake and hatchet. Attributed to the sculptor Frederick Bazin (1897–1956), this is one of the finest examples of its type. 1920s, 5½in (14cm) high, **K**

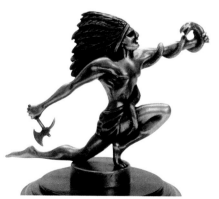

A 1930s large Bentley "B" car mascot, with swept-up wings. Bentley car mascots with two wings extending from the back of the B usually date from the 1930s and 1940s and are more common than those with one wing. 1930s, 5¼in (13cm) wide, **L**

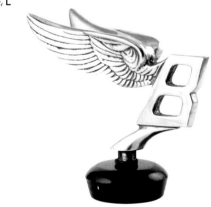

A nude mascot by R. Varnier, with a long, flowing headdress, and complete with a period cap. This stylish mascot is finished in silvered bronze. This is the largest of two sizes originally produced. c1920, 6¼in (15.5cm) high, **K**

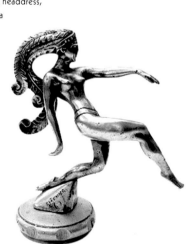

WROUGHT IRON GALLERY

EDGAR BRANDT ◊ WILHELM HUNT DIEDERICH

The interwar years represented the last great flowering of the art of decorative wrought ironwork. The greatest exponent of Art Deco ironwork was the Frenchman Edgar Brandt. Brandt's foundry, which he opened in 1902, was originally dedicated to the production of artillery mortars, but his financial success allowed him to experiment with decorative metalwork for interior and exterior uses.

Although Brandt's early work is in the Art Nouveau style, his later creations exemplify the Art Deco style in their use of richly textured metallic surfaces, incised lines, repeating metal patterns, and varied effects of colour by combining iron with brass, copper, silver, zinc, and nickel. As his popularity grew Brandt gained more commissions to create large-scale custom work for private houses and apartments, but he also produced smaller pieces such as light fittings and fire screens.

Another leading French ironworker was Raymond Subes (1891–1970), whose wrought-iron grilles, panels, and furnishings are characterized by scrolls and curls, and later in the 1930s by architectonic motifs such as stepped plinths and fluted columns.

Interest in Brandt's work spread to the USA, where the Hungarian-born Wilhelm Hunt Diederich (1884–1953) and Oscar Bach (1884–1957) were the foremost ironworkers in the early 1920s. Diederich created skeletal and elegant weathervanes, fire screens, and lighting in painted, patinated, or oxidized black iron, while Bach produced wrought- and delicate cast-iron architectural fixtures, sometimes partially gilded or of patinated gunmetal colour.

Because mild steel is cheaper and easier to mass-produce, wrought iron gradually disappeared. It is no longer produced on a commercial scale, but is still made for replication, restoration, and conservation of historical pieces.

LEFT
A French set of wrought-iron gates, with a typical Art Deco sunburst motif over diamonds enclosing circles and vertical stems, unmarked, and with a new black enamelled finish.
c1930, 97in (246cm) high, **H**

A French fire screen, attributed to Edgar Brandt, made of wrought iron with a polished and hammered finish. This piece has the Cubist rose design, popularized by Brandt in the early 1920s, and distinctive stepped fan detail at the top. Richly decorative smaller pieces by Brandt such as domestic lighting and screens are highly sought after by collectors. Early 1920s, 28½in (72cm) high, **H**

A pair of wrought-iron gates in the style of Wilhelm Hunt Diederich, with leaping hounds and stags in a stylized landscape, unmarked. Diederich's style of ironwork was noticeably lighter and more delicate than pieces produced in France. Silhouetted images of horses are also found in his work. 1930s, 62¾in (159cm) high, **H**

A pair of wrought-iron interior gates by Edgar Brandt, with a stylized water fountain and swirling stems of leaves and pierced flowers, above strings of vines. Abstracted fountain and flower motifs are particularly distinctive of Brandt's ironwork. This piece is stamped with his mark: "E. Brandt/France". c1924, 51in (130cm) high, **I**

A wrought-iron and bronze aquarium, unsigned. Aquaria were particularly popular in the 19th and early 20th centuries as elaborate parlour ornaments, and often placed atop lavishly carved tables or, like this piece, had a cast- or wrought-iron frame. The stylized bronze fish add an appealing decorative element. c1925, 15¼in (38.5cm) wide, **K**

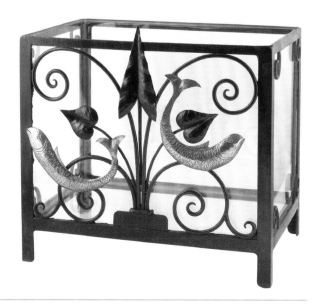

WARREN MCARTHUR & ALBERT CHASE MCARTHUR

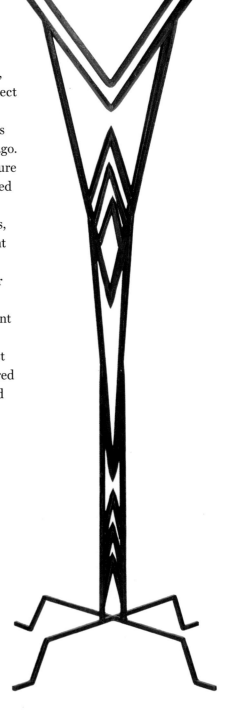

The brothers Warren McArthur (1885–1961) and Albert Chase McArthur (1881–1951) were responsible for one of the most distinctive unified interior designs of the American Art Deco period, the Arizona Biltmore, in Phoenix, Arizona, which opened in 1929. Along with their brother Charles, Warren and Albert were surrounded by Modernist design at an early age, as their father, Warren McArthur Senior, had commissioned the renowned architect Frank Lloyd Wright (1867–1959) to design their house in Chicago.

Warren studied mechanical engineering at Cornell, graduating in 1908. One of his early patents for lamp designs is still in production by the Dietz Lantern Co. in Chicago. He moved to Phoenix in 1913 to work with Charles, and later moved his metal furniture business to Los Angeles. With financial support from their father, the brothers created innovative methods of standardized assembly and a durable metal-dying technique for tubular aluminium furniture. They produced an extensive range of lounges, sofas, tables, and stands with decorative grids and overlaying bars, and upholstery in bright contrasting colours such as red, black, and yellow.

Having trained (though never graduated) as an architect, Albert Chase McArthur worked with Frank Lloyd Wright between 1907 and 1909, opened his own firm in Chicago in 1912, and then moved to Phoenix in 1925. There, with Wright as consultant and collaborating with his brothers, he worked on his most important architectural design, the Arizona Biltmore Hotel. It was erected entirely from pre-case blocks, first used by Wright to build private homes, cast in 34 different geometric patterns inspired by the trunk of a palm tree. These patterns carried through to the interior design and original furnishings, which were later removed from the hotel.

RIGHT
A monumental Art Deco wrought-iron fern stand for the lobby of the Arizona Biltmore Hotel, by Warren McArthur and Albert Chase McArthur, unmarked. c1928, 30in (76cm) high, **J**

DONALD DESKEY

Donald Deskey (1894–1989) was one of the pioneering American industrial designers of the 1930s, working in a variety of media. Born in Minnesota, he studied architecture and fine art in California. In 1925 he visited the Paris *Exposition Internationale* and became familiar with European Art Deco, meeting designers from the Bauhaus School in Germany and the De Stijl movement in the Netherlands. From the late 1920s he collaborated with furniture designers and manufacturers in New York, producing screens and cabinetry in lacquered and metallic finishes with brightly coloured zigzag designs.

At the American Designers' Gallery in 1928, Deskey exhibited his "Man's Smoking Room" as one of a number of complete room settings. Both the decoration and objects displayed within it featured strong horizontal and vertical lines and geometric and rhythmic forms, such as a jazzy sawtooth-shaped lamp in chrome-plated steel and glass. From the late 1920s and 1930s he collaborated with manufacturers such as the International Silver Company in Meridien, Connecticut, where high-quality silver and plated objects were mass-produced to his designs. He also worked on chromium-plated and steel furniture for Ypsilanti Reed Furniture Co., and on iron and brass fireplace sets for Bennett Co. Deskey is best known, however, for his Art Deco designs for the furnishings and interiors of Radio City Music Hall, New York (1932).

The firm that he established, Donald Deskey Associates, continued after the Second World War to work in industrial design, including packaging for Proctor and Gamble (1949–76) and office furniture for the Globe-Wernicke company (1948–54). He also was responsible for lamp post design no. 10, the standard streetlight still in use in New York City.

FAR LEFT
A pair of aluminium and enamelled steel andirons by Donald Deskey, unmarked. The striking vertical lines are typical of Deskey's designs. 1930s, 17¾in (45cm) high, **I**

LEFT
A five-piece brass and cast-iron fireplace set consisting of andirons, a fire screen, poker, and brush, designed by Donald Deskey for Bennett Co., the andirons stamped "Bennett". c1940s, 19½in (49.5cm) high, **K**

FIGURAL CLOCKS GALLERY

PIERRE FARGETTE ◊ JOSEF LORENZL

The style and form of many Art Deco clocks represented the popular fashion for bronze figural sculpture, at a time when new methods of serial production had enabled founders to manufacture smaller bronzes at more affordable prices for a mass market. The most popular subjects were women, often in dancing poses, engaging in sports, or representing exotic figures or those from classical mythology. Animals such as panthers, antelopes, and gazelles also reflected the contemporary fascination with African and Asian art.

Most Art Deco figural clocks are of the mantel clock type, designed to be displayed as a statement ornament on a mantelpiece, and a huge variety were produced, especially in France. As well as bronze figures, Art Deco French clocks are made with materials including onyx, marble, silver, copper, spelter, and exotic stones such as jade and malachite. They are usually in a more elaborate style than those from elsewhere, and consequently more expensive. Particularly valuable today are those clocks that feature bronze figures by well-known sculptors of the day. Of these, the most famous was the Austrian Josef Lorenzl (1892–1950); his pieces command high prices and are sought after by collectors worldwide. His bronze, spelter, or bronze and ivory figures are generally nude or semi-clad women, caught in animated or acrobatic poses, and often holding props such as fans. They were frequently made in various sizes. Other leading sculptors producing figures for clocks included Georges Benoit of Paris, who specialized in animal subjects.

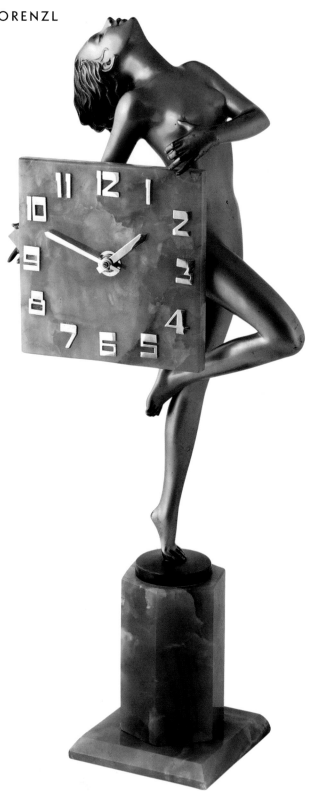

RIGHT
A large bronze figure modelled holding a clock on an onyx base, by Josef Lorenzl. This clock has the sculptor's standard signature "Lorenzl" in the bronze, although he also used abbreviations of his name, "Lor" or "Enzl", and many pieces were unsigned. c1930, 21¼in (54cm) high, **I**

A rare French mantel clock by Pierre Fargette, with gilded bronze stylized floral decoration, silver sunrays, and nude copper relief on an onyx base, signed on the back. Fargette exhibited at the 1925 *Exposition Internationale* in Paris and was known for his lighting designs. The sunrays are a classic Art Deco motif. 1920s, 13in (33cm) high, **H**

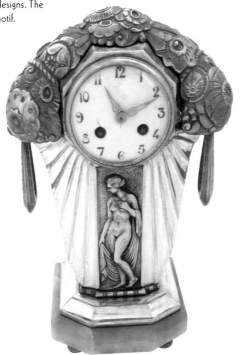

A malachite, jade, and enamel mantel clock, probably French, with a green engine-turned enamel face and angular plinth with carved jade phoenix birds to either end. The use of richly coloured stones and engine-turned enamel are a distinctive feature of the luxurious style of French Art Deco clocks. c1930, 14¾ in (37.5cm) wide, **K**

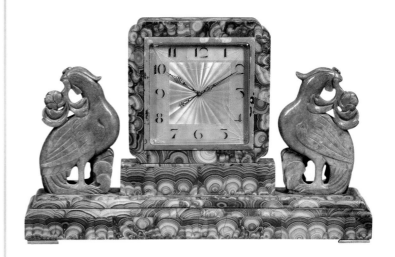

A spelter and alabaster mantel clock. Spelter was a less expensive alternative to bronze for figural clock sculpture. Clocks in this material are not as valuable today as those made in bronze, but the angular forms, alternating colours, and stylized numbers on the clock face give this piece decorative appeal. 18½in (47cm) wide, **L**

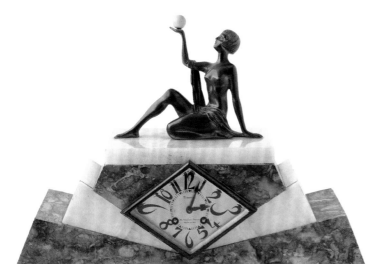

A French onyx mantel clock, mounted with two antelopes with ivory horns, the pentagonal dial inscribed "Feunten, Brest", chiming half-hourly. The antelopes represent the contemporary fascination with African art, which was widely collected and imported into Europe in the 1920s and 1930s. 21¼in (54cm) wide, **L**

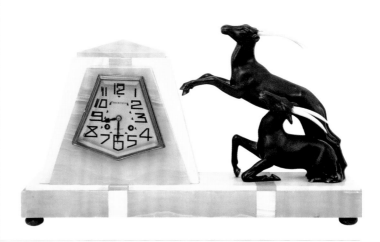

ØTHER CLØCKS GALLERY

CARTIER ◊ GENERAL ELECTRIC ◊ GÉRARD SANDOZ ◊ SIMONET ET DIEUPART ◊ TELECHRON ◊ TIFFANY FURNACES ◊ ZODIAC

Art Deco clocks represent the full range of the period's design influences and also include the latest technological innovations, for example, electric clocks for domestic use. The finest craftsmanship in clockmaking was found in France and Switzerland. The French were the leading producers of mantel clocks in marble, onyx, brass, and chrome, often with figural sculpture or with classical motifs, like columns. Both French and Swiss makers – notably Arthur Imhof – combined synthetic plastics (Bakelite and Lucite) with traditional materials such as bronze and glass and new metals including chrome to create colourful contrasts.

In the USA, companies such as Ingraham, Seth Thomas, Waltham, and Telechron (a subsidiary of General Electric), mass-produced Art Deco clocks for the home. Both Seth Thomas and Telechron made use of Catalin plastic for geometric cases. Waltham clocks were often framed in alternating bands of marble or jade.

The prominent industrial designers Walter Dorwin Teague (1883–1960) and Raymond Loewy created clock designs for General Electric and Westinghouse respectively. Loewy's design of the "Columaire Jr" combined clock/radio was a tall, slender form and was later widely imitated. Novelty designs were particularly popular in this period, with Bakelite and nickel clocks in the shape of an aeroplane especially favoured in the USA. Vitascope clocks, first patented in 1941 and with distinctive curved Bakelite cases, had a recessed compartment above the dial to house an illuminated diorama of a ship.

RIGHT
French gilded bronze and enamel clock by Simonet et Dieupart. The sculptor Henri Dieupart (1888–1928) is best known for his work with Simonet Frères on moulded glass vases and lamps, and clocks such as this are a particularly rare example of their collaboration. c1925, 11½in (29cm) high, **H**

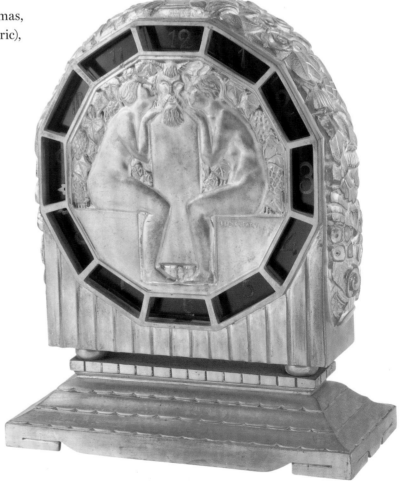

THE SIGNATURE MARK
Signature of the sculptor Henri Dieupart
on the clock shown right.

A clock by Tiffany Furnaces, featuring an enamel pattern set against a gold doré finish, signed on the clock face and underside, the mechanism signed "Chelsea Clock Co.", with a key. Patinated bronze versions of this clock are also found. 5½in (14cm) high, **H**

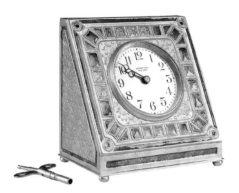

A French "Shutter" watch, designed by Gérard Sandoz, in sterling silver with eggshell lacquer and black geometric enamel decoration, Swiss movement by Otomato and 18-carat gold numerals. The clock face is revealed by depressing the ends of the watch. c1930, 1½in (4cm) high, **I**

A "Circe" alarm clock by General Electric, model 7H92, with a stylized floral medallion to the reverse-painted arched glass face, on a stepped chrome base, and with die-stamped marks. The use of chrome was common in American Art Deco clocks. 8in (20cm) wide, **L**

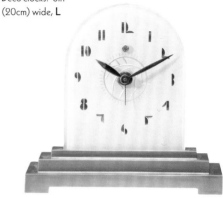

A rare table clock by Cartier, with one diamond rhomb, in rose quartz, onyx, and enamel, with a striped lever movement, inscribed "Geneva Clock Co.", the movement numbered 23652, in a fitted case. Cartier clocks of the Art Deco period are among the most outstanding and valuable examples found today. c1930, 3½in (9cm) wide, **E**

A circular bronze eight-day mantel clock by Zodiac on a rectangular plinth. A clock with an eight-day movement is one that requires winding only once a week, as opposed to less expensive 30-hour clocks that had to be wound every day. 11½in (29cm) high, **K**

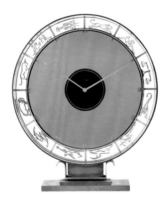

A green Catalin electric clock by Telechron, with an alarm and a light bulb set inside the silvered ring around the dial, designed by Paul Frankl (1886–1958) and made by the Warren Telechron Co., Ashland, Massachusetts. Frankl was one of America's leading furniture designers and an exponent of the celebrated "skyscraper" style, as seen in this clock. 19½cm (49.5cm) high, **L**

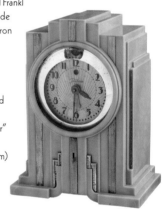

A German sub-miniature carriage clock, with a light blue guilloché enamel and silver case and an eight-day three-quarter plate movement with lever escapement, fully marked on the case and numbered. Carriage clocks with their original travelling case will fetch a premium. c1925, 1½in (4cm) high, **J**

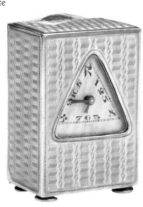

A Modernist clock, of black glass on a clear glass base, with chrome numeral marks, hands, and a square face holder. The abstract lines instead of numerals give this clock a particularly striking appearance and contemporary appeal. 1930s, 7¼in (18.5cm) high, **J**

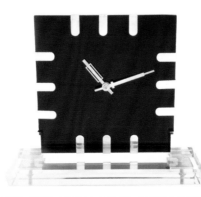

A French mantel clock, with a brown marbled stone stand and base, mounted in a patinated brass frame with stylized floral decor, 14-day movement striking on a silver bell on the half hour, and complete with a pendulum and key. c1925, 14in (35.5cm) high, **J**

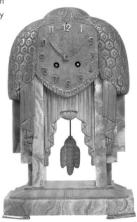

PLASTICS GALLERY

BAKELITE ◊ CORONET ◊ DUNLOP ◊ VENT-AXIA

Durable, inexpensive, adaptable, and colourful, new synthetic plastics suited to batch- or mass-production revolutionized mass consumption from the early 20th century and helped to make the Art Deco style affordable for all. Synthetic plastics such as celluloid had been invented in the 19th century but it was the invention of Bakelite by the Belgian chemist Leo Baekeland (1863–1944) in 1907 that ushered in the new plastic age. A type of resin that set hard on heating, it could be moulded under pressure into complex shapes. Other new plastics included Catalin, a phenol formaldehyde that could be cast into long rods, then sliced, cut, or polished.

Many early applications of plastics simply involved replacing traditional materials, such as exotic woods, ivory, or ebony, for example, for the handles of drawers and of tea and coffee urns. Eventually, however, industrial designers – such as Henry Dreyfuss, Walter Dorwin Teague, Wells Coates (1895–1958) and Norman Bel Geddes – began to exploit the inherent durability and flexibility of coloured plastics to generate new forms for many different types of products, jewellery, desk accessories, tableware, and especially radios. Bakelite, for instance, was marketed as the "material of a thousand uses". Their low cost helped manufacturers to meet demand for innovative product designs during an age of economic depression. By the end of the Second World War other plastics, including Perspex, polythene, and polystyrene, had been developed and became available on a much wider scale for commercial and industrial uses and for the production of larger objects such as furniture.

BELOW
A group of miniature "Midget" cameras by Coronet, with different coloured mottled Bakelite bodies, each with a leather flip case (not shown). Most "Midget" cameras are found in black and brown – brighter Art Deco colours such as blue are more sought after and valuable. c1935, each 2½in (6cm) high, **M** each

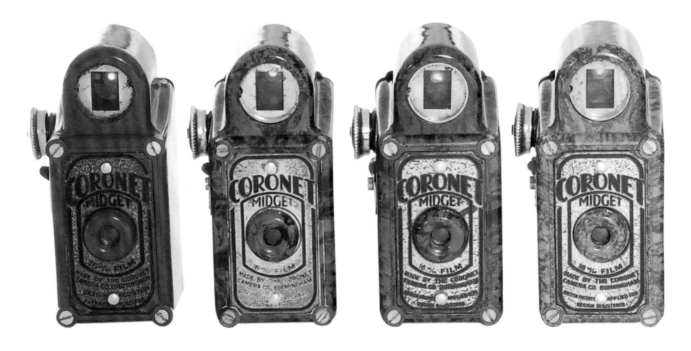

A rare green acrylic and black Bakelite ink stand. Desk accessories were among the many popular items produced in the new plastics in simple moulded forms in the Art Deco period. 1940s, 6½in (16.5cm) wide, **M**

A set of six Australian pale blue Bakelite kitchen canisters. A full set of these canisters in blue is extremely rare, although separate pieces can be found. Plastic was ideal for tableware as, being inert, it did not alter the taste of the food or the drink that it contained. 1930s, largest 9½in (24cm) high, **M**

A Bakelite wood, chrome, and metal desk fan, made by Vent-Axia, registered nos 442469, 429958. Vent-Axia was a pioneering company responsible for the invention of the first electrically operated window ventilator in 1936. 1940s, 13in (33cm) high, **M**

A urea-formaldehyde plastic ashtray for the *Queen Mary*, one of the most famous ocean liners of the period. This piece combines the simple geometric forms and new materials so distinctive of the Art Deco period. Marked "British Buttner Product". 1930s, 4½in (11.5cm) wide, **M**

A phenolic resin plastic design "Cleopatra" box with green lid and black base. The name of this piece reflects the craze for all things ancient Egyptian in the Art Deco period, following the discovery of Tutankhamun's tomb in 1922. 1930s, 3¼in (8cm) high, **M**

A Dunlop Rubber Co. ashtray, manufactured by Roanoid Ltd, with folding black Bakelite cigarette rests and base, and mottled green and cream urea formaldehyde top. The black cigarette rests fold back inside to make a complete sphere. Mid 1930s, 5in (12.5cm) diam, **N**

A rare brown Bakelite combination clock and bedside table lamp. The revolving shade has numbers and a fixed marker to indicate the time, and with an indistinct registration number to the base. 1920s–1930s, 13in (33cm) high, **M**

A "Bandalasta" ware Bakelite Art Deco tea set, with cup and saucer. "Bandalasta" refers to a series of plastic wares made from a synthetic resin discovered and developed by British chemists in the 1920s and produced by an English firm, Brookes and Adams.1930s, teapot 6¾in (17cm) wide, **L**

A rare jade green GPO 200 Series Bakelite telephone. These telephones are found mainly in black and so other colours are more sought after. These classic vintage pieces from the earliest age of mass communication, with traditional cord and rotary dial, are now highly collectable. **K**

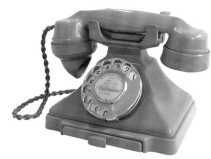

RADIO SET GALLERY

BENDIX ◊ EKCO ◊ FADA ◊ INTERNATIONAL RADIO CORPORATION ◊ SPARKS–WORTHINGTON

The invention of radio was one of the great technological advances of the modern age, and Art Deco radio sets still today evoke the progressive spirit and utopian ideals of industrial design, technology, and manufacture of the 1920s and 1930s. From 1894 the Italian inventor Guglielmo Marconi (1874–1937) built the first complete wireless telegraphy system based on radio transmission and established a company to develop and produce radio communication services and equipment. The first public radio broadcasting stations were launched in the USA in the 1920s and soon spread around the world.

As manufacturers had no other reference point for this new medium of communication, early radio sets were made of wood and their cases derived from traditional furniture forms. However, manufacturers such as Fada, E.K. Cole, Emerson, Philco, and Zenith soon adopted synthetic resins and plastics such as Bakelite, Catalin, and Plaskon, as these could be dyed and coloured, and moulded in single pieces, eliminating the need for hand assembly.

Simplified forms and motifs were preferred as they required less work to produce than intricate ones, although decorative speaker grilles – slotted, round, square, or other shapes – were often overlaid with typically Art Deco designs, such as stylized leaves and trees or geometric patterns. Tuning knobs, dial parts, and handles were commonly made separately in a contrasting colour.

The moulded plastic radio sets of the 1920s and 1930s can be either vertically orientated, inspired by skyscraper forms; horizontal, with rounded corners and edges; or curvilinear, reflecting the American fashion for streamlining. Condition is all important when collecting Art Deco radio sets as the coloured plastic or resin cases have frequently been damaged or have faded over time.

LEFT
An AC97 black Bakelite radio by Ekco, with chrome and ivory Bakelite detailing and original grille cloth. This radio was made by E.K. Cole of Southend-on-Sea, one of the leading British manufacturers of radios and Bakelite cabinets.
1937, 21in (53.5cm) high, **L**

A Bakelite radio, with four valves and a replacement grille cloth. The ridged parallel lines extending over the front and top of this radio evoke the forms of Art Deco architecture. c1934, **M**

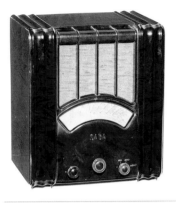

A butterscotch and blue Catalin radio by Fada, with ribbed knobs. This model was the first radio produced in Catalin, a synthetic resin developed in about 1927 when the patent for Bakelite expired. 8in (20cm) wide, **M**

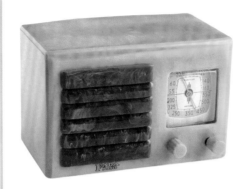

An RS3 Bakelite radio by Ekco, with a circular speaker and fret-cut mounted. Speaker grilles were often made of decorative or figurative fretwork to enhance the set's decorative appearance. c1931, 18in (45.5cm) high, **L**

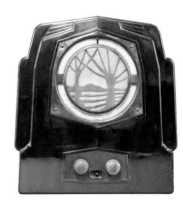

A model 1000 "Bullet" radio by Fada, in butterscotch Bakelite with handle, circular dial, and ribbed knobs, marked "Fada" on the dial and with a Fada paper label. The set's curvilinear form echoes that of streamlined trains and planes. 1940s, 10¼in (26cm) wide, **L**

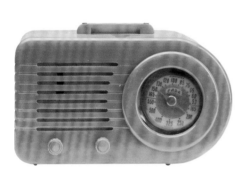

A Type A.D.75 radio receiver by Ekco in a circular Bakelite case, designed by Wells Coats (1895–1958). The clean, geometric lines he had pioneered in an earlier variation of this design in 1932 were highly influential on radio design. 1940s, 14in (36cm) diam, **L**

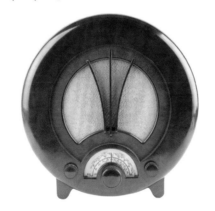

A "Kadette Jewel" radio set by International Radio Corporation (IRC) in red Catalin, with a clear Lucite fretwork grille. The "Kadette", made by IRC, founded in Ann Arbor, Michigan, in 1931, was the first mass-produced line of AC/DC radios. 1930s, 7in (18cm) wide, **L**

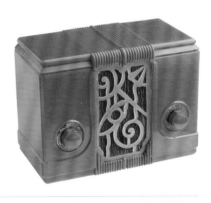

A Sparton Model 557 "Sled" Radio, with three knobs, square dial, blue mirrored glass-covered case, chromed horizontal slats, and an ebonized wood base, lacking back. Designed by Walter Dorwin Teague for the Sparks-Worthington Company of Michigan, this radio is highly sought after as one of the best examples of the streamlined style. 1936, 17in (43cm) wide, **K**

A model 526C jade green marbled, white, and black Catalin radio by Bendix. First produced in October 1945, this model was the first domestic radio manufactured by the Bendix Aviation Corporation, which had previously specialized in military avionics. 1945, 11in (28cm) wide, **M**

A model L56 blue and butterscotch Catalin radio by Fada. The luxurious marbled tones of the Catalin resin are characteristic of the way plastics were exploited to imitate more expensive materials, such as tortoisehell, alabaster, and ivory. c1939, 9in (23cm) wide, **M**

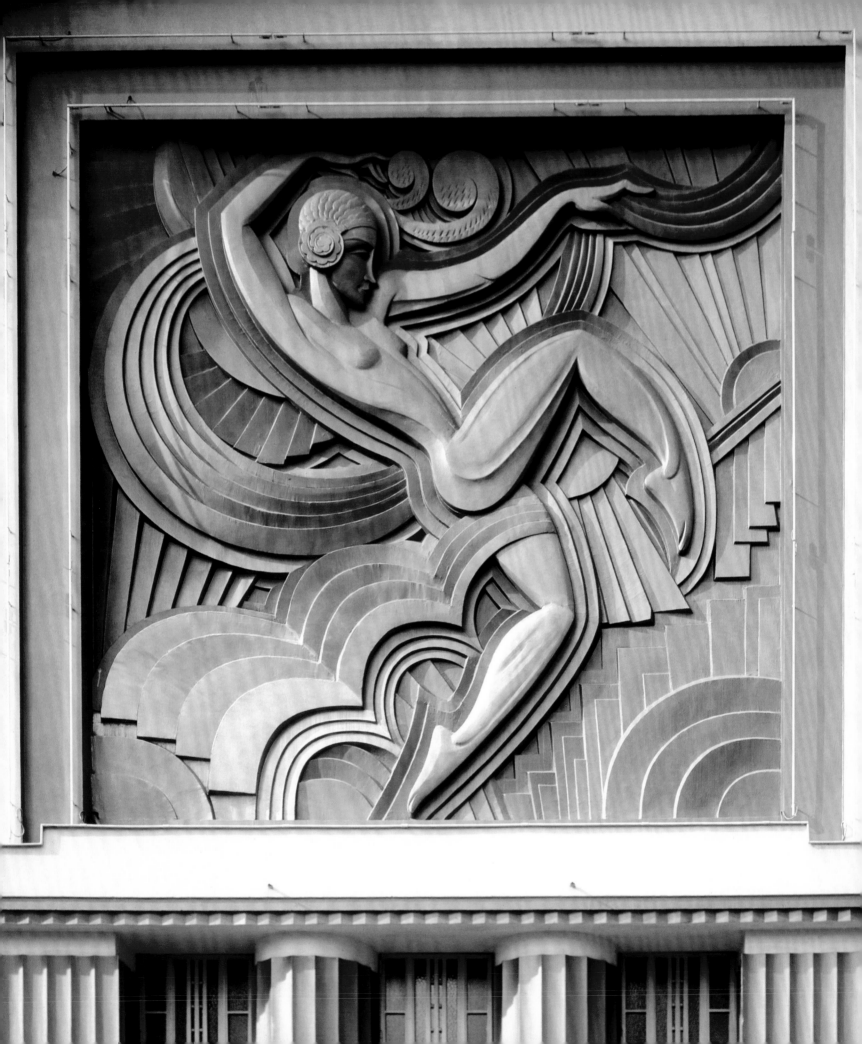

— CHAPTER FIVE —

SCULPTURE

BRONZE AND IVORY

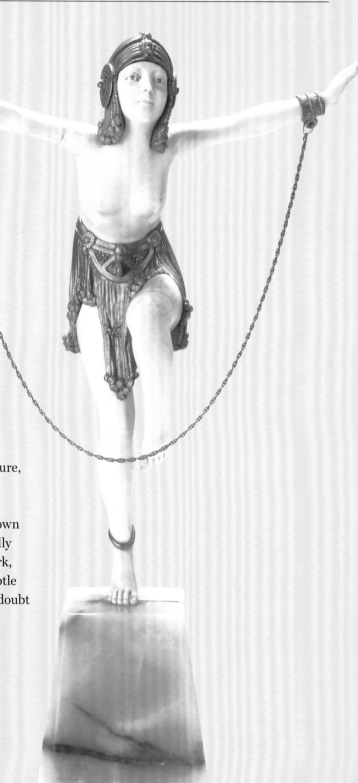

ew works of art synonymous with the Art Deco era epitomize the style in such dramatic and artistic terms as the superb figural ivory and bronze sculptures of the period. The masters of the art, including Demetre Chiparus, Ferdinand Preiss, and Bruno Zach, produced some of the most iconic examples of the genre, yet their use of these combined materials was nothing new.

The term "chryselephantine" is generally used to describe these exemplary composite creations. In fact, the word stems from the ancient Greek and was used to delineate statues fashioned from gold and ivory. Such figures – typically found in temples – would have been constructed in a complicated kit-like way with other materials such as glass, jewels, and other metals, used as part of their overall decoration. The tradition of mixing materials in sculpture can historically be traced throughout many different cultures and is particularly prevalent in the fine tradition of Japanese *Okimonos* and also in the 19th-century German and Austrian custom of fashioning figures from silver and ivory – particularly in the medieval style.

As a continuation of this practice and to the evolution of bronze sculpture, eminent exponents of the art such as Albert-Ernest Carrier-Belleuse (1824–1887), who worked through such trends as the 19th-century Neo-Baroque to the advent of Art Nouveau, clearly illustrate how the well-known up-and-coming champions of the elegant, lithe, enigmatic, and beautifully stylish bronzes of the Art Deco period gained their inspiration. Their work, based upon the artistic and technically proficient juxtaposition of the subtle softness of ivory and the demonstrative hardness of bronze, has without doubt led to the creation of many of the most iconic creations of any design era.

RIGHT
"Chained Dancer" by Demétre Chiparus, a carved ivory and bronze figure of a dancer wearing handcuffs joined by a long brass chain. Gold painted, mounted on a base of light green onyx. c1925, 12½in (31.5cm) high, **F**

OPPOSITE
Vaslav Nijinsky in costume as the Golden Slave in *Scheherazade*, c1910. Having achieved great success as a soloist in St Petersburg and Moscow, Nijinsky joined Sergei Diaghilev's Ballets Russes in Paris in 1909. *Scheherazade* was created specifically for him by Michel Fokine, the company's choreographer.

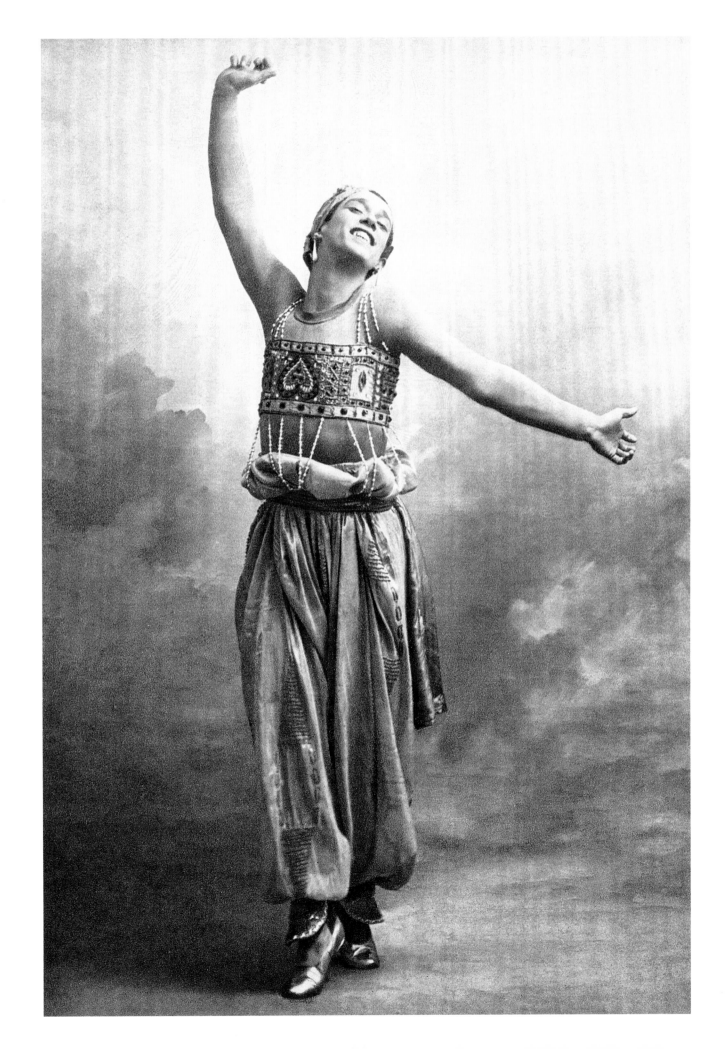

FERDINAND PREISS

The name of Ferdinand Preiss (1882–1943) is synonymous with some of the finest ivory carving of the early 20th century. Born in Erbach, Germany, Preiss was apprenticed to the renowned ivory carver Philipp Willmann (1846–1910), his maternal uncle. In 1901 he travelled throughout Europe, continuing his studies and earning his living as a designer and modeller. Fortuitously, he met Arthur Kassler and together they formed the company Preiss & Kassler, with Kassler taking responsibility for the commercial side of the business, leaving Preiss to concentrate on the artistic production.

Initial output centred on small ivory carvings, mainly of children, classical nudes, or religious subjects and was rewarded with moderate success. However, Preiss had greater ambitions and in 1910, in association with the Gladenbeck foundry of Berlin, the first combination figures of bronze and ivory (chryselephantine) were created. Most were of classical maidens, Neo-Tadema in style, and mounted on marble or onyx plinths. Variations included figural bookends and clocks and it seemed – at last – that the firm had found its true niche. Within a few years "P&K" employed six skilled ivory carvers with a large proportion of exports going to the UK, USA, and Russia.

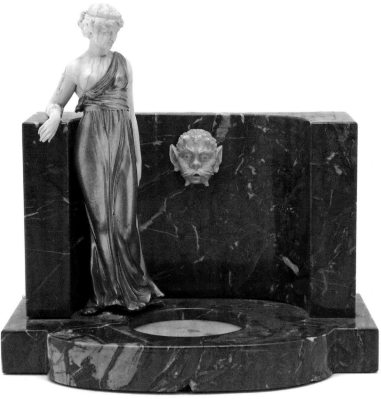

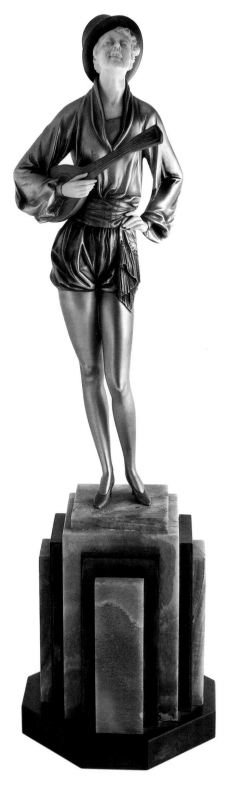

LEFT
"The Spring" by Ferdinand Preiss, a gilt-bronze and ivory classical female figure standing beside a fountainhead, mounted on marble. c1925, 6½in (17cm) high, **I**

RIGHT
"Champagne Dancer" by Ferdinand Preiss, a bronze and ivory figure, enamelled in black and signed in the plinth. c1930, 16½in (42cm) high, **H**

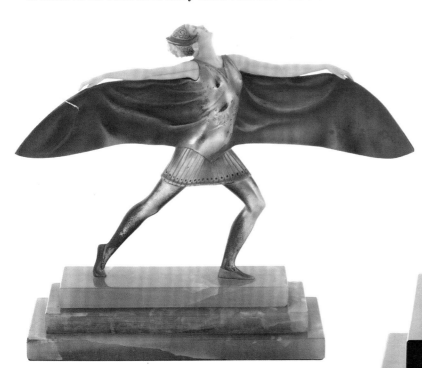

The outbreak of the First World War led to the closure of the factory. When it reopened in 1919, shortages of ivory, non-existent foreign trade, and economic difficulties meant Preiss & Kassler had to be resourceful to continue trading. The expensive figures were replaced by smaller items such as jewellery carved from ivory billiard balls, which – by all accounts – were purchased from hotels.

During the economic upturn of the 1920s, Preiss & Kassler produced some of its most iconic work. Preiss's artistic skill led to an indisputable series of superlative naturalistic figures depicting women in sporting, dancing, or theatrical poses. The sporting figures were particularly popular around the time of the 1936 Berlin Olympics. Preiss died in 1943 but his reputation as a master of his art lives on in the beauty of his consummate creations.

ABOVE
"Bat Dancer" by Ferdinand Preiss, a cold-painted bronze and ivory figure, signed "F. Preiss", on a stepped rectangular green onyx base. c1925, 9¼in (23.5cm) high, **I**

RIGHT
"Flame Leaper" by Ferdinand Preiss, an exceptional cold-painted bronze and ivory figure of a girl leaping over flames, on a stepped black marble base incised "F. Preiss" and "Les Annees Folle". c1925, 13¾in (35cm) high, **F**

DEMÉTRE CHIPARUS

Born in Romania, Demétre Chiparus (1886–1947) travelled to Italy in 1909 and attended classes at the Florence studio of Raffaello Romanelli (1856–1928); in 1912 he moved to Paris to study at the École des Beaux-Arts under Antonin Mercié (1845–1916) and Jean Boucher (1870–1939). His early sculptures were realistic in style, notably of young girls and children; his first series of figures was exhibited at the Paris Salon of 1914. He went on to exhibit there in 1923 and 1928.

Chiparus's distinctive style is characterized by the constant use of detail. His unerring application of finely patterned surface casting and decoration originated in his work at the beginning of the 1920s and evolved throughout the decade. This was the decadent Jazz Age and avant-garde Paris was shamelessly at its centre. Sergei Diaghilev (1872–1929) had already caused a sensation with his inaugural Ballets Russes in 1909, after which the fascination for all things Russian seemed de rigueur. Chiparus was no exception and found inspiration from the dancers and their exotic, extravagant bejewelled costumes designed by the visionary Léon Bakst (1866–1924). Some of the sculptures show a close resemblance to the leading Russian dancers, such as Vaslav Nijinsky (1889–1950) and Ida Rubinstein (1883–1960), both in the features and decoration of the costumes.

Chiparus's figures eloquently catch the 1920s' glamour and spirit of the dancers, with their elaborate, exotic, pearl-encrusted costumes and striking poses encapsulated in his virtuoso frozen sculptural moments.

These theatrical influences and notably the sexually liberated French revues, such as the Folies Bergère, were a natural source of inspiration for the artistic fraternity. This was also a time of great discovery and the unearthing of Tutankhamun's tomb by Howard Carter (1874–1939) in 1922 fuelled a fervour for everything Egyptian. Chiparus fell under the country's spell too and subjects such as "Cleopatra" and Egyptian dancers were undoubtedly created as a result of this mania.

RIGHT
"Semiramis" by Chiparus, a silvered and enamelled bronze and ivory figure of a revue dancer, signed "Chiparus", with J. Lehman foundry stamp, on an onyx and marble base. c1925, 26 in (66cm) high, **A**

The modelling of such figures is of the highest quality. They were cast primarily at the Parisian foundry of Edmond Etling & Cie and secondly by Les Neveux de J. Lehmann. The exceptional quality of the finishes is also carried through into the bases, which often combined a variety of sculpturally arranged onyx and marble thus forming an integral part of the finished work. Production at the bronze foundries halted during the Second World War, during which time Chiparus continued sculpting, mainly animals in the Art Deco style, some of which were exhibited at the Paris Salons of 1942 and 1943. He died in 1947 and is buried in Bagneux Cemetery, south of Paris.

RIGHT
"Bal Costume" by Chiparus, a patinated bronze and ivory figure group of a couple in theatrical costumes, signed "DH Chiparus" and with "Etling" foundry mark. c1925, 19¼in (49cm) high, **E**

FAR RIGHT
"Antinea" by Chiparus, a cold-painted and patinated bronze and ivory figure of an Egyptian dancer, on an onyx and marble base, signed "DH Chiparus" and with "Etling, Paris" foundry mark. c1928, 26½in (67cm), **NPA**

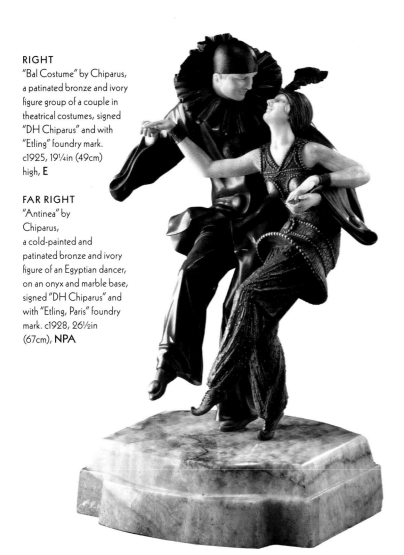

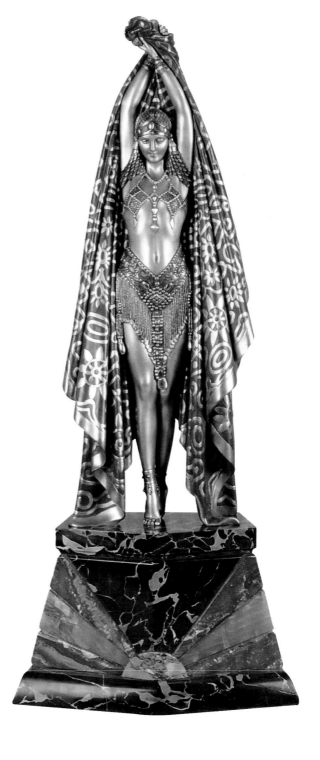

PIERRE LE FAGUAYS

A prolific sculptor, Pierre Le Faguays (1892–1962) worked in many mediums, including stone, marble, terracotta, wood, alabaster, and ivory, as well as bronze. He also created designs for Arthur Goldscheider's "La Stele" label.

Le Faguays was born in Nantes, France, and studied at the Beaux Arts in Geneva where he became friends with fellow students and sculptors Marcel Bouraine (1886–1948) and Max Le Verrier (1891–1973), who sculpted in distinctly similar styles. Le Faguays' skill enabled him to work in a number of different styles and he became particularly celebrated for his sculptures of dancers, many of which were inspired by the classical mould-cast Greek terracotta figures of Tanagra.

The Art Deco pieces often depict dancers or slave girls – sometimes mounted with alabaster urns as light fittings – which are particularly sought after by collectors. Le Faguays' female figures are lithe and willowy and are found both nude and semi-nude. Notably, unlike many of his contemporaries, he sculpted both male and female figures. The male figures are often historically inspired and have a homoerotic quality to them, showing a great deal of attention to muscular detail and anatomical accuracy. Archers and spear throwers emphasize a sense of suspended tensile strength in his sculpture and one can almost imagine the moment at which the arrow is released.

Works are primarily in bronze: either patinated or cold-painted, and less commonly bronze and ivory. Most works are signed "Le Faguays" but he also used the pseudonyms "Fayral" and "Guerbe" (the family names of his mother and wife). Many

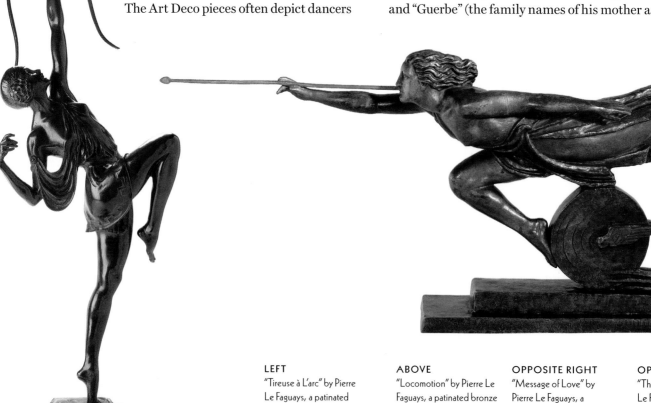

LEFT
"Tireuse à L'arc" by Pierre Le Faguays, a patinated bronze figure of a female Grecian archer drawing her bow, signed "Le Faguays" with Suisse Frères foundry mark. c1925, 25½in (65cm) high, **K**

ABOVE
"Locomotion" by Pierre Le Faguays, a patinated bronze female figure on a winged wheel, signed in the bronze. 1930s, 26in (66cm) wide, **J**

OPPOSITE RIGHT
"Message of Love" by Pierre Le Faguays, a patinated bronze figure of a nude girl releasing a dove from the palm of her hand, on a black marble base, signed "Le Faguays". c1930, 30in (76cm) high, **I**

OPPOSITE FAR RIGHT
"The Archer" by Pierre Le Faguays, a brown and silver patinated bronze and ivory figure of an archer, the marble base engraved "Le Faguays". c1925, 23¼in (59cm) high, **F**

of his pieces were produced by the Verrier foundry; however, works by Le Faguays were also produced by Susse Frères, Les Neveux de J. Lehmann and Etling, among others.

Information on La Faguays is surprisingly scant for such a prolific sculptor but perhaps it is the wide variety of his work that has made him less distinctive in the annals of sculptural history than some of his contemporaries. After the Second World War he became a painter on the Place du Tertre in Montmartre, Paris.

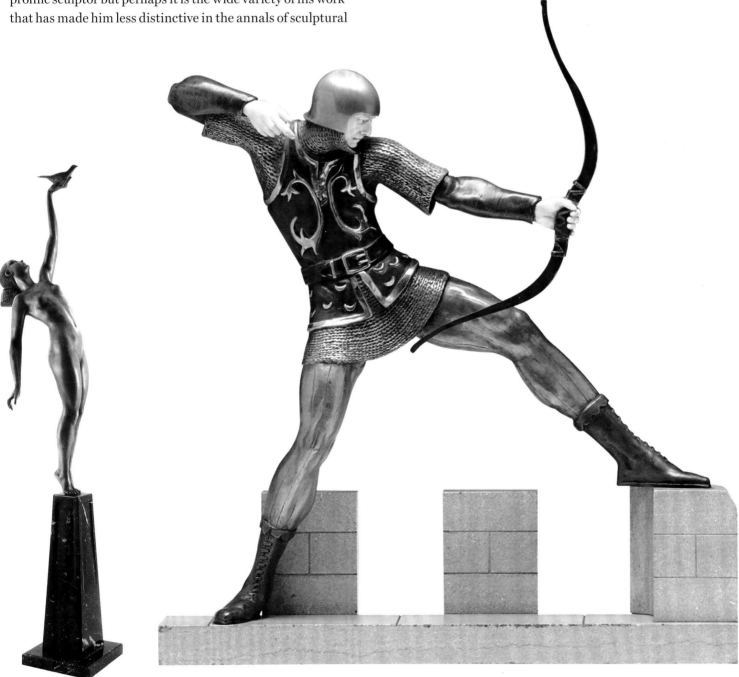

CLAIRE COLINET

Best known for her beautiful, fluid, dynamic sculptures of women, including odalisques, jugglers, exotic dancers, and cabaret artists, Claire Jeanne Roberte Colinet (1880–1950) was highly unusual in that she worked and became successful in a largely male-dominated domain. She was born in Brussels but later moved to Paris, where she studied sculpture with Jef Lambeaux (1852–1908) – famous for his monumental sculpture – and became a member of the prestigious Salon des Artistes Français, exhibiting there from 1913 onwards. She received a commendation in 1914 and was elected a permanent member in 1929, marking the occasion with a sculpture entitled "Dreams are Soap Bubbles". From 1937 to 1940, she exhibited in Paris at the Salon des Indépendants and joined the Union of Women Painters and Sculptors. Colinet enjoyed a long career of over 40 years and her sculptures were reverentially exhibited posthumously at the Paris Salon for almost 30 years.

Colinet's vibrant and often sensitively executed works are both bronze and a combination of bronze and ivory, and the finishes feel elegantly rich. They are usually patinated rather than cold-painted, opulently decorated, and sometimes jewelled, with luxurious gilded and chemically induced colours being a trademark of her luscious work. Poise and balance feature strongly too; like many of her peers, technical skill plays a large part in the presentation of her characters, one that is often overcome by the expertise of the foundries in producing works that are self-supporting and strong. Her sculptures were cast by Edmond Etling, Arthur Goldscheider, and J. Lehmann.

Her figures although dramatic are often womanly, with masterly inferred movement, such as dancers caught in mid-step. Larger works such as "Valkyrie – Into the Unknown" display a mythically induced attraction to the observer, and are technically superb. Many of the dancers are undoubtedly influenced by the Orientalist movement of the late 19th century and depict various different historical nationalities, including Assyrian, Hindu, Corinthian, Roman, Mexican, and Egyptian. Colinet's last exhibition was held in 1945.

LEFT
"Dance of the Daggers" by Claire Jeanne Roberte Colinet, a gilt-bronze figure of a girl holding a dagger in each hand, signed "C. J. R. Colinet". c1925, 19½in (49.5cm) high, **J**

"The Juggler" by Claire Jeanne Roberte Colinet, a gilt-bronze figure of a nude girl balanced on one leg juggling three balls, on a circular onyx base, signed "CL J.R. Colinet". c1930, 15in (38.3cm) high, **J**

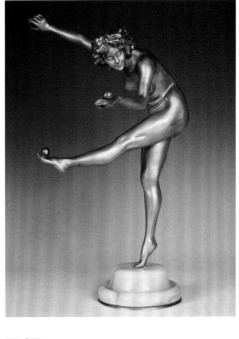

CLOSER LOOK

Claire Colinet's propensity for using ancient and biblical themes is well manifested in this example, "Theban Dancer". Dance, as a sculptural subject, is a perfect platform upon which to base a number of artistic elements and Colinet, like many of her contemporaries, masterfully uses the subject of movement to emphasize physical attributes, wonderfully sculpted fabrics, and perceived animation – captured in a certain instant – to great effect.

"Theban Dancer" by Claire Jeanne Roberte Colinet, a patinated bronze of a girl seated with outstretched arms, on a rectangular marble base inscribed 'CL JR Colinet'. c1925, 22in (56cm) wide, **I**

Variations on this model also include a partially gilded version together with various styles of marble base, one such type being mounted with an Egyptian cartouche.

BELOW
"Mexican Dancer" by Claire Jeanne Roberte Colinet, a bronze and ivory figure of a girl wearing a headscarf and holding a wide-brimmed hat, signed "CL. JR Colinet" and "50", on a marble plinth. c1925, 19¼in (49cm) high, **J**

"Theban Dancer", although in solid bronze, is by no means the most technically proficient example of her work but is still a skilful rendition; it can also be found in a lavish chryselephantine version.

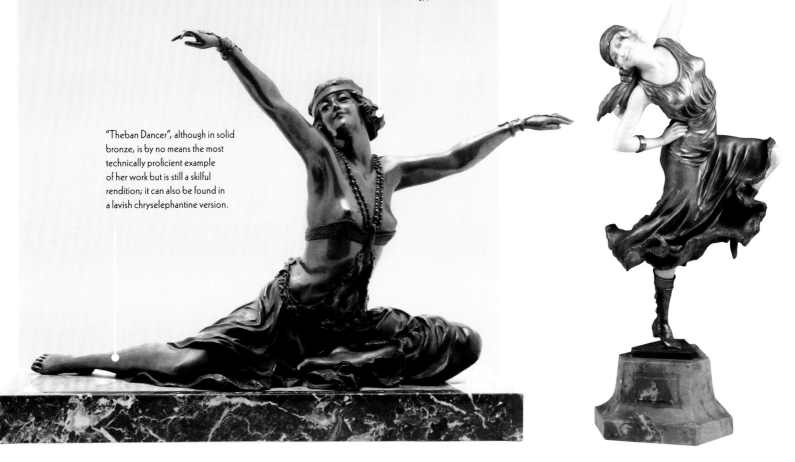

JOSEF LORENZL

Josef Lorenzl (1892–1950), who went on to become one of the most iconic figural sculptors of the Art Deco period, started his career at a foundry in the Vienna Arsenal. This environment enabled him to learn his craft and progress to the production of the figures for which he is so well known today. During this period, he experimented with creating both bronze and chryselephantine figures. His stylized sculptures are beautifully observed, often with an innate simplicity that so readily epitomizes the grace of the Art Deco period. The majority of his works portray slender, often nude, women in animated poses, frozen in the moment. They are invariably graceful, with long, flowing limbs. Most of the figures have green onyx bases. Lorenzl often signed his figures in full but sometimes abbreviated his name to "Lor" or "Renz". Some of his figures also bear the additional signature "Crejo", a talented artist who contributed desirable flourishes to Lorenzl's pieces by painting floral enamel work and adding decoration to the bronzes. These figures, bearing both signatures, are particularly sought after by collectors. Towards the end of the 1930s, wartime restrictions on metals forced Lorenzl to address production in a different way and he turned to working in spelter, a zinc alloy, designing a variety of figures in the same style, some of which were incorporated into clocks, lamps, and lighters. Most of the spelter pieces were not signed. His work was a great influence on other artists of the period, such as Stefan Dakon (1904–1992), who was a friend and produced many similar figures. Lorenzl's skills were also manifested in his success as a ceramicist designing for a number of manufacturers, including the Austrian company Goldscheider.

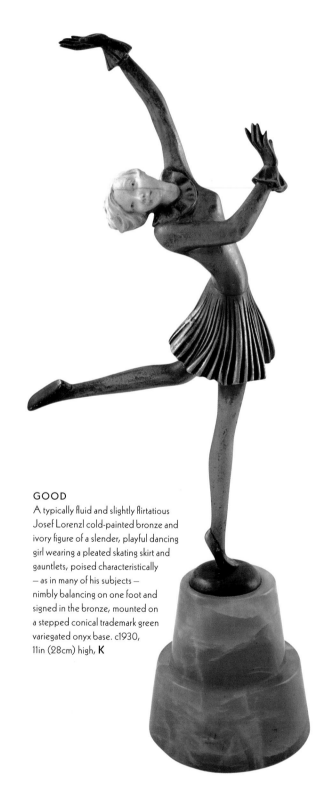

GOOD
A typically fluid and slightly flirtatious Josef Lorenzl cold-painted bronze and ivory figure of a slender, playful dancing girl wearing a pleated skating skirt and gauntlets, poised characteristically — as in many of his subjects — nimbly balancing on one foot and signed in the bronze, mounted on a stepped conical trademark green variegated onyx base. c1930, 11in (28cm) high, **K**

LEFT
A Josef Lorenzl silvered bronze figure of a nude dancing girl in an exaggerated pose, signed "Lorenzl", on a green onyx base. c1930, 15in (38cm) high, **J**

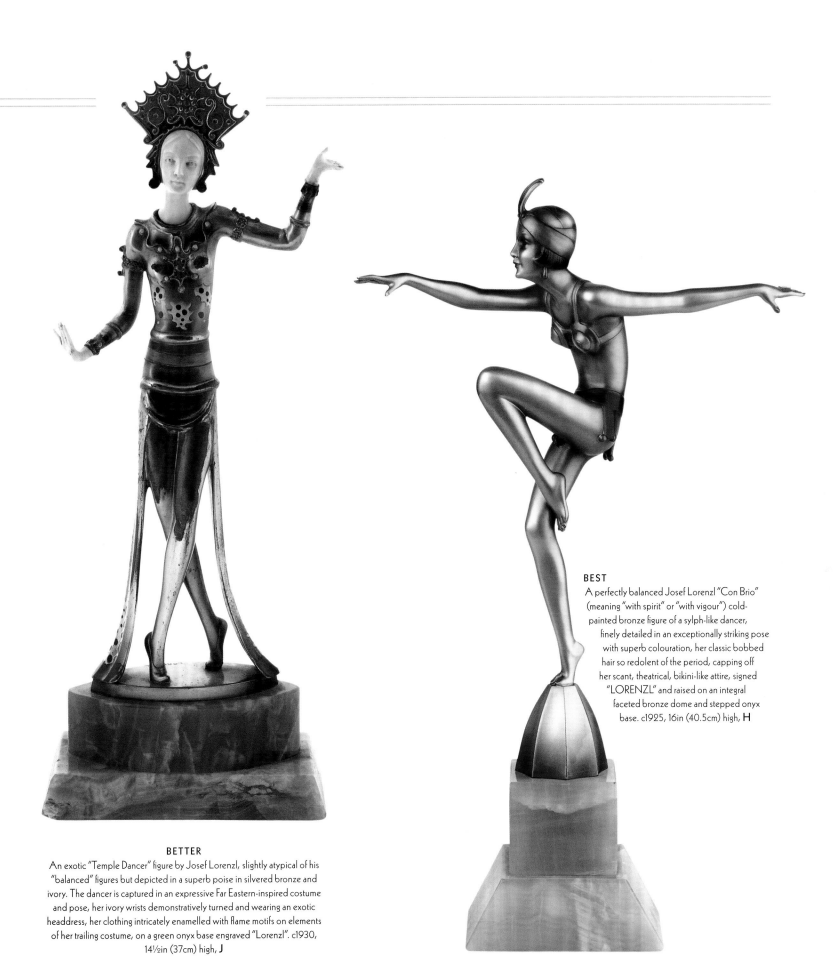

BEST

A perfectly balanced Josef Lorenzl "Con Brio" (meaning "with spirit" or "with vigour") cold-painted bronze figure of a sylph-like dancer, finely detailed in an exceptionally striking pose with superb colouration, her classic bobbed hair so redolent of the period, capping off her scant, theatrical, bikini-like attire, signed "LORENZL" and raised on an integral faceted bronze dome and stepped onyx base. c1925, 16in (40.5cm) high, **H**

BETTER

An exotic "Temple Dancer" figure by Josef Lorenzl, slightly atypical of his "balanced" figures but depicted in a superb poise in silvered bronze and ivory. The dancer is captured in an expressive Far Eastern-inspired costume and pose, her ivory wrists demonstratively turned and wearing an exotic headdress, her clothing intricately enamelled with flame motifs on elements of her trailing costume, on a green onyx base engraved "Lorenzl". c1930, 14½in (37cm) high, **J**

BRUNO ZACH

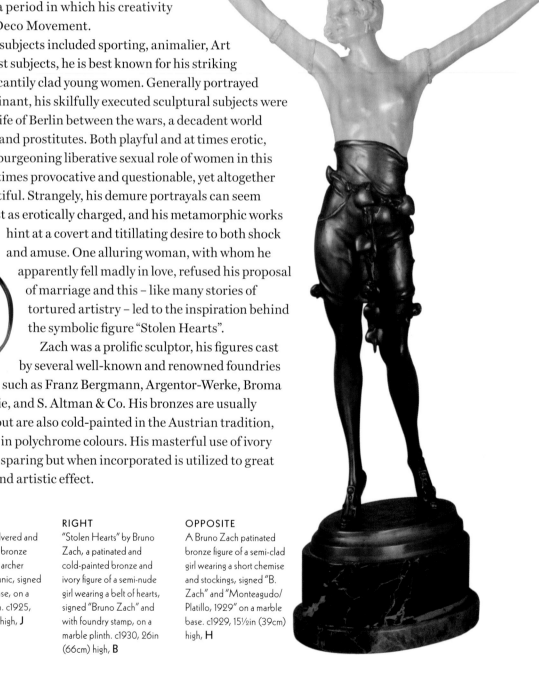

As a young man Bruno Zach (1891–1945) moved from his native Ukraine to Vienna, where he studied sculpture at the Vienna Academy under the tutelage of Hans Bitterlich (1860–1949) and Josef Müllner (1879–1968). Zach produced his main body of work between 1918 and 1935, a period in which his creativity captured the essence of the Art Deco Movement.

Although Zach's wide-ranging subjects included sporting, animalier, Art Nouveau, Western, and Orientalist subjects, he is best known for his striking and often challenging figures of scantily clad young women. Generally portrayed as tall, athletic, and sexually dominant, his skilfully executed sculptural subjects were influenced by the colourful nightlife of Berlin between the wars, a decadent world where he socialized with dancers and prostitutes. Both playful and at times erotic, Zach's aptitude for capturing the burgeoning liberative sexual role of women in this period is at times provocative and questionable, yet altogether beautiful. Strangely, his demure portrayals can seem just as erotically charged, and his metamorphic works hint at a covert and titillating desire to both shock and amuse. One alluring woman, with whom he apparently fell madly in love, refused his proposal of marriage and this – like many stories of tortured artistry – led to the inspiration behind the symbolic figure "Stolen Hearts".

Zach was a prolific sculptor, his figures cast by several well-known and renowned foundries such as Franz Bergmann, Argentor-Werke, Broma Companie, and S. Altman & Co. His bronzes are usually patinated but are also cold-painted in the Austrian tradition, sometimes in polychrome colours. His masterful use of ivory tends to be sparing but when incorporated is utilized to great technical and artistic effect.

LEFT
A Bruno Zach silvered and brown patinated bronze figure of a female archer wearing a short tunic, signed "Zach" on the base, on a green onyx plinth. c1925, 15¼in (38.5cm) high, **J**

RIGHT
"Stolen Hearts" by Bruno Zach, a patinated and cold-painted bronze and ivory figure of a semi-nude girl wearing a belt of hearts, signed "Bruno Zach" and with foundry stamp, on a marble plinth. c1930, 26in (66cm) high, **B**

OPPOSITE
A Bruno Zach patinated bronze figure of a semi-clad girl wearing a short chemise and stockings, signed "B. Zach" and "Monteagudo/ Platillo, 1929" on a marble base. c1929, 15½in (39cm) high, **H**

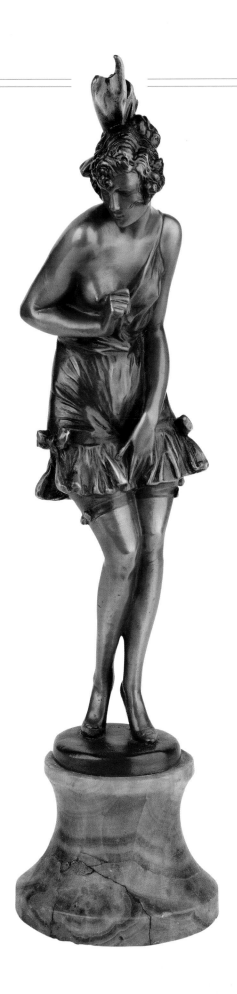

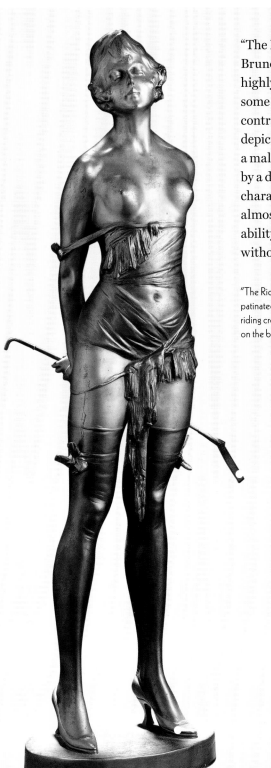

"The Riding Crop" is undoubtedly Bruno Zach's most iconic figure. This highly charged erotic depiction is in some ways a consummately skilled contradiction: an overtly accessorized depiction of a woman who is fulfilling a male-orientated fantasy emphasized by a dominant streak, yet her facial characteristics are softly relenting and almost unconcernedly content. Zach's ability to capture such nuances is without doubt highly masterful.

"The Riding Crop" by Bruno Zach, a green and gilt patinated bronze figure of a semi-clad girl holding a riding crop, signed "Bruno Zach" and with a monogram on the base. c1930, 32¾in (83cm) high, **B**

"The Riding Crop" comes in several versions and was also modelled with an ivory torso and arms; like many of Zach's figures, and other similar sculpture of the period, it is often found mounted on an onyx base.

Plain bronze versions seem less expressive than their colourfully patinated counterparts. Subtlety coloured variations, including elements such as the shoes, can add value to certain models.

BRONZE & IVORY GALLERY

DESCOMPS ◊ GERDAGO ◊ MOLINS ◊ PHILIPPE

The coupling of bronze and ivory is a classic Art Deco sculptural combination. Few periods lend themselves to such an obvious portrayal of the prevalent themes of the epoch. Bronze is a versatile alloy, commonly composed of 88 per cent copper and 12 per cent tin, which is both ductile and good for detailed casting. It also takes chemical patination well, providing a rich palette of chemically induced colours, from verdigris green and rich browns through to the darkest black, while lending itself effectively to cold-painting, giving it a wide range of artistic and sculptural possibilities.

The idea of combining bronze with ivory elements is rooted in antiquity. Ivory, which as a generic term includes the teeth and tusks of several animals, has been valued as a medium for carving for over several thousand years. The expertise of the best ivory carvers of the Art Deco period is manifested in their ability to meld the inherent strength and subtle grainy softness of elephant ivory with the hard, yet fluid rigidity of bronze and the fine detail that it affords. As a metal it is superbly relenting and the leading sculptors of the time, including Ferdinand Preiss, were extremely accomplished carvers who proficiently combined the two. These chryselephantine creations, so called from the ancient Greek name *crysós* for gold and *elenphántinos* for ivory, are often technically complicated with interior structures cleverly designed to hold apparently fragile, almost impossibly balanced, dancers, sportswomen, and historical figures, literally en pointe. Many such sculptures are a tour de force and epitomize the indisputably stylish nature of the period that they so emphatically and masterfully embody.

RIGHT
"Dancer on Points", by Joe Descomps (1872–1948), a cold-painted bronze and ivory figure of a ballet dancer in third arabesque position, on a stepped onyx base with engraved signature "Joe Descomps". c1925, **H**

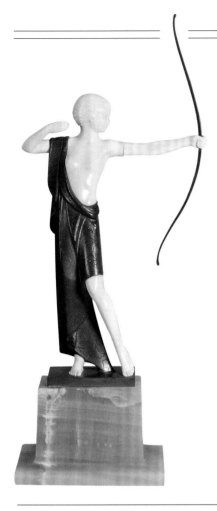

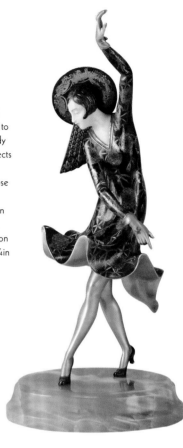

This elegant and classically stated figure of "The Archer" is typical of the work of Charles Henri Molins, who specialized in female dancers and sportswomen. The combination of ivory and patinated bronze elegantly portrays the slightly androgynous figure of an athletic female archer in a striking pose, drawing her bow with a powerful and simple symbolism inherent of many sculptural pieces of the period. She is mounted on a typical Art Deco Brazilian green onyx plinth. c1930, 16½in (42cm) high, **I**

Having studied art in Berlin and Paris, Gerda Iro (1906–2004) began working as costume designer in her native Vienna in the early 1930s. She adopted a professional pseudonym, Gerdago, which she also used to sign her sculptures. With her expressive body and dramatic outfit, this "Exotic Dancer" reflects her creator's roots in the theatre: a young woman in a wide-brimmed hat strikes the pose of a flamenco dancer, with her floral dress, the pattern of which is beautifully rendered in enamel, swirling around her legs. This cold-painted bronze and ivory figure is mounted on an onyx base signed "Gerdago". c1935, 12¼in (31cm) high, **H**

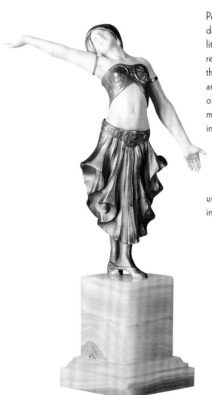

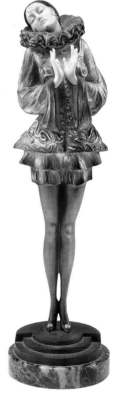

Perfectly poised, this demure-looking dancer by Joe Descomps seems a little reticent, perhaps shy, giving this rendition of an archetypal Art Deco theme a different nuance. Descomps was an accomplished sculptor and a member of the Paris Salon, winning several medals during the 1920s. He specialized in mythological subjects and stylish streamlined pieces while also being consummately adept at portraying the idealized 1920s female figure.

This patinated example with sparing use of ivory, on an onyx base, is signed in the stone. c1930, 11in (28cm) high, **I**

Polish-born Paul Philippe (1870–1930) is an enigmatic artist, a product of the Art Nouveau period who also worked skilfully in the later Art Deco style. Undoubtedly talented, he exhibited with success at most of the Paris Salons and this charming figure entitled "Pierrette" displays an alluringly observed and enchanting attraction. With a sparing use of ivory and cold-painted decoration, the figure is well-balanced and appealing, mounted on a bronze and marble base, signed "Philippe" and bearing the foundry mark for Rosenthal and Maeder, Berlin. c1925, 14½in (37cm) high, **G**

DECORATIVE

Labelling artists as sculptors, painters, or even designers is generally a narrow and slightly clinical form of attribution; by the nature of their creativity, many artists are able to cross from one dimension to two, while also applying themselves to product design, architecture, and interiors. We are sometimes slow to recognize the many multi-referential works emanating from the studios of well-known designers and artists, which draw inspiration from a mixture of sources, encompassing all aspects of contemporary as well as ancient and historic style, combined with purely original thought.

The Art Deco period is a good example of this creative ethos and beautifully emphasizes the clever juxtaposition between artistry, design, function, and Modernism, especially in the experimental and challenging use of materials. Perhaps the most iconic creation of the whole era is the "Maschinenmensch" (human machine), from Fritz Lang's 1927 landmark dystopian film, *Metropolis*. It is a product of a classic epoch, which at times blends the futuristic with the archaic, producing – for example – the many outstanding benchmark designs of the time, such as Lalique's Victoire car mascot, the furniture of Émile-Jacques Ruhlmann (1879–1933), or the fashion designs of Sonia Delaunay (1885–1979). It was a period of both mavericks and masters. From the pared-down purity

of Franz Hagenauer's (1906–86) metal and wood designs to the flamboyance of Claire Colinet's bronzes, many such items were too expensive for ordinary people, who had to be content with the watered-down versions of these superlative artistic productions. The style itself was largely formulated and developed in the early 1920s by the eclectic vision of designers and artists such as Léon Bakst, who designed sets and costumes for Sergei Diaghilev's famous Ballets Russes; its influence was felt in almost every aspect of life, even for those who were less well-off. From lamps to inkwells, bookends, and vases, the stylization of objects became an industry and decoration became key.

RIGHT
A nickel-plated bronze and red enamel decorative wall mask by Franz Hagenauer, modelled as a stylized woman's face, with red enamel lips and a long fringe, stamped "WHW WERKSTATTEN HAGENAUER WIEN". c1930, 10½in (26.5cm) high, **H**

OPPOSITE
Dating from around 1925, this illustration of a winged woman by Erté is typical of the Russian designer's work: his costumes for the stage as well as his fashion illustrations are glamorous, dramatic and highly stylized.

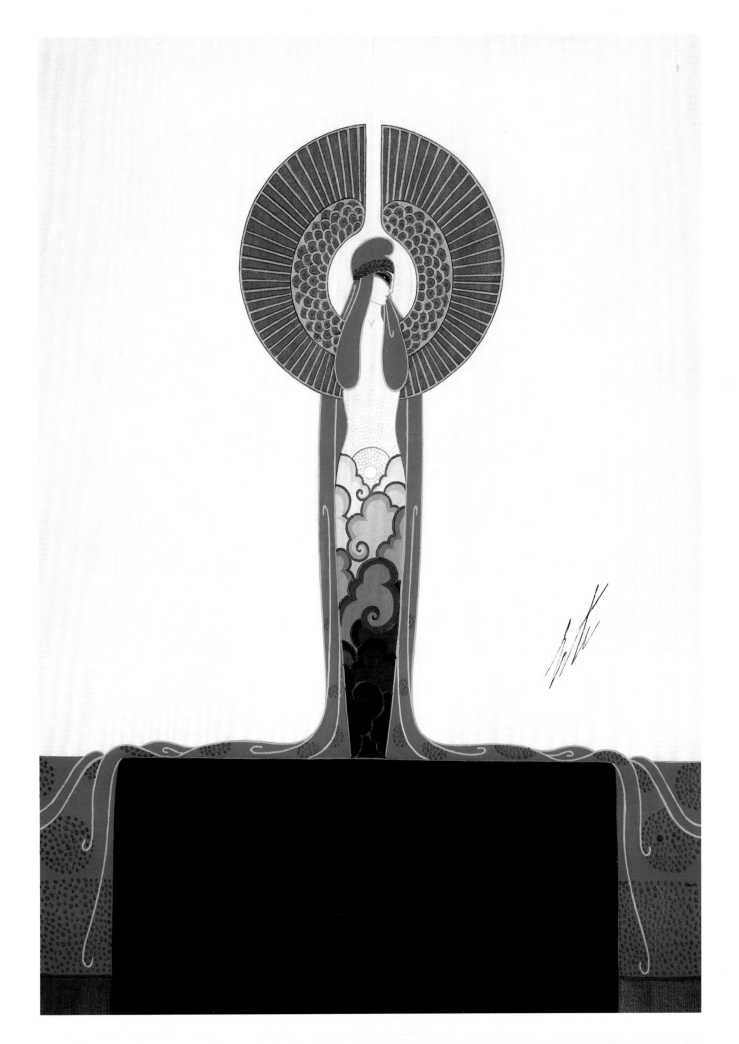

ERTÉ

B orn in St Petersburg, Romain de Tirtoff (1892–1990) was a naturally artistic child. The family expected him to follow a naval career but he flouted tradition to pursue a path as a fashion illustrator. He moved to Paris in 1910 and it was here – apparently to save his family embarrassment – that he began using the pseudonym "Erté".

Having found his true vocation, Erté quickly developed as a multitalented designer working in numerous creative fields, including sculpture, graphics, costume, theatre, and interior design. In 1915 he received his first commission from *Harper's Bazaar* and went on to design over 250 covers for the magazine. Renowned for his stylish Art Deco fashion illustrations of women, their lithely portrayed bodies characteristically accessorized with beads and plumage, his work also frequently appeared in publications such as *Vogue*, *Cosmopolitan*, and *The Illustrated London News*.

Early in his career Erté worked as an assistant to leading French couturier Paul Poiret (1879–1944) and later created costume and fashion designs for many stars of the day, including Joan Crawford (1905–77), Lillian Gish (1893–1993), Marion Davies (1897–1961), Anna Pavlova (1881–1931), and Moira Shearer (1926–2006), among others. In 1925, on the invitation of Louis B. Mayer (1884–1957), head of Metro-Goldwyn-Mayer, Erté had gone to Hollywood to design costumes for films. However, his extravagant designs did not translate well into practical costumes and within the year he had returned to Paris.

Erté went on to enjoy a long and successful career designing for ballets, operas, and theatrical revues,

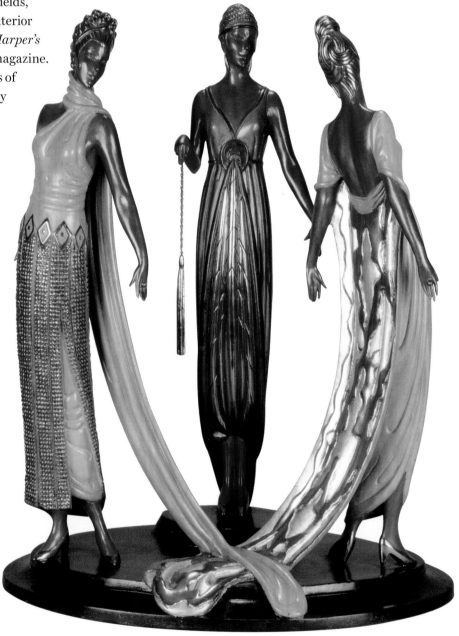

RIGHT
"The Three Graces" by Erté, a cold-painted and gilt-bronze group of three women depicting grace, charm, and beauty, inspired by Greek mythology, signed "Erté", numbered 41/375, dated 1987, and inscribed "Fine Art Acquisitions", with Meisner foundry mark. c1987, 15in (38cm) high, I

creating extravagant and opulent costumes and sets for the Paris Opera and Folies Bergère, and for the *Ziegfeld Follies* and George White's (1891–1968) *Scandals* in New York.

After relative obscurity in the post-war years, the Art Deco revival of the 1960s brought about a renewed interest in Erté's work and he began a new career re-creating his designs into limited edition prints, art jewellery and bronzes, such as the examples shown here.

Erté's legacy has proven highly influential and his work can be found in the collections of many leading museums, including the Metropolitan Museum of Art in New York, the Smithsonian Institution in Washington, the Victoria and Albert Museum in London, and the 1999 Museum in Tokyo. He died in New York at the age of 97.

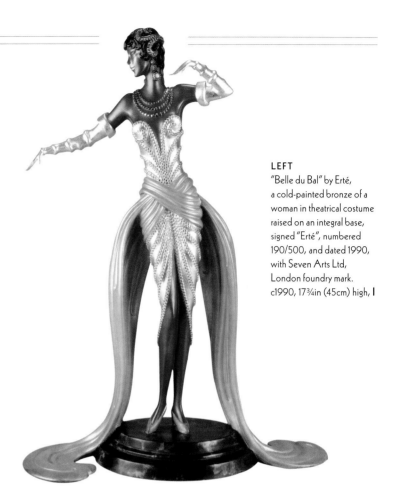

LEFT
"Belle du Bal" by Erté, a cold-painted bronze of a woman in theatrical costume raised on an integral base, signed "Erté", numbered 190/500, and dated 1990, with Seven Arts Ltd, London foundry mark. c1990, 17¾in (45cm) high, I

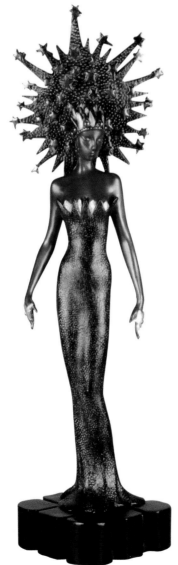

RIGHT
"Starstruck" by Erté, a cold-painted bronze figure of a young woman wearing a theatrical headdress depicting a constellation of stars, raised on an integral plinth, signed "Erté", numbered 87/375, and dated 1987, with Meisner foundry mark. c1987, 22in (56cm) high, I

FAR RIGHT
"Two Vamps" by Erté, a cold-painted bronze group of two elegant women dressed in Egyptian-style theatrical costume, signed "Erté", numbered, and dated 1990, with Seven Arts Ltd, London foundry mark. c1990, 18in (45.5cm) high, I

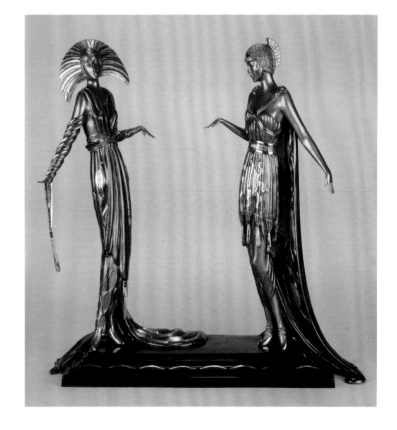

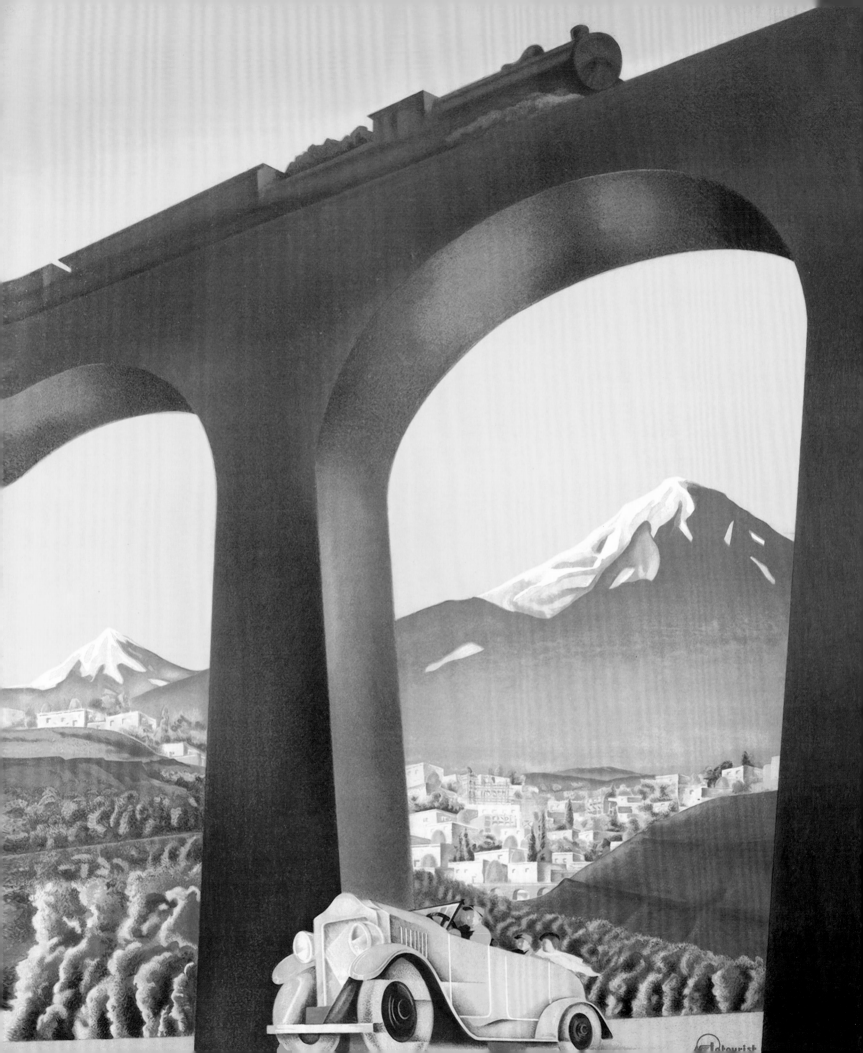

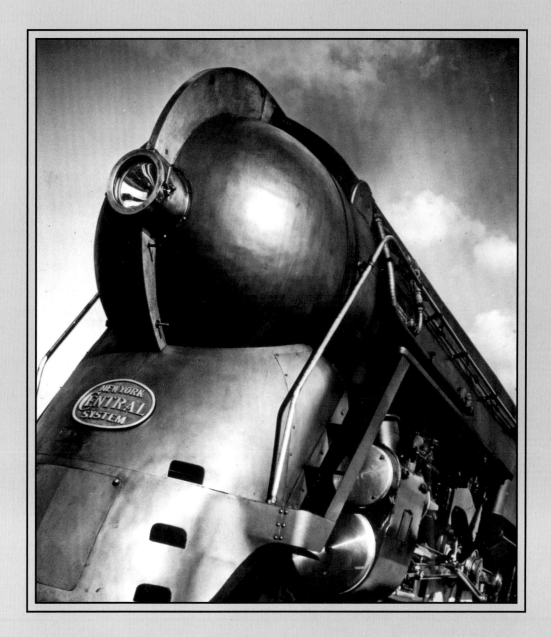

— CHAPTER SIX —

PØSTERS

JAN AUVIGNE

Jan Auvigne (1859–1952) was a French designer who in the 1930s created a number of designs for posters, brochures, magazine covers, and postcards for the Compagnie Générale Transatlantique, a French shipping company usually known as the French Line outside France (the company's name is also sometimes shortened to CGT or Transat).

Auvigne's most famous poster shows the French Line's most famous vessel, the *Normandie*, as an Art Deco icon, traversing the ocean. The steamship is surrounded by the star-shaped points of a compass and encircled by a list of destinations, and the hull's geometric shape is mirrored in the water. This is one of a number of posters Auvigne created to advertise the ship, whose lavish Art Deco interiors featured fittings by designers such as René Lalique (1860–1945) and Raymond Subes (1891–1970).

Auvigne's posters promoted the many different aspects of the French Line's activities. Another design for the company showed a pilot at the wheel of his ship, with shadows used to add a graphic element to the figure. The company's exotic tourist destinations included Algeria, Tunisia, and Morocco and a poster for these countries showed the simplicity of his sophisticated designs: a city in the desert framed by the night sky above and the sand below. Another design eschewed showing the company's boats or destinations in favour of a map showing the routes with the flags of the countries it served superimposed down one side.

LEFT
"Transat", by Jan Auvigne. A poster for the Compagnie Générale Transatlantique, a French shipping company, known as Transat or the French Line. Auvigne also designed brochures and postcards for the firm. 1938, 39½in (100cm) high, **K**

ABOVE
"Transatlantique" by Jan Auvigne. This very rare poster shows the *Normandie*, the fastest and sleekest ocean liner of her day. It was designed for the 1937 *Exposition Internationale* in Paris. 1937, 39½in (100cm) high, **J**

ALBERT FUSS

The German designer Albert Fuss (1889–1969) is best known for the promotional material he created for the Hamburg-American Line in the 1930s and 1940s. The German shipping company is also known as HAPAG, after the the intials of its full German name: Hamburg-Amerikanische Packetfahrt-Actien-Gesellschaft.

Fuss was a prolific designer and while his early work for events such as the Frankfurter *Internationale Messe* (1920), a German art fair, show an avant-garde sensibility, much of his later work is an expression of pure Art Deco. His travel posters illustrate many aspects of the Hamburg-American Line, from the ships – especially the company's "famous four": the SS *Hamburg*, the SS *Deutschland*, the SS *New York*, and the SS *Albert Ballin* – to their routes. Destinations along the Mediterranean coast are depicted in saturated tones that evoke the warmth of the sun, trips to Scandinavia and winter skiing resorts are advertised with endless clear blue skies and distant snow-capped peaks, and the Far East is represented as a land of cherry blossom and mountains. In one poster, the skyscrapers of Manhattan dwarf an ocean liner as it comes in to dock, while others show streamlined, geometric ships speeding through the water en route to their destination.

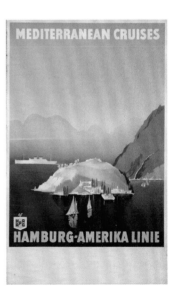

LEFT
"Croisières aux Pays du Nord" by Albert Fuss. This French-language version of a poster promoting a German steamship line's "Northern Cruises" provides a glimpse of the exotic sights on offer to travellers. c1935, 39½in (100cm) high, **L**

ABOVE LEFT
"To New York" by Albert Fuss. During the 1930s, Fuss designed many posters for the Hamburg-American Line. This stylish example shows four of the company's huge ships sailing side by side. c1930, 39½in (100cm) high, **K**

ABOVE
"Mediterranean Cruises" by Albert Fuss. As well as transporting passengers across the Atlantic in comfort, the Hamburg-based shipping company also offered options for leisure travel closer to home. 39¾in (101 cm) high, **L**

TRAVEL GALLERY

ALEXANDER ALEXEIEFF ◊ WILLEM FREDERIK TEN BROEK ◊ E. MCKNIGHT KAUFFER ◊ ROGER PEROT

Travel posters are among the most common and the most collectable Art Deco posters on the market. After the First World War, many people who could afford to began to enjoy travel as a leisure activity – whether by rail, sea, or road. In response to this development, shipping lines, railway companies, car manufacturers, and petrol companies were among those who employed artists and graphic designers to create memorable images to promote their services. The best examples feature bold, graphic, and highly stylized images in strong, bright colours. Whether travel was by train, car, or ship, streamlined shapes and modernity were emphasized.

Many posters for ocean liners – such as the example by Willem Frederik ten Broek (1905–93) shown here – show the great ships of the age at sea, from a low angle, and lending an Art Deco curve to the profile of the hull. These powerful, sweeping images show the modern glamour of cruising across the Atlantic and the new ships that made it possible.

Posters connected to rail and road travel generally focused on the possibility of speed. In the poster designed by Roger Perot (1906–76) for Delahaye, a car approaches the viewer at full speed, while a railway poster by Alexander Alexeieff (1901–82) shows the Night Scotsman racing silently across a dream-like night sky between King's Cross and Edinburgh.

Travellers hoping to escape the cities for the open countryside might be tempted to visit Devon thanks to the poster of the county's moors by Edward McKnight Kauffer (1890–1954), in which he shows them as a green expanse crossed by geometric roads. A poster he designed for the Cornish coast shows the shoreline as an Art Deco sweep of cliffs, wave, and sand enhanced by moonlight shining from banks of stylized clouds.

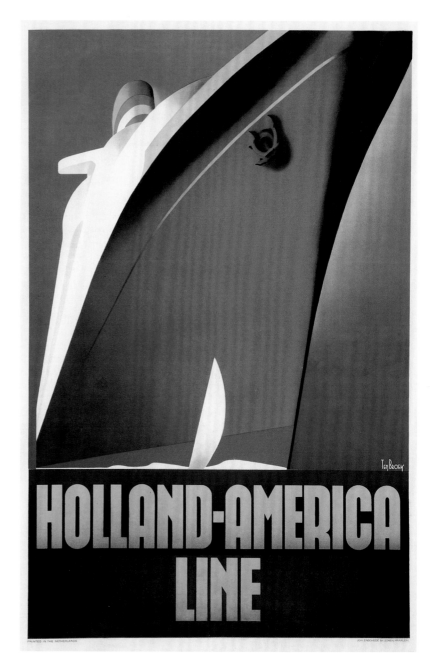

ABOVE
"Holland-America Line" by Willem Frederik ten Broek. The interwar years saw a huge expansion in luxury travel. The sweeping lines of this ocean liner convey the glamour of travelling by sea. 1938, 38½in (98cm) high, I

"Delayhaye" poster designed by Roger Perot. This classic French automobile poster dates from a time when cars were still an unusual sight — and fast cars were rarer still. After producing trucks and fire engines for a number of years, Delahaye returned to its roots in motor racing in the early 1930s. Success on the race track soon boosted the company's car sales. Here, a black Delahaye roadster comes roaring over a hill towards the viewer. The angled type adds to the sense of speed and movement. 1935, 61in (155cm) high, I

"The Night Scotsman" by Alexander Alexeieff is one of the world's most sought-after railway posters. Born in Russia, Alexeiff spent his working life in Paris, where he designed for the ballet before turning his attention to animation. He also worked as an illustrator. Alexeieff designed two versions of this evocative, highly stylized poster for the London and North Eastern Railway (LNER): this one marks the train setting off in London, the other in Edinburgh. 1931, 40in (102cm) high, H

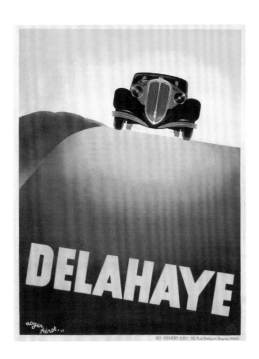

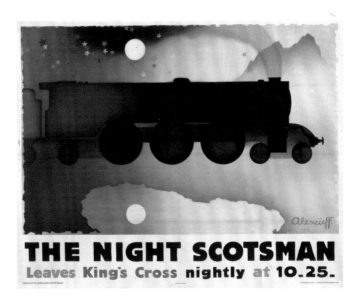

"Great Western to Devon's Moors" by Edward McKnight Kauffer. American-born Kauffer made his name in Britain, designing innovative and influential advertising posters. A pioneer of the pared-back approach and minimal use of type that define the Modern era, Kauffer was also inspired by the artists of his day. Anthony Blunt, the art historian who was later exposed as a Soviet spy, said of Kauffer's posters: "By using the methods of more advanced schools .. he has familiarized a very wide public with the conventions of modern painting". 1933, 39½in (100cm) high, H

"Go Great Western to Cornwall" by Edward McKnight Kauffer. As well as designing 140 posters for the London Underground between 1915 and 1940, Kauffer also worked for railway companies in Britain. For Great Western, he produced at least three different posters promoting travel to Cornwall, of which this one is the most striking, showcasing the skill with which he balances a bold, almost abstract illustration with modern typography. 1933, 39½in (100cm) high, H

DESTINATION GALLERY

E.M. EGGLESTON ◊ LUDWIG HOHLWEIN ◊ ERVINE METZL ◊ MUNETSUGU SATOMI ◊ ALBERT SEBILLE

As travel became more comfortable, faster, and more convenient, posters advertising potential destinations were produced in increasing numbers. Whether you were looking for a day trip by train or an overseas holiday, transport companies were keen to show you the possibilities on offer.

Companies including the Pennsylvania Railroad and Chicago Rapid Transport Line in the United States and London Underground and the London and North Eastern Railway (LNER) in the United Kingdom were among those who hoped to tempt commuters into using their services for leisure travel as well as work. Posters advertised suburban beauty spots, glamorous nightclubs, nearby seaside resorts, or the cultural highlights on offer in major cities.

The spirit of progress can be seen in the poster Munetsugu Satomi (1900–95) designed for the Japanese Government Railways as a train speeds through the countryside. As well as speed, the ease of travel was emphasized. A poster by Albert Sebille (1874–1953) for the French state railway and the shipping company Compagnie Générale Transatlantique illustrated the simplicty with which passengers could transfer from one mode of transport to another on their way from Paris to New York. Similarly, Ludwig Hohlwein's (1874–1949) poster for LNER shows Edinburgh's trams running through the city centre.

Other posters offered an escape from daily life. A poster by Edward M. Eggleston (1883–1941) for the Pennsylvania Railroad depicted the beaches and hotels of the Atlantic City resort in New Jersey as the place to enjoy the new fashion for sunbathing in a racy swimsuit.

In Britain, London Transport commissioned posters by leading artists to encourage people to use the network to enjoy the popular pursuits of the day, especially playing golf, and visiting places made more accessible by the railways such as suburban beauty spots or the January sales.

ABOVE
"Chicago" by Ervine Metzl (1899–1963). Following in the footsteps of the London Underground, Chicago's railway produced posters encouraging commuters to use its trains for leisure travel. 1920, 41¼in (105cm) high, I

"Japan" by Munetsugu Satomi. A highly unusual perspective characterizes this poster designed for the Japanese Government Railway. The blurry landscape and the long line of telegraph poles leaning away from the railway tracks evoke the sensation of a train speeding through the lush green Japanese countryside – the very picture of progress and modernity – while the Japanese flag and the pink blossom of a cherry provide a sense of place. 1937, 39in (99cm) high, **I**

"Edinburgh" by Ludwig Hohlwein, who worked as an architect before turning to poster design in 1905. His training is evident in the compostion of this poster, which features a selection of Edinburgh's architectural highlights, from the Assembly Hall (now known as the Hub) and the Royal Scottish Academy on the Royal Mile to the castle in the background. While Hohlwein was a prolific artist, this is one of only three posters he designed for the railway companies of Britain. 1928, 40in (102cm), **I**

"Paris – Havre – New York" by Albert Sebille, an artist who specialized in maritime subjects. This poster was designed to promote both the French state railway and a shipping company renowned for providing luxurious Atlantic crossings. Together, the two companies could offer travellers an easy journey from Paris to New York. The steamship shown awaiting the arrival of the train in the port of Le Havre is probably the SS *Normandie*, the most famous vessel in the Compagnie Générale Transatlantique's fleet. c1930, 39¼in (99.5cm), **J**

"Atlantic City" by Edward M. Eggleston, who attended art school in Ohio before moving to New York, where he worked as a commercial artist. This is one of three posters Eggleston produced for the Pennsylvania Railroad extolling the attractions of Atlantic City, New Jersey. The popular resort's sandy beach, boardwalk, and grand hotels serve as the backdrop for a bathing beauty in an eye-catching red swimsuit. c1935, 40in (102cm), **F**

ADVERTISING GALLERY

A. M. CASSANDRE ◊ PAOLO FEDERICO GARRETTO ◊ ANDRÉ GIRARD ◊ SEPO

Advances in printing techniques made it more economical than ever before to mass-produce large-scale, high-quality colour images from the 1920s onwards. As a result, a wide range of companies employed posters to advertise their services to an aspirational public.

Many of the greatest poster designers of the Art Deco era were based in Paris, and possibly the most iconic was A. M. Cassandre, the pen name adopted in 1922 by the Ukraine-born Adolphe Mouron (1901–68). He studied at the Académie Julian in Paris before starting his design career and later founded his own advertising agency, Alliance Graphique. The hallmark of Cassandre's posters is a lack of superfluous details – bold blocks of colour and dynamic streamlined images portray the advertiser's message in a modern, Art Deco style. His distinctive posters for La Route Bleue, a luxury bus service between London and the south of France, the railway company Chemin de Fer du Nord, and the ocean liner SS *Côte d'Azur* are typical of this. His posters for another ocean liner, the *Normandie*, and the Nord Express train are considered to be masterpieces of the genre. A poster for the Paris furniture store Aubucheron eschews depictions of the shop's wares to show a lumberjack cutting down a tree against a geometric backdrop of bold diagonal lines. Cassandre even condensed the sport of cycling to a collection of simple shapes in a poster for Brillant bicycles.

Buyers looking to try the new, faster cars being manufactured at the time might have been tempted by the poster designed by André Girard (1901–68) for Peugeot, which showed a car speeding along a racetrack, or the Amilcar poster by Paolo Federico Garretto (1903–91), which depicted two pedestrians stunned by the speed at which the advertised vehicle had just passed them.

ABOVE
In this poster for Peugeot by André Girard, a car rounds the corner of the racetrack made up of the colours the French flag, the firm's badge on prominent display as the vehicle threatens to career off the page. c1929, 63¾in (162cm) high, J

An advertising poster for Chemin de Fer du Nord, a French railway company, by A. M. Cassandre. Best known for his travel posters, this prolific French-Ukrainian artist combined bold lettering with a sophisticated, airbrushed illustration. 1929, 39¼in (99.5cm) high, **J**

A poster advertising Brillant bicycles by A. M. Cassandre. In an early example of his work, Cassandre streamlines the figure of the cyclist down to a stylized series of circles and curves, with the bicycle forming the axis of the composition. 1925, 46¼in (117.5cm) high, **F**

In this poster promoting the SS *Côte d'Azur* by A. M. Cassandre, the focus is on the steamship's central funnel, with smoke billowing out against an azure sky and a lifeboat suspended from the railings in front of the chimney. The image is framed by a border of red and blue text. 1931, 39in (99cm) high, **H**

This rare poster by A. M. Cassandre was designed for Aubucheron, a furniture store in Paris, and echoes an earlier piece he produced for the firm. The wide, elongated format sets the poster apart, while the stylized figure of a lumberjack and the strong diagonal of the tree he is felling are typical of Cassandre's work. 1926, 161in (409cm) wide, **D**

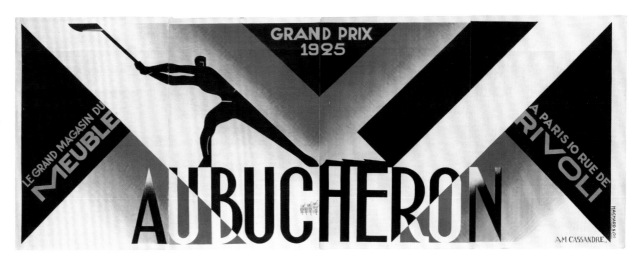

Together with the stylized blue waves and mountains in the background, the speeding train on this poster for Parisian department store Palais de la Nouveauté by Sepo (Severo Pozzatti, 1895–1983) promises a summertime escape from the city — and a reason to shop for new clothes. 1928, 63in (160cm) wide, **I**

An elegant poster in twilight shades by A. M. Cassandre advertises La Route Bleue, a luxury bus service that connected London, Paris, and the Côte d'Azur. The sun is setting on the horizon, and the gaps between the trees lining the road echo the windows of a bus. 1929, 39in (99cm) high, **F**

This witty poster was designed by Paolo Federico Garretto for Amilcar, a French car made between 1921 and 1940. A couple stands next to a poster showing the car, which, as the puff of smoke to their left and the text below them suggest, has just driven by at high speed. 1929, 62¼in (158cm) wide, **I**

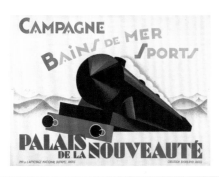

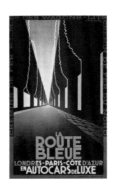

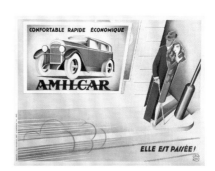

LESLIE RAGAN

Leslie Darrell Ragan (1897–1972) is famed for his illustrations of trains and cityscapes, depicted in a naturalistic yet dramatic manner. Ragan was born in Woodbine, Iowa, and studied at Cumming School of Art in Des Moines. After serving in the Air Force in the First World War, he studied at the Art Institute of Chicago and later taught at the Academy of Fine Arts in the city. He then moved to California, where he worked as an illustrator.

Ragan's early landscapes were influenced by the work of Oscar Rabe Hanson and the illustrator N. C. Wyeth, but it is his later work for which he is particularly celebrated. He designed posters for the Office of War Information during the Second World War, but he made his name with a series of travel posters and calendars he designed for the New York Central Lines. In 1925, the railway company launched a poster campaign to publicize the cities and natural landscapes its trains travelled to and through. Ragan's first commission from the New York Central Lines was to design a poster of a Chicago cityscape, which was published in 1930.

Ragan developed a distinctive and above all dramatic style, and he showed the latest machines and modern city life in light and airy settings, transforming their bulky forms yet maintaining a sense of realism. Landscapes, rows of buildings, clouds, and puffs of smoke were reimagined using a range of colours that enhanced their form and ensured that they caught the eye. He used perspective to glorify the new skyscrapers and the Machine Age

RIGHT
A bird's-eye view of New York's Rockefeller Center by Leslie Ragan, showing the landscaped roof gardens of this huge complex built in the 1930s. The spires of St Patrick's Cathedral, on the other side of 5th Avenue, are visible in the foreground. c1936, 40½in (103cm) high, **H**

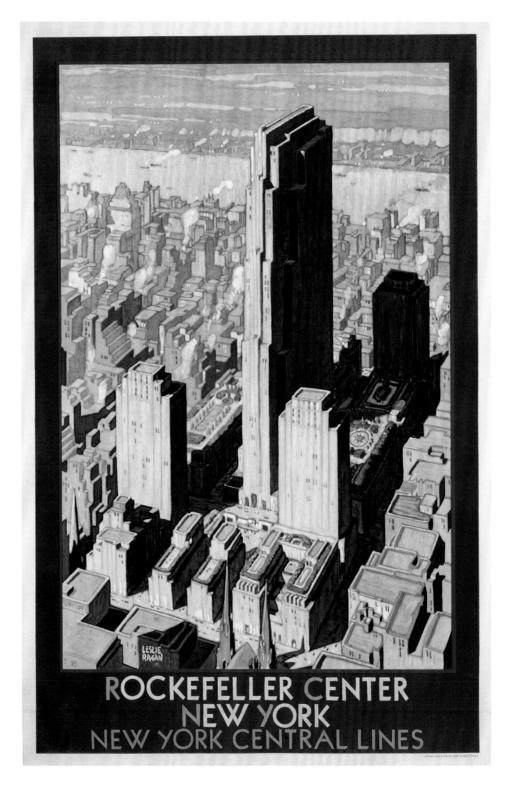

trains that were an emblem of New York City and the new age of travel, often depicting them from above. Buildings became monuments to progress, while streamlined, aerodynamic trains sped across the landscape in artwork that celebrated both the machine and the natural world.

Ragan produced work for New York Central Lines until the late 1940s, and went on to work for other transportation companies including Seaboard Air Line, the Budd Company, and Norfolk & Western.

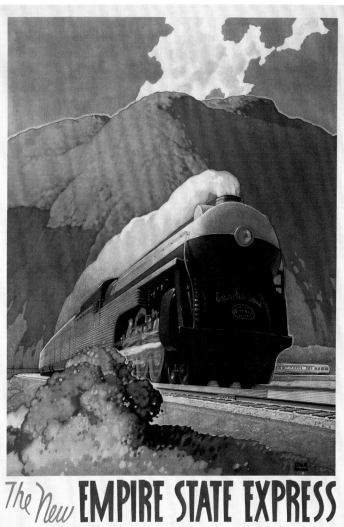

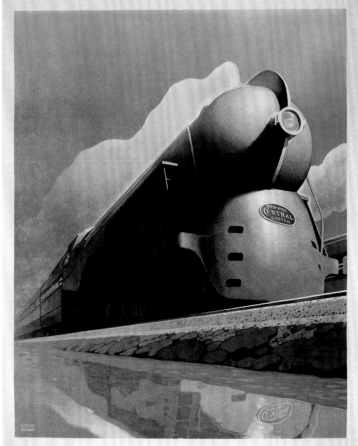

LEFT
"The New 20th Century Limited" by Leslie Ragan show's one of America's most famous trains: the express service that left New York every night at 6pm, serving cocktails in the observation car and breakfast in bed before arriving in Chicago. This poster has featured on stamps issued by the United States Postal Service to commemorate the 1930s. 1938, 40¾in (103.5cm) high, **F**

ABOVE
"The New Empire State Express" by Leslie Ragan, a poster produced to mark the introduction of a new train, hailed by the railroad company as being "as completely comfortable as modern science can make it", to run between New York City and Buffalo, almost 400 miles to the north-west. 1941, 41in (104cm) high, **H**

By the 1930s the "talking pictures" being produced in Hollywood had taken the world by storm and introduced cinemagoers worldwide to the Art Deco style. Film sets for movies starring Fred Astaire and Ginger Rodgers – including *The Gay Divorcee* (1934) and *Top Hat* (1935) – used glamorous Art Deco sets, while Busby Berkeley's movies *Footlight Parade* (1933) and *Dames* (1934) featured scenes in which geometrical rows of dancers performed in synchronized perfection. The films, and the worlds they depicted, were the perfect form of escapism during the Great Depression.

If proof were needed of the global appeal of Hollywood, and of the Art Deco style, Philip Kumar Das Gupta's 1938 poster advertising Calcutta as a holiday destination is it – glamorous moviegoers arrive at the city's Art Deco cinema to watch the latest MGM release. While the films on screen depicted an Art Deco world, many of the new cinemas were also built in the Art Deco style, and the posters used to advertise new releases were designed to match them. Film posters were produced in large numbers – after all, every cinema would have had them on display – and were printed in colour. However, relatively few have survived.

In 1920s Russia, the concept of the movie poster was revolutionized by brothers Vladimir (1891–1982)

and Georgii (1900–33) Stenberg. They moved away from the standard technique of depicting scenes from the film to creating photomontages. This style influenced many other poster designers, including the unknown artist who designed the poster for the Russian film *Loss of Feeling* (1935).

The best-known – and most rare – film poster of the Art Deco era is probably the design Werner Graul (1905–84) produced for *Metropolis* (1926). The film's director Fritz Lang (1890–1976) was inspired by a visit to New York in 1924 and the resulting science fiction morality tale now has a cult following and is lauded as German Expressionist film making at its best. At least four posters were produced for the German market: two eye-catching examples by Heinz Schulz-Neudamm (1899–1969) and Graul, and two less striking, one by Robert Schmidt, the other anonymous. Graul, who designed posters for several Berlin cinemas, is best known for this image of the film's central character Maria, depicted as a robot in an hypnotic image of stylized realism.

RIGHT
The glamorous Art Deco picture palace in this poster by Philip Kumar das Gupta could be in Paris or London, but as the title indicates, it's in India. The opening of the MGM-owned Metro in Calcutta in 1938 helped pave the way for today's thriving Bollywood film industry. 1938, 39in (99cm), **J**

FAR RIGHT
Released in 1935, the Russian film *Loss of Feeling* marks the first on-screen appearance of a robot, as illustrated in this poster by an unknown artist. The film was inspired by the work of Czech writer Karel Capek (1890–1938), whose 1920 play *R.U.R* introduced the world to the concept of robots. 1935, 34½in (87.5cm) high, **I**

RIGHT

A dystopian vision of the future,
Fritz Lang's film *Metropolis* is
filled with indelible imagery,
such as the creation of a
robot-double of the film's
central character, Maria. She
is depicted by Werner Graul
on a poster designed for the
film's initial run in Berlin, from
January to May 1927. The film
was significantly cut for length
and re-edited before going on
international release. 1926,
25¼in (64cm) high, **E**

SKI POSTERS GALLERY

PETER EWART ◊ J.E. ◊ H. M. JOANETHIS ◊ SASCHA MAURER

The growth in leisure travel in the 1930s led to a resulting expansion of holiday choices. For those with the money and inclination, skiing became a popular winter sport, and travel companies and ski resorts across Europe and North America used posters to promote their destinations. Such a dynamic activity inevitably inspired posters that celebrated the speed and freedom of skiing, often utilizing a simple, contrasting background of bright blue sky and pure white snow.

Artist Sascha Maurer (1897–1961) loved to ski and his posters express the joy he found on the slopes. Born in Germany, he studied at the Munich Academy of Fine Arts and emigrated to the United States after serving in the First World War. By the 1930s he was employed by New England ski resorts to advertise their facilities. Many of his designs feature a single, large figure in the foreground, while others rely on multiple figures – caught in mid-air or mid-slope – as their subject matter.

The annual Dartmouth Ski Carnival held in New Hampshire attracted students and sportsmen from around the world, and by the 1930s its poster competition (which continues today) was legendary. The poster designed by H. M. Joanethis in 1938 is considered to be the most graphically striking in the series.

Canadian artist Peter Ewart (1918–2001) is renowned for his dynamic designs. Over a period of 20 years from 1939 onwards, he designed 24 posters for the Canadian Pacific Railway and Canadian Pacific Airlines.

Other artists chose to depict moments of rest during an energetic day on the slopes. Skiers were depicted enjoying the view from a mountain top, waiting for trains and ski lifts, or simply posing in the snow.

ABOVE
This poster by Sascha Maurer advertising the Flexible Flyer brand of skis also promotes a ski area in Vermont – room was left at the bottom to allow for regional customization. 37in (92.5cm) high, **J**

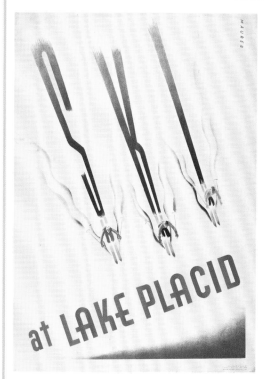

In this poster designed by H. M. Joanethis, a ski jumper launches himself into the air, providing a view of the bottom of his wooden skis. The first Winter Carnival was held at Dartmouth College in Hanover, New Hampshire, in 1911. The event, which featured ski races as well as dances organized by college fraternities, grew in popularity during the 1920s and the 1930s, going on to serve as the setting for a 1939 film comedy starring Ann Sheridan. 1938, 33¾in (85.5cm) high, **J**

In "Ski at Lake Placid", designed by Sascha Maurer, the typography takes centre stage: the elongated blue letters making up the word "ski" slide diagonally across the page in the wake of a trio of downhill racers, with the rest of the poster's text, set in red, serving as their finish line. c1938, 24½in (62cm) high, **J**

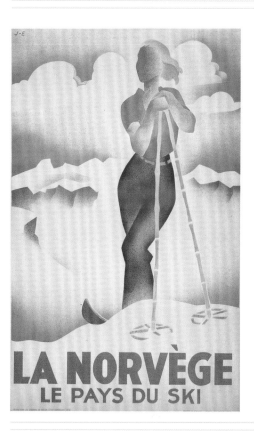

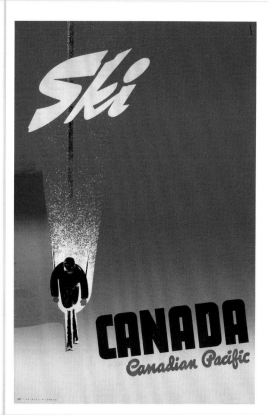

Aimed at the French-speaking market, this poster by J. E. promotes Norway as an ideal destination for skiers. Wearing a short-sleeved shirt in the winter sunshine, a skier takes a break at the top of a mountain, with snow-capped peaks in the distance. She stands propped up on her bamboo ski poles, her blonde hair blowing in the breeze. c1936, 38½in (98cm), **J**

"Ski Canada", one of numerous posters produced for the Canadian Pacific Railway by the painter Peter Ewart in the 1940s and 1950s. Against a deep blue background, a skier is shown racing down a sheer mountainside, raising a cloud of white powder snow. Raised in Montreal, Ewart studied commercial illustration in New York in the late 1930s, where he encountered the work of avant-garde poster designers of the day, including Cassandre and Kauffer. 1941, 35½in (90.5cm) high, **K**

WORLD'S FAIRS GALLERY

JANNO ◊ WEIMER PURSELL ◊ SHAWL, NYELAND & SEAVEY ◊ GLEN C. SHEFFER

Established to allow manufacturers and designers to publicize new ideas, products, and technological advances, the World's Fairs were based on the tradition of French *Expositions* and the 1851 *Great Exhibition* in London. In 1933, the Chicago World's Fair was the first to celebrate the Art Deco style with its streamlined, Moderne architecture. It was open for two years and received 39 million visitors. Weimer Pursell (1906–74) designed several posters for the fair, the most dramatic of which features the three towers of the Federal Building (one tower for each branch of the government) jutting into the sky and the text at the top of the poster.

Chicago was the first of the great fairs to be held in the United States after the Wall Street Crash of 1929. Glen C. Sheffer (1881–1948) promoted it as a modern attraction set against the more traditional Chicago skyline. The theme of the 1939 World's Fair in New York was "The World of Tomorrow", and the show was designed to ease the country out of the Depression and into a brighter future.

That same year, the World's Fair held on San Francisco Bay (the Golden Gate International Exposition) celebrated the new Golden Gate and San Francisco–Oakland Bay bridges. Its theme was the "Pageant of the Pacific" and it celebrated the nations bordering the Pacific Ocean. This was symbolized by the "Tower of the Sun" and a stylized statue of Pacifica, goddess of the Pacific ocean, both of which featured on posters for the fair.

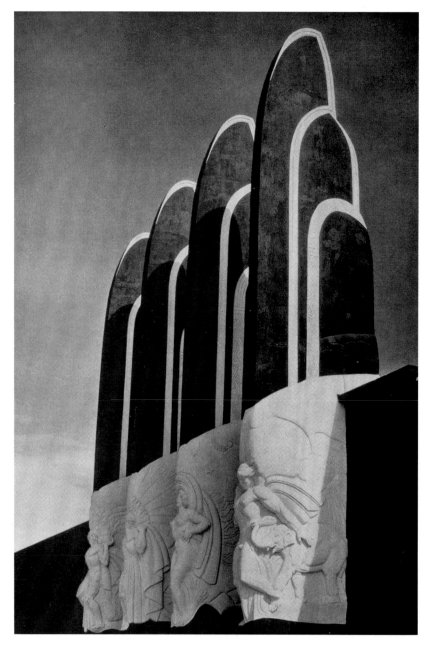

RIGHT
The Hall of Science at the 1933 Chicago World's Fair featured four streamlined pylons, the bases of which were decorated with Neo-classical reliefs.

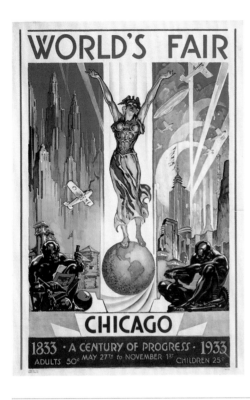

A poster for the World's Fair, held in Chicago in 1933, designed by Glen C. Sheffer. The title of the exposition was "A Century of Progress", and its motto was "Science Finds, Industry Applies, Man Adapts". The poster features elements of a futuristic cityscape as well as illustrations of buildings designed for the fair, such as the distinctive Art Deco tower of the Hall of Science by Paul Cret (1876–1945). 1933, 41¾in (106cm), I

One of several posters designed by Weimer Pursell for the Chicago World's Fair, this example features the three towers of the Federal Building, presented as if lit up at night by bright neon lights. Born in Tennessee, Pursell studied at the Chicago Art Institute and went on to design advertising posters for some of the most famous companies in the United States, from Coca-Cola to American Airlines. 1933, 41½in (105.5cm), I

Flanked by the Golden Gate Bridge and the San Francisco Bay Bridge, the "Tower of the Sun" is the focal point of this poster for the 1939 World's Fair, designed by Shawl, Nyeland & Seavey. The fair site was located on Treasure Island, an artificial island that had been specially constructed in San Francisco Bay. The official architectural theme of the fair was "Pacific Basin", but its signature tower owed as much to an Italian campanile as it did to Incan or Mayan structures. 1937, 34½in (87.5cm) high, I

This rare poster for the 1939 New York World's Fair, designed by Janno, shows a vessel from the Cunard White Star Line, a British shipping company, heading towards a highly stylized version of Manhattan – the green skyline is reminiscent of the Emerald City in the *Wizard of Oz*. The tall white pointed tower and the globe in the foreground are the Trylon and the Perisphere, two Modernist structures connected by a long, curving escalator that were designed to embody the fair's theme: "The World of Tomorrow". 1939, 39in (99cm) high, I

PAUL COLIN

Today Paul Colin (1892–1986) is revered as one of the most important French poster designers of the Art Deco period. Having studied under furniture designer Eugène Vallin (1856–1922) and artist Victor Prouvé (1858–1943), Colin made his name in 1925, when a friend commissioned him to design a poster for *La Revue Nègre*, a one-night event starring the American-born dancer and singer Josephine Baker (1906–75), who had newly arrived in Paris after starring in hugely successful Broadway musicals, such as *Shuffle Along* (1921). The poster launched his career and he went on to design 1,900 posters that celebrate the exuberance of Jazz Age Paris, as well as sets and costumes for hundreds of shows. Colin was a lover and life-long friend of Baker and illustrated the memoirs she published in 1927.

La Revue Nègre also helped to make Baker's name in Europe and, spurred on by her growing fame, in 1927 Colin staged the *Bal Nègre*, an event that was attended by 3,000 Parisians. In 1929 he further capitalized on the craze for music and dance inspired by his friend Josephine by publishing *Le Tumulte Noir* (The Black Craze), a portfolio of lithographs that captured the excitement of the Roaring Twenties in Paris.

Posters such as the one he designed for the Bal Tabarin night club in Montmartre celebrate the energy and freedom of the era and have a fluid, eye-catching appeal while maintaining an Art Deco geometric balance. Inspired by Surrealism and Cubism, Colin used bold shapes, striking colours, caricature, and highly stylized forms.

Colin often used a piano as a decorative element. His poster for André Renaud, a pianist renowned for playing two pianos simultaneously, took a Cubist approach with the star performer centre stage.

As well as commissions for theatres and nightclubs, Colin designed posters for Peugeot cars, the 1937 Paris *Exposition*, Balto cigarettes, Transatlantique French Line, Air France, and the Loterie Nationale Grand Prix De Paris horse race.

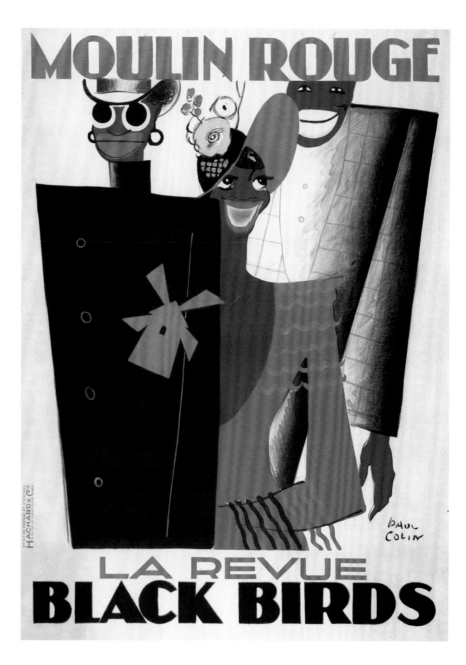

ABOVE
This extremely rare poster by Paul Colin features Adelaide Hall (1901–93), one of the stars of *Black Birds*, a hit Broadway musical that also ran at the Moulin Rouge in Paris for three months. 1929, 62in (157cm) high, **B**

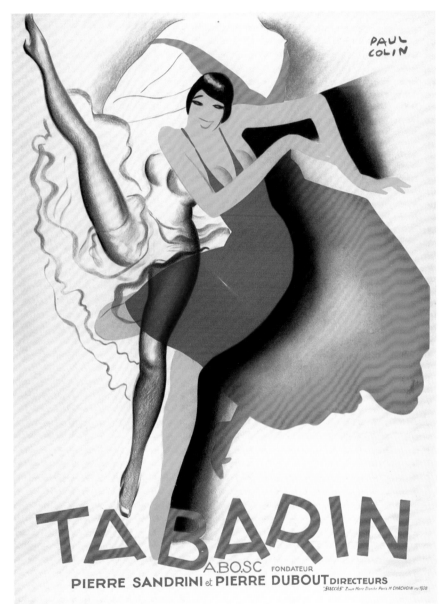

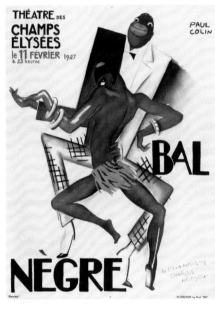

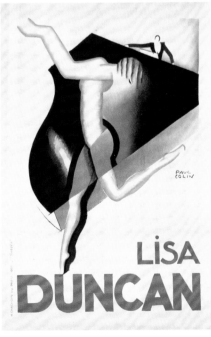

ABOVE
Three dancers become one on this poster for the Tabarin music hall in Montmartre, their costumes running the gamut from a tiered, ruffled can-can skirt to a low-cut little red cocktail dress. 1928, 63in (160cm) high, **I**

TOP RIGHT
In an image that looks like a double exposure, Paul Colin shows pianist André Renaud's playing two grand pianos at the same time, with the instruments overlapping in the centre of the poster. 1929, 63in (160cm) high, **G**

CENTRE RIGHT
In a poster advertising a revue called the *Bal Nègre*, Josephine Baker is sketched by Paul Colin in strong, fluid lines, while her dance partner is treated in a more abstract, geometric manner. 1927, 63in (160cm), **D**

RIGHT
Paul Colin depicts interpretative dancer Lisa Duncan (1898–1976) in a suitably avant-garde manner: with her body reduced to neo-cubist outlines, she has seemingly become one with a grand piano. 1927, 47in (119cm) high, **F**

JEAN CHASSAING

The French poster designer Jean Chassaing (1905–38) was influenced by the work of his mentors, Adolphe Mouron Cassandre and Paul Colin. However, only 11 of Chassaing's designs are known today, all of them completed between 1927 and 1931. Some of these works were not seen in public until 2003, when his personal collection of 72 posters by leading Art Deco designers was sold.

Chassaing's first poster was published in 1923, and two years later he began working for Cassandre as a graphic designer. It was during this time that Chassaing learned about techniques such as airbrushing and composition. His posters featuring faces – in particular those he designed after 1927 – also show the influence of his mentor Paul Colin, who founded a school for the graphic arts in Paris in 1933.

The known works by Chassaing include two aeronautical posters, one of them a promotional poster for the Bernay flying club and the other a poster for the French Ministry of War, informing young men of the possiblity of completing their military service as trainee pilots (both dating from 1927). His commercial projects incclude a poster for *C'est un Amour Qui Passe*, a German B movie that was released in France around 1931. Chassaing also designed a poster featuring the actress Janie Marèse (1908–31), a poster to mark the opening of the Casino de la Mediteranée in Nice, and an advertisement for sardines (all three 1928 and known only as maquettes); as well as images of the performer La Regia and posters for Kerlor, Le Blanc de Boka, and La Ligne Aurore, a line of women's shoes from Heyraud (all

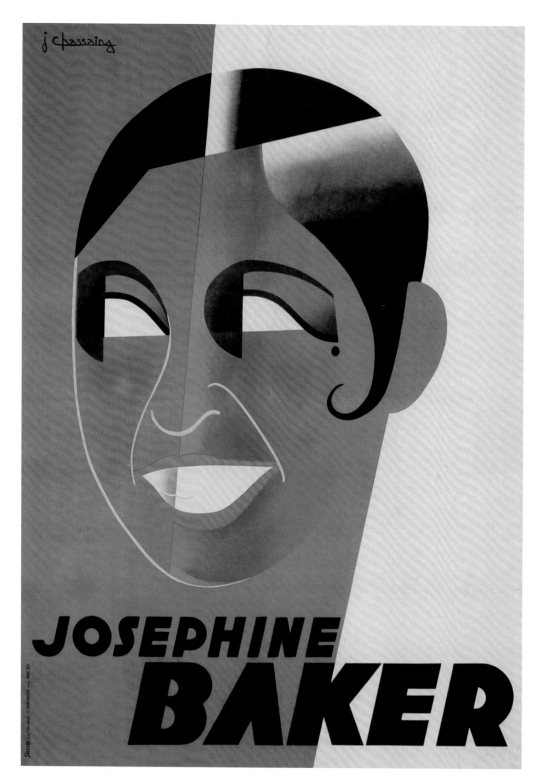

1930). This poster shows a large shoe with a stylized, elegant silhouette of a woman stretching over it to reach for a pair of red shoes lined up on a high shelf.

Chassaing died prematurely and in poverty in 1938, aged 33. His final and best-known poster – which was also the one of which he was most proud – features the exotic dancer Josephine Baker and dates from 1931. By this time Baker was already the star of the Casino de Paris (partly thanks to the striking promotional posters Colin designed for the venue). The poster's focus is a highly stylized depiction of her face, and the colour of the paper the poster is printed on is part of the design. With this poster, Chassaing follows Colin's method of focusing on the face of the subject being depicted: the background is split into geometric sections with a simple portrait in the centre, so that the viewer can concentrate on it. Today, it is considered to be his best image.

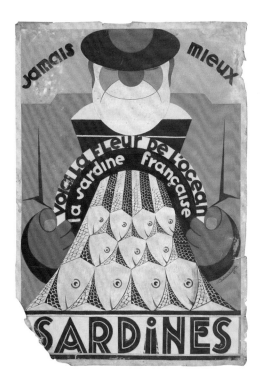

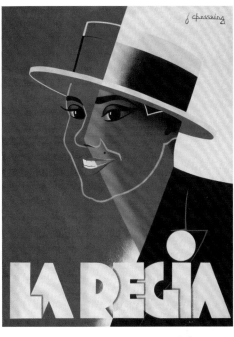

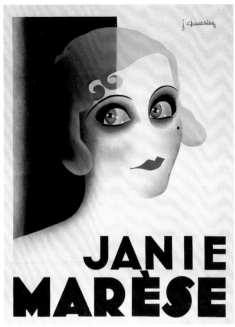

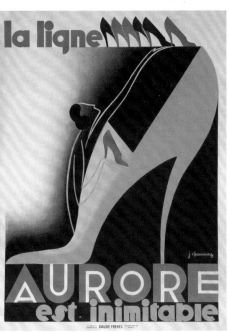

OPPOSITE
Jean Chassaing is best known for this striking portrait of dancer Josephine Baker, in which the white paper the poster is printed on is cleverly used to help form her eyes and her smile. 1931, 61½in (156cm) high, **H**

TOP LEFT
This design by Jean Chassaing for a poster advertising French sardines was never used. It shows a sailor pouring out a bucket of fish, with text running around the rim of his bucket. 1928, 25¾in (65.5cm) high, **K**

TOP RIGHT
In this poster depicting a performer known as La Regia, Jean Chassaing uses a bold, caricature-style approach, paring this portrait down to the bare essentials. c1930, 62in (157cm) high, **K**

BOTTOM LEFT
Jean Chassaing made the only poster portrait of Janie Marèse, a promising actress who got her big break by landing the lead in a film by Jean Renoir (1894–1979), but died in a car crash at the age of only 23. c1928, 63in (160cm) high, **I**

BOTTOM RIGHT
An advertising poster for La Ligne Aurore, a range of women's shoes. A streamlined, high-heeled shoe is overlaid with the elegant outlines of a woman reaching up to choose a shoe from a display shelf. c1930, 63in (160cm) high, **K**

In the Art Deco era, fashionable graphics were increasingly used to advertise events and products, with everything from dance performances to sporting events, toothpaste manufacturers to magazine covers following the trend. Many of these examples of graphic design took a new approach to combining illustrations and typography to get their message across. The pioneers of this style were based at the Bauhaus in Germany and the Wiener Werkstätte in Austria, and their influence can be seen in the work of French poster artists such as Adolphe Mouron Cassandre, as well as in the typeface that Edward Johnston (1872–1944) designed for the London Underground, an organization that also commissioned many Art Deco posters.

The influence of Cubism and Futurism on the work of Edward McKnight Kauffer can be seen in his poster for an exhibition by members of the London Group of artists. Using just two colours – and a symmetrical silhouette of abstract two figures against tumbling red blocks – he emphasized the modern nature of the art on show, which is echoed in the geometric typography.

Posters by the Lithuanian-born Boris Lovet-Lorski (1894–1973), who worked in the United States after 1920, are rare but echo the angular figures he created in his bronze sculptures. The influence of Cubism, Futurism and Constructivism can be seen in his poster for a performance by dancer Anna Robenne. The bold typography used by Jean Carlu (1900–89) in his poster for Gellé toothpaste is set against the backdrop of a silhouetted angular head baring its bright white teeth, and the head's even more geometric shadow.

Magazines such as *Vogue* and *Vanity Fair* featured Art Deco designs on their covers. Eduardo Benito's (1891–1981) design for the October 1927 edition of *Vanity Fair* shows a woman and her companions in a box at the theatre. The highly stylized figures show the woman with waved hair, and wearing a simple Flapper dress with bold jewellery and bright red lipstick.

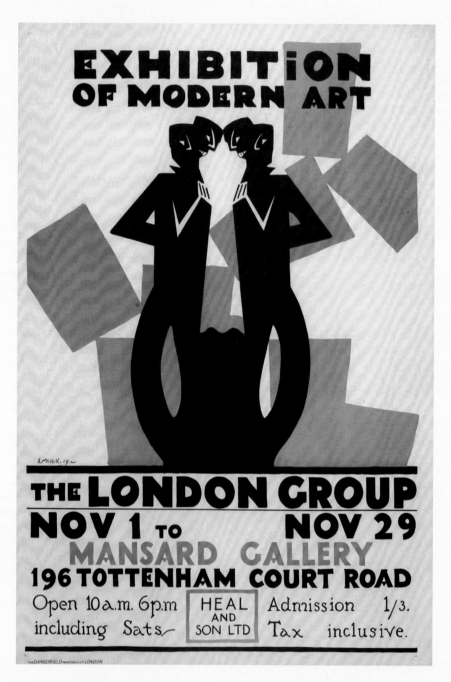

ABOVE

A bold, two-colour poster designed by Edward McKnight Kauffer for an exhibition by members of the London Group, an artist-led organization founded in 1913. 1919, 29¾in (75.5cm) high, **K**

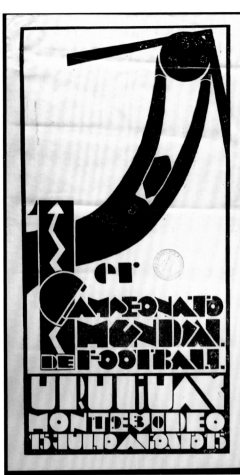

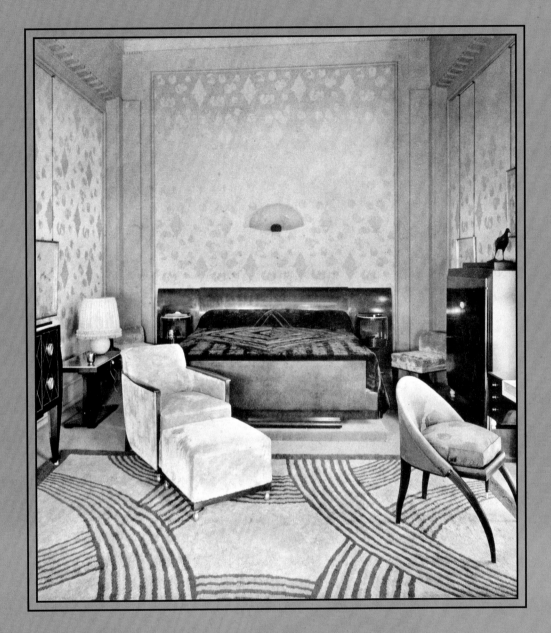

— CHAPTER SEVEN —

TEXTILES

INTRODUCTION

Textiles form an important part of everyday life. From our clothing to soft furnishings and carpets, the range and diversity of materials, textures, colours, and designs is almost infinite. Throughout history, design movements used textiles as a versatile medium for conveying an aesthetic, and none more so than in the Art Deco epoch.

Such movements are often considered elitist, available only to those with deep enough pockets to patronize the best and most famous artists and designers. At certain levels, this is true; as with any exclusive creation, intrinsic quality, artistic input, and rarity can elevate it to a lofty status, yet there is always a trickle-down effect that allows the average person to partake, and textiles are arguably one of the areas in which this can be achieved.

The Art Deco period undoubtedly led to a re-evaluation and wider appreciation of textiles. Consequently, designing within this field became a much more acceptable branch of design in general, one in which women were also able to excel and in which the names of artists could be applied to a design – something almost unheard of in previous eras. The "geometric abstraction" of Sonia Delaunay (1885–1979) is a prime example. Mass-production quickly made the most exclusive designs – or commercial versions of them – widely affordable. The bold geometric, abstract, and stylish patterns that are so redolent of the time turned upholstery fabrics and carpets into an integral and important facet of overall design concepts. Architectural projects were greatly enhanced by elegant and proportionately important designs made for defined spaces and interiors, particularly, for instance, in large-scale buildings and ocean liners like the *Queen Mary*, where designers such as Marion Dorn (1896–1964) produced exemplary work. Ordinary living rooms were transformed, bus seats were jazzier, and clothing prints became infinitely more vibrant.

ABOVE
This chair dating from 1923 is covered in a wool velvet fabric designed by Sonia Delaunay. The chair comes from the salon of the Delaunay family's apartment in Paris, the walls of which were covered in matching geometric fabric.

OPPOSITE
As this illustration from the mid 1920s of women in afternoon dresses shows, the bold lines and stylish patterns of Art Deco design were applied to fashion fabrics as well as textiles for domestic interiors and public spaces, such as theatres.

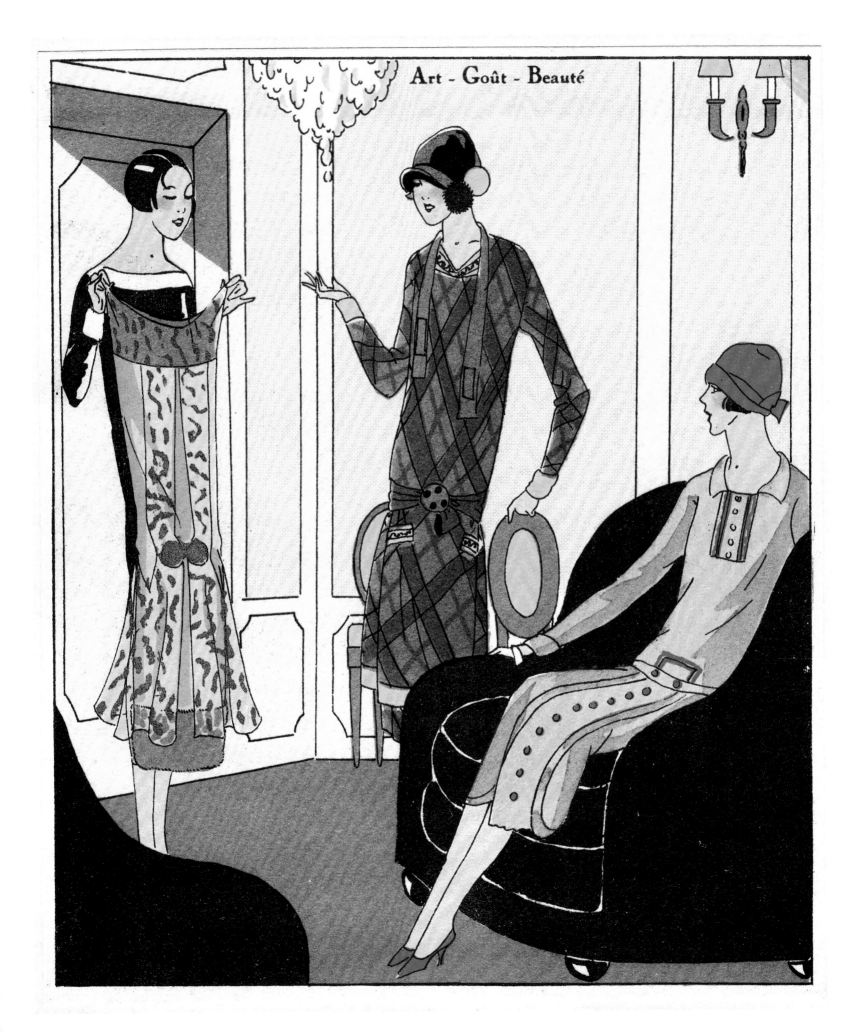

Art - Goût - Beauté

RUTH REEVES

Pioneering textile artist Ruth Reeves (1892–1966) attended the Pratt Institute in New York before moving to Paris in 1920 to study at the Académie Moderne under Fernand Léger (1881–1955). Here she was greatly influenced by artists of the Modernist movement, such as Raoul Dufy (1877–1953), as can be seen in her later designs for Radio City Music Hall in New York.

Many of Reeves's fabric designs are witty "toile de Jouy"-style narratives of everyday American life. Her work was exhibited widely throughout the 1930s and 1940s, but was never really a commercial success. In 1934, sponsored by the Carnegie Institution, Reeves travelled to Guatemala to study and collect textiles. Examples, along with her own designs inspired by the trip, were exhibited to critical acclaim in 1935. Indigenous crafts were a life-long fascination and she received many field research grants, often resulting in collections of textiles for exhibition. But perhaps her most important accomplishment was the "Index of American Design", which commissioned artists to document all genres of American art and remains the most complete survey of American folk art ever undertaken.

In 1956 Reeves received a Fulbright scholarship to travel to India where she lived until her death.

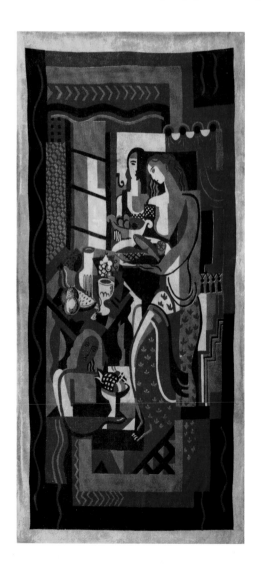

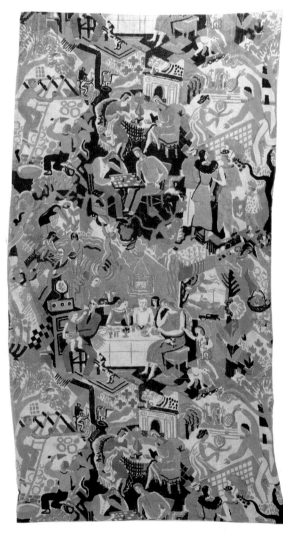

FAR LEFT
A "Figures with Still Life" block-printed cotton velvet tapestry by Ruth Reeves for the W. & J. Sloane textile company, signed "Ruth Reeves" within the print. c1930, 90in (229cm) long, **H**

LEFT
A "The American Scene" repeat pattern block-printed cotton panel by Ruth Reeves, depicting scenes from everyday American life, for the W. & J. Sloane textile company. c1930, 83in (211cm) wide, **I**

EILEEN GRAY

The legacy of Eileen Gray (1878–1976) is remarkable. As a woman operating in a predominantly male world, her place in history as one of the most influential designers of the 20th century is a triumph over the sexism of the time. Born in Ireland, she was one of the first women to study at the Slade School of Fine Art in London. In 1906, she moved to Paris partly to pursue her interest in lacquer-working techniques. Here, she studied with Japanese lacquer craftsman Seizo Sugawara, experimenting with its use in furniture production and architectural panels.

Gray received her first interior design commission in 1917, remodelling an apartment on the Rue de Lota. She designed most of the furniture for the project herself, including her iconic "Bibendum" chair. With its innovative use of lacquered screens, lighting, and geometric-patterned rugs, the resulting project was an opulent mix of Modernism and Art Deco. It was met with great critical acclaim and, spurred on by her success, she opened Galerie Jean Desert in order to sell her own designs.

After 1927, encouraged by Le Corbusier (1887–1965), Gray worked mostly as an architect, yet as history denotes, she remained somewhat in his shadow. She designed two superb Modernist houses in the south of France, for which she also designed the furniture. Other notable projects were exhibited at Le Corbusier's *Pavilion des Temps Nouveaux* at the 1937 Paris *Exposition Internationale des Arts Décoratifs*.

Although Gray carried on working throughout her life, constantly experimenting with plastics and unorthodox uses of material, postwar she faded into relative obscurity. It was not until the 1970s that her work began to be recognized again for its importance in design history. Gray died in Paris.

ABOVE RIGHT
A "Solidadi: Nude/Torso" wool rug by Eileen Gray, in an abstract grey, brown, and black pattern on a cream ground, with an Eileen Gray label on the reverse. c1930, 125in (318cm) long, **J**

RIGHT
A "Blue Marine" wool rug by Eileen Gray, in an abstract blue, grey, and black pattern, designed for her E-1027 villa near Monaco. c1925, 130½in (331cm) long, **J**

GRAPHIC GALLERY

There are certain – sometimes clichéd – characteristics that are commonly used to define Art Deco. It is easy to cite these influences – "speed", "motion", "aerodynamics" – as integral reasons and causes for the development of its identity, and it is largely true: all of these characteristics are amply accommodated in the designs of the era by a type of visual language based upon strong, bold, and colourful abstract notions of what "speed" appears like on a page. In fact, in its simplest and most effective manifestation, it can be represented by a slight slant – perhaps with a speeding locomotive or ocean liner, and some suitably placed "speed lines". Yet, arguably, one could not have existed without the other. It is also important to take into account influences such as economic change, architectural and technological advances, great social upheaval, and a huge media upsurge. When combined with unprecedented wealth – particularly in the USA – and the obvious demand that was created in sectors like consumerism, advertising, and packaging, these made the Art Deco period ripe for a revolution in graphic design, typefaces, logos, and posters. This rich explosion of geometric diversity was almost unprecedented in previous history and is amply illustrated by the iconic designs of many renowned graphic artists, for example A.M. Cassandre (1901–68) in his classic "Normandie" poster of 1935, a style that crossed every boundary of the design field. In textile and carpet design, the graphic language of the movement lent itself well to both repeating and abstract patterns in ultra colourful and even subtle palettes. National styles and use of colour are often easily interpreted in this genre, with American, French, and German designs showing characteristic nuances and differences.

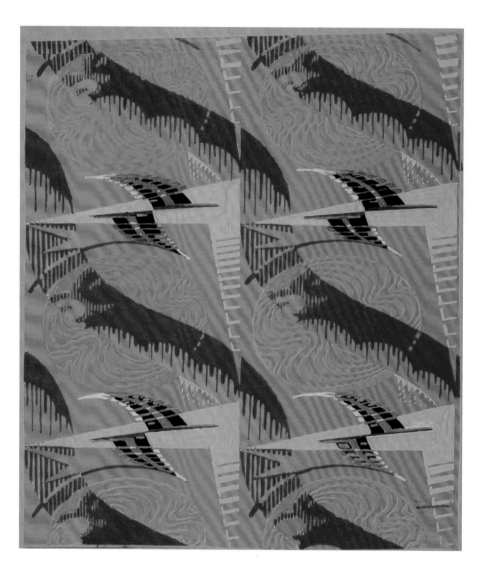

ABOVE
A striking fabric design by John Churton for the Silver Studio, with bold, geometric, bird-like shapes on a background of diagonal meandering lines and circular motifs in vibrant orange. The Silver Studio was one of the most prolific and influential design practices of the 20th century. c1934, **NPA**

GEOMETRIC GALLERY

FERNAND LÉGER ◊ OTTO PRUTSCHER

Like many artistic movements, Art Deco was born out of a number of different conditions, both social and design orientated. Throughout the ages, artists have striven to reinvent and revitalize the narratives of past movements by exploring a variety of visual languages. Out of the elaborate and "over-decorative" designs of the Art Nouveau movement came a new stark and pure adjustment to what many regarded as the more traditional styles of the past, while adapting the linear designs of some Art Nouveau designers, such as Charles Rennie Mackintosh (1868–1928), into a bolder and more significant geometry. From the "isms" of the avant-garde – such as Futurism, Cubism, and Constructivism – came a brave and colourful form of iconography, a geometry that became particularly prevalent in textiles and fashion. This, too, was easily applied to other disciplines such as architecture; yet historical influences were by no means banished from this new movement. In the transition period between Art Nouveau and Art Deco, these two, often contradictory, decorative disciplines intermingled in a wonderful fusion of geometry and ostentation.

RIGHT
A wool rug after a design by Fernand Léger (1881–1955), with a Cubist Art Deco pattern in grey, black, and beige on a dark purple ground. The design bears a close resemblance to the rugs designed by Léger for Maison Myrbor in the 1920s. 65½in (166cm) long, l

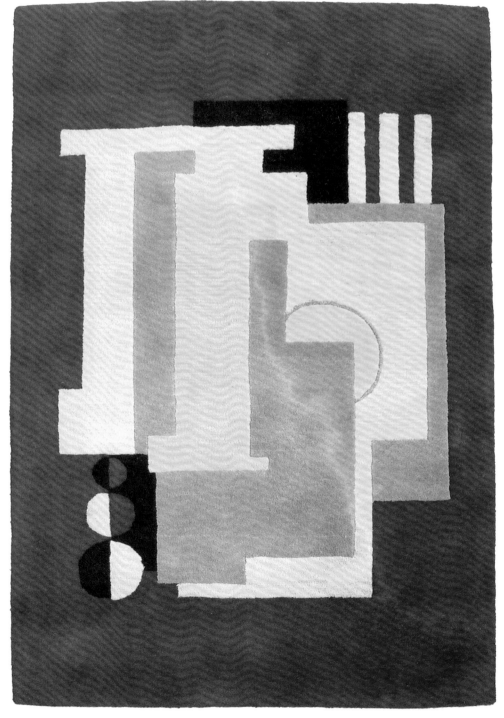

An Art Deco cotton textile, printed with an abstract geometric design in a muted palette on a cream ground. A typical example of British mass-produced soft furnishing fabric of the period, which was often used to introduce pattern and colour into otherwise plainly decorated interiors. c1935, **NPA**

A panel of French Art Deco plush-mohair velvet upholstery fabric, woven in autumnal shades of red, orange, and rust in a jazzy geometric repeating design. France was at the forefront of bold, geometric textile design in this period. c1930, 118in (300cm) long, **J**

An American Art Deco wool carpet by Donald Deskey (1894–1989), designed for Radio City Music Hall, New York, with a square patchwork design of musical instruments in shades of purple, rust, and gold, marked "RADIO CITY MUSIC HALL" to the reverse. c1933, 82in (208cm) long, **K**

A German Art Deco textile design, depicting boldly contrasting and stylized landscapes incorporating natural subjects such as mountain ranges, clouds, water, and trees portrayed in a delineated, highly graphic and geometric, brightly coloured palette. c1935, 9in (23cm) high, **L**

A pair of French Art Deco wool bedside rugs, each a mirror image of the other, with a geometric Modernist design in brown and teal on a tan-coloured ground, with the original fringe. c1930, 52in (132cm) long, **J**

A large Art Deco wool rug with a geometric design in muted polychrome colours on a light beige ground, initialled "GN" within the pile. Room-size rugs are rare and consequently particularly desirable. c1930, 138in (351cm) long, **I**

One of a pair of Art Deco-style woollen rugs, with a shaded green and peach ground with a black and white linear and concentric-ovoid design. 83in (211cm) long, **M**

An American Art Deco wool rug, with an asymmetric geometric design of overlapping diamonds and trapezoidal shapes in shades of peach, brown, grey, and black. c1930, 77in (195.5cm) long, **L**

A linen tablecloth designed by Otto Prutscher (1880–1949), manufactured by the Rhomberg factory, Bavaria, and distributed by the Wiener Werkstätte. Woven in turquoise and white in a geometric Secessionist-style design. c1919, 52½in (133cm) square, **J**

An Art Deco wool rug, with a bold, stylized geometric design giving the illusion of perspective and depth in blue, brown, and purple on a taupe-coloured ground. c1930, 85in (216cm) long, **L**

An Art Deco-style hooked wool wall hanging, the central oval containing a geometric design in shades of tan and blue outlined in black on a dark blue ground. c1950, 62½in (158.5cm) long, **L**

A striking French Art Deco upholstery fabric panel, with a bold and jazzy repeating geometric design of circles and triangles in brown and beige on a black ground. c1930, 18in (45.5cm) wide, **L**

An Art Deco, Viennese Secessionist cotton throw, woven in shades of blue and cream with a geometric floral design surrounded by a geometric pattern border with fringed ends. c1930, 99in (251cm) wide, **J**

HANDBAGS GALLERY

As the most eclectic and thematically diverse of styles, Art Deco lends itself to just about every cultural influence imaginable. From ancient South American art to the new "Machine Age" of mass-production, its metaphors are often complicated and conversely subtle.

What, you might ask, does this have to do with handbags? Bags are both a practical necessity and a superfluous form of adornment; their history can be traced from ancient cultures through to the symbolism of medieval marital sanctity and wealth and on to the surreal creations of Elsa Schiaparelli (1890–1973). They have over time essentially become vehicles for design and ornamentation, as well as symbols of luxury. In the Art Deco period, handbags proved to be a fertile testing ground for a plethora of new materials and designs.

Although largely based on traditional variations of 19th-century mesh purses and woven textile drawstring bags, Art Deco handbags used new processes to introduce surface pattern. Petit point, cut steel, and glass beads were still used to produce integral pattern variations but American companies such as Whiting & Davis mass-produced vibrant screen-printed and enamelled geometric and pictorial examples with their "modern" industrial techniques. The frames of beaded and textile bags were cheaply but stylishly manufactured from moulded celluloid and cast alloys, while borrowing designs from ancient

history, such as Egyptian scarabs, and from the Renaissance. Painted and "jewelled" borders were added for decorative effect.

The "pochette" or clutch bag became very fashionable in this period. Superlative abstract enamelled examples are highly desirable. An alternative form of evening bag was the minaudière: a small, rigid case with several compartments, usually fitted with a lipstick, a powder compact, and a space for small personal items.

Low-cost materials were also utilized, including woven straw and wooden beads. Composites and plastics, such as Bakelite, Catalin, and Lucite, proved perfect for the Art Deco ethic, giving designers the freedom to develop unusual and often playful moulded and sculptural forms, which tapped into the geometric ideals that we associate with the Deco style today.

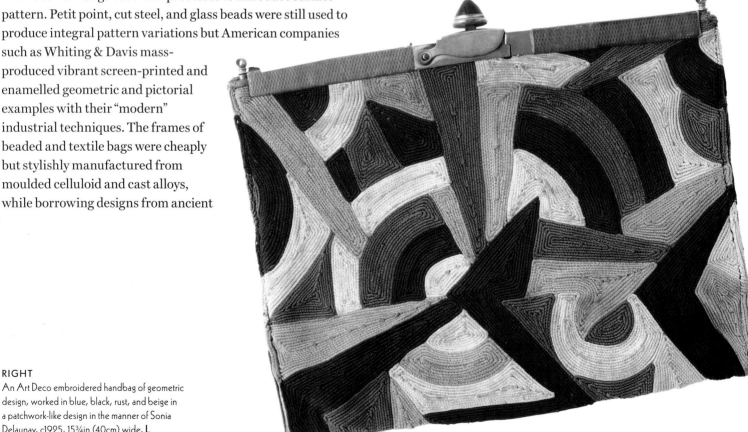

RIGHT
An Art Deco embroidered handbag of geometric design, worked in blue, black, rust, and beige in a patchwork-like design in the manner of Sonia Delaunay, c1925, 15¾in (40cm) wide, **L**

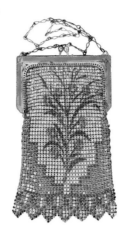

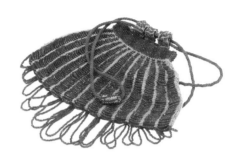

An American Art Deco metal mesh evening bag by Whiting & Davis, enamelled in polychrome colours with a central floral bouquet within geometric borders, the green enamelled frame with jewelled clasp and chain handle. c1925, **M**

An Art Deco drawstring evening bag, the light grey crochet ground worked with vertical rows of red glass beads, the bottom of the bag with long loops of red glass beads. c1930, **M**

A French Art Deco evening bag, the metal mesh body encrusted with rhinestones and hung with a decorative tassle, the brass frame with a chain handle. c1925, 8½in (21.5cm) long, **L**

An American Art Deco metal mesh evening bag by Whiting & Davis, with geometric black, red, and green enamel decoration, the wide frame enamelled in colours and with a chain handle, signed. c1925, 7in (18cm) long, **L**

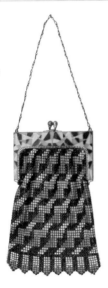

An Art Deco-style beaded "reticule" bag, profusely decorated in polychrome colours with rose bouquets within deep blue borders, closing with a corded drawstring. 1913, 7in (17.5cm) long, **M**

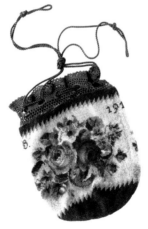

An Art Deco beaded evening bag, decorated with a peacock perched on a rose garland with beaded fringe edge, the metal frame with chain handle and the unusual feature of a leather lining. c1930, 7in (18cm) long, **M**

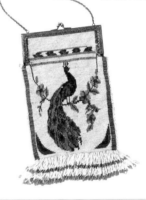

An Art Deco-style beaded evening bag, decorated with a wide band of overlapping circles in brown and lilac on a cream ground, the metal frame with a chain handle. c1950, 8in (20cm) wide, **M**

An Art Deco iridescent beaded handbag, the black ground with a white and brown fan-shaped design, with black Lucite and chromed metal frame and beaded handle. c1930, 7in (18cm) wide, **M**

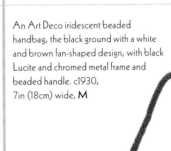

An Art Deco metallic beaded evening bag, in a burnt orange, brown, and black geometric design with a zigzag fringed edge, the gilt metal frame with jewelled clasp and chain handle. c1930, 7in (18cm) long, **M**

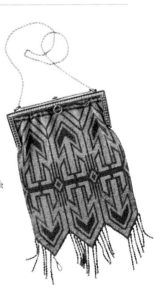

GLOSSARY

ACID ETCHING
Technique involving treatment of glass with hydrofluoric acid, giving a matt or frosted finish.

AMBOINA
Sometimes spelled amboyna, a decorative mottled hardwood varying in colour from light reddish brown to orange.

ANNEALING
Process by which silver is heated and then rapidly cooled in order to soften it sufficiently to be workable. Also refers to slow cooling of hot glass, which reduces internal stresses that may cause cracking once the glass is cold.

ARMOIRE
French term for a linen-press, wardrobe, or large cupboard.

ART NOUVEAU
Movement and style of decoration characterized by sinuous curves and flowing lines, asymmetry, and flower and leaf motifs, prevalent from the 1890s to c1910.

ARTS AND CRAFTS MOVEMENT
Movement advocating traditional handicrafts, a simpler way of life, and the value of well-designed domestic objects, spearheaded by poet and designer William Morris in Britain in the 1880s, before spreading to Europe, the United States, and Japan.

BAKELITE
Robust and attractive synthetic plastic invented by L. H. Baekeland in 1907, which became popular in the 1920s and 1930s. It was used for domestic items, jewellery, and electrical fittings.

BANDING
Veneer cut into narrow strips and applied to create a decorative effect; usually found around the edges of tables and drawer fronts.

BASE METAL
Non-precious metal such as iron, brass, bronze or steel.

BAUHAUS
German design school s founded by Walter Gropius at Weimar in 1919. The name is a play on the German word *Hausbau*, which means "building of a house". The school, which focused on industrial designs characterized by their functional, geometric and austere style, moved to Dessau in 1925 and to Berlin in 1932. It was forced to close by the Nazi regime in 1933.

BLOWN GLASS
A technique where the glassmaker blows air through a hollow rod or blowpipe to shape a mass of molten glass. The glass can be either free-blown or blown into a mould to create more uniform shape.

BURR
Also known as a burl, a burr is a growth that appears on a tree trunk. The wood inside is elaborately patterned and used for its decorative effect in veneering.

CARAT
Measurement of gold; one carat equals 200mg.

CASTING
Method of making objects by pouring molten metal or glass into a mould or cast made from sand, plaster, or metal, conforming to the shape of the finished object.

CHRYSELEPHANTINE
Figural sculptures in which the bodies are made of ivory and the garments of metal (usually bronze), from the Greek for gold (*chrysos*) and ivory (*elephantinos*).

CLOISONNÉ
Enamel fired in compartments (cloisons) formed by metal wires.

CUBISM
Abstract art movement of the early 20th century that analysed the interrelation of forms, with several views of the subject being combined or superimposed on one another.

CRACKLED GLAZE (CRAQUELURE)
Deliberate crackled effect achieved by firing ceramics to a precise temperature.

DE STIJL
Movement founded by abstract artists Piet Mondrian and Theo van Doesburg in the Netherlands in 1917, which focused on achieving harmony by reducing visual elements down to pure geometric forms and primary colours. De Stijl means "style" in Dutch.

DINANDERIE
Decorative brass, copper, or bronze objects with embossed decoration in stylized decorative patterns, originally made in Belgium in the late Middle Ages for ecclesiastical or domestic use.

EARTHENWARE
Term for a type of pottery that is porous and requires a glaze.

EBONIZED
Wood stained and polished black to simulate ebony.

ENAMEL
Form of decoration involving the application of metallic oxides to metal, ceramics, or glass in paste form or in an oil-based mixture, which is then usually fired for decorative effect.

ENGRAVING
Decorative patterns cut into a metal surface using a sharp tool.

FACETED
Decorative surface cut into sharp-edged planes in a criss-cross pattern to reflect the light.

FAIENCE
French term for tin-glazed earthenware.

FIELD
Large area of a rug or carpet usually enclosed by borders.

FINIAL
Decorative turned knob.

FLAPPER
An emancipated young woman of the 1920s, who rejected corsets and wore her hair bobbed short, revelling in the new-found freedoms in fashion and leisure during the Jazz Age.

FRIEZE
Long, ornamental band.

FROSTED GLASS
Glass that has been given a matt, near opaque finish similar to frost by the application of acid, sandblasting, or mechanical etching.

FUTURISM
Italian art movement of the early 20th century, inspired by the technology, dynamism, and speed of the modern world.

GILDING
Method of applying a gold finish to a silver or electroplated item, ceramics, wood, or glass.

GLAZE
Glassy coating that gives a smooth, shiny surface to ceramics and seals porous ceramic bodies.

HALLMARK
Mark on silver that indicated it has been passed at assay. The term derives from the Goldsmiths' Hall, London, where marks were struck.

HOLLOW-WARE
Any hollow items such as bowls, teapots, jugs; distinct from flatware.

INCISED
A pattern scratched into the body of a ceramic or glass vessel with a sharp instrument, such as a metal point, as decoration or to record an inscription, date, or name.

INLAY
Setting of one material (e.g. marble, wood, metal, tortoiseshell, or mother-of-pearl) in another (usually wood).

JARDINIÈRE
An ornamental receptacle, usually a ceramic pot or urn, for holding plants or flowers.

JUGENDSTIL
German and Austrian term for the Art Nouveau style.

LACQUERWARE
Oriental furniture and wooden artefacts coated with numerous polished layers of sap from the lacquer tree. Untreated, the lacquer dries to a lustrous black colour. However, it can also be dyed various colours, notably red, and inlaid with shells or decorative powders. European and American pieces have also been produced in imitation of the oriental originals.

LUSTREWARE
Pottery with an iridescent surface produced using metallic pigments, usually silver or copper.

MILLEFIORI ("THOUSAND FLOWERS")
Glassmaking technique whereby canes of coloured glass are arranged in bundles so that the cross-section creates a pattern. Commonly used in glass paperweights.

MINAUDIÈRE
Small decorative case for carrying personal items such as make-up or jewellery.

MITRE CUT
Type of cut decoration used on glass, made with a V-edged grinding wheel to produce a deep groove.

MODERN MOVEMENT
A vocabulary of architecture and design prevalent in Europe and the United States between the First and Second World Wars, based to a large extent on Le Corbusier's desire to render the home "a machine for living in". The movement is characterized by the use of chrome and glass furniture and fittings, pale walls and ceilings, abstract- or geometric-patterned textiles, and the minimum of displayed artefacts.

MOULD BLOWING
Method of producing glass objects by blowing molten glass into a wooden or metal shaper or mould.

NEO-CLASSICAL STYLE
Emerged in Europe in the 1750s as a reaction to the frivolous Rococo style. Drawing on Classical Roman and Greek architecture for inspiration, Neo-classical interiors were characterized by an elegance and lightness, with a general preferences for linear decoration.

ORIENTAL
Collective term used in the West for Eastern artefacts and styles of decoration and ornament. Includes Arabian, Chinese, Indian, Japanese, Persian, and Turkish styles.

PALETTE
Range of colours used in the decoration of ceramics.

PÂTE-DE-VERRE
From the French for "glass paste", a technique where ground glass is mixed with a liquid to form a paste. It is then pressed into a mould and slowly heated to form the required shape.

PATINA
Fine surface sheen on metal or wood that results from ageing, use, or chemical corrosion.

PEWTER
Alloy of tin or lead (and usually a variety of other metals), used for utilitarian domestic ware as a more affordable and durable alternative to silver since the Middle Ages.

PIERCING
Intricate cut decoration, originally done with a sharp chisel, later with a fretsaw, and finally with mechanical punches.

PLATE
Term originally applied to domestic wares made of silver and gold but now also used for articles made of base metal covered in silver, e.g. Sheffield plate and electroplate.

PRESSED GLASS
Developed in the United States in the 1820s and formed by pouring molten glass into a metal mould before pressing it home with a plunger. Resulting pieces have patterned exteriors and smooth interiors and can be finished by hand.

PRUNT
Blob of glass applied to a glass body for decoration. Prunts are sometimes impressed with a decorative stamp to form "raspberries".

ROUNDEL
Round, flat ornament.

SEAMS
Visible joins in metalwork that has been cast in several places.

SHOULDER
Outward projection of a vase under the neck or mouth.

SLIP
Smooth dilution of clay and water used in the making and decoration of pottery.

SLIP-CASTING
Manufacture of thin-bodied ceramic wares and figures by pouring slip into a mould.

SOLDER
Lead applied to repair cracks and holes in silver.

STERLING SILVER
British term for silver that is at least 92.5 per cent pure.

STONEWARE
Type of pottery fired at a higher temperature than earthenware, making it durable and non-porous. May be covered in a salt glaze.

STREAMLINED
Originally an engineering-design concept in which smooth, clean shapes are used to increase the speed of an object by reducing its resistance to the flow of air. This aesthetic was adopted in the decorative arts during the 1930s and used to create shapes denoting speed and dynamism.

STRETCHER
Rail joining and stabilizing the legs of a chair or table.

STUDIO GLASS
Glass that has been individually designed and crafted.

TAPESTRY
Western European flatwoven textile.

TAZZA
Large, shallow bowl on a stemmed foot made in glass, silver, and ceramics from the 16th century.

THROWING
The technique of shaping ceramic vessels by hand on a rotating wheel.

TREFOIL
Decorative motif shaped like clover, with three pronounced lobes.

TURNING
Type of process by which a solid piece of wood is modelled by turning on a lathe.

VENEER
Thin slice of expensive and often exotic timber applied to an inexpensive secondary timber (carcass) using glue.

VIENNA SECESSION
A breakaway movement formed in 1897 by former members of the Association of Austrian Artists, who were dissatisfied with that organization's conservatism and reliance on academic tradition. Its founding members included painter Gustav Klimt, architect and designer Josef Hoffmann, and artist Koloman Moser.

VINYL
Short for polyvinyl chloride, vinyl is a type of plastic that came into widespread use in the late 1930s.

WIENER WERKSTÄTTE
A progressive cooperative enterprise for art and design founded in Vienna, Austria, in 1903 by Koloman Moser and Josef Hoffmann. Inspired by the Arts and Crafts Movement, it evolved from the Vienna Secession and specialized in hand-made fabrics, furniture, and metalwork.

WROUGHT IRON
A malleable form of iron containing, unlike cast iron, little cementite or graphite, which makes it suitable for fashioning into shapes.

ZIGGURAT
Pyramidal temple towers originally built by Mesopotamian religious cultures, comprising a series of receding, stepped tiers rising from a rectangular, oval, or square base.

RESØURCES

UK AUCTION HOUSES & DEALERS

Alfie's Antique Market
www.alfiesantiques.com

Anderson & Garland Auctioneers
www.andersonandgarland.com

Ashmore & Burgess
www.ashmoreandburgess.com

Capes Dunn
www.capesdunn.com

Central Collectables
www.centralcollectables.com

Charles Ross
www.charles-ross.co.uk

Charterhouse Auctioneers & Valuers
www.charterhouse-auctions.co.uk

Cheffins
www.cheffins.co.uk

Chiswick Auctions
www.chiswickauctions.co.uk

Davies Antiques
www.antique-meissen.com

Dreweatts & Bloomsbury
www.dreweatts.com

Fieldings Auctioneers
www.fieldingsauctioneers.co.uk

Gorringes
www.gorringes.co.uk

Graham Budd Auctions
www.grahambuddauctions.co.uk

Hartley's
www.andrewhartleyfinearts.co.uk

Hickmet Fine Arts
www.hickmet.com

Lyon & Turnbull
www.lyonandturnbull.com

M&D Moir
www.manddmoir.com

Mallett Antiques
www.mallettantiques.com

On the Air
www.vintageradio.co.uk

Onslows
www.onslows.co.uk

Richard Gardner
www.richardgardnerantiques.co.uk

Richard Winterton
www.richardwinterton.co.uk

Roseberys London
www.roseberys.co.uk

Sotheby's
www.sothebys.com/en.html

Sworders Fine Art Auctioneers
www.sworder.co.uk

Tennants
www.tennants.co.uk

The Design Gallery
www.designgallery.co.uk

Toovey's
www.tooveys.com

Van Den Bosch
www.vandenbosch.co.uk

W&H Peacock
www.peacockauction.co.uk

Woolley & Wallis
www.woolleyandwallis.co.uk

US AUCTION HOUSES & DEALERS

Alan Moss
www.1stdibs.com/dealers/alan-moss

Belhorn Auction Services
www.belhornauctions.com

Craftsman Auctions
www.craftsman-auctions.com

DeLorenzo Gallery
www.delorenzogallery.com

Eileen Lane Antiques
www.eileenlaneantiques.com

Freeman's
www.freemansauction.com

High Style Deco
www.highstyledeco.com

James D. Julia Auctioneers
www.jamesdjulia.com

Leslie Hindman Auctioneers
www.lesliehindman.com

Lilian Nassau Ltd.
www.lilliannassau.com

Lost City Arts
www.lostcityarts.com

Macklowe Gallery
www.macklowegallery.com

Moderne Gallery
www.modernegallery.com

Rago Arts & Auction Center
www.ragoarts.com

Skinner
www.skinnerinc.com

Sotheby's, New York
www.sothebys.com/en.html

Swann Auction Galleries
www.swanngalleries.com

EUROPEAN AUCTION HOUSES & DEALERS

AUSTRIA

Auktionshaus im Kinsky GmbH
www.imkinsky.com/en

Dorotheum
www.dorotheum.com

GERMANY

Auction Team Breker
www.breker.com

Dr. Fischer Kunstauktionen
www.auctions-fischer.de

Herr Auktionen
www.herr-auktionen.de

Kunst-Auktionshaus Martin Wendl
www.auktionshaus-wendl.de

Quittenbaum
www.quittenbaum.de

Tecta
www.tecta.de

FRANCE

Gallery Yves Gastou
www.galerieyvesgastou.com

Olivia et Emmanuel
www.oliviasilver.com

Pierre Bergé & Associés
www.pba-auctions.com

Salle de Ventes Pillet
www.pillet.auction.fr

Sotheby's, Paris
www.sothebys.com/en.html

Tajan S.A.
www.tajan.com/en/

SWEDEN

Bukowskis
www.bukowskis.com

ONLINE

Cloud Glass
www.cloudglass.com

Decodame.com
www.decodame.com

Finesse Fine Art
www.finesse-fine-art.com

Modernism Gallery
www.modernism.com

MUSEUMS

UK

Brighton Museum & Art Gallery,
Brighton
www.brightonmuseums.org.uk/brighton/

Royal Museum, National Museums of
Scotland, Edinburgh
www.nms.ac.uk

Geffrye Museum, London
www.geffrye-museum.org.uk

Museum of Domestic Design
& Architecture, London
www.moda.mdx.ac.uk/home

Victoria and Albert Museum,
London
www.vam.ac.uk

Manchester Art Gallery,
Manchester
www.manchestergalleries.org

Bakelite Museum, Williton, Somerset
www.bakelitemuseum.co.uk

US

Los Angeles County Museum of Art,
Los Angeles, CA
www.lacma.org

Art Deco Museum (Art Deco Preservation
Leaguei), Miami Beach, FL
www.mdpl.org/welcome-center/art-deco-
museum/

Wolfsonian at Florida International
University, Miami Beach, FL
www.wolfsonian.org

Charles Hosmer Morse Museum of
American Art, Winter Park, FL
www.morsemuseum.org

Minneapolis Institute of Arts,
Minneapolis, MN
www.artsmia.org

The Metropolitan Museum of Art,
New York, NY
www.metmuseum.org

Museum of Modern Art,
New York, NY
www.moma.org

Virginia Musem of Fine Arts,
Richmond, VA
www.vmfa.museum

CANADA

Royal Ontario Museum,
Toronto, ON
www.rom.on.ca

AUSTRIA

MAK, Austrian Museum of Applied
Arts, Vienna
www.mak.at

BELGIUM

Clockarium Museum, Brussels
www.clockarium.info

FRANCE

Musée Paul-Belmondo,
Boulogne-Billancourt
www.museepaulbelmondo.fr

Musée des Années 30,
Boulogne-Billancourt
www.annees30.com

Musée de l'Ecole de Nancy,
Nancy
www.ecole-de-nancy.com

Musée des Arts Décoratifs, Paris
www.lesartsdecoratifs.fr

Musée Maillol, Paris
www.museemaillol.com

Musée d'Art Moderne de la Ville de Paris,
Paris
www.mam.paris.fr

Musée d'Art et d'Industrie,
Saint-Étienne
www.musee-art-industrie.saint-etienne.fr

GERMANY

Bauhaus-Archiv / Museum für Gestaltung,
Berlin
www.bauhaus.de

Bröhan Museum, Berlin
www.broehan-museum.de

Kunstgewerbemuseum (Museum of
Decorative Arts), Berlin
www.smb.museum

Bauhaus Dessau Foundation, Dessau
www.bauhaus-dessau.de

Museum für Kunst und Gewerbe.
Hamburg
www.mkg-hamburg.de

Museum beim Markt (Badisches
Landesmuseum), Karlsruhe
www.landesmuseum.de

ITALY

Gucci Museo, Florence
www.guccimuseo.com

Museo Salvatore Ferragamo, Florence
www.ferragamo.com

Casa Museo Boschi Di Stefano, Milan
www.fondazioneboschidistefano.it

Villa Necchi Campiglio, Milan
www.casemuseomilano.it

Murano Glass Museum, Venice
www.museovetro.visitmuve.it

PORTUGAL

Museo Calouste Gulbenkian,
Lisbon
www.museu.gulbenkian.pt

RUSSIA

State Hermitage Museum,
St Petersburg
www.hermitagemuseum.org

SPAIN

Casa Lis Museo Art Nouveau y Art Deco,
Salamanca
www.museocasalis.org

ACKNOWLEDGEMENTS

The publishers would like to thank the following organisations for supplying pictures for use in this book.

ALAN MOSS
www.1stdibs.com/dealers/alan-moss
p.30l; p.222r.

ALFIE'S ANTIQUE MARKET
www.alfiesantiques.com
p.71tc; p.111tr; p.157mc; p.167tc; p.229bc.

ANDERSON & GARLAND AUCTIONEERS
www.andersonandgarland.com
p.13tr; p.107b.

ANDREA HALL LEVY
p.229mr.

ASHMORE & BURGESS
www.ashmoreandburgess.com
p.111tc; p.111ml; p.111mr.

ATLANTIQUE CITY ANTIQUES SHOW
p.99bl; p.99br; p.165mr; p.169tc; p.169mr; p.169bc; p.169br.

AUCTION TEAM BREKER
www.breker.com
p.169tl.

AUKTIONSHAUS IM KINSKY GMBH
www.imkinsky.com
p.49tc; p.49mr; p.74; p.75bl; p.75bc; p.77tr; p.227mc.

BELHORN AUCTION SERVICES
www.belhornauctions.com
p.97l; p.97r; p.101br.

BEVERLEY
p.70.

BUKOWSKIS
www.bukowskis.com
p.44t.

CALDERWOOD GALLERY
www.calderwoodgallery.com
p.20; p.21b; p.22r; p.23l; p.49bc © ADAGP, Paris and DACS, London 2016.

CAPES DUNN
www.capesdunn.com
p.79b; p.93ml.

CENTRAL COLLECTABLES
www.centralcollectables.com
p.93mc.

CHARLES ROSS
www.charles-ross.co.uk
p.92.

CHARTERHOUSE AUCTIONEERS & VALUERS
www.charterhouse-auctions.co.uk
p.157ml.

CHEFFINS
www.cheffins.co.uk
p.71bc.

CHENU, SCRIVE & BERARD
p.48.

CHISWICK AUCTIONS
www.chiswickauctions.co.uk
p.90; p.91tc.

CLASSIC AUTOMOBILIA & REGALIA Specialists (C.A.R.S.)
p.157tr; p.157mr; p.157bc.

CLAUDE LEE AT THE GINNEL
p.71mc.

CLOUD GLASS
www.cloudglass.com
p.111bc.

CRAFTSMAN AUCTIONS
www.craftsman-auctions.com
p.101bl.

DAVIES ANTIQUES
www.antique-meissen.com
p.84.

DECO ETC
p.61tc; p.61mc; p.147bc.

DECODAME.COM
www.decodame.com
p.4r; p.5r; p.42; p.58; p.59ml; p.59bc; p.61tl © ADAGP, Paris and DACS, London 2016; p.61br; p.64; p.119r;

p.125tl; p.131tc; p.150; p.151l; p.154; p.155tl; p.159tl © ADAGP, Paris and DACS, London 2016; p.163tl; p.165tc © ADAGP, Paris and DACS, London 2016; p.165bc; p.217br; p.225br; p.227tl; p.227br; p.229tl.

DELORENZO GALLERY
www.delorenzogallery.com
p.19l; p.19c; p.19r; p.53l.

DOROTHEUM
www.dorotheum.com
p.39t; p.86l; p.86c; p.87r; p.91ml; p.95c; p.117t; p.131tr; p.134; p.145mr; p.165ml; p.165br; p.174r.

DR. FISCHER KUNSTAUKTIONEN
www.auctions-fischer.de
p.77bl; p.123bl; p.131mr; p.133tl; p.133mr.

DREWEATTS & BLOOMSBURY
www.dreweatts.com
p.59bl; p.77mr; p.145mc; p.145br; p.147bl; p.153mc; p.167bl; p.169mc; p.180; p.193mr.

EDISON GALLERY
p.169bl.

EILEEN LANE ANTIQUES
www.eileenlaneantiques.com
p.29tc; p.29mr.

FIELDINGS AUCTIONEERS
www.fieldingsauctioneers.co.uk
p.66l; p.66c; p.69l; p.71tl; p.71bl; p.71br; p.82l; p.83t; p.83bl; p.83bc; p.88l; p.89bl; p.91mc; p.91bc; p.111bl; p118l © ADAGP, Paris and DACS, London 2016; p.118r © ADAGP, Paris and DACS, London 2016; p.133tc; p.133mc; p.166.

FINESSE FINE ART
www.finesse-fine-art.com
p.157tl; p.157bl; p.157br.

FREEMAN'S
www.freemansauction.com
p.22l; p.29bc; p.37t © DACS 2016; p.41t © FLC/ADAGP, Paris and DACS, London 2016; p.137br; p.141tr; p.153mr; p.165mc; p.179r; p.229tc.

GALLERY 1930 / SUSIE COOPER CERAMICS
p.78; p.87bl.

GALLERY YVES GASTOU
www.galerieyvesgastou.com
p.23r.

GLAS VON SPAETH
p.118r.

GORRINGES
www.gorringes.co.uk
p.175l; p.183l.

GRAHAM BUDD AUCTIONS
www.grahambuddauctions.co.uk
p.217tl.

GRAHAM COOLEY COLLECTION
p.123mr; p.125tc.

HARTLEY'S
www.andrewhartleyfinearts.co.uk
p.68r.

HERR AUKTIONEN
www.herr-auktionen.de
p.25; p.145tl © DACS 2016.

HI-LO MOD
p.99t.

HICKMET FINE ARTS
www.hickmet.com
p.176 © ADAGP, Paris and DACS, London 2016; p.177r © ADAGP, Paris and DACS, London 2016; p.184r; p.185r; p.187tl; p.187tr; p.187bl; p.190 © Sevenarts Ltd/DACS 2016; p.191t © Sevenarts Ltd/DACS 2016; p.191bl © Sevenarts Ltd/DACS 2016; p.191br © Sevenarts Ltd/DACS 2016; p.192 © ADAGP, Paris and DACS, London 2016; p.193tc; p.193tr; p.193mc; p.193bl; p.193bc; p.193br.

HIGH STYLE DECO
www.highstyledeco.com
p.31r; p.59tl; p.147tl; p.149r; p.151t.

J. WORBLEWKIE
p.225tr.

JAMES D. JULIA AUCTIONEERS
www.jamesdjulia.com
p.113tc; p.117bl; p.117b; p.127r; p.165tl.

JAZZY ART DECO LTD.
p.56; p.57bl; p.227bc.

JEANETTE HAYHURST FINE GLASS
www.bada.org/dealers/d/jeanette-hayhurst-fine-glass/154
p.122; p.123tl; p.123tc; p.123tr; p.123bc;
p.125mc.

JOHN JESSE
p.59mc; p.69r; p.95r; p.153bc; p.167ml;
p.167bc.

KUNST-AUKTIONSHAUS MARTIN WENDL
www.auktionshaus-wendl.de
p.229tr.

LE BLASON D'OR
p.120l.

LESLIE HINDMAN AUCTIONEERS
www.lesliehindman.com
p.29tl; p.29mc; p.59tc; p.136; p.174l;
p.181bl.

LILI MARLEEN
p.24l; p.24r; p.28; p.29tr; p.49mc; p.61mr.

LILIAN NASSAU LTD.
www.liliannassau.com
p.123mc; p.127l; p.133bl; p.133br.

LOST CITY ARTS
www.lostcityarts.com
p.50.

LYON & TURNBULL
www.lyonandturnbull.com
p.3 © ADAGP, Paris & DACS, London
2016; 5cl; p.33l; p.33r; p.38r; p.40 ©
ADAGP, Paris and DACS, London 2016;
p.57tl; p.57r; p.67b; p.89t; p.91r; p.93tr;
p.130; p.131ml; p.177l © ADAGP, Paris
and DACS, London 2016; p.178l; p.183r;
p.185l.

M&D MOIR
www.manddmoir.com
p.115l; p.115r.

MACKLOWE GALLERY
www.macklowegallery.com
p.135tl.

MALLETT ANTIQUES
www.mallettantiques.com
p.111br; p.121l; p.121r.

MODERNE GALLERY
www.modernegallery.com
p.21t; p.26; p.61bl; p.61bc; p.77tl; p.98;
p.155br © ADAGP, Paris and DACS,
London 2016; p.159br; p.164l; p.164r; p.228.

MODERNISM GALLERY
www.modernism.com
p.77mc.

MOOD INDIGO
p.167mc.

NICK AINGE
p.71ml; p.71mr.

OLIVIA ET EMMANUEL
www.oliviasilver.com
p.145bc.

ON THE AIR
www.vintageradio.co.uk
p.168.

ONSLOWS
www.onslows.co.uk
p.199tr; p.197r.

PAUL SIMONS
p.167tr.

PIERRE BERGÉ & ASSOCIÉS
www.pba-auctions.com
p.73cl.

PORT ANTIQUES CENTER
p.111tl.

QUITTENBAUM
www.quittenbaum.de
p.36l © DACS 2016; p.36r © DACS
2016; p.46; p.61ml; p.75t; p.77bc; p.77br
© ADAGP, Paris and DACS, London
2016; p.93bl; p.110; p.114; p.125tr; p.128;
p.129r; p.131bl; p.131bc; p.133r; p.133bc;
p.140; p.141bl; p.141br; p.143t; p.145tc;
p.145bl; p.147mr; p.148c; p.148r; p.155bl;
p.187br.

RAGO ARTS & AUCTION CENTER
www.ragoarts.com
p.27; p.29ml; p.29bl; p.29br; p.30r; p.31l;
p.37b © DACS 2016; p.38l; p.39b; p.43l;
p.44b; p.45t; p.49ml; p.49br; p.49tr; p.49bl;
p.5l; p.52; p.53r; p.54l; p.54r; p.55; p.59mr;
p.72; p.73cr; p.73r; p.75br; p.93br; p.94l;
p.94r; p.96; p.100l; p.100r; p.101t; p.101bc;
p.104; p.106l; p.106r; p.107t; p.108l; p.108r;
p.109l; p.112; p.113tl; p.113tr; p.113ml; p.113mc;
p.113mr; p.113bl; p.113bc; p.113br; p.116; p.119l
© ADAGP, Paris and DACS, London 2016;
p.125br; p.125mr; p.126; p.135tr © ADAGP,
Paris and DACS, London 2016; p.135bl;
p.135br © ADAGP, Paris and DACS,
London 2016; p.145tr; p.147tc; p.147ml;
p.148l; p.149l; p.151bc; p.151br; p.153tl;
p.153ml; p.153br; p.156; p.158; p.159tr;
p.159bl © ADAGP, Paris and DACS,
London 2016; p.160; p.161l; p.161r; p.165tr;
p.169ml; p.188; p.222l; p.223t; p.223b;
p.225bl; p.226; p.227tc; p.227ml; p.227mr.

RICHARD GARDNER
www.richardgardnerantiques.co.uk
p.165bl.

RICHARD WINTERTON
www.richardwinterton.co.uk
p.167br.

ROSEBERYS LONDON
www.roseberys.co.uk
p.59br; p.61tr.

SALLE DE VENTES PILLET
www.pillet.auction.fr
p.193tl; p.193ml.

SKINNER
www.skinnerinc.com
p.163tr; p.227bl.

SOTHEBY'S
www.sothebys.com
p.88r; p.131tl; p.131br.

SOTHEBY'S, NEW YORK
www.sothebys.com
p.59tr © ADAGP, Paris and DACS,
London 2016.

SOTHEBY'S, PARIS
www.sothebys.com
p.49tl.

SWANN AUCTION GALLERIES
www.swanngalleries.com
p.5cr; p.196l; p.196r; p.197l, p.197c;
p.198; p.199tl; p.199bl; p.199br; p.200;
p.201tl; p.201 © DACS 2016; p.201bl ©
ADAGP, Paris and DACS, London 2016;
p.201br; p.202 © ADAGP, Paris and
DACS, London 2016; p.203tl; p.203tc;
p.203tr; p.203m; p.203bl; p.203bc;
p.203br; p.204; p.205l; p.205r; p.206l;
p.206r; p.208; p.209tl; p.209tr; p.209bl;
p.209br; p.211tl; p.211tr; p.211bl; p.211br;
p.212 © ADAGP, Paris and DACS,
London 2016; p.213t © ADAGP, Paris
and DACS, London 2016; p.213mr ©
ADAGP, Paris and DACS, London 2016;
p.213ml © ADAGP, Paris and DACS,
London 2016; p.213br © ADAGP, Paris
and DACS, London 2016; p.214; p.215tl;
p.215tl; p.215tr; p.215bl; p.215br; p.216;
p.217tr © ADAGP, Paris and DACS,
London 2016; p.217bl.

SWORDERS FINE ART AUCTIONEERS
www.sworder.co.uk
p.4c; p.32; p.66r; p.89br; p.91tl; p.152;
p.153tr; p.163br; p.169tr; p.181br; p.227tr.

TAJAN S.A.
www.tajan.com/en/
p.120r.

TECTA
www.tecta.de
p.60.

TENNANTS
www.tennants.co.uk
p.4l; p.43r; p.83br.

THE DESIGN GALLERY
www.designgallery.co.uk
p.80; p.229bl.

THE SILVER FUND
www.thesilverfund.com
p.142; p.143bl; p.143bc; p.143br; p.147br.

THOMAS DREILING COLLECTION
p.137tl; p.137tr.

TOOVEY'S
www.tooveys.com
p.181tr; p.184l.

VAN DEN BOSCH
www.vandenbosch.co.uk
p.144.

VON ZEZSCHWITZ
www.von-zezschwitz.de
p.34 © ADAGP, Paris and DACS,
London 2016; p.41b © ADAGP, Paris
and DACS, London 2016; p.77tc; p.129l;
p.131mc; p.133ml; p.137bl; p.145ml;
p.155tr; p.172 © ADAGP, Paris and
DACS, London 2016.

W&H PEACOCK
www.peacockauction.co.uk
p.167mr.

WOOLLEY & WALLIS
www.woolleyandwallis.co.uk
p.9r; p.45b; p.57br; p.67tl; p.67tc; p.67tr;
p.68l; p.71tr; p.73l; p.76; p.77ml ©
ADAGP, Paris and DACS, London 2016;
p.79t; p.82r; p.86r; p.87tl; p.89bc; p.91tr;
p.91bl; p.91br; p.93tl; p.93tc; p.93mr;
p.93bc; p.95l; p.111mc; p.123ml; p.123br;
p.124; p.125ml; p.125bl; p.125bc; p.132;
p.146; p.147tr; p.147mc; p.153tc; p.153bl;
p.157tc; p.162; p.163bl; p.175r; p.178r;
p.179l; p.182l; p.182r; p.186.

**ADDITIONAL PHOTOGRAPHIC
CREDITS**

akg-images Jean Tholance/Les Arts
Décoratifs, Paris 220.
Alamy LOOK Die Bildagentur der
Fotografen GmbH 102.
Bridgeman Images Bibliotheque des Arts
Décoratifs, Paris/Archives Charmet 105;
Brooklyn Museum of Art, New York 18;
Christie's Images Ltd/© Sevenarts Ltd/
DACS 2016 189; Stapleton Collection
219.
Corbis 221; Christie's Images Ltd 65; Dan
Forer/Beateworks 14; Stapleton Collection
17.
Getty Images Robert Yarnall Richie 195; A
Jemolo/De Agostini 81; Ann Ronan/Print
Collector 9m; Cate Gillon 62; Chicago
History Museum 47; Cosmo Condina
7; DeAgostini 103; Fox Photos back
endpaper; General Photographic Agency
10, 15; George Rinhart 85; Herbert/
Frederic Lewis 171; Heritage Images 139;
Hulton Archive 8; Jonathan Kim/Corbis
via Getty Images front endapaper; Mark
Sykes 138; Maurice Branger/Roger Viollet
6; Museum of Science and Industry,
Chicago 210; Oliver Strewe 13b; The Print
Collector/© ADAGP, Paris and DACS,
London 2016 35; Universal History
Archive/UIG via Getty Images 51.
Image Courtesy of Museum of Domestic
Design & Architecture, Middlesex
University 224, 225tr.
Mary Evans Picture Library Grenville
Collins Postcard Collection 63.
Scala Namur Archives 16.
© TfL from the London Transport
Museum collection 11.
The Art Archive Gianni dagli Orti 9l;
Kharbine Tapabor 170; Theatre Museum
London/V&A Images 173.
The Kobal Collection UFA 207.
© Victoria and Albert Museum, London
218.

ADDITIONAL PICTURE CAPTIONS

Endpapers, front: A cabin aboard the
Normandie, a French ocean liner launched
in 1935.

Furniture, p14: A variety of Art Deco
elements, from the glass ceiling light to the
geometric design of the metal banister, can
be seen in this contemporary home.

Furniture, p15: This glamorous Art Deco
living room was designed and built for the
1929 film *Our Modern Maidens*, which
starred Joan Crawford.

Ceramics, p62: A collection of Clarice
Cliffe teacups from the 1920s and 1930s.

Ceramics, p63: Photographed in the
1930s, a young employee of the Poole
Pottery shapes a pot at the potter's wheel.

Glass, p102: Designed in 1921 as an Art
Deco picture palace, the Tuschinski cinema
in Amsterdam still shows films today.

Glass, p103: The diamond dealers'
pavilion at the 1925 *Exposition
Internationale des Arts Décoratifs et
Industriels Modernes*. The panels of the
glass roof and the light fittings on the sides
of the building echo faceted gems.

Silver, Metalware, Clocks & Plastic, p138:
The aluminium and gilt ceiling of the lobby
of the Daily Express Building in London.
The building was designed in 1932 by Ellis
and Clark, and the spectacular entrance
lobby by Robert Atkinson.

Silver, Metalware, Clocks & Plastic, p139:
The exit to the foyer of the Odeon cinema
in London's Leicester Square, 1937.

Sculpture, p170: The facade of the Folies
Bergère in Paris features a relief of stylized
female figure, designed in 1926 by Maurice
Picaud (1900–77), known as Pico.

Sculpture, p171: The Graybar Building
at 420 Lexington Avenue, New York.
The building was completed in 1927,
and its entrance is flanked by bas-reliefs
of Assyrian-style figures: one is holding a
telephone, the other a truck.

Posters, p194: An English-language poster
promoting Soviet Armenia, produced
around 1935 by Intourist, the Soviet state
tourism agency and designed in the Social
Realist style.

Posters, p195: A 4700 horsepower
"Hudson" steam locomotive on the New
York Central Train System, photographed
around 1933. These trains were designed
by Henry Dreyfuss (1904–72), and built by
the American Locomotive Company.

Textiles, p218: Printed cotton furnishing
fabric produced by William Foxton Ltd in
England around 1928. In the 1920s, the
firm became known for its innovative, artist-
designed textiles.

Textiles, p219: An elegant bedroom
designed by Émile-Jacques Ruhlmann
(1879–1933), featuring a luxurious
bedspread, upholstered furniture and a rug
in a bold Art Deco design.

Endpapers, back: A line of young
Flappers, photographed around 1925.

INDEX

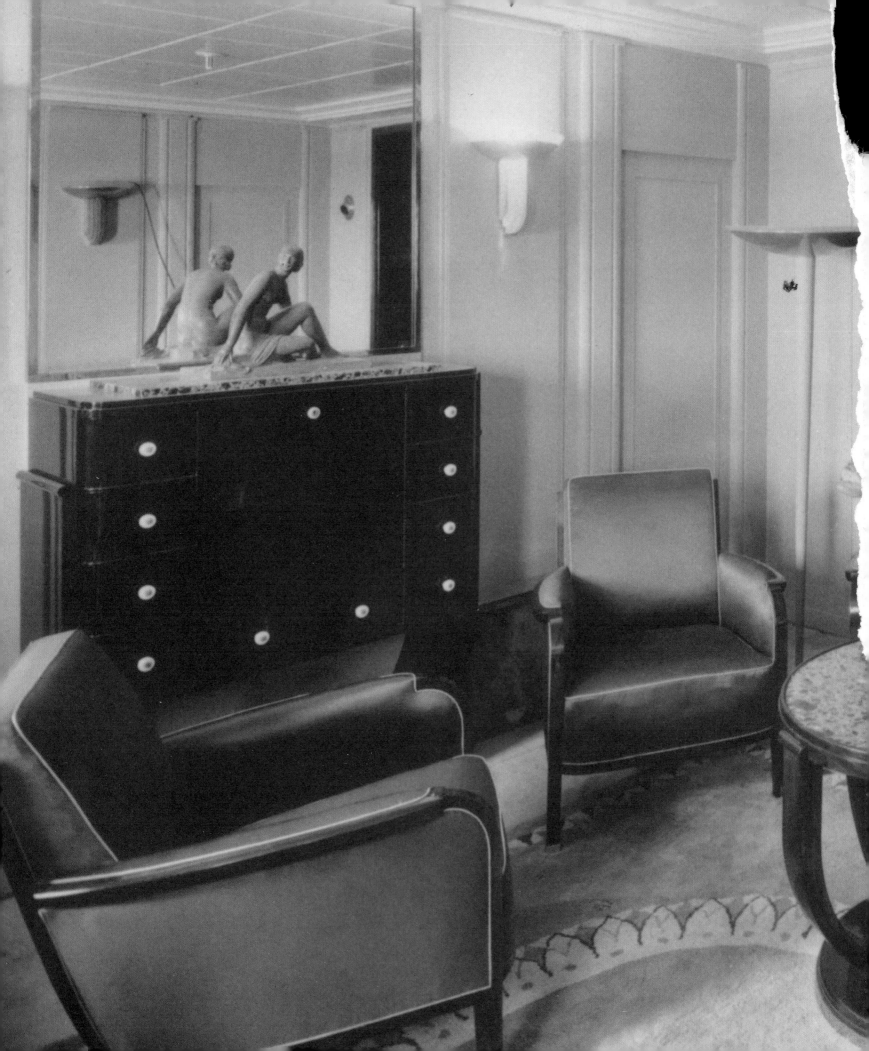